Jacopo della Quercia

VOLUME I

Jacopo della Quercia

VOLUME I

James Beck

COLUMBIA UNIVERSITY PRESS
NEW YORK

THE PRESS WISHES TO ACKNOWLEDGE THE GENEROUS AID
OF THE CITY OF BOLOGNA AND OF MAYOR RENZO IMBENI
IN THE PUBLICATION OF THESE VOLUMES.

Columbia University Press
New York Oxford
Copyright © 1991 Columbia University Press
All rights reserved

Library of Congress Cataloging-in-Publication Data

Beck, James H.
 Jacopo della Quercia / James Beck.
 p. cm.
 Includes bibliographical references and index.
 ISBN 0-231-07200-7 (SET). ISBN 0-231-07684-3 (VOL. I).
ISBN 0-231-07686-x (VOL II).
 1. Jacopo, della Quercia, 1372?–1436. 2. Sculptors—Italy—
Biography. 3. Jacopo, della Quercia, 1372?–1436—Catalogues
raisonnés. I. Title.
NB623.04B39 1991
730′.92—dc20
[B] 90-22467
 CIP

Casebound editions of Columbia University Press books are Smyth-sewn
and printed on permanent and durable acid-free paper

Printed in the United States of America

c 10 9 8 7 6 5 4 3 2 1

For Darma, Nora, and Larry

Contents

VOLUME I

VOLUME II

Acknowledgments

THIS BOOK has taken a dreadfully long time to complete, following my dissertation at Columbia University (1963) and the monograph on the Portal of San Petronio (1970) that was derived from it. I had decided to await the appearance of Charles Seymour, Jr.'s monograph (Yale University Press, 1973) and the Quercia celebrations of 1975, whose acts were published in 1977, before completing my own work. Somewhat disgracefully, still another decade has passed; but throughout these years, former teachers, colleagues, friends and students have always been helpful, beginning with Rudolf Wittkower, under whose direction I first studied Jacopo, and Charles Seymour, Jr., whose remarkable knowledge, friendliness, warmth and generosity were constantly available. Others including H. W. Janson, U. Middeldorf, R. Krautheimer, Enzo Carli, Otto J. Brendel, C. H. Smyth, H. McP. Davis, Howard Hibbard, and John Pope-Hennessy have been helpful on specific matters and were generously encouraging. Other colleagues, including Giovanni Previtali, who had organized the Quercia celebrations, offered support, as has Antonio Romiti and Sonia Fineschi, the remarkable director of the Archivio di Stato in Siena. Cesare Gnudi was instrumental in putting my work on the right track at early stages of research, as was my friend, the distinguished Bolgonese historian, Mario Fanti. Carlo del Bravo, John Paoletti, Anne Coffin Hanson, A. M. Matteucci, and Harriet McN. Caplow have given invaluable advice. Dr. Gino Corti has made a timely contribution by reading over the transcriptions of the documents. I have had the help of graduate students, including Elinor Richter, Gail Aronow, Ruth Eisenberg, and Jane Nicol. I happily acknowledge excellent suggestions made by Perry Brooks and Mary Bergstein, while they read long sections. In particular, I wish to express special gratitude to Maria Grazia Pernis, who has served as my Research Assistant during the past several years and who intelligently and unselfishly aided me in getting the manuscript prepared for the Press.

Finally, I am pleased to acknowledge the support of Jennifer Crewe, editor at the Columbia Press, who took a sympathic stance toward the publication of this demanding work, as did its Director, John Moore. The contribution of Ann Miller of the Columbia University Press, who conscientiously edited the manuscript, is nothing short of remarkable. She goodnaturedly but pointedly made suggestion after suggestion, improving the manuscript at every step.

List of Illustrations

Illustrations appear in Volume II.

Introduction

JACOPO DELLA Quercia's preeminent standing in the history and criticism of European art has long been assured. It has been based, in no small measure, upon the conscious and widely recognized admiration that Michelangelo heaped upon the earlier master through his own image-making. The Florentine found in Jacopo not merely a kindred spirit from the recent past but an artist of high invention and stubborn integrity, whose figural types, especially the nudes and his compositional solutions, offered the *terribile* Michelangelo insights unavailable elsewhere. Jacopo's Genesis reliefs from Siena and Bologna provided Michelangelo with jumping-off points from which the Sistine Chapel ceiling fresco gains much of its power. And if his painting echoed Jacopo's direct, self-controlled vision, Michelangelo's sculpture also benefited from analogous impulses, as is recognized in the statuettes for the Arca of San Domenico in Bologna and for the *Bruges Madonna*.

In emphasizing Jacopo della Quercia as the proto-Michelangelesque artist *per eccellenza*—more so, to be sure, than even Donatello—is an injustice to both Michelangelo and Jacopo being perpetuated? The answer probably requires both a "Yes" and a "No." Jacopo pertains to a three-centuries-long tradition in Italian sculpture that first flourished with Nicola Pisano and Arnolfo di Cambio, and in a more specialized context with Giovanni Pisano; it bursts forth again with Jacopo himself and with Nanni di Banco, and it gained new vitality in Michelangelo. All of these artists were essentially not modelers but carvers who attacked the resistant stone with physical energy, confidence, and knowledge.

On the other hand, to see any gifted artist merely within the context of his contribution to a given movement or the development of other artists is to marginalize his intrinsic worth and personal expression, which lie, for me, at the heart of the critical study of art. Instead of recognizing Jacopo as vital "source" for Michelangelo and consequently to be esteemed, we are on firmer

footing in joining with Michelangelo in savoring Jacopo's inventions, in isolat-
ing his specific contributions, his unique interpretations; and further, by defin-
ing his personality, some of his secrets might be revealed.

If the approach of this book appears to be monographic, such is not an
accident, because a monograph about an early Renaissance artist still retains
value, usefulness, and authority. Over and above movements, trends, cultural
patterns, stylistic ruptures and revivals, economic booms and busts, political
turmoils and political calms, the requirements of patrons, the ever-rising and
ever-falling of the middle class, history—and the history of art—is made by
individuals, according to a well-established Renaissance notion that continues
to have validity for me. Consequently I am offering here a monograph on
Jacopo della Quercia, within a framework of criticism that reaches at least as
far back as Vasari and further still, to Vasari's sources, Ghiberti's *Commentar-
ies* and Manetti's *Life of Brunelleschi*. The public and private life of an artist is
inextricably interwoven with his artistic production, the chronology of his
works, the development and changes in his style. What I am presenting then is
a time-honored formula combining an exploration of the life and work of a
master. On the other hand, I would not give the impression that my handling of
the data is necessarily conventional, certainly not in relation to earlier Quercia
studies, and, I should hope, not with respect to monographs on other fifteenth-
century masters either, because each artist requires a treatment suitable to his
unique *persona* and creative nature.

————

As if part of a grand design, Jacopo's artistic career, subsequent to a period of
training, falls into three readily distinguishable phases, each represented by a
major project. His career can quite effortlessly if somewhat mechanically be
organized into early, middle, and late phases. The *Ilaria Monument* in Lucca,
despite serious losses, epitomizes his first manner, or the early phase; the *Fonte
Gaia* in Siena, still more seriously damaged—mainly, in this case, by the
vagaries of time—represents the second, or middle phase; and the *Main Portal
of San Petronio* in Bologna, the third or late phase of his art. All of the other
sculptures connected with Jacopo can be clustered around these three master-
pieces.

The three phases coincide with Jacopo's periods of prolonged activity in
three diverse centers, Lucca, Siena, and Bologna, which of course signify three
different histories and cultures within the larger framework of Renaissance
Italy. The conditions that gave birth to the vigorous Sienese style in the thir-
teenth century—a style that continued to feed upon itself for fully two centuries
and more—were distinct from those in Bologna that Jacopo inherited when
embarking upon the *Portal of San Petronio* in 1425. His sculpture for Lucca
had to take into account a cultural climate that was often calibrated to events
north of the Alps rather than to Tuscany, at least in terms of the wealthy patrons.

Hence Jacopo had to constantly adjust his own artistic language, making concessions or at least accommodating the local requirements in the centers where he found himself at different times.

Perhaps the most striking result of my study has been the realization that of all of Jacopo's contemporaries—artists of first rank such as Ghiberti, Nanni di Banco, Donatello, Brunelleschi, Michelozzo, and Masaccio, all of whom he must have personally known—not only was Jacopo the only non-Florentine but he was in every sense the least provincial. In a large measure this condition was the product of his curious background: born in Siena of Sienese lineage, he grew up in Lucca, where he was trained during his crucial formative years. The ambience of the coast nearby with the endless marble deposits at Carrara and Pietrasanta, as well as the artistic quarries of ancient and medieval art at Pisa, was part of his early heritage. Thus we have a lad who had been oriented in Sienese habits but was trained in the local shops of Lucca. As a young artist he went off to Florence, where he became aware of the newest developments among his progressive contemporaries. Yet his formation did not stop in Tuscany. Quite soon in his artistic life Jacopo went north to Emilia; he was recorded in Ferrara and very likely spent time in Bologna as well. Once there, it is easy to imagine a trip to Venice and another to Milan, where vast sculptural undertakings were in progress at San Marco and at the Milanese cathedral. Like Nicola Pisano before him, Jacopo should be regarded, more than any one of his great contemporaries, not as a Tuscan or even a Sienese master, but as *the "Italian" master* of the fifteenth century, free from the localisms that encumbered many of the others. Only Antonello da Messina has a regionally varied background that rivals Quercia's in richness.

This book is composed of four large sections: the biography of the artist, in its broadest aspects; an exploration of the style of his art; a catalogue of works that can be securely attributed to him, with extensive notes and comments; and the original texts of more than five hundred documents related to the artist and his work, accompanied by comments where desirable. The latter two parts are conceived as largely independent units that can be consulted rapidly to control a given work, to verify a particular document. Inevitably, repetition between sections may result, which, I trust, will be outweighed by the utility of easy reference.

In the section devoted to the life of the artist, a conscious effort has been made not only to treat the confirmable facts surrounding his life, his whereabouts, his family, and his activities, but to offer insights into his way of thinking, his private personality. By carefully studying the documentation, including autograph letters—wringing dry, as it were, the available data—conclusions can be made about Jacopo that have not been drawn earlier. The desired result is to tighten the knot between understanding the person and

understanding his art. Jacopo, we learn, had relationships with numerous artists and artisans, whose cause he seems to have championed whenever he could. As far as his immediate family is concerned, Jacopo attentively looked after a sister and her daughter and also appears to have been concerned about the well-being of his brother, the painter Priamo della Quercia. For the first time we have a glimpse at the private person, who comes through as a highly sympathetic man—which coincides, at least from a human point of view, with what can be read in his art.

A study of the style of Jacopo's sculpture, approached chronologically, reveals a somewhat unexpected complexity—certainly, a greater complexity than ever before perceived. The massively proportioned yet simplified figures, the heavy musculature, the direct compositions, should not be permitted to obfuscate the subtlety of Jacopo's mind nor the breadth of his artistic intentions. His three principal projects may be interpreted as pioneering, innovative statements within their individual typological categories. For example, the *Ilaria Tomb Monument* was one of the first if not *the* first such work produced in the Renaissance. The introduction of winged, nude putti in the context of a funerary monument in the early years of the fifteenth century had a substantial impact. These attractive boys represented an attitude toward antiquity that was especially precocious; as a type they became indelibly identified with the entire historical period. Jacopo's design for the *Fonte Gaia* is an ambitious exploration in the area of public sculpture, one that has few antecedents from the medieval past. Further, the life-size standing marble figures of nearly nude women are typologically among the first free-standing statues of the Renaissance. The *Main Portal of San Petronio* was not only influential for the side portals for the same Bolognese church done a hundred years later, but the individual sculptures, both the reliefs and the in-the-round lunette figures of the Madonna and Child and San Petronio, paved the way for analogous figures on the façade, as well as for such advanced projects as the Santa Casa of Loreto. But most of all the Portal provided Jacopo della Quercia with an appropriate vehicle for expanding the exploration of narrative devices.

The catalogue section contains all of the sculptures that I accept as by the master *in toto* or in part, as well as those made in his shop under his personal guidance. Each entry seeks to include in accessible form and in a single place the relevant information about the work. A discussion and an evaluation of the more recent criticism is also included. At the end of the catalogue section I have provided a list of those works often associated with Jacopo that I do not accept.

The section devoted to the documents seeks to reproduce all of the documents that have turned up over the centuries that have to do with the master, including a number of unpublished, partially published, or incorrectly published ones. In addition to serving as a data bank for further Quercia studies, this section functions as a collection of notices about a quattrocento artist, a paradigm that goes beyond the artist to function as a case study, parallel to the

notices surrounding the life of Lorenzo Ghiberti. With Donatello, the complete documentation in the original texts has never been published. In Jacopo's case, much more published material is already available. Many of the documents are accompanied by a Comment that seeks to clarify points raised by the text or to address collateral issues worthy of discussion.

The Jacopo della Quercia who surfaces from this study demands appreciation as original, strong-willed, independent, and creative, as an artist who no longer can be eclipsed by Ghiberti or Donatello, but can stand beside them as one of the most distinguished innovators of a remarkably creative period in the history of man. Jacopo della Quercia managed to retain an equilibrium between a rapport with past exemplars such as Nicola Pisano and, further back, with the Etruscan and Roman tradition, and a perception of the newest achievements of his own time. Not only should he be considered as the most "Italian" among his great contemporaries but also as the artist most able to interpret the tradition of the recent past, not through compromise, but through a sense of fairness, humanity, and visual intelligence.

Jacopo della Quercia

VOLUME I

[I]

Jacopo della Quercia: The Man

INSIGHTS INTO the public and particularly the private lives of fifteenth-century Italian artists are obtained only with difficulty. And since the hard-and-fast evidence is almost always limited, open-mindedness together with a healthy measure of common sense are necessary to an investigator. In the study of Renaissance art conflating details of the artist's life and especially assumptions about his personality with the style manifested by his works is common-place. The classic instance of such an interweaving is Raphael: his gracious style is taken to be synonymous with his character and behavior.[1] Michelangelo's comportment continues with tiresome insistence to be described as *terrible,* as are his anguished figures. Fra Angelico is probably the model example from the quattrocento, because his saintly nature appears to be an exact parallel to his humble, pious, restrained paintings.

Masaccio painted in a direct, dignified, and simple manner: was he also that kind of person and would we, somehow, recognize him as such? Lorenzo Ghiberti's relief sculpture is extremely skilled, encyclopedic, genial, and refined. From the extensive evidence that has been unearthed, he appears to have been an able businessman who successfully ran a complex shop from which he earned a significant fortune. Among his immediate influential contemporaries—Brunelleschi, Donatello, Leon Battista Alberti, and Masaccio—Ghiberti appears to be the most "normal," in that he was married, had a family, was concerned with the education and careers of his children, and even had a gentlemanly villa in the country. A gathering of contracts, letters, payments and other transactions, as well as autobiographical passages, have offered insights into Ghiberti the man as well as the artist. We know that Ghiberti saw himself within the wider tradition of painting and sculpture in Tuscany, since he wrote a brief history of the artists who preceded him. Not only has he left self-

1. I have treated this question on pp. 9–12 in Beck, ed., *Raphael Before Rome,* vol. 17 of *Studies in the History of Art* (Washington, D.C., 1986).

portraits, he also provides an autobiographical sketch of his own career, although, significantly, utterly failing to reveal any aspect of his private life, or, for that matter, his illegitimate birth.[2]

Donatello was described in fifteenth-century anecdotes; contemporaries frequently made reference to him. Nonetheless, we have virtually nothing written in his own hand, as is also the case with his longtime friend Filippo Brunelleschi. Pippo, however, was the subject of a lengthy, well-informed biography, the material for which had been collected during his own lifetime.[3] He was even a central player in a contemporary novel in which Donatello also appeared.[4]

For Jacopo della Quercia the situation is somewhat different. Although nothing is known of him in biographical or autobiographical form, suppositions based upon numerous documents and other contemporary data produce an indicative sketch of the artist. We know, for example, that like Ghiberti (and Paolo Uccello, who married late) but unlike Brunelleschi, Donatello, Alberti, and Masaccio, Jacopo appears to have been married. His wife is named only once in the extant documents after the marriage, and she is not mentioned at all in Jacopo's will written shortly before his death, leading to the assumption that she had died before her husband (possibly in childbirth, like Ilaria del Carretto; see doc. 492). Whatever the case, no reference to children is found in the same will: Jacopo's heirs were a brother, a husbandless sister, and her unmarried daughter.

In addition to ecclesiastical and communal records, which reveal relatively little about the sculptor's private life, there are nearly a dozen letters to and from the sculptor as well as other documents concerned with Jacopo and his activities, among them accusations of theft and sodomy in Lucca and of the abuse of funds while in office in Siena. Jacopo's will also offers valuable clues to his personality and character. On the basis of all the surviving contemporary evidence, the life of this remarkable sculptor will be reconstructed in this chapter.

A chronology provides at least one of the skeletal frameworks upon which a biography can be modeled, and in the following pages such a structure will be formulated. Since Giorgio Vasari's accounts in both editions of his *Vite de' più eccellenti pittori, scultori ed architettori* were the most influential descriptions of Jacopo's life and art until the middle of the nineteenth century and the advent of Gaetano Milanesi's exemplary documentary studies, they should be noted despite their errors before moving to a more thoroughly credible treatment. Here is a summary of the data about Jacopo in Vasari's first edition (1550):[5]

2. Ghiberti, *I Commentarii*. See also various papers in *Lorenzo Ghiberti nel suo tempo*, especially P. Murray, "Ghiberti e il suo secondo Commentario," 2:283ff.

3. Manetti, *Vita di Filippo Brunelleschi, preceduta de la novella del Grasso*. ed. by D. de Robertis with notes by G. Tanturli, Milan, 1976.

4. The "novella del Grasso" of note 3 above.

5. For the complete text see appendix 1. Vasari's text from the second edition (1568) is reported in appendix 2.

1. Two wooden panels with figures in relief were created in Siena.

2. The tomb of the wife of Paolo Guinigi (i.e., the *Monument*) was carved in the church of San Martino in Lucca.

3. The portal of the church of San Petronio, Bologna, was created.

4. The relief of the gable on the Porta della Mandorla was carved for the Florentine cathedral.

5. The marble fountain was created in the main square of Siena (the *Fonte Gaia*).

6. Jacopo was knighted by the Comune of Siena.

7. Jacopo was promoted to Operaio of the Cathedral of Siena.

8. Jacopo died in Siena in 1418 and was buried in the cathedral.

According to the account in Vasari's first edition, Jacopo was knighted for his sculpture, which was produced with "goodness, modesty and affability;" Vasari also comments that Jacopo was "a very gracious person." Undoubtedly he was deeply impressed by an artist who had moved beyond the artisan class, as was true of Jacopo's Florentine contemporary who had been knighted in Spain, Dello Delli. It is readily apparent, however, that not only was Vasari's information faulty, but he was far off the mark on some of the basic facts about the artist.

In the second edition of *Vite* (1568), Vasari enlarged his earlier biography of Jacopo and changed the chronology to the following order:

1. Jacopo's first important works were executed in Siena at age nineteen, including the larger-than-lifesize equestrian statue of Giovanni d'Azzo Ubaldini, captain of the Sienese forces.

2. Two lindenwood bearded figures in relief were produced for the Siena cathedral.

3. Some marble prophets were carved for the façade of the Siena cathedral.

4. Jacopo went to Lucca to escape the plague, famine, and political discord in Siena. In Lucca he carved the tomb of the wife of Paolo Guinigi in the church of San Martino.

5. Jacopo went to Florence to compete for the commission of the second set of bronze doors for the baptistery.

6. On the recommendation of Giovanni Bentivoglio, Jacopo was called to Bologna to carve the main portal of the church of San Petronio.

7. Jacopo returned to Lucca to execute the *Trenta Altar* and the effigies of Federigo *(sic)* Trenta and his wife in the church of San Frediano.

8. In Florence Jacopo worked four years on the gable of the Porta della Mandorla, apparently completed before the competition for the bronze doors took place.

9. For the tidy sum of 2,200 gold scudi, Jacopo produced over a period of twelve years the fountain in the main square of Siena, the *Fonte Gaia*, from which he obtained his nickname, Jacopo della Fonte.

10. Jacopo produced three bronze reliefs depicting the life of John the Baptist on the font of the Sienese baptistery, as well as several of the figures in the round between the reliefs.

11. Jacopo was knighted by the Comune of Siena and promoted to the position of Operaio of the Cathedral, a post that he held for three years.

12. Jacopo died at age sixty-four in Siena.

Vasari substantially expanded the data between the first and second edition. In the intervening period he appears to have had access to more information obtained from his friend, the Sienese painter Domenico Beccafumi, including a likeness of the sculptor that he used in his book (see frontispiece). Beccafumi, who seems to have held a high opinion of his Sienese predecessor, was well acquainted with details of Jacopo's life. Indeed a situation can be imagined in which Michelangelo also was instrumental in maintaining the reputation of Jacopo della Quercia among his contemporaries, including Beccafumi and Peruzzi, who would have been especially prone to propagate the fame of their countryman. Not only was Michelangelo in Bologna twice for extended stays, but he worked on the *Piccolomini Altar* for the Sienese cathedral as a young sculptor.

Documents that have come to critical attention in the nineteenth and twentieth centuries indicate that both of Vasari's scenarios are fundamentally incorrect, at the same time that his evaluation of the artist and recognition of his importance for the period is highly instructive. After all, Vasari introduces the entire Renaissance with the life of Jacopo, giving him a preeminent position in the unfolding of the Tuscan quattrocento style (which may, in fact, be something of a distortion, based in part upon the erroneous assumption that Jacopo was the author of the sculpture for the gable of the Porta della Mandorla, unquestionably by Nanni di Banco).[6] Nevertheless, Jacopo did institute innova-

6. G. Brunetti, in "Jacopo della Quercia a Firenze," p. 5, used Vasari to support her theory that Jacopo della Quercia had participated on the lower zones at the embrasure of the Porta della Mandorla, but I believe she missed Vasari's point in the first edition, in particular. Vasari said that, in effect, Jacopo must have made the gable, not Nanni di Banco, because the former was in Florence for a period of four years prior to the competition for the second doors. No contemporary evidence supports Vasari's assertion, however. The heart of the problem is that Vasari believed that the gable for the Portal della Mandorla was carved by Jacopo before the competition, but in actual fact it was done nearly twenty

tive solutions that give him a lofty status among the originators of the new style.

A chronology revised in accordance with documents and other data found since Vasari's time can now be offered, which must serve as the basis for a modern interpretation of Jacopo della Quercia:[7]

1394 Jacopo in Lucca. His father, Piero d'Angelo, had already moved to Lucca, where he was commissioned to do an Annunciation in that year.

1400–1401 Jacopo in Florence. He is among the contestants for the bronze doors projected for the baptistery, and apparently he is accompanied by his fellow Sienese sculptor Francesco di Valdambrino.

1403 Jacopo in Ferrara. The executors of the testament of Virgilio dei Silvestri commission Jacopo to carve a Madonna and Child for his family chapel in the cathedral.

1407 Jacopo in Ferrara as a witness to a notarial act.

1408 Jacopo in Siena (December 1), when chosen as *consigliere* to the General Council for January and February 1409 (modern).[8]

1409 Jacopo in Siena, where he gains the commission for the *Fonte Gaia*.

1412 Jacopo in Siena. Provisions are made to pay him an advance of 180 florins for the *Fonte Gaia*.

1413 Jacopo in Lucca (May 13). The Sienese order him to return to Siena within eight days, but he stays until nearly the end of the year.

1414 Jacopo in Siena. He writes to Paolo Guinigi on behalf of Giovanni da Imola, his collaborator in Lucca, who has been imprisoned.

1416 Jacopo in Siena when a dispute breaks out between him and the suppliers of the marble for the *Fonte Gaia*, which is finally settled.

years later, by Nanni. Already in the sixteenth century it was well known that Nanni was the author of the relief, as is demonstrated in F. Albertini, *Memoriale di molte statue e pittore della città di Firenze* (Florence, 1510), p. 10. Albertini states that the Assumption is by Johannis Banchi.

7. All of the documents used to create this summary may be found in the Documents section of this book.

8. During the fifteenth century in Siena and Florence, the new year was calculated from March 25. Throughout this book, the period from January 1 to March 24 is transformed to the modern calendar, and is designated "modern" to avoid the confusion that has so often arisen.

1416 Jacopo in Siena where he obtains a safe conduct to return to Lucca. His Trenta tomb slabs have an inscribed date of 1416.

1417 In Siena, Jacopo is commissioned to produce two bronze reliefs for the *Baptismal Font* in San Giovanni.

1418 Jacopo receives partial payment for a small wooden crucifix in Siena.

1418 In Siena (November 28), his presence is requested in Todi for work on the church of San Fortunato.

1419 In Siena the accounts are closed on the *Fonte Gaia*.

1421 In San Gimignano, Jacopo is commissioned to produce an Annunciation and receives a partial payment.

1422 Date inscribed on the *Trenta Altar* in Lucca.

1424 Jacopo is documented in Siena where he received a dowry of 350 florins from Agnese, daughter of Giovanni di Domenico Fei.

1425 In Bologna, Jacopo signs the contract for the *Portal of San Petronio* (March 28).

1425–1427 Payments to Jacopo in Bologna (October 3, 1425–May 2, 1427) for work on the portal, and for trips to northern Italy to obtain stone.

1427 Jacopo commissioned to execute the upper portion of the *Baptismal Font* in Siena.

1427–1428 Jacopo in Bologna (June 25, 1947–September 1, 1428), where he receives payments for work in process and for trips to obtain future stone for the portal.

1428 Jacopo in Florence on his way from Bologna to Siena, acts as a courier for the Sienese government.

1428–1429 Payments to Jacopo for work on the Bolognese portal.

1430 Final payments to Jacopo in Siena for his share on the *Baptismal Font*.

1430–1433 Payments (September 1, 1430–December 29, 1431) to Jacopo in Bologna for work on the portal.

1434 In Siena Jacopo obtains the assignment to procure marble for six statues for the Loggia di San Paolo and to execute as many as three statues himself. In Bologna payments are made to him (March 1–November 22) for work on the portal.

1435 In Siena Jacopo is selected Operaio of the Cathedral and is knighted as part of the office. In Bologna payments are made to him (April 14–October 22) for work on the portal.

1436 In Siena (January 22, modern) Jacopo requests permission to leave Siena. Payments are registered in Bologna to him.

1437 Jacopo is in Bologna, where payments are made to him for work on the portal.

1438 Jacopo dies in Siena, October 20.

With this schematic summary of events in his career as a guide, a more specific and detailed examination of the artist's life may now be undertaken, beginning with his name.

JACOPO DELLA QUERCIA OR DELLA GUERCIA?

Was he really Jacopo della Quercia, that is, "from the oak," as has been favored and is retained here, or Jacopo della Guercia, that is, "of the wall-eyed woman"? According to the documents, there is only one instance in which "della Quercia" can be confirmed.[9] In the few places where Gaetano Milanesi transcribed the name as "della Quercia," new readings show that the name was actually written "della Guercia."

The artist's name as "Jacopo della Guercia" appears for the first time in a Sienese document when he was chosen *consigliere* (councilman) for the General Council, the main governing body in Siena, for the semester January 1, 1409 (modern) to June 30, 1409, representing his section of the city, the Terzo of San Martino (doc. 24). A few years later, sometime between January 1 and March 25, 1412 (modern), when he received a payment of 120 florins, he is referred to as "maestro Iacomo di Piero de la Ghuercia" (doc. 33). And on November 15, 1413, while Jacopo was occupied in Lucca for the Trenta family and consequently neglecting his responsibilities for the *Fonte Gaia,* the Sienese officials ordered his immediate return and in so doing addressed him as "Magistro Iacobo magistri Pieri de la Guercia" (doc. 42). In still another case, on December 26, 1413, after charges concerning his moral conduct had been made in Lucca, the Comune of Siena wrote a vigorous defense of his character in which he is referred to as "civem nostrum dilectum magistrum Iacobum magistri Pieri de al Guercia habitatorem civitatis vestre Lucane" (doc. 45).

If there were any doubt, in fifteenth-century Sienese usage, the G and Q were not, in fact, interchangeable. On August 30, 1418 Jacopo acted as guarantor for Jacopo di Corso detto Papi, a stone carver from Florence who was active in Siena. In this document, too, he is referred to as "Magister Iacobus Pieri della

9. ASS, Regolatori, no. 6, fol. 387v; in F. Bargagli-Petrucci, *Le fonti di Siena e i loro acquedotti,* 2:337. For key to abbreviations of archives used throughout, see introduction to Documents, p. 333.

Guercia" (doc. 87). Coincidentally, further along in the same record book and written by the same scribe we find that a certain "Segna quodam Nelli de [*sic:* not "della"] Quercia Grosso," a town near Siena that represents Vasari's explanation of where Jacopo came from, is spelled clearly with a *Q*.[10] Consequently one may conclude that Maddalena "detta Lena," wife of Piero d'Angelo, whom she had married in 1370 with a dowry of 180 lire (doc. 1), was "la Guercia," and her sons Jacopo and Priamo as well as her daughter Elisabetta were all known as "de la Guercia."[11]

On the other hand, when Jacopo's father paid a small tax in Siena in 1410 he was referred to as "Piero d'Agniolo della Ghuercia," which raises an alternative possibility. The "la Guercia" in question may not have been Jacopo's mother after all, but his paternal grandmother (doc. 30). In contemporary usage the word *guercio* or *guercia* refers to someone with an eye defect, or it can also mean one-eyed, cross-eyed, or wall-eyed. The Bolognese painter Gian Francesco Barbieri (1591–1666) was better known as "Il Guercino," for example. His nickname was apparently based upon a visual defect of his own, whereas Jacopo's name reverts back to a female member of his family, either his mother or grandmother—a situation resembling that surrounding Piero della Francesca's name.[12]

That such an unflattering name as "della Guercia" became "della Quercia" is also comprehensible. Since Jacopo's actual name was "della Guercia," the question still remains: when and how was this modification perpetuated? I suggest that "Quercia" appears for the first time in Ghiberti's *Commentario, secondo,* in the list of the contestants in the famous competition that had unfolded a half century before he was writing.[13]

10. ASS, Gabella Contratti, no. 167, fol. 56v. U. Morandi ("Il nome di Jacopo," *Jacopo della Quercia nell'arte del suo tempo,* p. 323) made a strong case for the correct name of our artist as "della Guercia." Had Jacopo come from the village of Quercia Grossa, as is often claimed, the correct form would be "de" and not "della," as in the documented cited. Seymour's account of the name (*Quercia,* pp. 15–16 and n9) is misleading when he seeks to associate the notion of an oak with the artist's name.

11. Bacci, in *Alcuni documenti nuziali,* pp. 17–18, published a document of 1440 in which Priamo, Jacopo's brother, is referred to as "Priamo di Piero de la Guercia" (also cited in Bacci, *Francesco di Valdambrino,* pp. 435–436). In a document of 1439, Jacopo's sister is called "Domina Elisabetta olim filia magistri Pieri della Gucci [*sic*]," for which see Bacci, *Francesco di Valdambrino,* pp. 437–438.

12. In Poliziano's so-called *Tagebuch,* ed. by A. Wesselki (Jena, 1929), is the following: "Il medesimo [messer Matteo Franco] al guercio: tu hai gli occhi spaiati, uno a scoppietti, l'altro a calcagnini."

The condition surrounding Piero della Francesca's name may also be raised in this context. The Francesca in Borgo San Sepolcro apparently was his grandmother, for which see E. Battisti, *Piero della Francesca,* (Milan, 1971), ii, p. 212. Perhaps such a situation also explains why Lorenzo di Pietro was called "il Vecchietta." On the other hand, C. B. Strehlke, in K. Christiansen, L. B. Kanter, and C. B. Strehlke, eds., *Painting in Renaissance Siena, 1420–1500* (New York, 1988), terms the name "curious," and translates it as "the little old one" (p. 258).

13. Since Ghiberti was well acquainted with his Sienese contemporaries he must have known the correct name of one of his competitors, who was likely one of his enemies as well. But since the only manuscript of the *Commentarii,* which is located in the Biblioteca Nazionale, Florence (II, I, 333), is probably an imperfect rendering of Ghiberti's notes, perhaps it was Ghiberti's copyist who set the error in motion, which was then embellished by Vasari, who relied upon Ghiberti's text for his *Vite.* The paper upon which the Florentine manuscript was written bears a watermark that corresponds to Briquet no. 9131, datable to 1456—that is, after Ghiberti's death (C. M. Briquet, *Les filigranes,* Leipzig, 1923,

A look at Jacopo's will, which was made out only seventeen days before his death, should settle the matter. The relevant line reads: "Spectabilis miles dominus Iacobus olim magistri Piero della Guercia [*sic*] detto maestro Iacomo della Fonte" (doc. 492). While surely too late to alter the habit of centuries of usage, as is likewise the case for Sassetta (really Stefano di Giovanni and never "Sassetta" in his lifetime), it is appropriate to acknowledge the historical name of the master.

If Jacopo's correct name can be determined with reasonable confidence, the date of his birth cannot. As is the case with many artists who flourished in the quattrocento and without the benefit of the usually reliable evidence of the Florentine *catasti*, or tax declarations, Jacopo's date of birth is undocumented. Furthermore, the divergence among opinions is wide enough to seriously effect any sensible sketch of his art, with scholars offering a range from 1367 (Krautheimer) to 1375 (Seymour). All of the dates that have been assumed for the master make him somewhat older than Brunelleschi (b. 1377) and Ghiberti (b. 1378) and quite a bit older than Donatello (probably b. 1386). In order to achieve a more precise dating, the evidence, sparse as it is, should be reexamined. To clear the table, the contradictory information supplied by Vasari, which has only led to confusion, once and for all must be abandoned as irrelevant.

Jacopo's father, Piero d'Angelo di Guarnieri, a goldsmith and sculptor, received a dowry from Maddalena ("la Guercia"?) on April 21, 1370 (doc. 1 and comment). Most modern scholars accept the year of Jacopo's birth as 1374, integrating several statements made by Vasari; in fact, that year was used in calculating Jacopo's 600th anniversary, celebrated in Siena in 1974–1975. As we have seen, in the second edition of the *Vite,* Vasari claims that Jacopo's earliest work of any importance was a statue of Giovanni d'Azzo Ubaldini, a *condottiere* under Siena's employ. The over-lifesize equestrian statue, according to Vasari, was constructed of filler, cloth, and gesso, a technique the biographer praised highly, remarking that his own contemporaries structured models in quite the same manner. Milanesi, however, proved that there never had been a statue of Giovanni d'Azzo in the Sienese cathedral; instead the soldier had been commemorated with a painting (doc. 5 and comment; also doc. 13). Vasari in effect confuses Giovanni's monument with that of another *condottiere,* Gian Tedesco da Pietramala, who died in Orvieto in 1395 and who actually was the subject of an equestrian statue placed in the Sienese cathedral. After the expulsion of the Milanese from Siena in 1404, cathedral officials removed the statue to the interior face of the main façade ("a capo la porta mezo da lato drento").[14]

IV). If these dates can be believed to have close precision, the version in Florence could not have been written by Ghiberti himself, nor for that matter corrected by him.

14. According to Milanesi (ed., *Vasari, Le vite,* 2:110–111 *n* 2), the statue was originally located near the chapel of San Sebastiano and was removed to the inner side of the façade at the main portal in 1404, where it remained until 1506, at which time it was destroyed by order of Pandolfo Petrucci—in

According to Vasari, Jacopo was but nineteen years old when he made the statue of Giovanni d'Azzo. If one were to assume that Vasari was actually referring to the statue of Gian Tedesco, Jacopo would have been born in 1376 (i.e., 1395 less 19). On the other hand, Vasari also maintains that Jacopo died at the age of 64; we know, but Vasari apparently did not, that he died on October 20, 1438. With this reasoning, one could arrive at the year 1374, which is the date most commonly held for his birth. The first time Jacopo's name appears in a historical context is Ghiberti's account of the baptistery doors competition in the already mentioned *Commentario secondo* (doc. 7). Jacopo was among the contestants, along with his countryman Francesco di Valdambrino, whose career is closely intertwined with his own, as will be demonstrated in subsequent pages.[15] Whatever the case, any reconstruction of Jacopo's life and work must begin with the year of the competition, 1401, and from there turn backward to more hypothetical terrain, including the crucial question of the date of his birth. This is hardly an idle issue, not only for the historical justice of the case, but because the date for Jacopo's birth determines a catalogue of works that may have been available to him in his formation, his precise position with regard to his contemporaries, and the cultural climate in which he began.

Piero d'Angelo, Jacopo's father, settled in Lucca in the period 1391–1394. In 1401, he received payment for designing a seal for Paolo Guinigi, the young lord of Lucca (doc. 8). This is a significant connection because Guinigi would become Jacopo's patron a few years later for the *Ilaria Monument,* and we must assume that the connection was already established by his father. Since Jacopo's name does not occur in the extensive and well-preserved records of the Sienese cathedral during the last decade of the fourteenth century, Vasari's claims that he worked there as a young man—not only on the equestrian statue, but on carved wood reliefs and on marble prophets for the façade—can be excluded, whatever the date of his birth. Nor is there any other mention of Jacopo's name (or that of his father) in the surviving documents in Siena for the following years until the end of 1408 (doc 24). I suggest that he was, in fact, too young to have been employed up to the time he left for Lucca with his father, sometime between 1391 and 1394. Documents in Lucca also fail to mention Jacopo's name for this period, although it is fair to say that the Lucchese records are quite incomplete for these years, especially the cathedral archives.

Consistent with more recent studies of the lives of fifteenth-century masters in which traditional birthdates have been challenged, including those of Fra Angelico, Andrea Mantegna, Giovanni Bellini, and Andrea del Castagno, it

which case Vasari would never have actually seen it. In an inventory of 1467, it is mentioned on the interior façade (Labarte, "L'Eglise cathedrale de Sienne," p. 285).

15. The most recent detailed discussion of Francesco di Valdambrino since Bacci's monograph of 1936 may be found in Bagnoli and Bartalini, eds., *Scultura dipinta* (1987), pp. 133–150, with entries written by Bagnoli, who places Francesco's birth as 1380 "at the latest" (p. 133).

seems reasonable to assume that Jacopo della Quercia was about twenty years old when he entered the competition in Florence, a shade younger than Brunelleschi and Ghiberti and slightly older than Donatello (who, of course, did not compete). Jacopo's brother, the painter Priamo della Quercia, who was still living in 1467, is widely assumed to have been born around 1400. His name first occurs in documents in 1426 (doc. 153). The number of years that separate Priamo and Jacopo, when the conventional dates are used, is excessive. Furthermore, taking the earliest suggested birth date of 1367 or even that of 1374/75 means that at the time of his marriage in 1424, Jacopo was as old as fifty-seven or at least fifty (an unusually late age, to say the least, though of course not impossible). To conclude the discussion of this issue, given the complete absence of documentation before 1401 or of convincing attributions that can be dated to the 1390s, together with the other circumstances, I take Jacopo's birth to have occurred ca. 1380. Since we know for certain that he died in 1438, he would have lived fifty-eight years.[16]

JACOPO'S TRAINING

Although virtually nothing is known about Jacopo's early life and training, certain suppositions may be entertained. We can assume, for example, that Jacopo, like most young boys in the fourteenth century in Tuscany, worked in his father's shop, first in Siena and then in Lucca. Hence he must have been trained mainly as a goldsmith, at the start at least, which would have qualified him to participate in the competition of 1401 for the bronze doors of the Florentine baptistery. On the other hand, not all of the participants in the contest were goldsmiths by trade: Niccolò Lamberti, for example, was a stone carver; Francesco di Valdambrino's background is still unknown, although early on he was a wood carver; Simone da Colle's background is a mystery, but he must have been associated with Siena, since he came from Colle Valdelsa—the birthplace, incidentally, of Arnolfo di Cambio. Niccolò d'Arezzo was indeed a goldsmith.[17] Like Brunelleschi, Ghiberti, Donatello, and Michelozzo, Jacopo

16. That Jacopo was born nine or ten years after Piero d'Angelo's marriage (if indeed the marriage had taken place immediately upon the receipt of the dowry) is parallel to the situation of Donatello, whose mother Orsa was approximately forty-one when he was born, judging from the Catasto of 1427. Michelozzo seems to have been a late child, since his mother was listed as seventy years old in the Catasto of 1427, making her about thirty-nine when he was born in 1396 (see Caplow, *Michelozzo*, 1:17). Of course in these cases the age of the parents could have been exaggerated in the tax records in order to receive a better deduction; cf. U. Procacci, "L'uso dei documenti. . . ," *Donatello e il suo tempo* (Florence, 1968), especially p. 20. G. Previtali, in "Domenico dei Cori e Lorenzo Vecchietta: necessità di una revision," *Storia dell'arte* (1980), 38/40:141–144, has argued sensibly that Domenico di Niccolò was born about ten years later than the usually accepted date of 1363 and was, incidentally, a reasonably close contemporary of Jacopo della Quercia. On Domenico, see the very detailed entry by Bagnoli in Bagnoli and Bartalini, eds., *Scultura dipinta*, pp. 105ff.

17. The actual date of the competition is not certain, but A. Manetti (*Vita di Filippo Brunelleschi*, Tanturli pp. 60–61), who deals only with the two finalists, Ghiberti and Brunelleschi, says it took place

della Quercia seems to have been introduced to the mysteries of art through a goldsmith's training.[18] Jacopo maintained a reputation for such activity, since many years later he was commissioned to produce two bronze reliefs for the *Baptismal Font* in Siena, only one of which he actually produced (and that with reluctance) (doc. 73). The commission for the basin-level decoration for the *Font* was shared with two other workshops, that of Ghiberti and that of Sano di Turino and his son Giovanni, all of whom were goldsmiths.[19] Jacopo's inclusion in the project, and Donatello's as well, is *de facto* confirmation that he had, at least, a modicum of experience with metalwork techniques.

The drawing for an early (first?) project of the *Fonte Gaia*, now shared between New York and London, shows tight modeling and detailing that betrays a goldsmith background (figs. 20 and 21), as does the ease with which Jacopo treated the small-scale reliefs for the predella of the *Trenta Altar* (figs. 34–39).[20] Furthermore, Jacopo appears to have been particularly attuned to both antique and contemporary metalwork throughout his career, feeling comfortable in using examples from that sphere as jumping-off points for his marble reliefs. Like Pietro di Landi in the previous century, a goldsmith who also worked in wood, Jacopo's father produced documented sculptures in Siena and Lucca that are in that material. Attempts have been made to ascribe a portion of a polychromed Annunciation produced in Lucca for a nearby town to Jacopo, in a role as his father's assistant (doc. 3).[21] During his lifetime Jacopo certainly produced wood statuary, and, in addition to several documented pieces, a significant number of other such sculptures have been attributed to him.

While there is reason to believe that Jacopo learned metalwork and wood carving from his father, it is unlikely that Piero taught him to sculpt in marble, since he was never known to have worked in that medium himself.[22] Yet Piero

in 1401. Ghiberti, who we know was awarded the commission in 1402, implies that the date was 1400 (Ghiberti, *I Commentarii*, p. 42). As for the appearance of Jacopo's competition panel, notwithstanding Vasari's remarks, nothing can be confirmed. B. Hanson ("Fear and Loathing on the Trail of Missing Masterpieces," pp. 355–356) saw a relief that could have reflected Jacopo's entry in a Roman shop, but this has not been traced. Parenthetically, I doubt that Jacopo ever made a bronze entry but in terra-cotta, clay, or wax, due to the time and expense that would have been involved.

18. For Donatello's early experience as a goldsmith and his rapport with Brunelleschi see Beck, "Ghiberti giovane e Donatello giovanissimo," 1:111ff.

19. An exemplary study of the *Font* is provided by J. T. Paoletti, *The Siena Baptistry Font: A Study of an Early Renaissance Collaborative Program, 1416–1434* (1979), which I will have frequent opportunity to cite.

20. On the subject of the goldsmith during the quattrocento, see the excellent catalogue produced under the direction of M. G. Ciardi Dupré dal Poggetto, *L'oreficeria nella Firenze del quattrocento* (Florence, 1977). The trecento Sienese sculptor, engineer, and architect Lando di Pietro called himself an *orafo* in one of the two highly personalized dedications hidden in a wooden cross he had carved. For this work, which is located in the Basilica dell'Osservanza (museum), Siena, see A. Bagnoli in Bagnoli and Bartolini, eds., *Scultura dipinta*, pp. 65–68.

21. P. Cardile, "The Bernabbio Annunciation and the Style of Jacopo della Quercia's Father, Piero d'Angelo," *Antichità viva* (1978), 17(2):25ff.

22. Some marble heads on the exterior of the Cathedral of San Martino in Lucca have been attributed to Piero, but in my opinion this attribution is highly problematic, although the idea is nonetheless suggestive. See Baracchini and Caleca, *Il Duomo di Lucca*, pp. 118ff and Handlist 8.

must have seen the value in having his son also learn to carve marble, since it was in wide use in Lucca, which had the advantage of proximity to the quarries at Carrara and Pietrasanta. In Lucca, where the abundant use of marble for decoration and for sculpture was practiced, the exteriors of both the cathedral and of San Michele are still evidence of that tradition. Being a court artist, Jacopo's father would have sought a master of distinction to teach his son marble sculpting, perhaps even asking his patron for advice. No one in the area had a sufficient reputation, with the notable exception of Antonio Pardini (of Pietrasanta). He had been active in his hometown already in 1389 but soon after came to Lucca, where he stayed for the remainder of his life, serving as *capomaestro* (head of the works) of the Cathedral of San Martino for a longer period, beginning in 1395. Pardini is the only credible candidate as Jacopo's teacher. His few surviving sculptures tell us practically nothing about him stylistically, however, although his career neatly overlaps that of Jacopo della Quercia. Chronologically he could easily have been Jacopo's instructor and mentor in the area of marble carving, which became, after all, Jacopo's greatest skill. In any case, Pardini must have had a significant part in the commission to Jacopo of the Apostle for the northern flank of the cathedral, presumably given out shortly after 1410. The *Sant'Aniello Monument* in the cathedral recently has been ascribed to Jacopo, but this has not received wide support, many critics preferring the more conventional attribution to Pardini. The stylistic confusion does indicate shared territory, as it were, supporting the theory that there was an active rapport between the two.[23]

THE EARLY YEARS (TO 1408)

While Jacopo was in Florence for the 1401 competition, he must have become acquainted with the impressive late medieval tradition of stone carving that was readily displayed in the city, as well as some of the newest, most progressive work currently being done in sculpture, especially at the Porta della Mandorla and on the Loggia dei Lanzi. The dominating figure that might have appealed to him was Giovanni d'Ambrogio, who worked at both places and whose massive Giottesque treatment of the figure must have found a sympathetic admirer in Jacopo. Thus, while Brunetti's claim that Jacopo actually carved some of the most advanced reliefs for the embrasures at the Porta della Mandorla in the 1390s does not hold up to close scrutiny, a connection with the art of Giovanni is all the same a tenable, even engaging, possibility.

Giovanni, on his part, perpetuated the monumental manner of Arnolfo di Cambio, who had operated in Florence more than two generations earlier. Jacopo too would have seen Arnolfo's sculpture in Florence, including the fine *Madonna and Child* (Museo dell' Opera del Duomo) over the central portal of

23. I consider the *Sant'Aniello* to be by neither of the two but, rather, to be a work of Giovanni da Imola, as will be discussed below.

the old façade of the Florentine cathedral. Jacopo may well have become personally acquainted with his colleagues—Ghiberti, Brunelleschi, and possibly the very youthful Donatello—during his stay in Florence, in addition to Giovanni d'Ambrogio, who belonged to the older generation. Under any circumstances, even at a precociously young age, Jacopo was in a position to see important new developments, since he was not content to remain in Lucca—or Siena, for that matter—but opted instead for wider horizons.

Following Ghiberti's victory at the competition, Brunelleschi departed for Rome apparently in the company of Donatello; Jacopo seems to have set off for Emilia, where he is documented in 1403, at which time he was commissioned to carve the *Madonna* for the Silvestri chapel in the cathedral of Ferrara (doc. 11).[24] The contract specified that the statue be of Carrara marble, which Jacopo was responsible for obtaining. Evidently Virgilio dei Silvestri's executors wanted a master familiar with working in Tuscan stone. Thus, this notice serves to establish that by 1403 Jacopo had been trained in marble sculpture, presumably under the guidance of Antonio Pardini.

The *Ferrara Madonna* (figs. 1 and 2) is the earliest commission for which there is contemporary documentation. Jacopo was about twenty-three years of age, at least according to the date of birth that has been assumed here. By then he must already have established a reputation, perhaps in nearby Bologna, in order to be eligible for the commission. A number of scholars including Venturi, Supino, Krautheimer, and Seymour have proposed a Bolognese connection, one that is convincing: Jacopo's connections with Bologna seem, in any case, to antedate the *Portal of San Petronio*, which was, after all, executed in the last phase of his life.

The documents pertaining to the Ferrarese commission offer guidance in the reconstruction of Jacopo's *ambiente* during the early years of the quattrocento. Three days after the original commission, the contract was redrawn, this time placing Jacopo in partnership with Tommasino da Baiso (or d'Abaiso), who had been mentioned as a guarantor in the previous version (doc. 12). Tommasino's responsibility was expanded, as if the executors were looking for a strong guarantee from someone they were familiar with locally. Tommasino was the head of a prestigious Modenese family of wood carvers, sculptors, and architects who were active throughout northern Italy. In subsequent years, as confirmation of a long-standing rapport, Tommasino's son Arduino became associated with Jacopo della Quercia. And, as if to close the circle a bit tighter, we know that Tommasino, Jacopo's partner in Ferrara, was working for Paolo Guinigi in Lucca in 1406, producing an inlaid armadio; in the next decade Arduino was to construct a *studiolo* of great value for the same patron who was, after all, Jacopo's principal patron in Lucca.[25] How much time Jacopo

24. Before arriving in Ferrara in September 1403, he may have first gone to Bologna to work for Giovanni Bentivoglio. There is an ambiguous reference to a Master Jacopo in a letter of 1401 written by Paolo Guinigi to his Bolognese counterpart, which may refer to him (doc. 9).
25. A. Ghidiglia Quintavalle, in *Dizionario biografico degli italiani*, s.v. (under Baiso).

actually spent in Ferrara is not documented, but it is excessive and unrealistic to assume, as does Rondelli, that he remained there during the entire span from 1403 until 1408, when final payments for the *Madonna* were made.[26]

THE MIDDLE YEARS (1409–1424)

According to the extant documentation, soon after the final payments were made for the *Ferrara Madonna,* Jacopo turned up in Siena (doc. 24). In December 1408 a decision was reached, and in the following month, on January 22, 1409, he was commissioned to execute the *Fonte Gaia* (docs. 22, 25). No doubt Jacopo must have already achieved a confirmed reputation as a stone carver, if the comune was prepared to award him such a demanding public commission, which involved vast sums of money. However fine, the *Ferrara Madonna* could not have been impressive enough to make Jacopo a viable candidate for a major public monument in Siena. Work of a grander order would have been required to bring him to the attention of the town fathers.

The tomb in Lucca dedicated to Ilaria del Carretto, second wife of Paolo Guinigi, must have been the vehicle that solidified the sculptor's reputation back in Siena (figs. 3–19). The power of the patron, coupled with the tomb's simplicity and infectuous beauty, was undoubtedly known to the Sienese, who would have been all the more impressed by the achievement of a native son. As is often the case, Jacopo's prestige was magnified at home by means of his successes abroad.[27] On the other hand, the issue is complicated because the *Ilaria Monument* is undocumented: all we know is that Ilaria died in childbirth on December 8, 1405 (doc. 14). From circumstantial and stylistic evidence, however, there remains good reason to believe that the tomb dates to the years 1406–1408, as will be developed in the next chapter. And although Jacopo's presence in Lucca cannot be specifically documented during the span, his father was living there, and Lucca was still his "home" even when he was active in Ferrara. Besides, his friend and companion Francesco di Valdambrino is himself registered in Lucca several times in 1406 and 1407 (docs. 16, 19, 20). Jacopo was also probably there much of the time too, working on the *Ilaria Monument,*

26. N. Rondelli, "Jacopo della Quercia a Ferrara 1403–1408," *Bollettino senese di storia patria* (1964) 71:131ff. The marble saint, the so-called *San Maurelio* also in the Ferrarese cathedral, occasionally has been associated with Jacopo. It does not belong to the first decade of the fifteenth century, in my opinion, but probably should be dated ca. 1450—that is, more than a decade following Jacopo's death—and can be associated with early Niccolò dell'Arca. No other sculpture that can be attributed to Jacopo from the early '400 can be identified in Ferrara, and none with a Ferrarese origin. If he had spent five years there, one could reasonably expect that he would have produced a body of work in addition to the *Madonna.*

27. J. T. Paoletti ("Nella mia giovanile età mi parti . . . da Firenze," *Lorenzo Ghiberti nel suo tempo,* 2:104–05) proposed that there was something of a pattern for sculptors at that time to test themselves in other localities, thereby bringing attention to their work at home. While this engaging idea is worth further analysis, Paoletti's suggestion, that Nanni di Banco had a role in the carving of the lunette of San Martino in Pietrasanta (datable to 1400–1405), cannot be supported by stylistic evidence. The older attribution to Antonio Pardini, or at least to the family shop, remains more persuasive.

presumably with Francesco as a collaborator and with assistants, including his father. If the *terminus post quem* for the tomb is the young woman's death in December 1405, an operational *ante quem* may be postulated as 1408, when Guinigi remarried. The thinking goes that good taste would have prevented him from being overly occupied with the tomb of a deceased wife with a new wife in hand. Furthermore, the contract for the *Fonte Gaia* drawn up in late 1408 and put into effect in early 1409 is evidence that the *Ilaria* was already known and probably finished or nearly finished by that time, leaving the sculptor free to take on a prominent commission in Siena.

Although brief spans of his life remain to be accounted for up to the *Fonte Gaia*, after January 1409 Jacopo's movements become easier to follow. The contract for the fountain went into effect at the beginning of that year when he obtained a substantial advance, amounting to 100 florins, in February 1409; he did not begin work right away, however. Instead he accepted commissions in Lucca (again), leaving the *Fonte Gaia* project virtually untouched until about 1414. It is hard to imagine why Jacopo was quite prepared to leave Siena for Lucca following the commission, except by considering that his entire family—his father, a sister, and a brother—were living there.[28] Perhaps, too, trouble erupted in Siena over the fountain, and especially over obtaining the necessary stone. In any event, Jacopo did not seriously take charge of his prestigious assignment until 1414.

Instead, the first decade of the new century ended and during the next few years he continued to be active in Lucca, probably for the cathedral, for which he produced the marble *Apostle* (and possibly ornamental heads for the exterior, as some scholars have suggested).[29] On the other hand, Jacopo's activity in the Trenta family chapel in San Frediano is reasonably well documented. Jacopo was responsible for a carved altarpiece of considerable size and complexity as well as for the tomb slabs, now in the chapel but probably conceived originally for a different location (fig. 23). His efforts there lasted from around 1410/11, and in any case 1412, when Lorenzo Trenta obtained permission to build a new chapel with burial rights, until 1422, the date that appears on the altarpiece, thus overlapping the years when Jacopo was occupied with the *Fonte Gaia*.

Typically Jacopo maintained several pressing commissions at the same time, even if they were located in different, even distant cities, requiring constant movement back and forth from one place to another. In order to do this, he must have developed shop organizations in the various locations where he had to work, and, furthermore, he must have been skillful at juggling his time as well as managing diverse operations simultaneously. While this practice was apparently a characteristic feature of his career, one should not assume that it

28. We have no evidence about his mother and whether she was still alive in these years. It is fair to say, on this point, that information about women is far less plentiful than that dealing with men from this period.

29. See note 22. In my opinion several allocated to him by critics are much later (eighteenth century?) replacements.

was unique to him or to the period. For example, his spiritual mentor from the past, Nicola Pisano, who was active in many of the same centers as Jacopo (Lucca, Pisa, Bologna, and Siena), maintained active shops in several places at the same time, as did Jacopo's contemporaries Donatello and Michelozzo. Jacopo was doing the same thing: while active on the *Madonna* (and possibly other work) in Ferrara, he was also carving the *Ilaria Monument* in Lucca, and obtaining a major commission in Siena.

Precisely what effect such a splitting of Jacopo's time and presence had upon his artistic and private life cannot be ascertained barring new evidence. However, he continued in the same pattern until the very end of his days, and it must be considered a fixed mode of life. One must assume that like a bigamist, Jacopo had networks of friendships and connections in the diverse places, and that he moved in and out of such relationships as he switched from one center to another. When the unique cultural characteristics of Lucca, Bologna, or Siena during the first half of the fifteenth century are properly taken into account, Jacopo appears to have had a far richer experience that many of his contemporaries.

In May 1413 Jacopo received in Lucca warnings to either come back to Siena or return the advances for the fountain (docs. 39–41). While the documents do not specify precisely what he was doing in Lucca, they do imply that he had already been there for some months. Nor did Jacopo return to Siena immediately; he stayed on in Lucca until almost the end of the year, although again in November and December he was ordered to report immediately to the local officials in Siena (docs. 42, 43). Not a single hint has been turned up to indicate that he had been preparing to do so, however; only some unpleasant circumstances persuaded him to leave Lucca.

From a plaintive letter of December 18, 1413 written by Giovanni Malpigli to Paolo Guinigi, we learn that Jacopo was active at the Trenta Chapel in San Frediano (doc. 44). The letter accuses Jacopo and Giovanni da Imola, who are referred to as those "ladroncelli senesi picchiapietre" ("those thieving Sienese stone cutters"), of dishonesty. The situation had become so tense that Jacopo quickly packed his bags and left for Siena; Giovanni, who never did get away, was imprisoned.

Only after his distressing reentry did Jacopo turn his full attention to the *Fonte Gaia* project. In the following years payments are recorded to him (docs. 48, 50), and on January 3, 1415 (modern) a dispute that presumably had been brewing for some time between Jacopo and the suppliers of stone was resolved (doc. 53). Jacopo finally had thrown his energies wholeheartedly into the assignment, perhaps because he had no distractions, and he was rewarded by a decision of the Sienese in 1415 to actually expand the program (docs. 54–56). If work in Siena was moving ahead full steam, progress on the *Trenta Altar* in Lucca had come to a sudden and definitive halt by the end of 1413, resuming only in 1416 when Jacopo once again removed himself to Lucca. On March 11,

1416 (modern), Jacopo was granted a safe conduct pass to proceed to Lucca, where he remained for some time (doc. 59). To be sure, the Trenta tomb slabs are inscribed with the year 1416. It is not clear how long Jacopo stayed in Lucca during this trip, and in any case, he probably moved back and forth between his *bottega* in Siena and that in Lucca. Toward the end of 1416, major revisions to the contract for the fountain were agreed upon, certainly requiring Jacopo's presence in Siena, so that a kind of split life continued (docs. 62–64).

Another major undertaking was being planned in Siena during 1416 that would set the stage for one of the most singular collaborations of the fifteenth century. The leading Tuscan sculptors of the age, Lorenzo Ghiberti, Donatello, and Jacopo, intersected on the same monument: the *Baptismal Font* in the church of San Giovanni Battista, located beneath the choir of the cathedral. Jacopo had not been included in the initial stages of planning for the *Font,* perhaps because he was still deeply preoccupied with the *Fonte Gaia* or because he was so often away in Lucca. The Sienese officials, for their part, sought to take advantage of the expertise in bronze casting of Lorenzo Ghiberti, who had been hard at work on the bronze doors of the Florentine baptistery for nearly fifteen years. He was invited to Siena for consultation on a newly projected *Baptismal Font,* since the old one was deemed to be in disgraceful shape. Ghiberti came, bringing with him two assistants.[30]

Jacopo was invited to participate on the font shortly before April 16, 1417, after the main outlines of the structure had been determined. He was awarded two of the six bronze "histories" Ghiberti conceived for the basin; the local goldsmith firm of Turino di Sano and his son Giovanni was also commissioned for two; the final pair was assigned to Ghiberti himself. That Jacopo was given a significant role despite his flagrant disobedience of local officials with respect to the still-unfinished *Fonte Gaia* is proof of the high esteem in which his art was held locally, but it was also, presumably, the result of *campanilismo* on the part of the Sienese, who were reluctant to abdicate to foreign artists the greater portion of the *Baptismal Font*'s decoration. Quite possibly Jacopo was selected over the objections of Ghiberti, who was, however, on very cordial terms with the Turini: clearly Jacopo della Quercia held an influential position in Siena, one that was to expand constantly, culminating with his appointment as Operaio of the Duomo two decades later.

The *Fonte Gaia* was to have been completed by 1418 at all costs, but work dragged on as Jacopo continued to accept other assignments. He produced a small wooden crucifix for a Sienese widow (the piece has been lost), and was associated with sculpture for the façade of San Fortunato in Todi. In a letter, the officials of Todi asked the Sienese Comune to permit Jacopo to come to

30. Krautheimer, *Ghiberti,* doc. 13, and Paoletti, *Baptistry Font,* doc. 3. The description of Ghiberti's assistants, "Giugliano e Bartalomeo maestri d'intaglio da Firenze," could refer to Giuliano di ser Andrea or Giuliano di Giovanni da Poggibonsi and either Bartolo di Michele or Bartolo di Niccolò, all of whom are mentioned as being part of Ghiberti's staff for the first doors (Krautheimer, *Ghiberti,* docs. 28, 31).

Todi, and there is other evidence that suggests that he actually produced sculpture for the place (docs. 85, 88, 89). Such activity served to widen his experience of the region south of Siena, if he had not known it from previous undocumented trips; he surely would have passed by the hill town of Orvieto, where the piers on the west façade of its remarkable cathedral would have offered him insights into the finest reliefs chiseled in the previous century in all of Italy.[31] Journies south are significant for an insight into Jacopo's background, simply because while ample indications survive of travels to Bologna, Ferrara, and later to Venice and Milan, there is no hard evidence that he turned in the direction of Rome. On the other hand, Assisi, Todi, and Perugia, and other places he seems to have known first-hand, lie between Siena and the Holy City, and Jacopo could certainly have taken one or another occasion to make the journey, following the same path as contemporaries including Brunelleschi, Donatello, Masolino, and Masaccio.

On October 20, 1419 the final payments and contractual settlements were registered for the *Fonte Gaia,* fully a decade after the first contract (doc. 96). To celebrate the fame of the monument, Jacopo was henceforth called Jacopo or Giacomo "della Fonte."

Jacopo did not consider the assignment of the two histories for the *Baptismal Font* for many years. In 1423 he transferred one of them to Donatello, perhaps because he was unenthusiastic about doing them anyway (doc. 109). Donatello moved ahead in a timely fashion to produce his relief, but Jacopo persisted in his procrastination, becoming the most tardy of all the artists on the project; he delivered his relief only in 1430, long after the others, and fully thirteen years after he had obtained the commission. I suggest that Jacopo had little desire from the start to work in bronze, either because he felt poorly prepared, or, as is more likely, because he found the medium unnatural for him. Once again what comes to mind is an analogy with Michelangelo, who sculpted by means of a process of taking away, not building up, which is the basis of producing models for eventual casting. (Only under duress did Michelangelo execute a bronze, the ill-fated over-lifesize statue of Julius II that was briefly placed on the façade of San Petronio before being torn down by an angry crowd and destroyed.) A further indication of Jacopo's disinclination for the cast bronze relief is, *ipso facto,* the inherently weak product he finally delivered.

Small adjustments to the *Fonte Gaia* were required in 1420. Toward the end of that year, Jacopo and Domenico di Niccolò dei Cori were selected priors for their section of the city, the Terzo di San Martino (docs. 98, 99). Relatively little is known, however, of Jacopo's artistic activities between 1420 and 1425. In 1421 he was commissioned to produce an Annunciation for the Collegiata of San Gimignano, although he probably did not actually carve the figures until

31. Many years ago Wolfgang Lotz told me that he had determined that these extraordinary reliefs were carved in Parian Greek marble, but to my knowledge this fact has continued to go unrecognized. Presumably the stone, which had been imported in antiquity, was reused from a Roman monument.

about 1424; they are dated 1426, when they were polychromed by his friend the painter Martino di Bartolommeo. In the meantime, Jacopo must have been working in Lucca at least part of the time. In an act of 1422, Piero di Angelo gave his son power of attorney to collect money owed to him by Giovanni da Imola, and in it Jacopo is described as "usually living" in Lucca (doc. 106).[32] In 1423 Jacopo was employed by the Comune of Siena along with several others to oversee fortresses in the countryside, a typical example of the public service he paid to his "country" (doc. 108). (One should be constantly aware of the remarkably progressive actions of the Sienese government in the early quattrocento. For example, on October 15, 1419, just as the *Fonte Gaia* was completed, the officials set up a mechanism to expedite building, because they recognized that there was a shortage of housing.[33]

On May 25, 1424 Jacopo was the recipient of a substantial dowry, amounting to 350 florins, from Agnese di Giovanni di Domenico Fei, possible a relative of the painter Paolo di Giovanni Fei (+1411; doc. 114). The sculptor's wife is mentioned once after this time, on the occasion of his election as Operaio of the Cathedral in 1435. She ("uxor") is promised the interest on the 1,000 florins Jacopo had to deposit, should he predecease her (doc. 415). Since she is not named in Jacopo's will of 1438, nor are there indications that the marriage produced children, we may assume that Agnese died sometime between 1435 and 1438, without issue. Parenthetically, there are indications that Jacopo lent out money, even large sums, from time to time, and realized a good return on his investment (docs. 110, 113).

THE LATER YEARS (1425–1438)

The year 1425 marks approximately a quarter-century of independent activity for Jacopo; at this time he began the main portal of the façade of San Petronio in Bologna, his most demanding commission, one that occupied the remaining thirteen years of his life. Indeed, it was still seriously incomplete at his death. Although the contract for the portal was signed on March 28, 1425, Jacopo must have spent time in Bologna immediately before this date formulating the details of the agreement, discussing the project, and preparing the drawing. In other words, we can assume that negotiations went on for some time before the actual contract was signed.

The next few years were spent in frenetic trips between Siena and Bologna, and between Bologna and Lombardy and the Veneto. Jacopo even temporarily returned the advances for the remaining bronze relief panel intended for the

32. Giovanni seems to have moved back and forth from Siena to Lucca after he was freed from prison in 1417, but he apparently settled permanently in Siena after 1423 if not before. His whereabouts must have been closely tied to those of Jacopo during these years.

33. Biblioteca Laurenziana Firenze, Antinori, no. 193 (a sixteenth-century copy of earlier Sienese statues), fol. 18v and following.

basin of the Sienese *Baptismal Font*, because of the new demands of the portal (doc. 125).

In addition to the actual carving of the sculptures in the round and the reliefs in Bologna, Jacopo was also responsible for acquiring the stone, which necessitated diverse trips to Milan, to the quarries near Verona, and to the warehouses in Venice. There he was able to obtain the Istrian stone (which is similar to but is not, strictly speaking, marble) that formed a major portion of the material he required, along with red and white marble from Valpolicella. The intensity of the life he must have led, especially in these later years, when he was frequently on the move and had to adjust to diverse and sometimes difficult living conditions, is a significant dimension of his personal biography. This way of life offered him new and renewed visual opportunities—the art of Venice and Milan, for instance—and insights into the latest developments in the north. Perhaps as much as any other representative of his generation, he had vast direct experience of much of central and northern Italy. While a Roman trip might realistically be postulated, a trip to Naples, such as Donatello had made, is less likely. Nor does Jacopo ever appear to have left Italy, notwithstanding the fact that a Burgundian visit could explain a good deal about his art and would be consistent with the strong Lucchese connections with Burgundy.

Although there are no indications in the documents that Jacopo was present in either Lucca or Siena during 1426, he was probably in both places, if only briefly. Unquestionably he was in Siena on June 20, 1427 for the signing of the agreement to execute the upper portion of the *Baptismal Font*—a considerable personal victory over its original designer, Lorenzo Ghiberti, who by then had obtained the commission for still another set of doors for Florence (doc. 187). Now Jacopo had an opportunity to employ some of his friends, among them Donatello. The Carrara marble for the *Font* was obtained in Pisa at the beginning of 1428, and later in the same year payment was made for the marble block from which Jacopo carved the statue of Saint John the Baptist (docs. 207, 212, 220). Furthermore, Jacopo must have been responsible for engaging Sassetta to prepare a design to scale of the *Font*, which served the workers while preparing the stones for the monument. The same procedure seems to have been employed by Jacopo for the Bolognese portal. Giovanni da Modena was hired in 1425 to draw a scale model of Jacopo's design on a provisional wall at San Petronio to provide the workmen with a point of reference, especially pertinent when the master was not available, which was, after all, very frequently (docs. 122, 124, 127, 203).[34]

34. In payments to Giovanni da Modena, the term *disegno* is used twice; it is the same word found in the payment to Sassetta. Giovanni was paid a total of 65 lire for his work of transfer and transposition, compared to Sassetta's 44 lire, but after all the Bologna portal was a much larger monument. The Bolognese lira was worth about twice as much as its Sienese counterpart at the time (i.e., 2 Bolognese lire for 1 florin and 4 Sienese lire for 1 florin), and consequently the payment to Sassetta would have been about equivalent, considering the diversity in the size of the two projects. There is disagreement in the literature concerning Sassetta's *disegno*. Some scholars claim that it was on paper and not a wall

Between 1426 and the end of 1428 the reliefs on the lintel (five New Testament subjects), the large Madonna and Child in the lunette, the prophet busts on the embrasures, and the decorative colonnettes on the lower zone of the portal were executed.[35] Jacopo probably carved the figure of Saint John the Baptist for the summit of the *Baptismal Font* in Siena while continuing to work on the relief showing the Annunciation to Zaccharias in the Temple during the same span, as well as supplying five prophets in marble relief for the same monument (docs. 324–327). In other words, not only did he divide his time between Bologna and Siena, but he actually produced works in both places virtually simultaneously.

Although he was almost constantly on the move, the second half of the 1420s was one of the most productive periods of Jacopo's career. He was famous, well-to-do if not rich, operating two busy shops at the same time, in full control of his craft, and capable of heightened artistic expression. On his various journies from Emilia to Tuscany he must have passed through Florence quite frequently, keeping a sharp eye on the art that was unfolding there and what contemporary sculptors were about, with special attention to Donatello, Ghiberti, and Michelozzo. Essential for understanding Jacopo della Quercia as an individual and as an artist is the recognition that he was acutely conscious of his place as an influential sculptor in his own generation.

In the final segment of his life, from about 1430 until 1438, when he died, Jacopo continued the pattern of work and of constant movement that had been well established in the past. During 1430 he worked on the *Portal of San Petronio* in Bologna as well as perfecting the bronze relief for Siena, and he completed the upper section of the Sienese *Baptismal Font* (docs. 326, 327). During the following year, Jacopo appears to have been active in Bologna; since the records are not conclusive, however, Jacopo might have spent significant time elsewhere as well. He was regularly recorded in 1432 in Bologna, whence he traveled once more to Venice and the Veronese region searching for material. The entire year 1433, when he went north again, was devoted to the *Portal*. The Old Testament reliefs that are widely recognized as his masterpieces as well as the statue of San Petronio for the lunette, put into place on the portal in 1434, were presumably carved shortly before. Indeed, in 1432 and 1433 Jacopo's name does not occur in the surviving Sienese documents; in early 1434, however, a new commission came his way in Siena: up to three statues for the Loggia di San Paolo, also called the Mercanzia (doc. 386). This would have offered him an opportunity to produce works equivalent to those of his Florentine counterparts, who filled the niches at Orsanmichele during the previous decades. But characteristically, soon after receiving the assignment Jacopo re-

drawing at all, although I believe that it must have been painted directly on the wall, judging from the amount of money involved (doc. 203).

35. In all fairness, critical opinion concerning the chronology is divided. I will take up the issue below.

turned to Bologna to assemble finished portions of the *Portal* (docs. 390, 393, 394, 396, 399).

A momentous shift in his career occurred in 1435, when he was about fifty-five years of age. During January and February he was chosen *priore*, representing his area of the city, this time the Terza di Città (he had moved from the Terzo di San Martino). He had been listed as a candidate for the prestigious and powerful position of Rettore of the Ospedale di Santa Maria della Scala (doc. 411), but before the final votes were taken, he was elected as Operaio of the Duomo, director of the cathedral work and the chief lay executive, with considerable responsibilities not only for the cathedral but for the Comune as well (doc. 412). Like the position of Rettore of the hospital, that of Operaio was filled by parliament.

Along with his new position went knighthood, and henceforth he is usually referred to as "Messer" Jacopo or Giacomo (doc. 418). The increased demands upon his time, which went far beyond those of *capomaestro*, the usual position for a sculptor or architect, forced him to cancel a commission he had been awarded to produce a marble figure for the Cappella del Campo (doc. 413). Almost immediately upon taking office, the new Operaio, with the approval of the *consiglieri* of the cathedral, sought to make urgently needed repairs to the dome as well as to the campanile (doc. 419).

Despite the honor and the power, Jacopo had made one important condition for accepting the new post, namely, that he would be permitted to attend to the completion of the *Portal of San Petronio,* a clear indication of where his priorities lay: he was above all a practicing sculptor (docs. 415, 416). The Bolognese, who were impressed with Jacopo's new honors, temporarily settled a long-standing dispute concerning overdue payments that had erupted again during 1435 (docs. 424, 430). The longer he remained away, the more anxious the Sienese became, but "Messer" Jacopo returned in time to make a complete inventory of the cathedral and the Opera (workshops and offices), a lengthy and fascinating document that still survives (doc. 439).

The conflict between Jacopo and the officials of the Fabbrica of San Petronio—that is, the governing body—resurfaced in the early part of 1436, to be resolved only in June when work began once more on the portal. In the spring of the following year, Jacopo wrote to the Sienese officials of the government concerning the military situation in northern Italy, which he continued to visit in search of stone for his portal (doc. 461). The pattern of his life appears to have remained much the same, with his time divided between Bologna and Siena. During the final months of his life Jacopo conducted the affairs of the cathedral and also worked on the decoration of the chapel of Cardinal Casini. On October 3, 1438 he drew up his last will and testament and seventeen days later died, presumably at the age of about fifty-eight (docs. 492, 494). He was buried not in the cathedral but at Sant'Agostino, in the sixth tomb of the first order of the portico (doc. 496).

JACOPO DELLA QUERCIA: A PERSONAL PROFILE

The known facts concerning the life and career of Jacopo della Quercia provide a scaffold upon which to construct a personal profile. From the documents we learn that at one time or another Jacopo had been present in the following centers: Siena, Lucca, Pisa, San Gimignano, Florence, Bologna, Ferrara, Parma, Milan, Verona, Venice, Todi, and Perugia. Possibly he visited Rome, though this city is never mentioned in the documents connected with him, nor are there works recognized as by him that were made for a Roman patron. Due to his remarkable mobility, the identification of Jacopo with any single local tradition is by no means adequate. He should not be automatically labeled as an exemplar of the so-called Sienese School or tradition—the most logical and most frequently expressed association—much less of a Lucchese or Bolognese one.

Like his famous contemporaries Brunelleschi, Ghiberti, and Donatello, Jacopo was a much sought-after artist during his lifetime, probably enjoying an excellent reputation even when still quite young. He achieved one of the highest public positions in Siena, notwithstanding his artisan origins. By the time of his election as Operaio of the Cathedral, he was in a position to deposit the 1,000 lire required as a guarantee, hardly a minor accomplishment and one that reflects Jacopo's success in his business dealings. It is certainly impossible to imagine that, say, Masaccio would have been able to raise that kind of money; it is unlikely that Donatello could have done so either, although Michelangelo would have had no difficulty.

As a responsible brother Jacopo looked after his sister and her daughter, for whom he provided a generous dowry. He was in a position to employ any number of artists and artisans as director of the cathedral, thereby giving impetus to the careers of Domenico di Bartolo and Antonio Federighi, among others. But he was also skilled in obtaining influential commissions for himself, beginning with the *Ilaria Monument,* for which he made good use of his father's connections in Lucca, and followed by the *Trenta Altar,* also for Lucca; the *Fonte Gaia,* from the city government of Siena, which also awarded him the responsibility for the upper zone of the *Baptismal Font;* statues for the Loggia of San Paolo; and one for the Cappella del Campo. He succeeded in obtaining the commission for the *Portal of San Petronio* in Bologna through his own devices, as well. Clearly he was quite able to manage his own career while looking after those of some of his friends.

Not long after his death, Jacopo was acclaimed as one of the best sculptors in Italy by Filarete, himself a trained goldsmith, and he was also praised by Giovanni Santi several decades after that. Filarete, indeed, would have employed Jacopo for the decoration of his ideal city were that possible: "e per uno sanese arei mandato, il quale era bonissimo maestro che si chiamava Jacomo della Quercia [*sic*], lui ancora era morto ["I would have sent for a Sienese called

Jacopo della Quercia, who was a very excellent master, were he not dead"].[36]
His style, in any case, was perpetuated in Siena by Antonio Federighi and
slightly later by Francesco di Giorgio Martini. Still later, Matteo Civitali in
Lucca and Niccolò dell'Arca in Bologna may be considered followers of Jacopo
della Quercia, as Vasari proposed.

Jacopo's Letters

The few autograph letters written by Jacopo della Quercia to the officials of San
Petronio in Bologna, to the Sienese government, and to the Opera del Duomo
in Siena deserve careful scrutiny in the ongoing quest to penetrate the mind of
the master. The earliest, dated June 26, 1426, was written at the "Tavern of the
Hat" in Verona to the officials responsible for the Fabbrica of San Petronio
(doc. 149). From this letter and the others, it can be concluded that Jacopo had
some schooling; he was quite capable of expressing himself clearly and often
quite vividly. We find no evidence, however, that he ever learned Latin, being in
the same category as Ghiberti and Leonardo, the self-proclaimed "omo sanza
lettere." Nor does Jacopo reveal a *cultura* beyond that of other artisans of his
time and class, and nowhere does he demonstrate either Ghiberti's knowledge
or disposition for fathoming the ancient past.

In the letter from Verona, Jacopo writes that a few days earlier he had
transmitted a letter from the cardinal legate of Bologna, Louis Aleman, to the
doge of Venice (Francesco Foscari) "nelle proprie mani," containing a request
to waive the gabelles (duties) for the white Istrian stone purchased in Venice for
the *Portal*. The letter to the doge failed to produce the anticipated effect, but in
order not to waste time arguing the case Jacopo paid the two and a half ducats
levied and left for Verona to continue his search for other stone—the sign of an
impatient artist with a practical turn of mind desirous of moving ahead with his
work. That he actually was not loathe to deal directly with the doge himself, if
he is telling the truth, is nonetheless impressive.

Jacopo also recounts that he had to stay a few more days in Verona than had
been agreed upon, in order to be absolutely certain that the stone was ready for
shipment. He spells out in detail the expenses incurred and in so doing refers to
the drawing of the portal that he had left with the officials, presumably the
same one mentioned in the original contract of 1425. In minutely documenting
his expenses he sought to avoid disagreements later on, showing insight into the
mentality of the *fabbricieri;* he also urges the Bolognese to pay for the stone as
soon as possible in order that it be shipped promptly. Apparently the sellers
would not provide credit to the Basilica of San Petronio.

36. [A. Averlino], *Trattato di Architettura*, 1:172. Giovanni Santi mentioned him as "Mes[s]er
Iacopo detto dala Fonte," directly after Donatello and Desiderio da Settignano, among the great
sculptors.

Jacopo "recommends" his shop workers to the Bolognese, requesting that his chief assistant, Cino di Bartolo of Siena, be paid what he asks during Jacopo's absence, since he is honest and needs the money. This concern for his *garzoni,* which was characteristic of Jacopo throughout his life and is most clearly manifested in his last will and testament, went beyond being merely a good business tactic (doc. 492).

In a letter from Bologna of July 4, 1428 to the Operaio of the Siena cathedral, Jacopo reveals himself to be a keen observer of the fluid situation in contemporary architectural practice (doc. 243). Having been asked to recommend an architect for the Loggia di San Paolo in general and to comment specifically about a Sienese master named Giovanni then employed by Niccolò d'Este, Jacopo replies that Giovanni is engaged on the Este castle in Ferrara. Furthermore, he adds, Giovanni is being paid the impressive sum of 300 ducats annually, plus expenses.[37] "I am positive of this!" writes a triumphant Jacopo, leaving the impression that with such good wages and benefits, Giovanni, whom he surely knew personally ("el qual m'è noto"), would be unlikely to accept an offer from the Sienese. Furthermore, according to the sculptor, Giovanni was not the kind of architect to work with his hands; rather, he was a designer ("chomponitore") and engineer. Jacopo's ability to distinguish between the old-fashioned master builder and the modern supervisor of buildings leads to the conclusion that he was well attuned to the operational mode of progressive new architects.[38]

Jacopo also recommends another master, the Bolognese Fioravante, who previously built the palace of the Papal Legate in Bologna and who had been employed by Braccio da Montone in Perugia.[39] Like Giovanni da Siena, Fioravante did not work as a bricklayer but was more concerned with "la forma de

37. This Giovanni da Siena was probably the designer of the castle of Belfiore in 1435, although the attribution is unconfirmed by documents. See Gundersheimer, *Ferrara: The Style of Renaissance Despotism,* p. 254. The cultural and artistic connection between Siena and Ferrara in the early quattrocento should not be ignored. Besides Jacopo's own earlier activity in Ferrara, he was a frequent visitor there while active on the Bolognese portal, because his stones from the Veneto came through Ferrarese canals. Significantly, Niccolò d'Este's favorite mistress, Stella dei Tolomei, was a Sienese noblewoman who mothered both Leonello and Borso, eventual rulers of the city, who were consequently half-Sienese. She died in 1419 (see Gundersheimer, *Ferrara,* pp. 77–78). The Sienese Professor of Canon Law, Mariano Sozzini, was patronized by Niccolò for the first time in 1433. See Nardi, *Mariano Sozzini,* pp. 33ff. It is also known that the proto-Mantegnesque Bono da Ferrara was active in Siena in the 1440s.

38. Jacopo's friend Mariano di Jacopo, known by his nickname "il Taccola," was acquainted with Brunelleschi. See Beck, "The Historical 'Taccola,'" p. 311, and F. D. Prager and G. Scalia, *Mariano Taccola and His Book 'De ingeneis,'* (Cambridge, Mass., 1972), pp. 11ff. These authors believe that Taccola made a long paraphrase of Brunelleschi in his treatise, a point I rejected in my *Mariano di Jacopo detto il Taccola,* pp. 35–36n18. That Jacopo was personally acquainted with Brunelleschi, either at the beginning of the century or later through their mutual friend Donatello, seems quite likely.

39. The architect Fioravante, or Fieravante, who had shared a patron with Jacopo in Louis Aleman, rebuilt the legate's palace that stood near San Petronio while Jacopo was, in fact, working on the portal there. See Supino, *L'arte nelle chiese di Bologna,* 2:11–12, and C. Ricci, "Fieravante e l'architettura bolognese nella prima metà del sec. xv," *Archivio storico dell'arte* (1891), pp. 92–111. From this letter it also appears that Jacopo had been to Perugia, since he displays what amounts to first-hand knowledge of the city, which he could have visited while working in nearby Todi. There, he would have familiarized himself with the important monuments of the place including Giovanni and Nicola Pisano's public fountain.

le chose *[sic]*." Jacopo took it upon himself to talk with the architect, who seemed quite prepared to entertain an eventual offer, but the Sienese, we know, ultimately settled for a local man. In discussing Fioravante, Jacopo comments further that because he travels so much, he is more adept at being a pilgrim than anything else—a remark that might be interpreted as a veiled reference to his own pilgrimlike pattern of life, especially in these very years.

During August 1428 there was an exchange of letters between Jacopo in Bologna and the Sienese Signoria, who had requested his immediate return to take up work on the upper portion of the *Baptismal Font* as agreed upon in the previous year (doc. 262). In his answer of August 22 (doc. 263), Jacopo respectfully declines, asserting that he would prefer to obey, of course, but, in his colorful words, the "rope of reason ties me down here for the moment." Nonetheless, he does reiterate his promise to complete the *Font* "in the time allotted." His humble tone, which is something of a pose, is emphasized by an admission of his "uneducated" use of language. On the other hand, Jacopo clearly had no intention whatsoever of leaving Bologna, in view of the fact that work on the *Portal* was at peak intensity at that moment.

The Sienese, who could hardly have expected Jacopo's negative reply, responded with an officiously worded letter on August 26, this time ordering him to return within ten days or be subject to the considerable fine of 100 florins (doc. 266). To emphasize the seriousness of the situation, the Sienese hit the sculptor in the pocketbook by requiring him to pay the expenses of the messenger bringing the letter, a not indifferent 8 lire. Jacopo, in his turn, answered complaining of the unfairness of the charge and reminding the officials that justice stood at the very heart of the Sienese republic, as if to conjure up in their minds Ambrogio Lorenzetti's fresco of Good Government in the Palazzo Comunale. In a letter dated August 28, 1428, Jacopo reminds the Signoria that they must be fair to the weak as well as the strong: "I have not failed nor do I intend to fail, for it would be a mistake to disobey the Signoria, and I do not plan to do so," he asserts, agreeing to return to Siena as requested. The sculptor does ask, in a tone less exuberant than usual, that the 8 lire owed to the messenger be deducted from his stipend for the *Baptismal Font* because he has no cash on hand in Bologna. Within the stipulated ten-day period, Jacopo actually left Bologna, where his last action was to make sure that his four assistants would be paid while he was away (doc. 271). He did not actually make it to Siena for fully another month, however, judging from the documents we have. On his way back to Siena at the end of September, Jacopo had stopped in Florence, where he was given a letter by the Sienese ambassador in Florence for delivery to the Signoria (doc. 274). At the end of this official report the Signoria is informed that news from Bologna will be supplied first-hand by Maestro Jacopo. Thus, although he had been reprimanded for his lack of punctuality, Jacopo continued to retain the trust and respect of the authorities, being used as a trusted messenger and valued commentator.

Soon after his reentry to Siena, Jacopo notified the officials of San Petronio

by letter that he wanted to finish the *Portal,* but this time he imposed certain conditions (doc. 280). All the materials had to be ready and waiting for his return to Bologna so that six or seven assistants could begin work without wasting time. He did not wish to spend his days being miserable: "one can be miserable anywhere," he says, alluding to his previous stay in Bologna. "Those who have no choice but to work there [i.e., in Bologna] have little hope," he affirms, referring no doubt to his *garzoni,* who never had been paid. Jacopo says he is prepared to return to his task even though Bologna is under attack from war and pestilence. He prays that Christ in his divine compassion will free Bologna from adversity, bringing peace to its citizens—an exhortation that transcends the basic purpose of the letter and appears to be quite genuine.

In a statement Jacopo made on February 2, 1434 in Siena (doc. 386), we gain further direct insight into his way of thinking. Agreeing to supply six marble blocks for statues to be carved for the niches of the Loggia of San Paolo (the same building for which the Sienese had asked his advice about an architect six years before), Jacopo also consented to carve as many as three of the statues himself. The terms of the *scriptura* that was approved by the Sienese officials on February 9 contains a highly revealing passage:

> And I the aforementioned Jacopo promise the above-mentioned citizens, over-seers of San Paolo, to make two or three figures from the above-mentioned blocks, or more or fewer as would please your reverences, vowing to carve the figures in such a manner as to be deemed work skillfully done by masters each of whom is well known in Italy for his ability or experience as a sculptor. If I were to retain said commission, and if my finished work is worthy of praise, I would like, or rather, I intend to receive the [same] payment for my work that is customarily made to today's famous masters who are working or who have worked in the city of Florence, and more or less in accordance with the discrete wisdom of the officials and citizens who are my superiors and masters of this work.

One could hardly wish for a clearer statement of Jacopo's self-evaluation, registered during the last decade of his life. Undoubtedly he esteemed himself on a par with the most prestigious masters in Florence including Donatello, Ghiberti, and Michelozzo (and perhaps Nanni di Banco, who was, however, long since deceased), all of whom he knew personally and whose work was familiar to the Sienese authorities as well as to himself. He quite possibly recognized what later critics have acknowledged, namely, that his art had had an impact upon these very masters. Revealing too is his failure to mention any local artists, as if to say that he was so far beyond anyone in Siena that to put himself in their category never would have crossed his mind. Rather, given the opportunity (again), Jacopo expected to carry out his work in accordance with the highest standards of the finest sculptors in all of Italy.

Elsewhere in the same declaration he reveals himself anxious to achieve

proper recognition as a sculptor, and he makes a critically brilliant distinction between those whose reputations were well deserved and those whose reputations were artificially concocted. Also concerned about his stipend, he is dissatisfied with the rates, demanding the same rate paid his peers in Florence. In this straightforward statement, Jacopo specifically compares himself as a sculptor to those active in Florence, rather than those in Bologna, Milan, or Venice. We must assume that he recognized that the Tuscans were then the finest sculptors in Italy, an opinion shared by experts ever since; besides, and more remarkably, he deemed himself equal to the best. One is left with the distinct impression that Jacopo was secure in his mind about his proper place as an artist within the larger view.

Because of his duties as Operaio of the Cathedral, which occupied most of his time, together with his insistent responsibilities in Bologna, Jacopo never did carry out the statues for San Paolo, a regrettable omission. They were finally done, not without flair, in the 1450s by his pupil Antonio Federighi and the painter-sculptor Vecchietta. Had Jacopo carved them, they would have represented his late style in lifesize, in-the-round statuary, following closely upon the San Petronio figure for the lunette of the Bolognese portal.[40] While Operaio, Jacopo continued to be conscious of his responsibility in Bologna, insisting on being allowed to finish his assignment there, which he described as "magne sue fame et maxime pretii," that is, "the highest paid and the most important of his career" (docs. 414, 416). Thus he reiterated his fundamental concerns for personal recognition as an artist and for substantial financial compensation as a confirmation of his ability. Judging from the payments he received between 1435 and 1438 from the Bolognese, I do not believe that the financial reward *per se* was uppermost in Jacopo's thinking; he could have walked out on the project, since he had obtained most of the monies owed him and, besides, had a perfectly good excuse to do so. Optimistically he thought he could finally see an end of the work in six or seven months, during which time he would commute between Bologna and Siena—still today an awkward journey, almost inevitably requiring passing through either Florence or Pistoia. The Sienese authorities agreed to his timetable, as they did to his request that he be exempt from wearing the *birreta* required by his office as Operaio—a request that may be interpreted as a sign of modesty.

By 1435 Jacopo had been awarded one of the most prestigious positions available to a member of the artisan class in his native city; he had even been knighted. Substantial sums of money for maintenance, repairs, and decoration of the cathedral were put at his disposal, and he was in a position to manipulate artistic taste in the city. After having settled affairs at home, Jacopo took off

40. As it happened, Federighi's figures in particular reflect Jacopo della Quercia's later style. It is tempting to postulate—though there is no evidence whatsoever—that Jacopo had made several *bozzetti* (or models) for his figures, which were made available to Federighi. They could have formed the starting point for his sculptures. Federighi is the subject of a monograph by Elinor Richter in press (Edizioni Edam, Florence), based upon her 1985 Ph.D. dissertation at Columbia University.

once more for Bologna in March or early April, where he remained until the end of October or early November, thus to some extent violating his promise to divide his time "partim in Bononia et partim in Senis."

In two letters directed to the sculptor in Bologna, he was justifiably reprimanded by the Sienese for failure to carry out his duties back home (docs. 433, 434). The *consiglieri* of the Opera del Duomo were particularly upset, but so were many citizens ("tutto questo popolo," an obvious exaggeration) who also complained about Jacopo. Notwithstanding the actual and moral pressure, however, Jacopo persisted in Bologna, a clear indication of how much the *Portal* meant to him; perhaps he sensed that his reputation would rest upon it. History seems to have confirmed Jacopo's instincts. Unpredictably, the sculpture on the *Fonte Gaia* did not withstand the centuries, and it has come down to us as a magnificent wreck; the *Ilaria Monument* was dismantled and remains only an echo of its original appearance.

The *Portal* continued to be uppermost in Jacopo's mind, and in March 1436 he wrote to the officials of San Petronio, this time from Parma. Precisely what Jacopo was doing in Parma is not clear (doc. 443). Apparently in the previous month he had set out once again from Siena to Bologna, but had left the city following the eruption of a conflict with church officials. The controversy was centered in part upon previous credits claimed by Jacopo but never paid. This time he told them in no uncertain terms that he had left Bologna "not to escape my obligations but to be free and unfettered because a man who is trapped is neither listened to nor understood." Insisting that he was fully prepared to fulfill his contractual obligations fairly, he wished to preserve his honor; besides, the officials had not lived up to their agreements with him. In a bit of Tuscan homespun philosophy he adds, "Ma quando la passione e la invidia è finita, la ragione e 'l vero è manifesto tanto quanto besognia a fare le menti contenti" — "When passion and envy are put to rest, reason and truth are evident as much as the necessity of making minds content." He would wait three or four days for an answer and if none was forthcoming, he would head back to Siena.

The outcome of the dispute is not clear. Three weeks later Jacopo was back in Siena, conducting business for the Opera, probably an indication that no resolution had yet been achieved (doc. 444). Finally in June and July 1436, the "litibus, causis, et questionibus controversiis et diferentiis" with the Bolognese were settled. According to the negotiations surrounding the accord, we discover that Jacopo, though under intense political pressure, successfully defended his rights and those of his assistants against men of power. Clearly he showed himself to be a tenacious opponent, and in the end the officials of San Petronio were forced to concede to his wishes.

In a letter to the Sienese Signoria written on April 4, 1437, Jacopo reported on the military and political situation in northern Italy as seen from his vantage point in Bologna (doc. 461). Obviously fascinated by the ingenious tactics, he describes in detail the Milanese victory over the Venetian forces at the river

Adda. The narration continues with a description of the situation in Genoa, where the doge had been overthrown by his brother, implying that one of the most feared *condottieri* of the moment, Niccolò Piccinino, had been involved in the episode. With a certain flourish, Jacopo signs himself "cavaliere ed operaio de la katedrale chiesa senese." We learn from this document that he was a man in tune with his time, a keen, attentive observer of the conditions that surrounded him.

In April 1438, Jacopo requested that the Signoria excuse Pietro del Minella from his assignment as castellan of the fortress of Capalbio that had come to him by lot (doc. 481), explaining that Pietro was needed to work on the Loggia di San Paolo, over which Jacopo seems to have had a supervisory role. He warns that progress on the Loggia would be jeopardized should Pietro be forced to leave, for no other person of sufficient skill was available. In addition, he explains, the Signoria should not employ foreigners because this would cause delays and cost more money. Apparently the Sienese preferred to employ locals as a matter of unwritten policy. They had inquired about Giovanni da Siena and failed to hire Fioravante of Bologna. One wonders whether the policy was based upon cost, chauvinism, or simply the desire to give their own citizens employment and to keep money from being taken out of the city. Possibly the truth lies in some combination of these diverse motives.

Last Will and Testament (1438)

Among the most telling contemporary documents concerning Jacopo is his last will and testament, signed on October 3, 1438, seventeen days before he died (doc. 492). He left his money in equal shares to his brother Priamo, a painter, and his sister Lisabetta. Jacopo stipulated that Priamo and Lisabetta were each to purchase real estate that could neither be sold nor otherwise disposed of. By insisting on a sound investment as a guarantee that his heirs would not frivolously squander their inheritance, Jacopo demonstrated the practical side of his nature. In the event of his sister's death, her property would revert to her daughter Caterina; if Priamo died first, his property would go to Lisabetta were she still alive, and if not, to Caterina, his niece. If there were no direct heirs, the property would revert to the Hospital of Santa Maria della Scala.

The other portions of the estate were also to be divided between Lisabetta and Priamo after specific bequests had been allocated. Showing a keen sense of family responsibility, and perhaps a personal affection as well, Jacopo provided his niece with the generous dowry of fully 400 florins. She was to marry either Maestro Pietro del Minella, a "messer Bastiano," whose further identity is unknown, or Cino di Bartolo, Jacopo's longtime assistant. If Caterina were to die before marrying, the dowry would go to destitute young women without dowries, the monies to be administered by a charitable institution, presumably

the Hospital.[41] Caterina in fact married Cino di Bartolo a few days after this will was written and actually before Jacopo's death (doc. 493). Evidently Jacopo had looked after his sister and her daughter following Piero d'Angelo's death, sometime between 1422 and 1437. In 1437 he even arranged to bring his sister and niece to Siena.

As already observed, Jacopo exhibited an admirable lifelong concern for the well-being of his assistants.[42] When he died, he left Cino di Bartolo a respectable 60 florins, Pietro del Minella 10 florins, and Castore di Nanni 5 florins. Other shop workers received 4 florins each for a *cappuccio* (hood) and a belt, and Paolo and Tonio di Baccio were each willed 5 florins for a cape. Thus Jacopo demonstrated his affection for his workers and made a distinction between simply leaving several florins in cash and leaving the same amount for the specific purpose of purchasing wearing apparel that would have been otherwise beyond the beneficiary's means. He obviously chose one or the other alternative depending upon his interpretation of the individual and his needs.

Professional Conduct

Jacopo della Quercia showed himself to be generous toward his immediate family, his assistants, and his friends, but he nonetheless through it all maintained keen common sense. He had earned a great deal of money during his lifetime: according to Priamo, 800 florins were taken (stolen) by Cino di Bartolo from a purse after Jacopo's death. Like Michelangelo, Jacopo seems to have accumulated gold coins that he kept in his house (doc. 492, comment). Jacopo appears to have been an effective manager of his money, unlike Donatello, for example, who was vague about fees. While Donatello was actually underpaid for his work on the *Baptismal Font* because of an unfavorable calculation of the value of the florin, Jacopo always stood firm on having full compensation. When payments were not forthcoming, as happened from time to time while he was at work on the *Fonte Gaia* and the *Portal of San Petronio,* he would simply halt and turn to other commitments until he was properly paid.

Indeed, the sculptor seems to have put his cash to work by lending it out. According to documents dating from 1424, he selected a banker to collect an outstanding debt of 100 florins owed to him by a private individual (doc. 113). In the same year he obtained a dowry of 350 florins from his fiancée's family, an amount far in excess of the 54 florins that his father had been given at the time of his own marriage in 1370 (doc. 1). Jacopo, as we have seen, was even

41. The dowries of poor girls were the subject of one of Domenico di Bartolo's frescoes in the Pellegrinaio in Santa Maria della Scala. This recently restored cycle has been thoroughly treated by Carl Brandon Strelhke in "Domenico di Bartolo," a 1986 Ph.D. dissertation written at Columbia University. See also D. Gallavotti Cavallero, *Lo Spedale di Santa Maria della Scala,* pp. 147–172.

42. Also in this regard, he once obtained the release of one of his *garzoni* from prison in Bologna (doc. 180).

more generous with his niece, to whom he provided a dowry of 400 florins. (Parenthetically, Priamo della Quercia, who was married in either 1438 or 1439, received 240 florins from his wife's family.)

Accustomed to transactions involving large sums of money, in 1425 Jacopo entered into the contract for the portal at Bologna, which originally promised him 3,600 florins exclusive of the cost of material. This amounted to nearly double the compensation for the *Fonte Gaia,* which was also, for that matter, a lucrative undertaking. A few years after the original commission, Jacopo was even able to expand the Bolognese assignment by assuming the responsibility of decorating the inner façade of the portal for an additional 600 ducats (though he never did this work, as far as we know); in so doing he had to waive standing claims he had against the Fabbrica of San Petronio, a beneficial exchange, we must assume.

If Jacopo was adamant and unbending about his compensation, he was often negligent about carrying out large-scale assignments promptly and almost never met the schedules stipulated in the contracts, a pattern that seems to have been widespread in the quattrocento. Usually his patrons had to request, plead, order, and threaten him to get the promised work done. Even the Sienese Signoria had to put pressure on the artist, forcing his return from Lucca in 1413 for the *Fonte Gaia;* but, as we have seen, he only obeyed when circumstances made it impossible for him to do otherwise. After much delay, Jacopo promised to complete the *Fonte Gaia* in 1417 without fail, and he repeated a similar promise in 1418, yet still another full year went by before his work was complete. Of course, the delays were not always his fault. In January 1418 (modern), the parties agreed to expand the fountain project (doc. 82). Jacopo, however, was absent from Siena so often that much of the blame for the slow progress must be laid at his doorstep.

Despite pressing deadlines, Jacopo often took on new, if minor, assignments. For example, in 1418, the year that pressure was the most intense to finish the *Fonte* as well as the *Trenta Altar* in Lucca, Jacopo agreed to make a small wooden crucifix for a private patron in Siena; he must have received other such commissions, although they are not documented (docs. 85, 88). While active on the *Portal* at Bologna, which, as is well known, remained unfinished, Jacopo agreed to carve the tomb effigy of Giovanni da Budrio and possibly other works (fig. 130). Perhaps the original contractual stipulation that the *Portal of San Petronio* was to have been finished within two years after the stone had been acquired was overly optimistic, but even after thirteen years important sculptural elements, including the gable area, had not been started.

In the case of the upper zone of the *Baptismal Font* that Jacopo had been commissioned to execute within twenty months, he was somewhat more punctual. Work on the *Fonte Gaia* was extremely slow, the *Trenta Altar* took a decade to complete, and the Annunciation to Zaccharias relief for the basin of the *Baptismal Font* was thirteen years in coming. The *Portal of San Petronio*

and the Casini lunette were never finished, and even the *Trenta Altar* lacked a final stage in places. The tardiness with his commissions that Jacopo della Quercia exhibited throughout his lifetime may be attributed to poor planning, but also to artistic license as well as a perfectionism that took priority over any schedule.

Furthermore, Jacopo presumably paid little attention to the disorganized way he conducted his life. When his successor as Operaio in Siena was selected on November 16, 1438, less than a month after Jacopo died, the councillors of the Opera consented to fix up the residence of the Operaio (where Jacopo had lived), which was in serious disrepair.[43] Jacopo's quarters and studio in Bologna were neglected and run down, as the inventory taken when Niccolò di Pietro Lamberti took it over in 1439 testifies.[44] On the other hand, although his life must have been hectic since he was constantly moving from one place to another, we have no record of Jacopo ever complaining about his living conditions in the way that Michelangelo would a century later. Jacopo seems to have lived the same kind of distracted existence that is often associated with the lives of artists; one is reminded of Manetti's colorful description of how Brunelleschi and Donatello lived when they were together in Rome shortly after the turn of the fifteenth century: "Non dava noia nè all'uno né all'altro la cura familiare, perché non avevano né donne né figliuoli, nè altrove; e poco stimavano ciascuno di loro come si mangiassono e beessono o come si stessono o vestissono." ("Neither of them were bothered by household matters since neither a wife or children anywhere: neither of them cared much about how they ate or drank or how they were or how they dressed.")

Once Jacopo was made Operaio, he must have moved into the quarters set aside for him near the cathedral.[45] To be sure, the cathedral inventory of December 1435 includes a section devoted to the residence of the Operaio indicating that the rooms put at Jacopo's disposal were a combination of office, studio, and storage in addition to actual living space; all the rooms contained a haphazard admixture of Jacopo's personal property and objects belonging to the Opera (doc. 439).

43. AODS, no. 21 (Deliberazioni), fol. 33v. The precise language of the deliberation was: ". . . veduto che lo Operaio sicondo le provisioni nuovamente facte e obligato habitare nella case della detta Opera et veduto che essa casa a bisogno essere aconcia volendo potere habitare con qualche commodità e anco per se medesima deliberaranno d'accordo che remeterrare e remissero e commissero pienamente nel detto misser lo Operaio che essa casa facci aconciare in quelli luoghi e per quello modo che a lui parrà essare di bisogno. . . ."

Vasari's vivid statement about artist-bohemians of his own time in Florence comes to mind: "Ma quello che era cosa non so se degna di riso o di compassione, egli era d'una compagnia d'amici, o piuttosto masnada, che sotto nome di vivere alla filosofica, viveano come porci e come bestie; non si lavavano mai nè mani nè viso nè capo nè barba, non spazzavano la casa, e non rifacevano il letto, se non ogni due mesi una volta; apparecchiavano con i cartoni delle pitture le tavole, e non beevano se non al fiasco ed al boccale: e questa loro meschinità, e vivere, come si dice, alla carlona, era da loro tenuta la più bella vita del mondo . . ." (Milanesi, ed., *Giorgio Vasari, Le vite*, 6:451).

44. Supino, *La scultura a Bologna*, doc. 88, and Beck, *Portale*, p. 56n1.

45. The exact location of the house of the Operaio is not clear. It seems to have been somewhere within the *canonica* (residence of the canons), a conclusion drawn by G. Aronow, who kindly passed it on to me. See AODS, no. 710, fol. 96v.

According to several committees created after his death to review his administration of the Opera del Duomo, Jacopo had been guilty of misconduct and abuse of office. They harshly concluded that he had made personal use of 2,500 lire's worth of goods and services during his tenure in office, which lasted exactly three years, seven months, and twenty-three days (docs. 501–03, 505). The accusations and condemnations fell into several categories, the least serious of which was related to previously inventoried objects not found after Jacopo's death, including a chalice with a paten, the cup section of a chalice, and small pearls for a pivial.[46] Some missing objects were indeed located in a later search, including the chalice and paten, but others were not. A sum of 44 lire, 1 soldo to cover the costs was ultimately charged to Jacopo's estate. Apparently Jacopo did not take and dispose of these articles; rather, he failed to properly supervise their care.[47] (Some of them were missing from the Opera even before he took office, having been carried over from one inventory to another without checking.) We may also speculate that some of his trusted *giovani* may have taken advantage of the ingenuous Operaio.

More damaging to Jacopo's honor was the accusation, subsequently confirmed, that he regularly used workmen and materials belonging to the Opera for his own private commissions. In one instance, carpenters who were salaried by the Opera made repairs on Jacopo's own house; he also appropriated the lumber belonging to the Opera. In the case of Cardinal Casini's chapel (Cappella di San Sebastiano) in the cathedral that Jacopo was decorating, the charges are more serious. According to investigators' reports, the marble for the chapel belonged to the Opera; furthermore, a large portion of the labor was done by artisans employed by the Opera, for a total value of 342 lire, 14 soldi—this, despite the fact that Jacopo had personally received 140 florins as partial payment from the cardinal. In Jacopo's defense, the chapel was after all part of the fabric of the cathedral, and the dividing line between his personal responsibility and that of the Opera had not been rigorously drawn.

Jacopo made liberal use of the *maestri* and *garzoni* salaried by the Opera for other private jobs. Sometimes they accompanied him on trips to Florence and Bologna, and in general spent a great deal of time at the "utilità del detto missere Jacopo. . . ." Matteo di Domenico, Pietro del Minella, Castore di Nanni, and young Antonio di Federigo are specifically mentioned. Jacopo, we also learn, appropriated wine belonging to the Opera for his own use.

In another category of abuse, Jacopo was accused posthumously of siphoning the funds from the Opera del Duomo: a certain maestro Polo di maestro

46. Among the items that were missing from the Opera and were charged to Jacopo following his death was a lectern to hold books ("leggio da tenere libri") that he had donated to a monastery (doc. 501).

47. The language of the report puts it as follows: ". . . parte per mala custodia avuta d'esse, et parte perchè in lui proprio prevenute." Paoletti ("Quercia and Federighi," pp. 281–284) has reviewed the case against Jacopo, asserting that he had been absolved and that the accusations were for the most part unfounded, a conclusion I reluctantly do not share. Still important is Bacci, *Jacopo della Quercia: Nuovi documenti*, pp. 295–312.

Michele di Belagiunta, Jacopo's assistant, was placed on the cathedral's payroll as *garzone* of the Opera. The commissioners found that Polo "worked little or not at all; in addition he was often absent and did not let the others work. . . ." Jacopo was even accused of keeping most of Polo's salary for himself. These findings cost Jacopo's estate 222 lire in the final settlement. Polo, who worked at the Bolognese portal and who apparently enjoyed a privileged relationship with the Operaio, is probably the same person remembered in Jacopo's will with 4 florins for a *cappuccio*. The misuses of funds belonging to the Opera that were revealed after his death tarnished Jacopo's reputation for honesty. Yet the examiners only concern was the recovery of outstanding funds; the documents reveal no concern for moral issues.

Another blemish upon his reputation is revealed in the letter written by Giovanni Malpigli to Paolo Guinigi discussed previously, in which serious accusations were directed against Jacopo together with his sometime associate, Giovanni da Imola (doc. 44). The irate Malpigli refers to Jacopo as "il traditore di maestro Iacopo da Siena," accusing him along with Giovanni of having committed the "peccato abominevole di Sodoma" with Clara Sembrini, who was Malpigli's sister-in-law. According to the plaintive letter, Jacopo della Quercia had admitted to Lorenzo Trenta, his patron, that he had acquired jewelry and other possessions from her. Indeed, Jacopo appears to have taken part in several transactions involving valuable objects that may have been stolen or which he purchased legitimately from Donna Clara, the wife of Niccolò Malpigli. The letter leads us to suspect that something approaching an orgy had taken place towards the end of 1413 in Lorenzo Trenta's newly finished sacristy in San Frediano, a scene that was apparently reenacted more than once.[48]

Throughout his life, Jacopo served the *comune* in diverse roles: he was Siena's undisputed leading sculptor at home while fulfilling prestigious public commissions. A respected public servant for nearly thirty years, he had been *consigliere* of the General Council and *priore* of his section of the city on several occasions, as well as functioning as a member of a commission to supervise the

48. See ASL, Governo di Paolo Guinigi, no. 2, fol. 264. There was a law on the books in Siena that if a convicted sodomite does not pay a fine of 300 lire, "sia impiccato per le membra virili nel Campo del Mercato et sia ditenuto in e nel decto modo per tutto el di" (Mengozzi, *Il Feudo del Vescovado di Siena*, p. 100*n*; that is, he would be tied up by his male member in the Piazza or the market and held there in that fashion for an entire day). The actions against homosexual acts were not exclusively motivated by moral considerations; ever since the Black Death of 1348 and recurring outbreaks of the plague thereafter, dire need to replenish the decimated population was widely recognized. The Sienese even went so far as to institute a communal regulation that required men between the ages of twenty-eight and fifty to be married within a year after its enactment or be prohibited from accepting any communal office. The regulation was cancelled shortly afterwards, apparently having been deemed unworkable (see *Miscellanea storica senese*, anno 1893, 1:167). Saint Bernardino frequently preached the importance of marriage for the same reasons.

In the case raised by the letter in Lucca, the "sin of Sodomy" may simply refer to adultery. On this point see G. Ruggiero, *The Boundaries of Eros: Sex Crimes and Sexuality in Renaissance Venice* (New York and Oxford, 1985), especially pp. 109–122. On the other hand, laws were constantly enacted against sodomites during the fifteenth century, including one in Lucca "Contra Sodomitas, hereticos et Patturinos" that dates from July 12, 1414.

defense positions in the countryside. Jacopo supplied treasured information to the Signoria on various topics, including political and military notices obtained during his travels. He oversaw the construction of the Loggia di San Paolo, and in the most prestigious of all his appointments, that of Operaio of the Cathedral, he concerned himself with pressing maintenance and restoration of the building.

, The data concerning Jacopo's public life is fragmentary, and what has surfaced is probably only a partial representation of the position he held in the civic life of Siena. Undoubtedly he had become a well-to-do artisan who achieved a powerful position in the life and the art of Siena, and prestige abroad. He traveled extensively, gaining insights into the wider world of the Renaissance that was unfolding in Italy. His advice was frequently sought, especially in artistic matters, and he constantly made astute observations. He may have confused his public and private roles too often to personal advantage, but he appears nevertheless to have been a loyal and productive citizen who brought honor to his city.

Jacopo Seen Through His Art

The art of Jacopo della Quercia is the final body of data offering insight into his total identity. The attempt to analyze an artist through his art requires an accurate and at the same time open-minded reading of his *oeuvre*. Because Jacopo was born more than six hundred years ago, the details surrounding his life, his relationships, his joys, and his disappointments are poorly or not at all recorded. His finest early work, the *Ilaria Monument*, was taken apart long ago; what has come down to us is surely but a sad fragment of its initial splendor. The *Fonte Gaia*, his highest achievement in Siena, retains only a faint shadow of its original beauty. The crowning elements of *The Portal of San Petronio* were never executed, and it has undergone at least one major dismantling; furthermore, it has been subjected to centuries of weathering, to threatening pollutants more recently, and, finally, adding to the injury, to a dubious cleaning. On the whole, then, the overall appearances of Jacopo's major efforts have come down to modern times considerably altered; fortunately, however, individual elements have survived in reasonably good and sometimes excellent condition, permitting conclusions to be drawn about his artistic identity. Buried within his work, too, are features of his character, his vision of the world, and his own place within it.

JACOPO'S LIKENESS

Among the New Testament reliefs on the lintel of the Bolognese *Portal* are several scenes in which Saint Joseph appears (figs. 91, 93, 97). Jacopo portrays

him with compassion, departing from the traditional interpretation as a decidedly nondescript personality to offer a more singular and personalized image. He is shown in his late forties, about the same age as Jacopo at the time the reliefs were carved; and the generosity and concern that induced the artist to remember his assistants and provide for his niece's dowry is consistent with his treatment of Joseph.

In the Nativity, for example, Joseph is given a prominent role in the composition, seated in the foreground; the massive figure occupies nearly as much space as Mary (fig. 91). Jacopo's treatment of the subject may be compared to Ghiberti's on his first doors for the Florentine Baptistery. There too Joseph is placed in the foreground, but low and well beneath Mary, opposite the ox and the ass. Jacopo's is the more sympathetic interpretation. While Ghiberti's Joseph is inactive, captured in a moment of puzzled sleep, Jacopo della Quercia's figure is a blunt, robust Tuscan peasant, thick of limb, with large hands—more a *paterfamilias* than the usually acquiescent grandfather. Joseph, who looks at the newborn child, has been fully integrated into the narrative.

In the Flight Into Egypt, Joseph, conventionally shown leading the ass, prods the trusting beast from behind. The heads of Mary and the Child lovingly touch in an attitude of tenderness that has precedents in Byzantine usage as well as in Donatello's *Pazzi Madonna;* this sensitivity is matched by Jacopo's portrayal of a dutiful Joseph engrossed by awesome responsibility.[49]

The sculptor never made an actual self-portrait—at least, he did not make one that has been recognized among the reliefs or in-the-round figures. The engraved representation Vasari used in his *Vite* may have been a complete invention, or it could have been based upon a likeness that was available to Domenico Beccafumi in Siena. The oval painting of Jacopo della Quercia in the Uffizi is either a source, or more likely is derived from the engraving accompanying Vasari's *Vite* (frontispiece). Of course, the identification of likenesses within quattrocento paintings or reliefs without solid, convincing evidence—in the form of inscriptions, for example—is inevitably a risky activity. With this warning understood as a given, suggestions may be offered. The standing, beardless prophet in relief who looks downward on the tabernacle of the *Baptismal Font* (fig. 141) has a full round face similar to the bust relief depicting a prophet from the left side of the *Portal of San Petronio*, strategically placed at the very bottom of the pilaster (fig. 125) and closest to the spectator. These two representations, in turn, appear to be at least generically related to the engraving of Jacopo in Vasari and to the portrait in the Uffizi. The type has facial characteristics found in the representation of Joseph, especially as rendered in the Nativity: could they embody the artist's own features?

49. The large relief in Berlin has been challenged as a sixteenth-century copy recently by B. A. Bennett and D. G. Wilkens, in *Donatello* (Mt. Kisco, N.Y., 1984), p. 229n30. Bennett and Wilkens date the original to the 1420s or 1430s; it is not clear whether priority should be given to Donatello or Jacopo.

JACOPO'S FIGURAL PREFERENCES

Like Nicola Pisano before him and Michelangelo after, Jacopo was exclusively a sculptor of the human figure, communicating his measure of the world through the scale of his figures in relation to the spaces in which they find themselves. Landscapes, atmospheric effects, architectural settings and objects never compete for the attention of the spectator because they are secondary elements. Jacopo's treatment of such elements is quite unlike Ghiberti's, especially on Ghiberti's second doors of the Baptistery, and it differs for the most part from Donatello's treatment for the main altar of Padua's Il Santo. Ghiberti's narratives are set within a world of trees, animals, plants and flowers, buildings, and cloud-filled skies and mountain ranges. In Jacopo's *San Petronio* reliefs, the figures entirely overshadow their settings, which are often only faintly etched. Furthermore, Jacopo emphatically favors the nude over the clothed figure, whenever iconographically permissible and sometimes when not. In depictions of the Creation of Adam, the Creation of Eve, and the Fall, nudity is required or at least highly acceptable. In Expulsion scenes and Adam and Eve at Work, Adam and Eve are usually shown clothed or at least with their genitals covered, but not in Jacopo's Bolognese reliefs. In fact, comparison with Ghiberti's interpretation of the same scenes accentuates the degree to which Jacopo departed from pictorial custom and to which he shares the same propensity as Michelangelo.

In these later works in particular, the sculptor preferred thick, muscular figures with heavy limbs and oversized hands and feet. The slow-moving supermen were rendered without excessive attention to detail; the modeling of muscle, bone, facial features, and drapery tends to be generalized in favor of pure physicality. Although Jacopo did not use live models, his male nudes are convincing, particularly sensuous presences, combining actual observation and knowledge of antique sculpture.[50] The females tend to reflect a slightly different formula, although they share a monumentality of form and conception. The heavy-limbed and powerful Eve from the portal's Creation of Eve, a type repeated in the Temptation, betrays a gracefulness of pose in the tilt of the head, in her soft high breasts, in the elegant turn of her wrist and her flowing hair, all elements that are associated with ideals of female beauty. With the exception of Michelangelo's *Dawn* from the Medici Tombs in San Lorenzo, a worthy daughter to some of Jacopo's figures at San Petronio, neither Donatello or Michelangelo ever demonstrated an analogous sensuousness in their depictions of women.[51]

50. On the subject see A. C. Hanson, "Jacopo della Quercia fra classico e rinascimento," Chelazzi Dini, ed., *Jacopo della Quercia fra Gotico e Rinascimento*, pp. 119–130.
51. Donatello's bronze David has been described as "effeminate," corroborating contemporary anecdotes referring to the sculptor's alleged homosexuality. There is a long and labored literature on the subject, for which see Bennett and Wilkins, *Donatello*, p. 232n32. A somewhat similar set of conclusions has been reached concerning the "masculine" qualities found in Michelangelo's treatment of the female

JACOPO'S CIRCLE

Jacopo had frequent contacts with other artists and craftsmen in all of the centers where he had been active, ranging from great masters to artisans and assistants. He was acquainted with Donatello, and around 1423 he turned over to him one of the two bronze reliefs he had been commissioned to execute for the Sienese *Baptismal Font* (doc. 109). Shortly afterward, probably in 1425, Donatello entered into partnership with Michelozzo, and Jacopo must have been known to him as well.[52] Previously Michelozzo had been closely associated with Ghiberti and may have already encountered Jacopo. By farming out to Donatello a share in the decoration of the *Baptismal Font,* Jacopo offered the Florentine an opportunity to compete with his archcompetitor Ghiberti and make inroads into lucrative commissions in Siena. Indeed Jacopo allied himself with Donato—which also meant with Michelozzo, Masaccio, and Brunelleschi —and in opposition to Ghiberti. Ghiberti had participated in discussions for the design of the *Font* from the very start and was a good friend of the Sienese goldsmiths Turino di Sano and especially of his son Giovanni, who also worked on the *Font*. Giovanni di Turino's reliefs publicly demonstrate his admiration for Ghiberti's reliefs on the first baptistery doors in Florence, where Giovanni is documented to have made diverse trips.[53]

In a revealing letter of April 16, 1425 affectionately addressed to his "caro amicho Giovanni," Ghiberti mentions that he had lent the Sienese goldsmith Goro di Neroccio drawings of birds that the latter apparently passed on without permission to Domenico di Niccolò dei Cori; Ghiberti wants Giovanni di Turino to get them back for him.[54] In the same letter Ghiberti sends regards to Francesco di Valdambrino but makes no reference to Jacopo della Quercia, who on the heels of his success with the *Fonte Gaia* must have been regarded as Siena's leading sculptor. Coupling this omission with the fact that Jacopo had turned over an important commission to Donatello, we can infer that in Tuscany there were two cliques or factions among the sculptors and goldsmiths. Such a split could have reflected a lingering backlash from the old rivalry between Ghiberti and Brunelleschi during the competition of 1401, but would also have been perpetuated by the later competition for the cupola project for the cathedral of Florence, which apparently reflected an on-going rivalry. Donatello was on Brunelleschi's side, although the two had an overt break sometime

nude. I do not believe that it is possible to make judgments about an artist's sexuality using the images alone as the evidence. There are, simply speaking, too many variables, including a range of sexual preferences and experiences that an artist (or anyone else) may have had at certain times or stages but not at others.

52. On the partnership see Caplow, "Sculptors' Partnerships in Michelozzo's Florence," pp. 156ff, and Lightbown, *Donatello and Michelozzo.*

53. Paoletti, *Baptistry Font,* docs. 5, 57; pp. 109–113 provide a good summary of Giovanni's career.

54. Paoletti, *Baptistry Font,* pp. 86, and Krautheimer and Krautheimer-Hess, *Ghiberti,* doc. 85.

later over the decoration of the Sagrestia Vecchia in San Lorenzo for the Medici; so was Michelozzo, who had left Ghiberti's shop around 1423. To this group we should add Donatello's longtime assistant Pagno di Lapo, who had been active in Siena for the *Font* and other work, plus Masaccio, Mariano di Jacopo from Siena, who was called "Il Taccola," and Jacopo della Quercia. On Ghiberti's side were his enormous workshop (to which Donatello had belonged for a short time early in the century) and Giovanni di Turino in Siena.

Jacopo's friendship with Donatello could have been reinforced in Pisa, where Donatello was working along with Michelozzo on the *Brancacci Monument,* which was sent by ship to Naples. Jacopo may well have run into Donatello's and Brunelleschi's young friend Masaccio when the latter was painting the altarpiece for the Carmine church in Pisa in 1426.[55] The marble for the Sienese *Baptismal Font* was purchased from Maestro Pippo di Giovanni di Gante, a Pisan mason and entrepreneur of stone who had built ser Giuliano di Colino's chapel in the Carmine where Masaccio's altarpiece was placed. Maestro Pippo may have been active in Florence in the early 1420s (see doc. 212, comment) and is the same person from whom Jacopo purchased the block of Carrara marble.

The art of both Michelozzo and Masaccio demonstrates a debt to Jacopo della Quercia that must have been reinforced by personal contact. In touch with the most progressive artists in Florence in the first phases of the unfolding Renaissance, Jacopo, on his part, had a keen awareness of the best works by Florentine masters.

Two Sienese progressives, Il Taccola and Domenico di Bartolo, were both well known to him personally. Jacopo was the godfather to Taccola's daughter and had given important employment opportunities to Domenico di Bartolo (docs. 219, 422, 457). Both masters, in turn, were witnesses for Jacopo in a public declaration of 1435 (doc. 420). Taccola was personally acquainted with Brunelleschi, as Taccola acknowledges in his *Liber tertius,* and quite likely Jacopo too had personal contact with the magical Brunelleschi.

Francesco di Valdambrino, a frequent collaborator who had served Jacopo as guarantor for the *Fonte Gaia* contract, was undoubtedly on close terms with the sculptor (doc. 45, for example). A talented carver of elegance and refinement in his own right, as demonstrated by his three wooden reliquary figures that have since been reduced to busts and are now housed in the Museo dell'Opera del Duomo, as well as an engineer of the waterworks of the city, Francesco was Jacopo's longtime friend and collaborator.

Among the other Sienese artists and artisans who knew Jacopo and had rapport with him, the most influential was the somewhat older Domenico di Niccolò dei Cori (b. ca. 1363 or later). An unrivalled intarsia specialist as well as a leading sculptor in polychromed wood, he also supplied a design for the

55. Beck, *Masaccio: The Documents,* pp. 31–36.

mosaic floor of Siena Cathedral.[56] Jacopo was a close friend of the painter Martino di Bartolommeo, for whom he acted as a guarantor in 1420 and with whom he collaborated on the San Gimignano *Annunciation* (doc. 100); he also served as godfather to Martino's children (docs. 72, 103). And Jacopo may have maintained at least casual friendships with Sassetta, whose drawing for the *Baptismal Font* Jacopo had been instrumental in commissioning, and with Sano di Pietro and Giovanni di Paolo (docs. 203, 295).

In addition to the stoneworkers mentioned in his will, Jacopo knew Jacopo di Corso, called "Papi," for whom he guaranteed a loan, and Paolo di Martino, who was eventually in charge of the construction of the Loggia di San Paolo, and for whose child he stood as godfather (docs. 87, 445). Also, Jacopo was guarantor in a contract between an otherwise unknown woodcarver from Assisi, Alberto di Betto, and the Opera del Duomo (doc. 101). Jacopo seems to have been the recipient of a constant stream of requests from other artisans for help of one kind or another, indicating a willingness on Jacopo's part. Other persons that Jacopo favored included the goldsmith Goro di Neroccio (doc. 186) and his friend and associate from Emilia, Giovanni da Imola (doc. 47).

Presumably Jacopo had analogous connections with artists and artisans in the other centers where he had been active. We know he had dealings with Fioravante in Bologna, as well as with Giovanni da Siena in Ferrara (doc. 243). He sought the collaboration of Giovanni da Modena, who was undoubtedly the best painter in Bologna, for a scale design of the *Portal,* and from time to time he obtained advice from the woodworker Arduino da Baiso, who was Jacopo's guarantor for the contract of the *Portal of San Petronio* in 1425 as his father Tommasino had been in Ferrara two decades before (docs. 117, 171, 172). Jacopo was well positioned in Lucca, especially in the period before he settled in Siena, and had a rapport with the ruler of the place and some of the main businessmen, including Lorenzo Trenta as well as the Operaio of the Cathedral, Antonio Pardini.

What we know of Jacopo's connections, interactions, and exchanges with artists, artisans, and patrons must be but a portion of the actual network of friends and associates that defined his professional life. All the way through, Jacopo appears to have been sensitive to the needs of others, maintaining a camaraderie with his fellow workers and a willingness to accept social and artistic responsibility.

The Jacopo who results is an artist with wide personal contacts and commitments who participated in the life around him in many of its complex aspects. He maintained friendships and was generous in his personal involvement. He also demonstrated a political awareness and responsibility to his *patria,* serving in various assignments and bringing it lasting cultural glory.

56. On Domenico as a sculptor, see the entries by Bagnoli in Bagnoli and Bartalini, eds., *Scultura dipinta,* pp. 104–132, and E. Carli, *Gli scultori senesi* (Milan, 1980), pp. 34–35; for the intarsias of the pavement, see G. Aronow, "The Pavement of Siena Cathedral," Ph.D dissertation, Columbia University, 1985.

[2]

Jacopo della Quercia's Artistic Style

T HE DEFINITION of Jacopo della Quercia's style requires that artificial and misleading distinctions frequently proposed for the period in which he was active, ca. 1400 to 1438, be adjusted. A formulation in which certain artists working in the first decades of the century are characterized as "Gothic" while others as "Renaissance" overcompartmentalizes the fluid cultural situation.[1] A more efficient approach is to classify the sculpture of this period simply in terms of its epoch, namely quattrocento, without preconceived stylistic prejudices. If aspects of form-making, of constructing drapery, or posing the figure recall previous habits, a more generic and less qualifying term such as "trecento" better serves an analysis than "Gothic." Indeed, the traditional Gothic-Renaissance distinction creates an unavoidable confrontation between "old fashioned (Gothic)" and "modern (Renaissance)," "backward" and "progressive," and by extension, "bad" and "good,"—or good and bad, depending upon one's allegiances.

Jacopo della Quercia, in short, should be studied within the context of his generation, those born in the same score of years from about 1370 to 1390— artists, that is, who emerged as recognizable masters around 1400. His art follows the same cultural urgencies as that of Donatello, Brunelleschi, Nanni di Banco, Ghiberti, and other influential contemporaries. Brunelleschi's and Ghiberti's competition panels for the baptistery in Florence are a starting point for the study of sculpture as it was unfolding at the very outset of the new century, and Jacopo was also a contestant. His earliest recognized works, the *Ferrara Madonna* and the *Ilaria Monument,* were roughly coeval with the Seated Evangelists commissioned in 1408 from Donatello, Nanni di Banco, and Niccolò Lamberti for the façade of the Florentine cathedral (Museo dell' Opera del Duomo, Florence), and with their earliest commissions for Orsanmichele.

1. See in particular Pope-Hennessy (*Italian Gothic Sculpture* and *Italian Renaissance Sculpture*), surely the most influential writer on Italian sculpture over the past half-century.

Italian sculptors, like painters, customarily are catalogued according to local "schools."[2] Within this time-honored system, based upon a tenacious tradition of local historical study, Jacopo della Quercia has been conveniently labeled Sienese, in quite the same way that Ghiberti and Donatello are Florentine. In Jacopo's case the appellation misses much of the complexity of his training and visual orientation, especially as he intensely confronted other centers in Italy throughout his life. To demonstrate how inadequately the unqualified adjective "Sienese" defines him, we should recall that while Jacopo was born in Siena of Sienese parents, as a lad of perhaps eleven or twelve he moved with his father to Lucca, where an alternative artistic-cultural situation prevailed. His education in the arts unfolded outside of Siena, in a town that was politically and environmentally quite distinct from his native place. Lucca is situated on a flat plain not far from the Tyrrhenian coast, nearby to the vast marble quarries at Pietrasanta and Carrara, and a short journey from Pisa, which in Jacopo's day was in decline but was still one of the most magnificent Italian cities. Siena, of course, is a stately land-locked town in the soft hills of southern Tuscany, with strong overtones of a fortified very ancient place, characterized by high walls and deep red brick structures.

Jacopo undoubtedly cut his aesthetic teeth in Lucca within the confines of his father's *bottega,* not in Siena at all, although Sienese shop habits would have formed a vital component in Piero d'Angelo's method.[3] As already suggested, Jacopo must have studied marble carving with someone other than his father, and Antonio Pardino is the most likely candidate. An element of the lad's informal training would also have been a familiarity with Pisa's wealth of fine medieval sculptures as well as its unique accumulation of Roman antiquities, unsurpassed for a Tuscan town.

Jacopo was in Florence around 1401 for the competition, when he undoubtedly familiarized himself with the newer currents that were percolating in Tuscany, including the recent activity on the Porta della Mandorla and at the Loggia dei Lanzi—not to mention the older monumental sculpture scattered about the city, especially the majestic work on the façade of the cathedral, produced a century before by Arnolfo di Cambio.

Further evidence of the diversity of Jacopo's orientation is the fact that in 1403 he was in Emilia, where he may have already been active—possibly for a year or more—in another decidedly un-Sienese artistic climate. In Bologna, particularly, he could have come into contact with a spirited local tradition that had strong connections to Venice, and he even may have had first-hand contact with Venetian sculptors active there.[4] In nearby Ferrara he could hardly have

2. I have taken up some of these issues as they pertain to painting in Beck, *Italian Renaissance Painting* (New York, 1981), pp. 9ff.

3. On Piero see E. Carli, *Gli scultori senesi* (Milan, 1981), pp. 27–28.

4. A recent discussion of later trecento sculpture in Bologna is that of R. Grandi, "Progetto e maestranze del basamento petroniano," in R. Rossi-Manaresi, ed., *Jacopo della Quercia e la facciata di*

been blind to the inventive purity of the medieval sculptural tradition, especially at the cathedral.

And if we are certain that Jacopo was in Ferrara during the first decade of the quattrocento and reasonably sure that he was also, unavoidably, in Bologna at least for brief stopovers, trips and even a stay in Venice or the Veneto, an easy journey from Ferrara, cannot be excluded.[5] A trip to Milan can also readily be imagined, which along with Venice was a wealthy center where activity on the cathedral required skilled sculptors. In the Lombard capital Jacopo would have encountered local masters together with artists who had come from north of the Alps in search of employment.

How, then, does Siena fit into this picture? From what is known for certain, after leaving the city as a boy, Jacopo reentered Siena as a practicing master only toward the end of 1408—fully formed, widely traveled, and, indeed, famous as a marble sculptor. Can we usefully consider him "Sienese" in the same sense as Giovanni di Turino or Sassetta (who was actually from Cortona)? I suggest not.

Jacopo must have inherited Sienese form-making patterns as part of his earliest introduction to art, because he became increasingly cosmopolitan, more so than other sculptors of his generation. Even after he had settled semipermanently in Siena following the contract for the *Fonte Gaia* (1408–09), his point of view would not have been restricted to the Tuscan hills, as was the case with the painter Giovanni di Paolo, for example. Jacopo's art, to be sure, had a lasting impact on his Sienese heirs. His pupil Federighi remained loyal to a Querciesque language in his largely local career; Francesco di Giorgio, born too late to have known Jacopo personally, was a spiritual son, at least as a sculptor.[6] But Jacopo's art also had an impact in other centers, especially although not exclusively where he had been active. In Bologna a host of lesser, mostly anonymous carvers turned out images in his manner that were exhibited at San Petronio following his death. Niccolò dell'Arca, who followed Jacopo in Bologna by nearly a full generation, was called his pupil by Vasari, although no direct rapport between them was possible on chronological grounds. Powerful echoes of Jacopo's art are to be found on the Arca of San Domenico. Michel-

San Petronio a Bologna (Bologna, 1981), pp. 177–193; still more recent is Grandi's contribution in the exhibition catalogue *Il Cantiere di San Petronio* (Bologna: Nuova Alfa, 1987). Essential is Wolters, *La scultura veneziana gotica (1300–1460)*.

5. G. Freuler, in "Andrea di Bartolo, Fra Tommaso d'Antonio Caffarini, and Sienese Dominicans in Venice," *Art Bulletin* (1987), 69:570–586, and Gilbert, in "Tuscan Observants and Painters in Venice ca. 1400," call attention to Sienese penetration to the area. The tomb monument of *condottiere* Paolo Savelli (+ October 30, 1405) in San Maria dei Frari—for which see Wolters, *La scultura veneziana*, vol. 1, cat. no. 155, pp. 229–230—has been associated with Jacopo. The attribution to Jacopo is Valentiner's ("The Equestrian Statue of Paolo Savelli in the Frari," pp. 281–292). I suspect that the group as well as the sarcophagus was created by artists of the dalle Masegne shop, around 1406–1410.

6. See Richter, "Antonio Federighi, Sculptor." The most recent study of this remarkable Sienese "uomo universale" is that of R. Toledano, *Francesco di Giorgio Martini, pittore e scultore* (Milan, 1987), who does not, however, give any importance to Jacopo in Francesco's vision.

angelo, who was the most faithful continuer of Jacopo's artistic vision, probably first encountered his art in Bologna during the 1490s.

Although the sculptures in Venice attributed to Jacopo by Cesare Gnudi, including the *Judgment of Solomon* of Istrian stone from the Ducal Palace, cannot be accepted,[7] nonetheless Jacopo almost *could* have made them. They contain points of similarity to his known productions, which signifies that Jacopo's art has features in common with the progressive sculpture being created in Venice in the early quattrocento. This situation can be explained by two considerations: Jacopo shared analogous experiences and common sources with the Venetians of his generation, especially the *cantiere* at San Marco; and Jacopo's own work had become known to sculptors active in Venice during the first quarter of the century, both local masters and the "imported" Tuscans.

What grows from the recognition of these conditions is that Jacopo's art should be studied in a context that includes interchanges with important centers north and south of the Apennines and, perhaps, even north of the Alps. Once these relationships are recognized, a "Sienese" designation for Jacopo can be rehabilitated, in the same way that Michelangelo may be called "Florentine." Michelangelo had what amounted to a fixation for his native Florence, although he spent decades, really more than half his adult life, in Rome. The usual phrase of "Michelangelo the Florentine" is, somehow, acceptable; "Michelangelo the Roman" is not. (Leonardo, in distinction, fails to give any hint in his vast body of extant writings of nostalgia for Florence; he too spent the greater part of his adult life away, in Milan, Rome, and France.) Undoubtedly Sienese by sentiment, Jacopo's political loyalties were directed toward his native republic, where he had many friendships. One can also imagine that his pattern of speech, his syntax, not to say his verbal orientation, would have been symptomatic of his south Tuscan roots. He "returned" to Siena in 1408 a celebrity and held important office there.[8]

Even when he was absent, either in Lucca during the 1410s or in Bologna in the period after 1425 on and off until his death, Jacopo retained his Sienese ties and a Sienese aura. Politically, sentimentally, and linguistically he was Sienese; artistically, although Sienese components cannot be ignored, it is more accurate to consider Jacopo an "Italian."

───────

7. See Wolters, *La scultura veneziana*, vol. 1, cat. no. 245, pp. 287–288, for a summary of the attributions. Wolters assigns the work to Bartolommeo Buon, dating it ca. 1435. The attribution to Jacopo was set forth in a public lecture given by Gnudi in Venice in 1966. As for the *doccioni* on the north façade of San Marco, also associated by Gnudi with Jacopo, see Wolters, 1:249.

8. There is no doubt but that traditionally artisans were asked to hold various offices in Siena. Antonio di Vincenzo, the architect of San Petronio in Bologna, had an impressive record of public service, as Gonfaloniere del Popolo in 1383 and as one of the Reformatori dello Stato di Libertà in 1400. Nanni di Banco and his father were both frequently public servants, and Brunelleschi had appointments as well. See M. Bergstein, "La vita civica di Nanni di Banco," *Rivista d'arte* (1989), anno 34, 4th series, 8:55–82.

The sculpture of Jacopo della Quercia cannot be understood outside of a broadly perceived cultural situation that includes references to the other sculptors of his generation who, in his own words, were "honestly famous in Italy" for their ability (doc. 386). He should be considered as pertaining to the first generation of Italian quattrocento sculptors—Brunelleschi, Donatello, Ghiberti, and Nanni di Banco, all Florentines who were at the forefront in defining the new formal language, as well as with Francesco di Valdambrino from Siena, Matteo Raverti from Milan, and the Venetian Bartolommeo Buon. A vital place in the first stirrings of the Renaissance in the fine arts was held by the sculpture Jacopo produced between 1406, the date of the execution of the *Ferrara Madonna,* and 1415, when he became deeply engrossed in the sculpture for the *Fonte Gaia* after having successfully produced the *Ilaria Monument* in Lucca.

His efforts coincided with the earliest statements of the new style in Florence: Donatello's *David, Isaiah,* and *Saint John* for the Duomo as well as the *Saint Mark, Saint Peter* (with Brunelleschi), and the *Saint George,* for Orsanmichele; Ghiberti's *Saint John the Baptist* and *Saint Matthew* for Orsanmichele, as well as Nanni di Banco's majestic *Quattro Santi Coronati* and his other contributions to the same building.

The clock of change ticked at different speeds for the various arts at the beginning of the Renaissance. Painting only "caught up," as it were, in the mid and late 1420s and in the 1430s, with the contributions of Masaccio, Fra Filippo, Fra Angelico, and Domenico Veneziano. And to keep the record straight, it appears that even before the precocious sculptors were carving and casting their majestic, self-contained figures and reliefs, humanists such as Coluccio Salutati were effectively rediscovering and reconstructing through systematic study a vision of the ancient world. New forms and new solutions were first transposed into buildings by Brunelleschi toward the end of the second decade of the quattrocento, nearly a decade after the breakthroughs in sculpture of Jacopo, Donatello, Nanni, and the others. Jacopo, who was in close touch with his Florentine colleagues, produced images that are essentially harmonious with the others at about the same moment if not earlier.[9]

———

Four categories of artistic impulses are useful in formulating an analysis of Jacopo's style throughout his career: the work of his immediate predecessors and teachers; the more distant medieval tradition; antiquity; and the art of his own generation. None of these categories is distinct and independent from the others; they should be understood as having overlapped and intermingled in his thinking. Jacopo's contemporaries, for example, operated under conditions very similar to those that affected him, each incorporating what was available and

9. My purpose in emphasizing Jacopo's contemporaneity with regard to the innovations in the early '400 is to rectify the widely held critical perception that he was somehow outside the mainstream. (For this view, see for example Del Bravo, *Scultura senese del Quattrocento,* pp. 23ff.)

attractive, which varied according to the expressive requirements of the individual sculptors. Jacopo no doubt had considerable first-hand experience with authentic Roman and Etruscan objects, but he also was able to approach antiquity through the eyes of his heroes from the Tuscan past, Nicola Pisano and Arnolfo di Cambio, as well as through the interpretations of progressive contemporaries such as Donatello and Nanni.

Furthermore, each type of influence was nourished by those that preceded it; the generation of Jacopo's teachers was deeply conditioned by the sculptors of their immediate past (i.e., their teachers and the teachers of their teachers), especially by Giovanni Pisano and Andrea Pisano. Jacopo must have studied the same masters first-hand, as well as indirectly through their pupils and followers. Needless to say, all of these artists were acquainted with the art of antiquity in varying degrees, having studied it both directly and from intervening applications.

I present these categories not in chronological sequence but in the most likely order in which they affected Jacopo della Quercia. Among his immediate predecessors, the first category, obviously his father Piero d'Angelo di Guarnieri belongs at the top of the list. As has already been noted, Jacopo would have first learned his father's point of view and style. There is a tendency to expect that a great master must have had a great teacher as an early guide, but I doubt that any meaningful correlation between the two can be established. Someone may be a fine instructor but an uninspired practitioner, such as Cosimo Roselli, whose pupils (including Piero di Cosimo) held him in the highest esteem. Nanni di Banco was surely trained by his father, an unremarkable stoneworker. Ghiberti's stepfather was his teacher; on the other hand, Donatello was probably first trained by Brunelleschi.

In Lucca, probably under the spell of Antonio Pardini, Jacopo turned from metalwork (and wood sculpture?) to marble as his main vehicle. Among other members of the previous generation who measurably shared in Jacopo's formation, as will be demonstrated, was the Florentine stone carver Giovanni d'Ambrogio, and later, when he reentered Siena, Domenico di Niccolò dei Cori, mainly a master of wood. In Emilia and in the Veneto Jacopo came in contact with the art produced by the de Sanctis shop as well as that of the dalle Masegne, who together dominated the later trecento in northeastern Italy, which still had a strong impact in the first years of the quattrocento.[10]

In the second category, medieval influence, the available Pisan-Lucchese tradition made a strong impression on the sculptor early, starting with the work of Nicola Pisano and Arnolfo that Jacopo knew in Lucca, in Pisa, and later in Florence and Siena.

The third category, antiquity, is the broadest and the most diffuse. Jacopo would not have been familiar with original Greek sculptures, for in his day

10. See, above all, Wolters, *La scultura veneziana*, vol. 1.

nothing of that sort had been found, but he may well have known and even owned small-scale Roman and Etruscan marble and bronze copies and variations. He probably had direct knowledge of Etruscan art, which turned up from time to time; he must have been still better acquainted with Roman sculpture, particularly reliefs, plentiful in Tuscany and especially so in Pisa. Under the rubric of antiquity, a body of works that appear to have been especially meaningful to him at various phases of his career should also be considered: Early Christian metal and ivory reliefs.

The fourth category includes the art of often-mentioned contemporaries, including Brunelleschi, Donatello, Nanni di Banco, and Ghiberti.[11] In addition, when considering the rapport Jacopo had with his own generation, we should be aware that there was inevitably a give-and-take among them and that Jacopo was not merely reacting to what these masters were producing but that they were watching his efforts with interest. Jacopo proved to have had an awareness of architecture, although nowhere in his reliefs is there present a serious devotion to convincing structures in a coherent modern style;[12] nor are there indications of a Humanist connection or pretension such as Ghiberti had shown.

The value of the four categories for examining Jacopo's sources will change from work to work, depending upon circumstances, including patronage, local conditions, and available material. Naturally the expressive requirements at any given moment drastically affected Jacopo's treatment of the subject and the sources he might wish to draw upon; it must have always been a fluid situation with infinite variables.

FORMATION AND EARLY KNOWN WORKS

To determine the ingredients that define Jacopo's art, we should begin with what is known through confirmable contemporary evidence, then move backwards and forwards to less firmly buttressed attributions. Judging from longstanding practice, Jacopo had been destined for his father's occupation and began his training at the age of about twelve, if not earlier. As has already been maintained, his first artistic education must have come from his goldsmith-woodcarver father, Piero d'Angelo di Guarneri, who is poorly documented. Known to have married in 1370, Piero in that decade carved three gilded angels for the main altar of the Sienese cathedral.[13] The single documented sculpture

11. Jacopo reveals in his sculpture very little direct sympathy with contemporary painting, which consequently is not discussed in this text.

12. In terms of letters, Jacopo appears not to have peripherally participated in the humanist circle in Siena inspired by Mariano Sozzini, out of which Pius II came.

13. For Piero, see Carli, *Gli scultori senesi*, pp. 22–28, and Cardile, "The Benabbio Annunciation." For attributions of heads on the exterior south transept wall to Piero see Baracchini and Caleca, *Il Duomo di Lucca*, p. 34. For Duccio's *Maestà* on the high altar (final payments, 1376), Piero made no longer identified wooden angels that moved mechanically up and down on command during the mass.

by him is the polychromed wood Annunciation in the church of Santa Maria in Benabbio (near Barga). If the provisions of the contract of 1394 were maintained, it was produced in that year (doc. 3).[14] Only the most generic connections with the known sculpture by Jacopo can be isolated in the two figures of this Annunciation, although Jacopo could have participated in their carving and probably did. After all, he was about fourteen years old at the time, and would not have had any significant independent role.[15] Whatever the actual case, one can easily imagine, judging from these statues, that young Jacopo was soon casting his sights beyond the limited expectations of Piero d'Angelo. Jacopo's father, perhaps taking notice of his son's gift, evidently encouraged him to seek more ambitious horizons.

The *Ferrara Madonna* and the *Ilaria del Carretto Tomb Monument* have excellent claims to be among Jacopo's earliest works, and together they form the platform for studying his early style.

If my argument for ca. 1380 as the date of Jacopo's birth is accepted, many sculptures that have traditionally been associated with his earliest stages can be eliminated on chronological grounds alone. The most frequently suggested works for the early Jacopo are: the *Piccolomini Madonna* (Duomo, Siena); a relief with a Pietà and prophet busts (predella of altar, Cappella del Sacramento, Duomo, Lucca); the *Tomb Monument of Sant'Aniello* (Sacristy, Duomo, Lucca); embrasure reliefs, Porta della Mandorla (Duomo, Florence); *Annunciation* (Museo dell'Opera del Duomo, Florence); *Madonna of Humility* (National Gallery, Washington, D.C.); and *Angel of the Annunciation* (main altar, San Francesco, Bologna). As can be determined from a mere listing, each denotes a different scenario for Jacopo's very early activity, placing him variously in Siena, Lucca, Florence, or Bologna (see Handlist, 1–6).[16]

They are described in the inventory of December 21, 1435—that is, the inventory supervised by the newly elected Operaio Jacopo della Quercia: "Uno [in the margin] Altare maggiore di marmo con una tavola suvi dipenta da ogni parte colla figura [di] Nostra Donna e di più santi e con tutta la passione de Iesu Cristo, colle voltarelle da capo in quatro bordoni di fero con tre tabernacoletti dentrovi tre angnoletti *[sic]* relevati e dorati e quali descendono alla ministratione della santa messa . . ." (AODS, no. 867, fol. 17).

14. Cardile ("The Benabbio Annunciation") suggests that the Madonna of the Benabbio group is at least in part by Jacopo, pointing out what he sees as a possible difference in the carving between the fairly recently restored Mary and the Gabriel. I do not find the distinction significant (nor does Carli; see *Gli scultori senesi*, p. 28), but the possibility of a collaboration between father and son remains quite strong anyway. The search for specific passages by Jacopo in the group is probably fruitless, as is the possibility of finding Michelangelo's hand in passages among Ghirlandaio's frescoes in Santa Maria Novella. Furthermore, connections between the Virgin of the *Benabbio Annunciation* and the *Piccolomini Madonna* (Duomo, Siena) proposed by Cardile, following Baracchini and Caleca (*Il Duomo di Lucca*, p. 39), are not convincing.

15. Cardile calls attention to the arrangement of Mary's hair, which he sees as similar to that on the effigy of the *Ilaria Monument*. On the other hand, the tomb was carved more than a decade later and we could hardly expect close connections, anyway.

16. Those works that have relatively strong claims to be by Jacopo will be treated in the following pages. In my judgment, however, only the Pietà with several of the busts have anything more than a whimsical interest for the proper reconstruction of early Quercia.

THE *FERRARA MADONNA* (1403–1406)

The *Ferrara Madonna* (Cathedral Museum, Ferrara) was contracted in 1403, at which time drawings had been prepared (docs. 11, 12, 15, 18, 19, 21, and cat. 1). The statue was actually carved during 1406, but its conception (in the form of a drawing?) appears to date to the contract's signing. Jacopo shows the Child standing erect on Mary's left leg. The combination of seated Madonna and standing Child has antecedents in fourteenth-century practice.[17] The character and general disposition of the figures, however, share two Tuscan components: the tradition of Nicola Pisano together with that of his occasional collaborator, Arnolfo di Cambio, represented by works located in Lucca, Pisa, and Florence; and later trecento sculpture, from the epoch of Jacopo's immediate predecessors and teachers.

The rectangularity of the Carrara marble block from which the almost oppressively frontal group was carved can be mentally reconstructed by the spectator. The round-faced, unblemished Mary, who looks almost straight ahead, has a ponderous, stiff and axially posed body covered by a simplified system of drapery. The expressionless Child, who disconcertingly and blankly stares out, supports his body with the weight primarily on the right leg, in a somewhat incongruous pose. Seen from the rewarding viewpoints of either side, Mary's refined profile is partly framed by easy flowing, rhythmically arranged sweeps of hair. With an unfussy crown resting atop the large head, a strong neck, and columnar torso, Mary recalls Arnolfo's Madonnas, especially the one formerly in the lunette over the central portal of Florence's cathedral (Museo dell'Opera del Duomo), undoubtedly known to Jacopo. The type of Child, although not the pose, also has affinities with the same statue.

Jacopo was well prepared to appreciate Arnolfo's contributions in Florence by his long-standing awareness of the work of Nicola Pisano, which he probably effectively studied as a lad from the lunette and the architrave of the left portal of the Lucchese cathedral. The lunette, which depicts the Deposition from the Cross, has figures whose monumental proportions, treatment of draperies, and a general heroic air reveal a style or at least a point of view consistent with Jacopo's *Ferrara Madonna,* despite the one hundred and fifty years separating them. Jacopo could have constantly confirmed his admiration for this phase of Nicola's art during trips to Pisa, which must have been a mecca for the budding marble sculptor both for its late medieval treasures and its

17. Brunetti ("Jacopo della Quercia a Firenze") has suggested that there may have been a specific trecento model for the figure. Seymour (*Jacopo della Quercia*, p. 32 and fig. 16) refers to a Sienese type of seated Mary with the standing Child, illustrating one in the Walters Art Gallery (Baltimore). He terms this work "in the style of Giovanni di Balduccio"; it is closely related in type to a polychromed statute in Anghiari (San Bartolommeo), for which see Carli, *La scultura lignea senese,* fig. 10. In this instance, the Child, instead of standing in an easy contrapposto as in the other examples, moves vigorously toward something that Mary once held in her right hand. Lombard examples are also plentiful.

antiquities. The Madonna in Nicola's relief of the Adoration of the Magi, for example, or in the Nativity from the pulpit in the Pisan baptistery, is a first cousin to the *Ferrara Madonna*. Nicola, in turn, had a well-confirmed dependence upon Roman sarcophagi, so that while Jacopo was enriching himself on Nicola's solutions, he was also approaching Roman antiquity through them. And what Jacopo was seeing in Nicola was reinforced by his directly approaching the very same models that the precocious Nicola had pondered so effectively. The massive proportions, the insistence upon the gestural force of the body, a clear, uncomplicated narrative, and a facile yet magisterial handling of the medium were features of Nicola's art that must have attracted Jacopo. Furthermore, Nicola's relationship with the antique, his system of extensive borrowing coupled with decisive compositional gifts, are paralleled in Jacopo's approach. As will be demonstrated, his rapport with Nicola's art never entirely dissipates; even in Bologna at the end of his career, Jacopo continues to have a lively interest in Pisano's inventions.[18]

By the time Jacopo was carving the *Ferrara Madonna,* were traces left of a residual artistic connection with his father? Putting aside the abyss that separates him from Piero d'Angelo in terms of invention and sheer verve of execution, one must assume that by 1406, if not already sometime before, Jacopo had obliterated any measurable stylistic dependence upon his father. On the other hand, among his father's contemporaries, Antonio Pardini looms as the most suggestive candidate to have had a meaningful share in Jacopo's independent development.[19]

That a Venetian flavor can be isolated in Jacopo's early works, which betray the influence of the dalle Masegne brothers, has been widely suggested in recent writing on Jacopo della Quercia.[20] R. Krautheimer takes a particularly vigorous and tenacious stand in favor of a role of the dalle Masegne in Jacopo's artistic evolution.[21] He cites as the primary evidence the *Tomb of Andrea Manfredi* in the Servite church in Bologna, claiming that the black and white marble slab was executed certainly shortly after Manfredi's death, which occurred in 1396, and that it is the most important link between early Jacopo della Quercia and the Venetians active in Bologna immediately before the end of the century. The contention that the *Manfredi Tomb* effigy was made shortly after Manfredi's

18. The Lucca *Deposition* owes much to ancient examples: the figure of the dead Christ is a direct reinterpretation and expansion of a figure in a relief on a sarcophagus lid preserved in the Pisan Camposanto. See G. Papini, *Catalogo delle cose d'arte e di antichità di Italia* (Pisa, 1910), vol. 1, cat. no. 62, which has not been superceded by the more recent publication of some of the same material by Arias, Cristiani, and Gabba, *Il Camposanto monumentale di Pisa*, pp. 160–161.

19. See chapter 1 for references to Pardini, who was undoubtedly the most influential personality in the Lucchese art world until his death in 1419, although little is known about specific details of his career, much less about his sculptural style.

20. Pope-Hennessy (*Italian Gothic Sculpture*, p. 38) seems to have been among the first to point to the possible impact of the dalle Masegne style upon Jacopo. Seymour (*Quercia*, p. 12) goes the farthest, claiming that Jacopo actually participated in the dalle Masegne's Bolognese workshop in the 1390s, but he finds little that is "Venetian" about the *Ferrara Madonna*, a conclusion I share.

21. See Krautheimer, "Quesiti sul sepolcro di Ilaria," pp. 92–93.

death is in direct contradiction to the venerate's testimentary instructions; nonetheless the notion is reasserted by R. Grandi, who cites Krautheimer's authority.[22] I continue to believe that the *Manfredi Tomb* is datable to 1474, as the surviving documents indicate.[23] Tombs made long after the death of the deceased are common, making the year of Manfredi's death anything but conclusive for determining when his tomb was constructed, especially since he specifically stated that he did not want an effigy. One of the stylistic features of the *Manfredi Tomb* that authors who maintain that it was made before 1400 have failed to take into account is the presence of the entire figure behind the surface plane and a *schiacciato* component, a relief technique that occurs only later. Furthermore, the figure has no architectural framework, unlike the late trecento tombs used in comparisons for defending the early date. In addition, although the figure is archaizing in its basic design, there is movement within it that breaks the central axis; it is quite unlike the stiff *Tomb of Ostasio IV Polenta* (+1396) in San Francesco, Ravenna, and the still later *Tomb of Michele Aiguani* (+1400) in San Martino, Bologna, which have been associated with the *Manfredi Tomb* by both Krautheimer and Grandi.

Jacopo could hardly have remained unimpressed by the enormous marble retable by the dalle Masegne for San Francesco in Bologna, which was contracted for in 1388 and finished by 1393.[24] Sometime later, in 1412, Jacopo himself was faced with executing a similar altarpiece for the Trenta chapel, although on a lesser scale, and echoes of the dalle Masegna may be isolated in that work. As far as a direct stylistic debt to the carvings at San Francesco is concerned, however, no specific borrowings can be pinpointed. The dalle Masegne's figures stand uneasily, even unsteadily in some cases, quite unlike Jacopo's handling. Of course there is considerable variation among the hands active on the Bolognese monument. The predella reliefs, for example, with greater generalization, due in part to the small size, appear to coincide more comfortably with Jacopo's taste than do the larger figures; but they had no impact stylistically upon either the *Ferrara Madonna* or the *Ilaria Monument*.

Other high-quality works by artists who were active in Bologna, either

22. Grandi, "Progetto e maestranze," p. 185.

23. For the documents, see J. Beck, "Niccolò dell'Arca: A Re-examination," *Art Bulletin* (1970), 47(3):335ff. The attribution of the *Manfredi Tomb* to Paolo di Bonaiuto, who was the author of the Ravennate one, is effectively disproved by the illustrations in Grandi's "Progetto e maestranze" (figs. 7. and 8). The effigy of Margherita Gonzaga (+1399) in the ducal palace of Mantua (but formerly in San Francesco), perhaps by Pierpaolo dalle Masegna, was part of a wall tomb ensemble, a work first brought to my attention by Ulrich Middeldorf; see Wolters, *La scultura veneziana*, cat. 147, vol. 1, pp. 224–225). The *Manfredi Tomb* type persists into the sixteenth century: for example, the Pasquino Cenarmi Tomb (+1506) attributed to Amico Aspertini in San Frediano, Lucca, in the Sant'Antonio chapel.

24. See Roli, *La pala marmorea di San Francesco in Bologna*. Seymour (*Quercia*, pp. 26ff and figs. 1–5, 7) goes so far as to attribute the angel Gabriel to Jacopo. Seymour is correct, however, in pointing out connections with Tuscan art in the Annunciation and bringing up the name of Nino Pisano. Perhaps precisely the Ninesque qualities in several statues on the Bolognese altar bring to mind early Jacopo, whose training was based to some extent upon the Pisan tradition, which had an effect in turn upon the dalle Masegne.

Venetian or local Bolognese assistants, have been seen as influential upon the young Jacopo: the quatrefoil relief busts on the base of San Petronio's façade, finished in 1393–94, and the sculptures for the niches of the Mercanzia, depicting the Virtues of saints Peter and Paul, of about the same date.[25] None of these works offers deep insight into Jacopo's early style, except perhaps the refined, half-length image of San Floriano at San Petronio, a documented relief by Paolo di Bonaiuto. Turned obliquely in space, the figure has sharply detailed features that once defined the face, as can still be seen in the nearby representation of San Domenico, but they have been seriously weathered, making an analogy with Jacopo's smoother surface treatment more palpable than actually was the case. One must also consider the common denominator: the impact of the Pisani and notably Nino Pisano, both in Tuscany and the Veneto.

The relation of the *Ferrara Madonna* to sculpture by Jacopo's contemporaries proves informative. A suggestion that Jacopo had been under the spell of Nanni di Banco when carving it, however, should be discarded, first of all on chronological grounds. The first characteristic works of Nanni seem to have been produced some time after Jacopo carved the statue in 1406. On the other hand, stylistic connections between the *Ferrara Madonna* and Nanni's seated *Saint Luke,* which was commissioned in 1408, may be traced to common sources, including the Virtues and the Madonna from the Loggia dei Lanzi as well as the relief sculpture on the embrasures of the Porta della Mandorla, which must have attracted both sculptors. The leading carver involved in the two projects was Giovanni d'Ambrogio, known to have been active from the mid-1380s until his death in 1418. For the Virtues, designs were supplied by Agnolo Gaddi, but in the three-dimensional resolution, nothing remains of the painter's language.[26] The Prudence, for example, shares with the *Ferrara Madonna* similar proportions, the arrangement of the hair, and the folds of the garments tied beneath the breasts. The unmistakable genius of Arnolfo di Cambio looms large for both figures.

More instructive and closely connected to Jacopo chronologically is the art of the younger masters on the Porta della Mandorla, the portal that opens in the direction of the Servi Church of the Annunziata.[27] Giulia Brunetti, an

25. See Grandi, "Progetto e maestiranze," pp. 189–90 and *n*41 for bibliography. The Mercanzia figures, which were carved from a local stone (not marble), have been cleaned and exhibited in the Pinacoteca recently (1987) and were treated in the exhibition catalogue *Il Cantiere di San Petronio* published by Nuova Alfa (Bologna, 1987).

26. In cases where painters were asked to supply drawings for the use of sculptors, as with the Loggia dei Lanzi or the socle reliefs of San Petronio in Bologna, I believe that the main purpose was to give the sculptors a general outline of the form and especially to supply the iconographical requirements for the figures—their necessary attributes, the appropriate costume; I do not believe that the designs were meant nor did they actually serve as stylistic exemplars. Perhaps painters were thought to have been better informed on such matters than carvers.

27. The seminal article is Seymour's, "The Younger Masters of the First Campaign of the Porta della Mandorla, 1391–1397" (1959). In essence Seymour seeks to identify two generations of sculptors working side by side on the sculpture for the portal in the 1390s. Since the measurements used by Seymour still need to be double-checked (as G. Brunetti told me in a private communication), some of his attributions for the various portions of the reveals may need revision, but the basic point is highly instructive.

eminent Tuscan sculpture specialist, proposed nearly forty years ago that Jacopo himself was present at the *cantiere* of the cathedral in Florence, working at the portal, actually contributing some of the sculpture.[28] Her ingenious argument, which has had a consistent following, rests exclusively on a stylistic analysis and an *a priori* assumption of what early Quercia should be. Included among the body of Florentine sculptures associated with Jacopo by Brunetti is the impeccably carved marble Annunciation that once may have stood in the lunette of the portal (Museo dell'Opera del Duomo), as well as two sections of the embrasure for the same portal. The Annunciation, whose great beauty has induced scholars to write countless papers, still has not been given an attribution that has attracted a consensus; few specialists, however, consider it to have been chiseled by Jacopo della Quercia.[29] Agreement persists, however, that the Annunciation is related in authorship to sections of the embrasure—namely, the two segments on the top and bottom of the left reveal, with angels holding scrolls and including the marvelous Hercules. Although nothing in my view specifically ties any of these fine, progressive carvings to Jacopo, they do present analogous artistic objectives and shared experiences. Undoubtedly they would have appealed to Jacopo and are informative for his *cultura,* combining the finest plastic tradition of Tuscany with a sharp eye to antiquity.

From what has been learned thus far, the *Ferrara Madonna* confirms that Jacopo was trained in carving marble in Lucca within a current that had been dominated by Nicola Pisano and Arnolfo from the early period, and by their second- and third-generation followers in the Pisan-Lucchese area, including Nino Pisano (and Tommaso) as well as the leading local master in the region, Antonio Pardini. An analysis of the *Ilaria Monument,* which was executed contemporaneously, supports the same conclusions.

THE *ILARIA DEL CARRETTO TOMB MONUMENT* (1406–1408?)

The monument to commemorate Ilaria del Carretto, second wife of Paolo Guinigi, is the uncontested masterpiece of Jacopo's early career and much more: it is one of the finest sepulcral monuments of the entire century and of Western

28. See Brunetti, "Jacopo della Quercia a Firenze," pp. 1–15, reprinted in English as "Jacopo della Quercia and the Porta della Mandorla." Brunetti's thesis is perpetuated and expanded to include the Hercules by M. Lisner in *Pantheon* (1976), 34(4):275–279. Although I reject any suggestion that Jacopo was a pupil or an assistant of Giovanni d'Ambrogio, the example of the Florentine was certainly not unknown to him.

29. I consider it to be by Lorenzo di Giovanni d'Ambrogio, as Vivian Gordon has suggested in an unpublished paper, and therefore datable to before 1405, when he died. What does connect him with Jacopo is that they were both in their bones carvers as opposed to modelers, and they belonged to the same generation, although Lorenzo died very young. Furthermore, both have qualities related to Giovanni d'Ambrogio, who my friend Gert Kreytenberg is convinced is the author. There may be room for compromise, because Lorenzo may have been the main assistant responsible for the execution of the commission that could have been given to Giovanni.

art.[30] The death of Ilaria on December 8, 1405, less than three years after the marriage, is described as follows by Sercambi, Paolo's official diarist:

> "Della quale morte il predicto signore suo marito fu sommamente doglioso . . . il predicto signore all'asequio di tal donna fè magnificamente quello che a ugni grandonna o signore si convenisse, così di messe, oratione, vigilie, vestimenti, drappi, cera, limozine in grande quantità, che serei lungo scrivere a dovere contare ogni particella . . ."[31]

> [The aforementioned lord, her husband, was deeply grieved by her death . . . the aforementioned lord made magnificent services for that woman as befitting all grand women and ladies with masses, orations, vigils, garments, drapes, wax candles, alms in large quantities all of which would take a long time if I were required to recount every detail . . .]

Oddly enough, Sercambi nowhere mentions the tomb monument, which might have been motivated by the funeral ceremonies.[32]

For Jacopo, the lucrative and prestigious patronage of Paolo Guinigi represented a formidable accomplishment and posed a challenge for establishing a reputation as a sculptor. As matters unfolded, the tomb gave Jacopo the occasion to test his mettle as a marble carver as well as a designer, and it was instrumental for the commission for the *Fonte Gaia* in Siena. What Jacopo created—and one must assume that a detailed project had been worked out in concert with the patron—was a singular free-standing tomb monument.

The Original Tomb

Ilaria died giving birth to her second child, a daughter, who was given her name.[33] Undoubtedly the tomb built for her must have been a splendid sight in the well-lighted, independent Guinigi family chapel dedicated to Santa Lucia, which was more like a small single-aisle private church, located in the cloister of San Francesco constructed during the mid-fourteenth century. In part due to its Lucchese location off the main routes of artistic innovation during the early Renaissance, and, more crucially, because around 1430 the monument was dismantled, its impact was fatally diminished.[34] Although it is still widely

30. See cat. 2. For his marriage with Ilaria, Paolo chose his procurators in November 1402; the decree of marriage was declared on January 1, 1403. (See ASL, Notari, Ser Domenico Lupardi, at the date November 25, 1402.)

31. Bongi, ed., *Sercambi*, 3:120.

32. This was suggested to me by Maria Gracia Pernis.

33. This second Ilaria, who had been provided with the enormous dowry of 21,000 florins from her father, went on in 1420 to marry Battista da Campofregoso, brother of the doge of Genoa. See Sercambi, 3:255, and Bongi, *Paolo Guinigi e delle sue ricchezze*, pp. 108–109n3.

34. Direct reflections of the *Ilaria*, at least of the sarcophagus and the effigy, may be found in the *Tomb of Barbara Manfredi* in San Biagio, Forlì, and in the *Foscari Tomb* in Santa Maria del Popolo, Rome, attributed to Vecchietta and conceived as free-standing (according to Pope-Hennessy, *Italian Renaissance Sculpture*, p. 322).

thought to have been originally conceived for the cathedral, the local Lucchese sources are in virtual agreement that the monument was destined for San Francesco.[35] The *Ilaria Monument* must have visually dominated the large chapel (10.60 × 17.80 m.) during the precious few years, from about 1409 until 1430, when it was permitted to rest unmolested there.

One can reasonably guess what Paolo Guinigi had in mind as a decisive motif for his wife's tomb: an "ancient" sarcophagus, for the usage of which there was a strong local and especially Pisan tradition.[36] One of the departures taken by Guinigi and his artist was that instead of reusing a pre-existing Roman sarcophagus as was often done, an entirely new sarcophagus was constructed from scratch, presumably because no fine antique one could be located, to the good fortune of history. There was a precedent: instead of an ancient sarcophagus, an imitation had been made by the Romanesque sculptor Magister Bindinus, who signed an urn that is now located in the Pisan Camposanto. The cultural conditions were such that when this work was carved, anything like a convincing imitation was out of the question—at least as judged by Renaissance or post-Renaissance eyes.[37]

Any discussion of the original appearance of Jacopo's *Ilaria Monument* must take into account Vasari, whose description of the sarcophagus and the effigy also refers to an intervening marble casket upon which rested the block containing the effigy (see cat. 2 for details). Consequently the Ilaria image was effectively separated from the Romanizing sarcophagus by another element that had been retained at least until the mid-sixteenth century when Vasari saw the tomb in the cathedral; by then it was no longer free-standing, and was without any superstructure.

In addition to the low base of black stone that now supports the sarcophagus —a replacement, but some such element must have been there—four distinct zones were originally conceived: (1) the sarcophagus, with ten carved putti supporting a weighty garland of fruits and flowers, the arms of the del Carretto and of the Guinigi families, at the effigie's head, and a foliated cross at the feet;

35. Lazzareschi ("La dimora," p. 80) was the first modern scholar to give the correct location of the tomb, although nearly all modern critics ignore this information. (A notable exception is Isa Belli Barsali, in her authoritative *Guida di Lucca,* p. 68.) The importance of the chapel for Paolo Guinigi is attested by the fact that when a son—born in September 1409 to his third wife Piagenta and given the names Francesco and Angelo—died a month later, he was buried ". . . nella cappella di Sancta Lucia a Santo Francesco" (Sercambi, 3:170). From the same source we learn that Piagenta was put to rest there, too (Sercambi, 3:233–234). The chapel was founded on February 17, 1354 following a provision in the will of Francesco Guinigi of 1350, mentioned in the inscription on the portal of the chapel (see Lazzareschi, "La dimora," p. 80*n*2).

36. See Papini, *Pisa,* vol. 1, cat. no. 81, and Arias, Cristiani, and Gabba, *Il Camposanto monumental di Pisa,* pp. 160–161. The sarcophagus was made for a Lucchese relative of Guinigi's first wife, Giovanni Parghia degli Antelminelli, and his wife Salvage.

The remains of Saint Richard, whose cult and relics were housed in the Trenta family chapel in San Frediano, had been placed in a late Roman sarcophagus with winged angels on the front, and this was incorporated into the altar of the chapel together with Jacopo della Quercia's retable (fig. 23).

37. See Papini, *Pisa,* vol. 1, cat. no. 223. It is quite possible that Jacopo recarved portions of the sarcophagus, including some corrections of the angels, and even produced the inscription.

(2) the casket, or *cassa,* probably with an inscription; (3) the effigy itself, with a dog beneath the feet; and (4) the canopy or other architectural elements, possibly with religious imagery. Of them, only the sarcophagus and the effigy zones remain.

The Question of Dating

In order to evaluate Jacopo's efforts on the tomb within the context of his overall style, an acceptable chronology is required. The date of the *Ilaria Monument,* however, has been the subject of debate. The assumption is widely held that the monument was produced swiftly following the death of Ilaria on December 8, 1405, probably finished toward the end of 1408 when Jacopo was awarded the assignment of the *Fonte Gaia.* Presumably the tomb brought Jacopo to the attention of the Sienese. He would hardly have been free to undertake the enormous requirements of the fountain if there remained much unfinished for the tomb. After Paolo Guinigi remarried on April 17, 1407, one would presume that he had good reason to see that the tomb for his previous wife was completed expeditiously, were it not already finished.[38]

Circumstantial evidence can be brought to the argument that helps corroborate the dating of the *Ilaria* to 1406 and 1407. In those very years, Jacopo's longtime friend and collaborator Francesco di Valdambrino is mentioned on four different occasions in Lucca (docs. 16, 19, 20).[39] Since he was not definitively registered in Siena until 1409, shortly after Jacopo's reentry into the city, one has to wonder whether they had been working in tandem in Lucca and then had come back to Siena together. In 1409 the cathedral officials awarded Francesco the commission to create in polychromed wood the Four Protectors of Siena as reliquaries (doc. 28 and comment). Jacopo, who was then in Siena, would have been available for all or part of this commission too, but either because it was thought that the *Fonte Gaia* was more than he could handle already or because he was not highly regarded as a wood sculptor, he failed to get the nod. To be sure, all the wood statues attributed to Jacopo are datable later, with the exception of the newly recognized *Annunciate Virgin* from San Raimondo al Refugio (Siena), which I believe to be about contemporary (i.e., ca. 1410; and see cat. 4).[40] It has been ascertained recently that Francesco had been in Pisa in 1403, where he signed and dated the so-called *Palaia Madonna*

38. Guinigi's third wife died on September 11, 1416, according to Bongi (*Di Paolo Guinigi e delle sue richezza,* p. 110n2).

39. Paoli, in *Arte e committenza privata a Lucca,* pp. 155–157 and figs. 118–120, and in "Una nuova opera documentata di Francesco di Valdambrino," *Paragone* (November 1981), 381:66–77, calls attention to a document of June 8, 1407 that refers to a final payment to "Magister Franciscus Dominici de Senis" of 30 gold florins for the wooden figure of San Niccolò of Tolentino for the church of San Agostino in Lucca, a work the author has identified with the statue now located in San Maria Corteorlandini.

40. For this work see below, and Bagnoli and Bartalini, eds., *Scultura dipinta,* pp. 153–154.

and Child.[41] A fairly consistent collaboration between the two, which is only hinted at by the documents, has been confirmed by modern criticism. Datable to the first decade of the fifteenth century, the so-called *San Cassiano,* which probably represents San Martino at the church of San Cassiano in the Lucchese countryside, has been attributed to Jacopo della Quercia from time to time.[42] The stylistic evidence, however, favors the conventional attribution to Francesco at the time he was firmly documented in Lucca in 1406 and 1407; the work would thus fall shortly before the related seated figures for the Sienese cathedral, three of which have been severely reduced to busts; the fourth has disappeared altogether.

In the earliest of the Lucchese documents Francesco di Valdambrino is referred to as "intagliatore," and in another as "magister lapidum," which is particularly informative; the implication is that he was then, in 1407 if not before, active on a stone project—that is, possibly the *Ilaria.* Still another document recognizes his double capacity as a carver of wood and of stone, referring to him as "magistro lignaminis et marmorum." In other words, we have good reason to suppose that Francesco was actively engaged on a stone-carving project in Lucca during 1407 if not earlier. Since these mentions coincide with the probable date when his countryman, Jacopo della Quercia, was working on the *Ilaria Monument,* a collaboration seems likely, confirming recent stylistic assessments that assign Francesco a role on the tomb.

Due to the presumed pressures to finish the *Ilaria* once Paolo Guinigi remarried in April 1407, Jacopo probably required additional assistance besides that of Francesco di Valdambrino. A likely candidate is Giovanni da Imola, who, after all, became Jacopo's coworker on the *Trenta Altar* only a few years later. Giovanni's whereabouts are completely unknown for the very years in question, but he certainly *could* have been in Lucca. Furthermore, later on he had a close documented rapport with Jacopo and with old Piero d'Angelo, to whom he owed money. He has shown himself to be intimately familiar with the *Ilaria* effigy, if my attribution to him of the *Sant'Aniello* is correct.[43] The cold linearism and the brittle drapery folds of the *Sant'Aniello* are combined with a

41. M. Burresi, in "Incrementa di Francesco di Valdambrino," *Critica d'arte* (July–September 1985), pp. 49–59, was the first to publish this sculpture after its recent cleaning. It had been illustrated in Carli, *La scultura lignea italiana,* fig. lxvii, as "School of Nino Pisano." The association of this work and others from the early career of Francesco with the current of Nino Pisano may help to pin down his origins as well as those of Jacopo della Quercia. For Francesco see also the full entries in Bagnoli and Bartalini, eds., *Scultura dipinta,* 133–151. The later career of Francesco is touched upon in another recent contribution by E. Neri Lusanna, "Un episodio di collaborazione tra scultori e pittori." She is able to date the statue in Sant'Agostino to about 1420 and tentatively gives it to Francesco: her caution is well taken.

42. Strom ("A New Attribution to Jacopo della Quercia") gives the sculpture to Jacopo, based upon a communication from U. Middeldorf. Parenthetically, I should add that she misunderstood my opinion: I believe that the impressive sculpture is by Francesco, and not by Jacopo della Quercia. Clearly, however, an active exchange in Lucca between the two displaced Senesi, already suggested by Bacci, must be assumed.

43. Paoli, in *Arte e committenza privata,* pp. 209–210, persists in attributing the *Sant'Aniello,* which he dates to ca. 1395, to Antonio Pardini.

confident control of the chisel that can be observed in passages on the *Trenta Altar* usually associated with him, and that are evident in the only documented work entirely by his hand, the San Marco relief for the new pulpit of the Sienese cathedral, now on display on the wall of the right aisle.[44] In terms of assistants and collaborators, I suggest that Jacopo had the competent cooperation of both Francesco di Valdambrino and Giovanni da Imola for the *Ilaria Monument*, together with help from less independent personalities, including his father.[45]

The Effigy

Crucial for a stylistic reading of the entire monument is the recumbent Ilaria. In order to fully participate in the expressiveness of this magnificent image, still mistaken for a sacred figure by devout visitors to the cathedral, the optimum viewing points must be determined. The effigy presents itself most informatively in profile at about eye level, that is, at a height as if Ilaria were resting on a casket that, in turn, had been set over the sarcophagus. Seen from above—the point of view often used in illustrating the monument, but impossible for anyone standing on the church pavement—Ilaria may look "Gothic," with sweeping curvilinear draperies. But from that view the high projection of the relief loses purpose: its plasticity is superfluous and effectively negated. I suggest that a view from directly above was never more than a residual aspect of the invention; in consequence, the notion that somehow Jacopo's figure was derived from the flat floor type of tomb should also be discarded. Furthermore, the Gothic qualities achieved from such a reading have misled many observers in evaluating the figure and its stylistic origins, and impeded an effective appreciation of the monument as originally projected and as it has survived.

The head of Ilaria is significantly raised by two decorated, puffy pillows protruding substantially from the mass of the single stone block out of which the woman and the dog have been carved. The upper torso is also sculpted in relatively high relief, almost independent of the block, in contrast to the lower body, where the legs and feet are rendered with much less independence. The reduction in the degree of relief projection has special meaning when viewed from the west, that is, from the feet, half hidden in drapery. This is where one reads first the alert, almost completely in-the-round *cagnolino*, whose paws and legs, however, are in lower relief (fig. 17). Looking beyond, the folded hands and finally the women's raised head, in extremely high relief, come into focus, in a crescendo effect.

44. A very useful summary of the activity of Giovanni, who died before January 13, 1425, can be found in Chelazzi Dini, ed., *Jacopo della Quercia fra Gotico e Rinascimento*, pp. 166–167, and a good illustration of the San Marco is plate XIX.1.

45. A division of labor will be proposed later on in this section.

Three main views for the effigy figure and consequently for the entire monument are essential: that from the feet (west), and the two views at the center of the long sides (north and south). A fourth view, that from the east, is not entirely satisfying, simply because the figure is blocked off from view by Ilaria's head and by the two cushions; however, the hair is superbly calibrated at the back of the head, offering other visual delights. Ilaria probably wore a metal diadem, since holes in the back of the head and what remains of metal bolts may still be observed.[46] Naturally such an ornament would have further obstructed an overview from the east. Even the action of the two "corner" putti at the east serves to deemphasize this side. From the south, a privileged viewpoint, one is confronted with the harmonious silhouette of the body's outline and the lifelike dog loyally turning upward toward its master, as if to direct our attention too.[47] The view from the north is quite similar, except that the dog's function has less intensity.

Another element that has induced critics to see Gothic qualities in the effigy is Ilaria's dress, a *cioppa* or *pellanda,* known already in the trecento; in this case, the garment was probably expressly imported for her from Flanders or France.[48] The costume worn by Ilaria has the same "International Gothic" flavor as the art produced around 1400 both north and south of the Alps. Its full broad sleeves tight at the wrists, the extremely high, narrow collar, the sweep of the falling material disrupted by the snug belt beneath the breasts are qualities of this aristocratic garment. Although the dress is "Gothic" in style we should not be misled into jumping to the conclusion that the sculptural style in which it is rendered is particularly Gothic. When seen from the proper view (in profile and not from above) and when the question of the costume is properly taken into account, the style in which Ilaria is carved does not appear to be at

46. As noted by Herald (*Renaissance Dress in Italy,* p. 218), Ilaria wears a *ghirlanda* made from cloth and decorated with spiraling flowers.

47. Lunardi (*Ilaria del Carretto o Maria Antelminelli,* p. 27) would have the dog a heraldic attribute of the Antelminelli family, and not, as maintained by Vasari, a symbol of conjugal love.

48. For illustrations of similar dresses, *Jacopo della Quercia nell'arte dell suo tempo,* figs. X.7, X.9, and X.o. Cf. Pisetzky, *Storia del costume in Italia,* 2:108. Although the author suggests that *cioppa* and *pallanda* (or *pellanda*) are the same thing, a distinction is made between them in a Pistoiese inventory of 1394. See L. Chappelli, *La Donna pistoiese del tempo antico* (Pistoia, 1914), p. 66. On the other hand, in a Lucchese document of 1414 we find "duos palandas vel cioppa" (cited in Lazzareschi, "La dimora," p. 94). Two such dresses were apparently taken with other items in pawn by Jacopo from Monna Clara Malpigli in 1413: "duos palandros vel cioppas videlicet unam viridas et olim vero coloris paonazzi" (cited by Lazzareschi, "La dimora," p. 94). Bongi (*Di Paolo Guinigi e delle sue richezze,* pp. 65ff) published an inventory of Guinigi that is undated but surely after 1414, with "palandre" and other items from France. (Parenthetically, the private library of Guinigi, also described in Bongi, pp. 74ff, contained among other works the pseudo-Aristotelian *Secreta Secretorum* in two copies, which gives some indication of the intellectual pretensions and achievements of Jacopo's early patron.) Business connections between Lucca and northern Europe were very strong, spilling over into the arts. For example, Galvano Trenta, who lived in Bruges in the early fifteenth century with his Florentine wife Bartolomea dei Bardi, sold a "tavola in fondo d'oro" in 1410 to the Duke of Orleans. See E. Lazzareschi, "Mercanti lucchesi in Fiandra," *La Nazione,* January 2, 1930 (extract in Kunsthistorisches Institut in Florence). See also A. Sapori, *Libro della comunità lucchese in Bruges* (Milan, 1947). The author informs us that Paolo Guinigi was himself in Bruges in 1392 (p. xxv).

significant variance with that of the putti on the sarcophagus or the acanthus leaves on its short sides.[49]

The *Ilaria Monument* has incurred losses, not merely through dismantlings and recompositions but possibly also through the disappearance of painted highlights and gilding that enlivened its surface, as has been suggested by Charles Seymour.[50] The practice of applying color to marble sculpture reverts back to antiquity; Nicola Pisano perpetuated it in his pulpit in the Pisa Baptistery. Florentine quattrocento sculpture also offers a host of examples. The glistening, finely polished, ivorylike surfaces of the *Ilaria* were played off, apparently, against a spare but effective application of blue, perhaps behind the putti and here and there in the effigy, together with bits of gold, probably in the hair and on the prominently displayed marriage ring.

The Sarcophagus

Each of the four sides of the sarcophagus has ample references to the total composition of the monument and the appropriate viewing positions. The blocks on the short sides are conceived as insets and do not occupy their entire sides, because the corner putti from the long sides overlap them and intrude, as it were, upon their space. One wing of the corner putto actually pertains to the short-side block.[51] At Ilaria's feet is a fanciful cross of acanthus leaves with a central rosette, similar in type to those found on Ilaria's headdress. The symbolism of the cross has been superceded by a decorative will, effectively disguising the traditional reference.[52] The acanthus leaf motif that is carried to the opposite (short) side is not entirely compatible with the design of the garlands that dominate the long sides.

As has already been observed, the corner putti operate somewhat differently on the east and on the west. At the west they look out directly, encouraging

49. Of course, if I am correct this means that there need not have been markedly different phases for the different portions of the monument: the relationship to the treatment of the acanthus leaves is particularly telling in this regard.

50. Seymour, *Quercia*, p. 33.The example of the well-documented *Altar of San Francesco* in Bologna, which has a certain importance for Jacopo della Quercia, may be cited. See Supino, "La pala d'altare di Iacobello e Pier Paolo dalle Masegne nella Chiesa," doc. 11, where the "depinture" of the altar is mentioned. See also Roli, *La pala marmorea di San Francesco in Bologna*. The Sienese *Baptismal Font* in which Jacopo had an important role (for which see below) was also highlighted with blue and gold.

In 1989 the *Ilaria* suffered an energetic cleaning that wiped away the patina of the centuries.

51. The putti's wings have been obliterated from the east side, which has the coat of arms, when the block had been reused as an independent marker in 1453, at which time the wings would no longer have had any meaning, since the putti were on the other blocks. Also there seems to have been a repair of the block where a narrow strip was added, but I suspect that this adjustment was made by Jacopo himself while preparing the monument, as was clearly the case of the Prophet's head for the upper zone of the *Baptismal Font* in Siena, first reported by Seymour (*Quercia*, p. 66).

52. The same kind of cross is repeated in the Arca dei Rapondi in the Cappella di S. M. del Soccorso in San Frediano (Lucca), for which see Paoli, *Arte e committenza privata*, fig. 190.

movement around the sarcophagus. On the east, however, although the figures are similarly located at the corners, their internal clues, the movement of their heads, and especially their implied glances, discourage the spectator from turning the corner, although he or she easily could. This situation has led me to believe that while the tomb was independent of the east wall in the Guinigi Chapel in San Francesco, it was planned to be placed close to the wall, and very possibly the supports of the canopy of the side closest to the wall were actually attached to the wall itself. In this location, the foliated cross would have faced the back of the altar, rather than having been somewhat hidden near or against the walk, as must have been the case with the arms.[53]

The long sides offer the most appealing and revealing views of the sarcophagus, with the winged, standing Victories supporting a heavily laden wreath of fruits and foliage. The four corner boys, who are carved with virtually complete freedom from the blocks, stand in comfortable contrapposto. The central putto on each side is, by contrast, carved with less relief projection and is consequently more pictorial. Cross-legged, running, or standing on one leg, these figures display engaging conceptual variety. They are the earliest fifteenth-century examples of large-scale putti, a motif that will play such a significant role in the art of the period.

Division of Hands

Scholars have frequently maintained that the two long sides of the sarcophagus were executed by different hands—according to some critics, by contemporaneous ones; according to others, by persons from different periods. I suggest that the problems raised by this line of reasoning can be resolved without difficulty. Already it has been shown that the monument must have been projected and executed with a free-standing sarcophagus *from the start*. No one would have designed a sarcophagus with three sides, the fourth against a wall. The fact that the four corner figures function as corner figures clinches the point. Remaining to be resolved is the question of the assumed attributional differences between the two contemporary putti friezes.

Following Paolo Guinigi's overthrow and expulsion from Lucca in 1430, each frieze underwent a different history, suffered a first of several dismantlings. The south flank, regularly and almost ironically considered the more Querciesque, the more exclusively "autograph" of the two, has been seriously worn, damaged, and generally rubbed, in distinction to the north flank, which has come down to us in nearly pristine condition (figs. 3 and 4). Not a single putto

53. The Church of San Francesco is oriented conventionally, that is, from west to east, as is the Chapel of Santa Lucia. Presumably the *Ilaria Monument* was placed with Ilaria's head oriented the same direction as the altar, that is, toward the east. Consequently the directions of the compass as we now find the monument in the cathedral are the same as they had been originally.

on the south flank has his nose intact, and the generally consumed character of this flank (oddly enough, virtually ignored by critics) makes a comparison between one side and the other far more complex than is usually admitted; some of the "divergences" between them that have been attributed to different hands may better be explained as the result of the varying states of conservation.

In fact, once condition is taken into account, all four corner boys appear to be contemporary, and either completely or largely by Jacopo himself. And since both blocks also contain three other figures besides the corner ones, Jacopo must have worked on them too; thus, we can be reasonably certain that he worked on both sides of the sarcophagus containing putti during the same campaign. The old attributional division between one side and the other consequently should be displaced. Jacopo must have invented the idea of the sarcophagus and produced the putti-garland friezes. To be sure, he appears to have had collaboration for some of the figures and for the swelling swags, though caution should be maintained when attaching names of the possible authors to one or another element.

Jacopo's personal chisel is evident on much of the south flank but also among the central children on the north one as well. At the same time, collaboration can be isolated for the south flank, in particular in the fourth putto reading from left to right (no. 4 in fig. 3). This figure, which is quite evidently not by Jacopo, corresponds to at least one figure from the north side, namely, the middle one, also cross-legged (no. 5 in fig. 5). As has been suggested, one of Jacopo's coworkers for the *Ilaria* was Francesco di Valdambrino. These two nude boys, one from each side of the sarcophagus, are candidates for Francesco's intervention, but not the other figures on the north flank as many scholars have maintained. Francesco probably had a share, perhaps a commanding one, in executing the short sides of the sarcophagus, with the elegant coats of arms and the acanthus leaves (west) and the cross (east).

Another hand may be isolated, the one that executed two of the putti on the north side (specifically nos. 7 and 8). Although the identification of this master is even more hypothetical than the attribution to Francesco di Valdambrino, Giovanni da Imola may be put forward as a candidate. I believe that there are very good claims for the attribution to Giovanni. As maintained, he was intimately familiar with the *Ilaria,* a fact revealed in the *Sant'Aniello,* perhaps executed around 1409. In the two putti I have assigned to him, a certain rigidity in the carving prevails, even though based upon a Querciesque model, and there is, perhaps, a lingering dalle Masegne flavor, which must have been part of his Imolese background anyway.

Notwithstanding collaboration in the execution of different portions of the tomb, the design, the invention, together with the subtle refinements, are undeniably due to Jacopo himself. Indeed, neither Francesco di Valdambrino nor Giovanni da Imola could have achieved the *all'antica* aura of the sarcophagus or could have rendered the monumentally conceived putti without Jacopo's

example. In fact, no other master in all of Italy so early in the century could have produced similar forms, derived as they were from ancient models. They were a breakthrough permitted by proximity to Nicola Pisano's works combined with the impetus of ancient sculpture, not to mention the potentialities of the Carrara marble itself. Not even Donatello, the true champion of the new language, nor Nanni di Banco, his worthy compatriot, showed the signs that Jacopo manifested in Lucca during the first years of the quattrocento; only in the following decade did they operate with the same spirit.

In seeking to clarify the stylistic components that went into the creation of the *Ilaria Monument,* two distinct categories may be formulated: the style of the monument as a whole, together with the related cultural traditions; and the style of the carving of the separate elements, especially the putti and the effigy and their presumed sources. Conflicting solutions have been put forward in the critical literature to explain the evolution of the monument as a free-standing tomb. The first is that the Ilaria effigy and sarcophagus grew, as it were, from the widespread practice of the low relief floor-tomb type common in the later Middle Ages and favored throughout the quattrocento, like those Jacopo himself designed for the Trenta family in San Frediano and for Antonio da Budrio in Bologna (figs. 45–47 and 130). In this context, Ilaria may be seen as having been three-dimensionalized, first to obtain a full presence for the effigy, and then, ever expanding from the ground, to achieve a *cassa,* followed finally by the sarcophagus. Related to this interpretation are the supposed connections with French tomb monuments, including the Royal Tombs at St. Denis.

An alternative theory is that the *Ilaria* was an adaptation of dugento and trecento wall tombs, united with the practice of free-standing, usually public monuments that were common in northern Italy: the *Scaligeri Tombs* in Verona, the *Tomb of Rolandino de'Passaggeri* in Bologna, and the *Antenore Tomb* in Padua. In other words, according to this explanation, Jacopo disengaged from the wall a monument like the *Tomb for Cardinal Guglielmo Fieschi* (+1256) in San Lorenzo fuori le Mura (Rome), permitting it to stand free. In this Roman example a casket that contains an inscription rests upon a sarcophagus, with the whole enclosed by a baldachin.[54]

The Cosmatesque *Tomb of Pope Clement IV* (+1268) now in San Francesco, Viterbo, perhaps by Pietro Oderesi, has a large base or "sarcophagus" zone, a casket, an effigy, and a canopy, all the ingredients that are assumed for the *Ilaria.*[55] Jacopo seems to have had an awareness of the Roman wall tomb tradition at least in terms of overall plan and design. But one should not fail to mention Arnolfo's *Cardinal de Braye Monument* in Orvieto, which has a Tuscan resonance, executed by an artist with whom Jacopo had an affinity. Also relevant is the early fourteenth-century monument to Luca Savelli in Santa

54. There was no effigy on this tomb, which was damaged during World War II. For an illustration see Venturi, *Storia dell'arte italiana,* vol. 3, fig. 790.

55. See White, *Art and Architecture in Italy, 1250–1400,* pp. 57–58.

Maria in Aracoeli, attributed to Arnolfo, which has significant points of similarity with Jacopo's project, especially the corner figures on the sarcophagus holding a garland.[56] In a related typological category of monument, *baldacchini,* including those designed by Arnolfo in Rome, are free-standing monuments in their own right that may also have had an impact upon the evolution of Jacopo's *Ilaria Monument.*

The origins of the individual elements that make up the tomb are found closer to home. The Pisan area was well supplied with Roman sarcophagi, including one formerly in San Vito with putti holding festoons. Not only the type of putto but the action of the corner figures makes this connection proposed by Péleo Bacci long ago a particularly convincing one.[57] The Roman sacrophagi that can be associated with Jacopo's example are not free standing, however, but were meant to rest against a wall, so that Jacopo's was a typological departure. In terms of the sheer quality of execution, he surpassed the ancient examples to which he had access, while intuiting from them the sophistication and beauty of the best models that stood behind these provincial examples.

Jacopo was the first quattrocento artist to render on a monumental scale the motif of the activated nude male child, which would rapidly become a favored subject in painting and sculpture. Hardly a Christ Child depicted in the quattrocento was not a disguised puttino; as a type its influence was vast. On the other hand, the motif was never completely forgotten during the Middle Ages. Examples may be recalled, including the tiny details from the façade of Orvieto Cathedral and the portal of the Pistoia baptistery, as well as the capital from the right aisle of the Duomo Nuovo of Siena associated with Giovanni d'Ambrogio, together with portions of the late trecento decoration of the Porta della Mandorla in Florence. Unlike these examples, however, Jacopo restored the putto and allowed it to function as a main motif in a scale consistent with ancient usage.

The style that Jacopo exhibited in the *Ilaria Monument* is homogeneous within the two surviving zones and is compatible with that exhibited in the *Ferrara Madonna.*[58] The rather sharp, unambiguous features of the *Madonna* reappear in the *Ilaria,* especially observable when the heads are compared as viewed from profile. If the types adopted for the sarcophagus are based ultimately upon Roman models, the way in which they have been rendered has no antique precedent. Rather, the style of Nicola Pisano and of his collaborator and continuator, Arnolfo di Cambio, is the tradition that Jacopo depended

56. See White, *Art and Architecture,* pp. 55–56, and A. M. Romanini, *Arnolfo di Cambio e lo 'stil nuovo' del gotico italiano* (Milan, 1969), pp. 152–158.

57. Bacci, *Francesco di Valdambrino,* pp. 100–101 and Papini, *Pisa,* vol. 1, nos. 84, 85, and 86. There is a post-Ilaria imitation (Papini, *Pisa,* vol. 1, cat. no. 333) of an ancient work, growing apparently from a similar cultural necessity, made for Abbot Benedictus (+143[?]), with *genietti* and garlands, but despite its later date, it has only a feeble rapport with antiquity.

58. The unsigned article (by G. L. Mellini) "Omaggio a Ilaria del Carretto," *Labyrinthos* (1987), vol. 11, has the following observation: "Chi disse che non c'è unità di stile (a parte la collaborazione dell' officina) non s'accorse che la variazione è progetturale . . ." (p. 108).

upon most heavily. Yet historically intervening experiences were also part of the quotient: on the one hand, the Pisan tradition of Nino, presumably filtered through the example of the almost mythic Antonio Pardini (in terms, that is, of identifiable works); and on the other hand, Florentine late trecento examples, including those on the Porta della Mandorla and the Loggia dei Lanzi. With the *Ilaria,* Jacopo emerges as a marble carver of the highest ability, matched only by the project's inventiveness. The act of stone carving was conducted with uncompromising self-confidence. The gleaming surfaces of Ilaria's costume, the soft flesh of the nude boys, the controlled rendering of the foliage and the hair, the demand for establishing a convincing three-dimensional reality, already mark Jacopo's originality at a fairly early stage in his career. The enthusiasm of youth, a willingness of take risks in entirely untested ventures, marks the ambitious *Ilaria Monument,* which on every level offered a worthy expression of the cultural and political pretensions of Jacopo's patron and eternalized his deep affection for the beautiful Ilaria, who left him two children in the brief span of their marriage.

THE *FONTE GAIA* DRAWING (1408?)

In mid-December of 1408 the Comune of Siena agreed to entirely remake an old fountain on the Piazza del Campo that had been in operation for the previous sixty or more years. It was already known as the "fonte gaia" in the trecento, presumably because of the spirited movement of the water. The Sienese entrusted the work to Jacopo della Quercia, setting a hefty 1,700-florin limit for overall expenses of the project (doc. 22). Their official commitment must have been based upon earlier discussions and consultations with the sculptor in Siena, Lucca, or both, together with a project drawing. For Jacopo the assignment represented not only the receipt of a visible commission with potentially ample earnings but also a decision to transfer himself to Siena, a place he had left as a boy, and conversely at least temporarily to abandon Lucca, which had been the center of his professional activity. In fact, the enabling action of the Comune of late 1408 is the first contemporary mention of any kind that fixes Jacopo, then about twenty-eight years of age, in Siena. Once back in that city, Jacopo was placed on the list of active citizens eligible to serve in various communal bodies; indeed he was chosen (by lot) as a representative of the section of the city where he took up residence, the Terzo di San Martino, as a *consigliere* in the General Council for the first semester of 1409 (doc. 24). On January 22, 1409, the assignment of the fountain was confirmed and the amount increased to 2,000 florins, while a drawing of the project was deposited with the notary of the Concistoro (Niccolao di Lorenzo di Belforte) (doc. 26).[59]

From the contract we learn that Jacopo was obliged to produce a detailed

59. Actually the contract is known only from a copy made three years later, in 1412, but there is no reason to doubt its accuracy.

drawing for the Sala del Consiglio in the Palazzo Comunale, presumably on a large scale, so that the city officials could graphically study his project and follow the progress of construction. The wall drawing must have been based upon the one on deposit with the notary mentioned in the contract of 1409, which was probably already prepared for the deliberations of December 15, 1408, and was very probably identical with the fragments that are now divided between the Metropolitan Museum in New York and London's Victoria and Albert. Hence, as an extant work by Jacopo, the drawing follows close on the heels of the final payments for the *Ferrara Madonna* and his completion of the *Ilaria Monument*.

Given the situation as known, Jacopo would have been a relative stranger to the city he had left with his father at the very start of his artistic apprenticeship. As has been demonstrated, Jacopo passed the next decade in Lucca, interrupted by a stay in Florence that was followed by a north Italian sojourn. Brief trips to Siena by Jacopo for family reasons between his initial departure in the early 1390s and 1408 are quite possible, though not documented; on the other hand, no signs whatsoever have turned up that he was working as a sculptor in Siena before 1408. Now finally in Siena on a more permanent basis, a worldly, well-traveled, proven marble sculptor, Jacopo "della Guercia" found himself a much desired *rara avis* for the city.

The effect on Jacopo's art of his residence in Siena must have been dramatic. All things considered, he was critically unfamiliar with Sienese monumental art, and he could hardly have avoided being overwhelmed by the illustrious tradition that, after all, represented his unsuspectedly powerful cultural roots. Consider the impact of the Sienese experience (as demonstrated in the *Commentarii*) upon the Florentine Ghiberti, when he came in 1416 for the *Baptismal Font*; multiply it by the fact of Jacopo's Sienese birth. Could Jacopo have failed to admire Nicola Pisano's treasured pulpit in the cathedral, intensifying his experience of Nicola's sculpture in Lucca and Pisa? Toward the end of the first decade of the 1400s, equally exciting must have been the discovery of Giovanni Pisano's brilliant, tense figures that occupied the cathedral façade. If Jacopo cut his teeth on Nicola and Arnolfo, unavoidably he had to cope with Giovanni in Siena and his lyric, curvilinear style on a monumental scale, to which he had been introduced in Pisa and Pistoia. And what of the ambitious, indeed unprecedented Duomo Nuovo, unfinished and destined to remain so forever, where Jacopo was to establish his *bottega*?

The vitality of the previous art and architecture that Jacopo found in Siena had no counterpart anywhere in Italy at the beginning of the century, with the exception of Venice. The extraordinary pictorial heritage of earlier Sienese painting, so highly praised by Ghiberti, could not have escaped the repatriated Jacopo's admiration, as he went to the Palazzo Comunale regularly in that first semester of 1409; nor the slim, elegant, fingerlike Mangia tower casting its shadow on the fan-shaped Campo, the bustling center of city life, then as today.

Here he had to construct a new fountain facing the seat of civic power and communal justice. His fountain, symbolic of a well-run republic capable of supplying its citizens with a constant supply of life-sustaining water, was on an axis with the Palazzo Comunale and the unfinished Cappella di Campo, which already contained some fine sculpture.

The first example of Jacopo's Sienese reentry is the drawing for the *Fonte Gaia,* which I believe was executed during the final months of 1408 (cat. 3 and figs. 20 and 21). In treating the drawing a distinction should be made between (1) the style of the figures, the architectural and decorative motifs depicted, and (2) the style of execution, that is, the stroke, the *tocco.* The most comprehensive discussion of the drawing is that of Charles Seymour, Jr., who concludes that it was probably done by Martino di Bartolommeo, under Jacopo's instructions and supervision.[60] Seymour seeks to explain a reference to a new drawing in a document of 1416 as pertaining to the one from which the two fragments derived, and he believes that the designation "Factum manu dicti Magistri Iacobi" need not be literally interpreted. While the entire issue of what such requirements actually signified in the quattrocento is fascinating—and Seymour is probably correct in assuming that the artists were not completely constrained, nor did they always follow the letter of the terms—in this case there is no particularly good reason to doubt the result.[61]

Behind Seymour's disattribution is his low esteem for the draftsmanship, that is, the execution (but not the conception), an opinion that has been widely shared. Of course, comparisons with other drawings by Jacopo are impossible simply because there are none, at least none that have a claim as strong as this one. Nor are there, for that matter, many recognized drawings by his quattrocento contemporaries that would provide an insight into what might constitute "sculptors' drawings," notwithstanding the rather substantial number attributed to Donatello.[62] In my view, not a single one of these drawings, which hardly form a particularly homogeneous body of works and which have no documentary foundation whatsoever, is by the master.

With Jacopo, the circumstances of his background and training should be brought to bear upon determining the merits of the *Fonte Gaia* drawing, which, after all is said and done, actually has an excellent claim on the basis of contemporary evidence. However, how could the convincing, truly tactile, physical qualities of his marble sculpture and this delicately executed drawing be reconciled as pertaining to the same individual? Should not a more robust drawing manner be expected of Jacopo, as consistent with his sculpture? These are the questions that lie behind the reluctance of certain critics when dealing with the drawing; but when one takes into account the fact that Jacopo's

60. Seymour, " 'Fatto di sua mano."

61. See A. Conti, "Un libro di disegni della bottega del Ghiberti," *Lorenzo Ghiberti nel suo tempo,* 1:148n2.

62. See Degenhart and Schmitt, *Corpus der Italienischen Zeichnungen, 1300–1450,* vol. 1 part 2, pp. 343–365. Most Donatello experts are skeptical.

earliest training was given to him by a traditional and undistinguished gold-smith, the doubts begin to fade. Having learned the skills of *disegno* necessary for metalwork, not stone sculpture, the fussy, tight, and even sometimes unsure touch of the *Fonte Gaia* fragments are comprehensible; indeed they serve as a confirmation of Jacopo's initial introduction to drawing. He had learned a particular way of conceiving in two dimensions, and on the rare occasions when he found it necessary to do so, he must have fallen back upon the manner he learned first. Nor does Jacopo appear to have been the kind of sculptor who was in the habit of making studies and *appunti* with the pen; and besides, there is no cogent reason to assume that he approached a blank sheet with the same conceptual vocabulary as when attacking a marble block. Even in the case of Ghiberti, who actually had a reputation as a skilled draftsman, the drawings associated with him (and for which no consensus has been achieved anyway) are not remarkable in quality.[63]

In analyzing the divided drawing for the *Fonte Gaia,* evidently the left-hand portion—that is, the section in the Metropolitan Museum—is more complete. The attention to detailing, especially in the architectural elements, including the floral frieze at the top of the fountain and another one about one-third the height of the inner wall below, is not present in the portion preserved in the Victoria and Albert. The drawing, as Seymour has convincingly demonstrated, had a legal function. So too did a drawing that Jacopo presented in 1425 to the officials of San Petronio, which was frequently referred to in later documents as having authority. In the contract for the *Portal* (doc. 117) we learn that only half of the design was delineated with all of the details ("... che tutte le cose della porta sian intagliate et ornate, come per il disegno di mano di maestro Iacomo appare ... deve far che nel detto disegno la colonna, la quale non è disegnata, delle sette historie, s'intenda esser come l'altra"). This condition, which seems to be the same for the *Fonte Gaia* drawing, was obviously intended to "save time" (for Jacopo, not for Martino di Bartolommeo or for Parri Spinelli, another name put forward for the drawing in the past).

When the whole drawing was dissected, perhaps in the eighteenth century, the section that found its way to the Victoria and Albert underwent serious trimming, particularly at the bottom, though also at the lower left, where nearly half the she-wolf is lost (fig. 21). Besides, the top was partially clipped off, as is demonstrated by the crown of the standing woman. The unfinished state of the London section is apparent everywhere: even the feet of the Virtues are not

63. In a letter of April 16, 1425, Ghiberti asks Giovanni di Turino to see that some of Ghiberti's drawings of birds be returned to him from Siena (see Paoletti, *Baptistry Font,* doc. 86). Among drawings connected with Ghiberti, the Saint Stephan shown in a niche (Louvre, Paris) has the best claim as an autograph. I believe it is the product of the workshop where, after all, many painters were employed, and not an autograph. L. Bellosi has also taken up another drawing associated with Ghiberti, the sheet with details for a Flagellation in Vienna's Albertina, thought to be a treasured original by the master for the relief on the North doors; see "A proposito del disegno dell'Albertina (dal Ghiberti a Masolino)," *Lorenzo Ghiberti nel suo tempo,* 1:135–146 (2 vols.; Florence, 1980). He concludes that it is a painter's, not a sculptor's drawing, specifically assigning it to Masolino.

drawn in. The left side of the drawing (New York) was given greater detail. To have put in the detailing only on one side for the purpose of saving time makes sense, but why more precision on the left than on the right? One cannot help wondering whether Jacopo della Quercia, like Leonardo and Michelangelo, was left-handed.

The manner in which the she-wolves function, how they were to have been placed on the fountain, is unresolved at the stage of the project represented by the drawing. It should be noted, however, that small children were to have been added to them in a subsequent contractual revision, perhaps because they had simply been left out by mistake (doc. 62). The *lupa* in the New York fragment is beneath the corner Virtue (Fortitude), while the one on the opposite side is below the Virtue (Justice) next to the corner one. Obviously, Jacopo was allowing for a several solutions, without giving preeminence to any single one.

A central image on the back wall of the fountain, probably a Virgin and Child with angels on either side, as was finally executed, or alternatively another Virtue, must have been provided in the drawing. The figures of the Virtues and the Archangel Gabriel on the extreme left and the Mary Annunciate on the extreme right are tightly circumscribed in shallow niches that have either slightly pointed or pure round arches, as with Justice, leaving a choice for the important architectural motif. The heavily draped figures are conceived as flat, with an emphasis on the surface plane and without convincing three-dimensionality. Although superficially similar to early trecento solutions, Jacopo's treatment of the figures as well as the space is never as sophisticated as that of Simone or Ambrogio Lorenzetti. His figures have thin, tapering hands; their usually tilted heads with finely incised features on oval faces turn in one or another direction. The rendering of foreshortening caused Jacopo discomfort, especially for the figures on the short arms of the fountain. The women at the corners, each with two children, one standing at the feet and another held in the arms, form groups conceived as free-standing sculptures on firm bases, notwithstanding the fact that the three-dimensional implications in the drawing lack conviction. As figural types they are closely related to the reliefs of the side saints on the *Trenta Altar*, which were projected several years after the drawing was presented to the Sienese government.

THE *TRENTA ALTAR*, UPPER SECTION (CA. 1410–1413)

In the search for a definition of Jacopo's stylistic transformations, the discussion of the *Fonte Gaia* must be interrupted, as his involvement was interrupted, and attention turned again to Lucca where around 1410 he was employed. This chronology need not preclude works in Siena in addition to the *Fonte Gaia*, but so far no marble sculpture has been proposed that fits into this period. Commissions for wooden figures, however, might have come his way (through Fran-

cesco di Valdambrino?) at this time, including the *Annunciate Virgin* from San
Raimondo al Refugio. The stylistic features that define the *Fonte Gaia* drawing
fragments are confirmed in the sculpture produced in Lucca shortly thereafter,
the *Apostle* for the cathedral, and resemble more closely still the reliefs on the
upper section of the *Trenta Altar* (cat. 5). Following the initial designing and
the legal details for the Sienese fountain, Jacopo seems to have put aside the
work altogether, perhaps because of the lack of money, and reestablished
himself in Lucca where he undertook the marble retable for the *Trenta Altar* at
San Frediano, as well as commissions in the city.[64]

First appearances to the contrary, the documentation, which is known almost
entirely second-hand from a seventeenth-century source, is by no means firm.[65]
Presumably on February 28, 1412, permission was granted to the wealthy
Lucchese merchant Lorenzo Trenta to dismantle and rebuild from its founda-
tions a chapel dedicated to saints Richard, Jerome, and Ursula, with rights of
burial and the display of the family arms. The date has been taken as the
terminus post quem for the sculpture in the chapel: even in this uncertain
chronology the design of the altar must have been worked out earlier, perhaps
a year or two before (doc. 32). During mid-1412 Jacopo was temporarily back
in Siena renegotiating the contract for the *Fonte Gaia*, so if work had actually
started on the Lucchese altar, it had come to a temporary halt.

Concrete evidence that Jacopo was actively engaged in Lucca occurs more
than a year later, in May 1413, when he was urgently requested to return to
Siena to take up his contractual obligations there, the implication being that he
had been away for some time already and that the Sienese were getting impa-
tient (doc. 40). Despite the urgings, the sculptor stubbornly persisted with his
Lucchese projects until nearly the end of the year. On December 18, Giovanni
Malpigli's desperate letter, discussed in the previous chapter, was addressed to
Paolo Guinigi. In it reference is made to the sacristy where Jacopo, Giovanni da
Imola, and a certain Massei were occupied (doc. 44). The letter provides evi-
dence that the sculptors were using the adjacent space as their workshop, and
that the sculpture on the altar must have been well along. All activities came to
an abrupt halt with the disclosures of Malpigli's letter, prompting Jacopo's
sudden departure and the arrest of Giovanni da Imola. Giovanni, who was
convicted in April 1414, languished in prison until June 1417. Jacopo, on his
part, did not return to Lucca again until the spring of 1416, almost two and a
half years later, when he was granted a safe conduct pass by Paolo Guinigi.

After the planning, designing, and perhaps the building of the chapel, which
I suspect was part of Jacopo's charge, the marble was obtained by reusing two
old tomb slabs, and actual carving on the altarpiece must have been taken up

64. The new altar was made to replace an earlier, wooden one that apparently had been consecrated
in 1154 (according to Puccinelli, *San Riccardo e sua cappella*, p. 43).

65. Doubts about the reliability of Pietro Carelli, "Notizie antiche di San Frediano" (MS. 414,
Biblioteca governativa di Lucca), are discussed as some length in cat. 4, under "Comments."

between ca. 1411 and 1413.[66] The walls of the chapel were once decorated with frescoes, and in some areas the paint can be seen through the whitewash. The walls may have been painted in the quattrocento, but what can be seen today appears to be the work of a *quadraturista* from the middle of the eighteenth century, covered over in 1883.[67]

Between 1411 and 1413 only the upper section, a genial technical as well as artistic accomplishment, was being executed. The seated Mary and the healthy, alert Child she holds are enframed by voluminous drapery. Behind, a cloth of honor, whose surface treatment is very much like the draperies on the figures, defines the back wall and the somewhat ambiguous spatial relationship. The striking, youthful saints Ursula and Lawrence on the left, who are barely distinguished in gender, and Jerome, the only older saint, with Richard, on the right, are all heavily enwrapped in weighty garments, similar to the Virgin's.

The Pietà at the center of the predella is on a block that juts out slightly from the others, as do the end reliefs, depicting saints Catherine on the left and Cristina on the right, which are carved in very low relief. Enframed at the sides by protruding pilasters with rectilinear articulation, the main field has five niches, each containing a sacred figure. The four side niches are surmounted by steeply pitched gables containing floral gatherings at the apex, from which rise half-length prophets, as they are usually called, or possibly evangelists. Over the central niche there must have been a crowning element too, either a crucifixion, the bust of the Redeemer, or more simply a florid cross like the one on the *Ilaria Monument*, although the place is now without any decoration whatsoever. Mary's niche, taller and nearly twice as wide as the others, permits her to dominate, despite the fact that she alone is seated. The scale varies from Mary and the Child, the largest figures on the altar, to the slightly smaller lateral saints, to the still more diminutive prophets at the top. As shall be demonstrated, the fluctuation in scale continues in the predella zone, where still other proportional relationships prevail.

A vertical emphasis is achieved by the insistently narrow side niches and the elongated figures within them, the sweeping, upward-reaching curves of the gables, and the engraved articulation on the slim pilasters whose missing crockets would have still further accentuated the perpendicular thrust. Quite possibly, statuettes representing an Annunciation stood at the corners of the upper section. As an antidote to the vertical pressures, alternative horizontal readings are provided. The supporting zone above the predella is really a series of bases for the corner pilasters, figures, and niche supports, closely related to those presented in the *Fonte Gaia* drawing. Visually they provide convincing support for

66. Silva, (*La Basilica di San Frediano in Lucca*, pp. 77–78 and 268) says that they were trecento slab tombs; the inscription of one belonging to Gebhard Bishop of Eichstatt is still visible on the back, according to the same writer, who was the first scholar to publish this information.

67. See Silva, *La Basilica di San Frediano*, p. 77, who cites an article by U. Nicolai, "Dipinti che tornano alla luce e anche sovrastrutture tolte nella Cappella Trenta", *Notiziaro storico filatelico numismatico* (1976), vol. 164–165, p. 28.

the superstructure and a horizontal stress like the string of capitals and the heads of the busts above, to counter the insistent verticals. The main field forms a rectangle that is wider than high, so that despite insistent "Gothic" signs, the figures give the impression of resting stably on a horizontal axis within an implied spatial context. In the final analysis, Jacopo is here a gifted composer in a culturally complex environment, in what superficially appears to be a traditional design for conservative patrons.

The origin of the design of the altar may be found in trecento usage, with obvious and frequently observed connections to Tommaso Pisano's altar for San Francesco in Pisa, as well as generic similarities to the dalle Masegne marble altar in San Francesco, Bologna—both familiar complexes to Jacopo.[68] The Pisan altar is closer in design, with the standing side saints in analogous niches and a concentrated central axis with Mary, in this case standing and accompanied by angels. Perhaps more provocative for the evolution of Jacopo's altar is the relation between the main field and the predella, treated like a continuous band. The Bolognese example (which like Tommaso Pisano's work was the high altar of a large Franciscan church) is essentially Venetian in type—not only much larger, more complicated and more fussily decorative, but the articulation of the base zone contains supports that interrupt the horizontal reading of the predella, contrary to Jacopo's solution.[69]

Evidence that the *Trenta Altar* design falls between the *Fonte Gaia* drawings of 1408/1409 and the changes that took place in the Sienese public fountain project after 1414 is provided by the shift in the treatment of the base level of the fountain. The drawing fragments for the *Fonte Gaia* only hint at an architectural articulation for the lowest zone (figs. 20 and 21). Indeed the figural elements at that stage seem to have been without visually convincing supports. On the *Trenta Altar,* on the contrary, each of the main figures has a well-articulated base, with decisive undercutting to set it apart from the others. In the *Fonte Gaia* as executed, however—our vision of which must be controlled by the old photographs taken before the monument was dismantled (fig. 48)— vigorous carved details allow an extensive play of light and shadow in the bright Tuscan sunlight. At the same time a collaboration between the object supported and the support was incorporated into the design, presumably as a direct consequence of Jacopo's experience on the *Trenta Altar.*

The figures on the *Trenta Altar*'s main field are stylistically related to those

68. For the Pisan material see particularly Burresi, *Andrea, Nino e Tommaso scultori pisani,* cat. no. 47, p. 191; she dates the altar to the 1360s. The Pisan altar is also discussed in Moskowitz, *The Sculpture of Andrea and Nino Pisano,* pp. 163–164, where it is dated to the late 1360s or early 1370s. For the Bolognese altar, see Roli, *La pala marmorea di San Francesco in Bologna.*

69. The reflections of the San Francesco main altar, which itself is an imaginative and somewhat unusual translation into sculpture of a gigantic painted altarpiece (as Ilke Kloten has reminded me), is another indication of Jacopo della Quercia's rapport with the Bolognese area, and indirectly, at least, with Venetian currents, early in his career. Bellosi ("La 'Porta Magna'," pp. 164–165) sees a "neo-Martinismo" at the altar, a revival, that is, of Simone's manner, which Jacopo would have shared with his contemporary, Sassetta.

on the drawing fragments in New York and London. The standing saints from the altar may be compared, for example, with the rendering of the standing Charities on the corners of the fountain, although the figures in the drawing should be understood as representing in-the-round rather than relief sculptures. The Saint Ursula has much in common with the woman on the London fragment, in particular. Both are long-limbed, attenuated figures who stand flat-footed in related poses that reveal only a vague reference to contrapposto, and both have small, ovid heads set upon proportionally rather thick necks. The hands with tapering fingers are elegant, the feet petite and delicate. The facial features are generalized, with the eyes, nose, and mouth treated schematically and unnaturalistically, all located close to the middle of the oval forms. The hair clings snugly to the cranium. The drapery functions to enclose the figures in sweeps of movement that only obliquely refer to the bodies they simultaneously protect and effectively hide.

The conception of the Madonna and Child group on the altar, the proportions, the contrapuntal movement, the draperies, is a confirmation of the drawn images of Faith and Hope. The group may have been related still more closely to the lost Madonna and Child that must have been part of the original presentation drawing. Parallels also may be drawn with Virtues actually executed (after 1414) for the fountain, as well as with Nanni di Banco's Madonna on the gable of the Porta della Mandorla, carved nearly a decade after Jacopo produced the drawing. Such figures revert back, more distantly, to Giovanni Pisano's marvellous Sibyls for his pulpit in Sant'Andrea, Pistoia, conceived fully a hundred years before. Quercia's monumentally conceived Madonna overwhelms the other images on the altar. The Child, at least a second cousin to the one beneath the standing Charity on the London fragment, is closely related to several putti on the sarcophagus belonging to the *Ilaria Monument,* as well as to the Child in the *Ferrara Madonna,* and represents one of the few classical links in the sculpture of the upper section. The explanation lies at least partly in the subject: standing saints, busts, and a Madonna and Child. Jacopo found a more suitable forum on the predella in which to demonstrate his admiration for ancient art, as will be demonstrated shortly.

The sculpture on the upper zone of the *Trenta Altar* has trecento precedents in monumental sculpture as well as in metalwork. The busts, for example, bring to mind the relief busts and statuettes made around 1400 by Brunelleschi and other goldsmiths for the Silver Altar in Pistoia's cathedral.[70] The alert, idealized, unblemished half-length figures are especially refined not only in style but in execution, although smaller in scale than the main figures on the same zone. In the broad current of European art of the years shortly before and after 1400, they pertain to what is most readily defined as the International Style.

In discussing the carving for the upper portion of the *Trenta Altar* the

70. See Gai, *L'Altare argenteo di San Iacopo nel Duomo di Pistoia,* especially 146 ff. Also see my review of this book in *Renaissance Quarterly* (1986), 39(1):107–109.

disconcerting realization soon emerges that the style is not especially character-istic of what is customarily thought of as Jacopo's mainstream work, misleading some observers into believing that most of the carving is the responsibility of assistants or collaborators, especially Giovanni da Imola. The somnolent saints, in particular, blatantly stare out from their niches with a confident but aloof air, only slightly tilting their heads to one side or turning to glance upward or downward. Mary, like a blind seer, is intensely introspective, hardly aware of the Child she vaguely holds, much less of the spectator in the chapel. Even the Christ Child is unexpressively calm, unlike the agitated putti on the *Ilaria del Carretto Monument,* for example. Only the prophets above saints Richard and Jerome are enlivened by carved pupils, refinements that seem like an emenda-tion; somewhere signals got crossed, or, more likely, Jacopo had intended to give life to the eyes of all of these figures, but never got around to it.

If the expression of the images can be disconcerting, I suggest that the execution is often superb; critics are hardly in agreement on this point, however. The silky, gleaming surfaces have in the course of the centuries acquired a subtle patina, achieving an effect that is closer to ivory than to polished marble.

If the invention of the ancona was entirely Jacopo's, how much of the sculpture was from his hand, and conversely, what share should be assigned to his companions? This is a burning question among Quercia scholars, and the answer is anything but simple. I believe that he was responsible for the entire monument (including the predella), and that he must have directed work while in Lucca, actually executing the largest share of the figural elements himself. At the same time he undoubtedly allotted to others decorative portions, including the niches, gables, and foliage as well as the architectonic features such as the pilasters and bases, not to mention some of the figures. In some of them he collaborated with Giovanni da Imola, but so closely that to seek to isolate Giovanni's hand specifically is a virtual impossibility. Nowhere is his harsh linear style, which is known for certain from a single documented relief in Siena, unquestionably evident on the main section of the *Altar.* As discussed elsewhere, I believe that Giovanni was responsible for the Sant'Aniello relief in the cathe-dral, which has been attributed either to Jacopo della Quercia or to Antonio Pardini.

In my view the collaborators on the *Trenta Altar* were so dominated by Jacopo, at least while he was present, that for all practical purposes the entire upper zone of the altar must be thought of as his. This is not to say that in certain places one might not find the execution a bit less resourceful than in others, as in the head of the bearded prophet above Saint Ursula, or the poses and the draperies of saints Jerome and Richard, but the assignment of such parts to different hands is a futile exercise that fails to provide insights into the creative energies of either master. For Jacopo, these years should be considered an artistic parenthesis between the monumental achievements of the *Ilaria* and the execution of the *Fonte Gaia.* A groping, puzzled Jacopo was experiencing

an indecisive stylistic interlude. He appears to have been seeking to conform to the taste of his patrons, who had a penchant for Northern European art. This moment of doubt need not be judged as necessarily negative, but rather as an essential passage in the maturation process, providing the platform for the innovations at the *Fonte Gaia* and the predella of the altar.

What about the internal chronology? Two distinct campaigns for the upper section of the *Trenta Altar*, one of about 1411–1413 and another of 1416, should be assumed. In the first, while designing, blocking out, and actually carving the figural portions, Jacopo had the heavy participation of Giovanni da Imola. I reject the suggestion of Krautheimer that one portion of the main field can effectively be dated to the period 1411/1413 and another to 1416.[71] Instead, the entire work reflects similar stylistic definitions and identical artistic premises. On the other hand, when Jacopo came back to Lucca in 1416 he may have made some final adjustments on the upper zone as well as getting started with the predella, but he could not have had the collaboration of Giovanni da Imola, who was still in prison. The figure style in the upper section, then, should be thought of as representing the period 1410–1413, that is, immediately precedent to the beginning of actual carving of sculpture for the *Fonte Gaia*, even if some finishing touches, detailing, and polishing were required when Jacopo returned to Lucca in 1416.

The standing saints should be read in pairs; furthermore, the two on the left, Ursula and Lawrence, are posed almost identically and even their garments are arranged similarly, a result of the bent right leg in both. Much the same is true for the figures on the right, saints Jerome and Richard, who stand flat-footedly with their cascading draperies analogously bunched on their right sides. Jerome wears sandals that show his bare feet; Richard has tight-fitting shoes.[72] One of the shoes is more fully articulated than the other, still further evidence of lack of finish; the hands of Saint Jerome are much more particularized, with veins and sinews, than Richard's smooth, almost rubbery ones. The left hand of Saint Lawrence, which holds a book, is not fully modeled, furnishing another clue to the degree of refinement the monument had achieved at the end of 1413, when work was halted for over two years.

THE *LUCCA APOSTLE* (CA. 1411–1413)

Two sculptures made in Lucca or in the region, and still located there, correspond to the first phase of Jacopo's activity on the *Trenta Altar,* preceding the

71. Krautheimer, in "Un disegno di Jacopo della Quercia" and in "A Drawing for the Fonte Gaia in Siena" has the side saints bracketed in the earlier phase, and the Madonna in the later one. Seymour (*Quercia*, p. 39) sees the commission itself as 1416, and thus his division of responsibility and chronology differs substantially from the one presented here.

72. According to M. Paoli ("Jacopo della Quercia e Lorenzo Trenta"), they may have a reference to local manufacturing.

actual sculpture for the *Fonte Gaia*. They are the marble *Apostle* located in the cathedral on a tall support at the southeast corner of the left transept nearby to the *Ilaria Monument* (fig. 40), and the polychromed wood *Benedictine Saint* in Massa (fig. 43). The attribution and the dating of both sculptures have been achieved on the basis of style alone, since the documents and the old sources are silent on them. The *Apostle,* which until modern times was located high on the north flank of the cathedral, is universally accepted as Jacopo's, although disagreement concerning the dating, widely regarded as falling between the years 1411 and 1413, persists.[73]

The *Lucca Apostle,* occasionally referred to as Saint John the Baptist, but which could also represent a youthful prophet for that matter, lost its original surface freshness long ago as a consequence of weathering. Its physical impact can be mentally reconstructed on the basis of other works, especially the sculpture on the *Trenta Altar*. It has experienced serious losses; much of the left arm (which may once have held a banderole or other attribute), and of a severely injured nose, is gone.[74] Despite its present condition, however, the pose and general characteristics, and its remarkable monumentality, can be appreciated.

Conceived to be read from the ground level at a sharp angle at some distance, Jacopo's *Apostle* embodies visual adjustments similar to those Giovanni Pisano had provided for his heroes on the façade of the Siena cathedral (housed today in the Museo dell'Opera): the length of the upper torso is exaggerated, while the youth's head is enlarged in proportion to the rest of the body. Despite such refinements and the carefully undercut, presumably original, pupils in the eyes, chiseled perhaps to enhance its intense expression, the pose and attitude of the figure are closely related to several saints on the main field of the *Trenta Altar,* especially the Lawrence. Although the weight is distributed equally to both legs, the right one in each figure is freed from the enclosing drapery to reveal the knee, and the arms moving around the cylindrical trunk also operate analogously.

The alert over-lifesize saint, whose externalized beauty is readily observed even in its new dark quarters, belongs to a small group of free-standing sculp-

73. Morisani (*Tutla la scultura,* p. 66), Klotz ("Jacopo della Quercia's Zyklus des 'Vier Temperamente' am Dom zu Lucca," pp. 92–93) and Del Bravo (*Scultura senese,* pp. 44–45) are the principal modern critics who date the *Apostle* to a later stage, that is, to ca. 1420, due to its assumed dependence upon Donatello's *Saint George* or to its relationship to the Gabriel from the *Annunciation* group in San Gimignano, incorrectly dated to around 1421. On the question see also Francovich, "Appunti su Donatello e Jacopo della Quercia." As already stated, one should avoid the notion that everything new or original from the early '400 must *per forza,* originate in Florence. Over and above a certain similarity in the profile views of the two figures, there is hardly any connection whatsoever between Jacopo's statue and the *Saint George* except, of course, the fact that they are virtually contemporary and share many of the same cultural sources. My views coincide with those of Baracchini and Caleca (*Il Duomo di Lucca,* pp. 122–23n406) in this regard. Indeed there is evidence that Jacopo had an impact not only personally but also artistically upon his progressive Florentine contemporaries, including Donatello, Michelozzo, Masaccio, and Ghiberti.

74. The damaged condition and its broken nose has left the impression that it has a more "antique" aura (like the figures from the *Fonte Gaia*).

tures produced during the second decade of the century. The most famous of these is easily Donatello's *Saint George,* probably conceived around 1410/1411, at nearly the same moment that Jacopo was working out the *Apostle.*[75] They represent an advance in the evolution of the free-standing quattrocento statue beyond Donatello's own slightly earlier marble *David* and Nanni di Banco's *Isaiah* (both for the Florentine cathedral), by being less swaying, schematic, and planar, and conversely more convincingly responsive to the forces of gravity.[76] The *Saint George* is nearly fully modeled and substantially detailed at the back, although once set into the niche, it would never have been visible from that view. Why Donatello went to such pains may be explained in at least two ways: the need to articulate the back in order to understand and develop the figure as a convincing whole; and the fact that while the *Saint George* would never be seen once placed in the niche at Orsanmichele, the sculptor's patrons and his companions would have been able to see the finished statue before it was hoisted into its permanent home, and thus Donatello wanted the statue to be seen in all its perfection, even if only for a brief time. Jacopo's *Apostle* was designed to stand freely in a light-filled atmosphere, white against the pulsating blue sky, while Donatello's *Saint George* and the other images produced for Orsanmichele were conceived instead as figures in niches and thus, in the final analysis, not truly free-standing.

Jacopo's marble statue must have been carved before his departure from Lucca at the end of 1413, since it is closely related to the saints for the *Trenta Altar* and unrelated in conception to the sculptures on the *Fonte Gaia,* which were begun in 1415/1416 and worked on for the next three years. The question of precedence for the common features shared by Donatello's *Saint George* and Jacopo's *Apostle* is an irrelevant issue. Both masters, who were sufficiently inventive to have come to the solution independently, were equally attracted by the elegant simplicity of the International Style in the second decade of the fifteenth century, along with Ghiberti, who had a deeper and more lasting attachment to these stylistic forces. Even the stoical Nanni di Banco was not left unmoved by the appeal of the International Style, as demonstrated by his *Saint Philip,* for example, produced for the Arte dei Calzolai on Orsanmichele during the same years as the *Saint George* and the *Apostle* in Lucca. It is well-known that all three niche statue groups that Nanni di Banco made for Orsanmichele, the *Saint Philip, Saint Eligius,* and the *Quattro Santi Coronati,* are undated by documents, and to put them into a persuasive chronological order has always caused difficulties. I believe that they were executed in the order offered, with

75. See Beck, "Ghiberti giovane e Donatello giovanissimo," in *Lorenzo Ghiberti nel suo tempo,* 1:111–134, especially *n*8.

76. I cannot agree with the conclusions of Wundram ("Jacopo della Quercia und das Relief der Gürtelspende"), followed by v. Herzner, that the *Isaiah* is by Donatello and that it should be thought of as a (another) *David,* for which see Beck, "Ghiberti giovane," *n*3. On this matter and on all questions related to Nanni di Banco see M. Bergstein's outstanding Ph.D. dissertation for Columbia University, "The Sculpture of Nanni di Banco" (1987), which is being prepared for publication.

Saint Philip the earliest and closest both in time and spirit to Jacopo's *Apostle* and Donatello's *Saint George,* as revealed by close study of the treatments of the niches and the relation of the figures to them.

Saint Philip has the simplest and the most traditional base and a rinceau relief beneath, executed about 1410/1411. The *Eligius,* datable to 1412/1413, has an unusual base element in which the relief depicting horseshoeing is raised at the center to function as a podium to support the erect saint in the niche above. The most complex niche is that for the *Four Crowned Saints.* If its predella is not easily explained, the base level immediately beneath the standing foursome is formed by a scooped-out half circle to echo the compositional arrangement of the saints in their enclosed space. Masaccio saw the enormous potentialities of this arrangement when plotting his *Tribute Money* more than a decade later. The trompe l'oeil draperies hanging onto the pilasters at the sides of the niche are a daring innovation that came after the other two, and consequently, the intricate ensemble can be dated to ca. 1413–1415, overlapping in part Nanni's activity on the gable of the Porta della Mandorla, which was commissioned to him in 1414. One cannot be too insistent about the dates of Nanni's statues, however, since he probably worked on several of them, in different stages, at the same time—a conclusion based upon what we know concerning the time required to execute similar sculptures: Donatello's *Saint John the Evangelist* and Nanni's own *Saint Luke,* for the cathedral façade, which took seven and five years respectively from the date of the commission to completion.

THE *BENEDICTINE SAINT* (CA. 1411–1413)

The polychromed wood *Benedictine Saint* located in the small church of Santa Maria degli Uliveti in Massa is occasionally called Saint Leonard (fig. 43). Cleaned in 1954, it has been correctly related to the saints on the upper zone of the *Trenta Altar,* specifically to the Saint Lawrence, just as the *Lucca Apostle* has been. The arrangement of the limbs is reversed, with the left leg exposed, but the placement of the hands and the ovoid shape of the head correspond closely.[77] Not a work of the highest invention, although, nonetheless, quite fine, the sculpture must have emanated from Jacopo's Lucchese shop before the end of 1413, and was executed largely by the master himself. In the *Saint,* Jacopo's trademark of an activated, undulating drapery offers some visual excitement.[78] Although representing one of the earliest examples of Jacopo's exploration of woodcarving, it is not *the* earliest. The fragmentary Virgin from an Annuncia-

77. A summary of the early attributions is in *Jacopo della Quercia nell'arte del suo tempo*, p. 170.

78. Unfortunately this figure was not shown in the exhibition "Scultura dipinta" held in 1987 in Siena's Pinacoteca, where many of Jacopo's wood sculptures were presented and where a comparison would have been possible.

tion (San Raimondo al Refugio, Siena) has a claim to being an earlier essay in polychromed wood by the master, at the time of his reentry into Siena (cat. 4).

THE *FONTE GAIA* (1414–1419)

Shortly after returning to Siena at the very end of 1413, Jacopo became intensively involved with the *Fonte Gaia* (doc. 48 and comment). Presumably he positioned himself to fulfill his contractual obligations for the prestigious fountain; at least there is no evidence that he was active outside Siena during 1414 or 1415. Measurable progress was being made on the fountain, since stones had been transported to Siena, resulting in an unpleasant controversy between the sculptor and the suppliers, which was only settled in January 1415 (doc. 53). In the same month a new agreement was drawn up that called for an expansion of the project, further proof of on-going progress (doc. 54). The requirements of the fountain, termed "noviter construendo," had been inaccurately or incompletely characterized in the previous contracts, causing vexing problems. For example, although the exterior surfaces at the sides and the back (not shown on the drawing) would be readily visible to the public, their articulation had not been specified previously. Now it was decided to provide these areas with appropriate embellishments. Furthermore, a change in the overall shape of the fountain was agreed upon, with the wings to be flayed outward at the front, an alteration requiring an increased cost of 400 florins. On the other hand, no portion of the wings could have been actually made up to this stage. Presumably the programmed expansion made room for two additional scenes that were determined to represent the Creation of Adam and the Expulsion of Adam and Eve from Paradise, reliefs not mentioned in the previous contracts nor rendered in the drawing fragments. The fact that Jacopo's wages were not increased until August 4, 1415 (doc. 56) suggests that no work on the Genesis reliefs had been undertaken until after that date. Since only a few internal clues are available for dating the various sculptural elements on the fountain, this fact is more precious than might appear, serving as a *post quem* for the two reliefs.

By August 1415, Jacopo appears to have already been paid a total of 6,250 lire out of the total of 8,000 lire agreed upon, calculating the 2,000 florins at 4 lire per florin; this represented slightly over three-quarters of the total sum set aside for him, but did not include the additional 400 florins (1,600 lire) that had been provided earlier that year.[79] Naturally of interest for Jacopo's stylistic evolution is the question of precisely how much of the sculpture had been produced up to this point, and which works he may have done. In any estimate, the purely decorative portions as well as the elaborate and time-consuming niches, bases, and other architectural elements, where he must have been more

79. The exchange rate of florins to lire was negotiable in quattrocento Siena.

inclined to make use of assistants, must be calculated. Because of their structural role, they seem to have occupied Jacopo's attention before significant activity had taken place on the figural sculpture, most, if not all, of which was produced between 1415 and 1419.

With the exception of the evidence supplied by the total advances and the revision to the program just mentioned, little other data upon which to base the progress on the figural aspects of the fountain can be produced. Even Jacopo's contemporary efforts in Lucca, especially in 1416, are not easily documented, with the exception of the *Trenta Tomb Slabs*. The poor state of preservation makes achieving an accurate internal chronology of the sculpture on the *Fonte Gaia* problematic. Some of the reliefs are totally ruined; all of them together with the free-standing figures have been severely weathered, and have even suffered from vandalism and accidental injury over the centuries as well as from modern graffiti. The *Trenta Tomb Slabs* are disappointing in this regard, too, because they are heavily worn.

Following an approximately six-months stay in Lucca, the program for the *Fonte Gaia* was again expanded in November 1416, this time to include two she-wolves with children seated upon them (doc. 62). In December the contract was renewed, at which time conflicts and ambiguities embedded in the previous agreements and additions (especially relating to the amount of money Jacopo was entitled to receive) were eliminated (docs. 63, 64). Substantial progress must have been made by the date of this new contract, allowing Jacopo to be particularly insistent that the terms be properly clarified. Also in December 1416, an agreement was reached fixing the exchange rate for the florin at an exceptionally favorable 4 lire 4 soldi 4 denari, demonstrative of Jacopo's strong position vis-à-vis the city with regard to the fountain.[80]

Early in 1417 plans progressed for the construction of the *Baptismal Font* for San Giovanni beneath the apse of the cathedral, when on April 16 Jacopo was contracted for two bronze reliefs (doc. 73). Reflecting his activity on the *Fonte Gaia,* where work was proceeding at a fine clip, he was referred to as "magister lapidum seu marmorum." In fact, on September 17, 1417 a promise was made on Jacopo's behalf that the *Fonte* would be finished in just four months, under heavy penalty if he failed to do so (doc. 78). Although fully two years, not four months, were eventually required, the brief period set forth in the document must have reflected an expectation based upon work already done. Given the evidence, we can determine that the sculpture for the *Fonte Gaia* was executed between 1415 and 1419, and that the Genesis reliefs, which were something of an afterthought, and the standing women at the front, who were structurally superfluous, were executed toward the end of the span.

The plaster copies of the *Fonte Gaia* sculpture (a set is located in rooms in the Palazzo Comunale) and old photographs made around 1850 (before the

80. The rate calculated for Donatello's relief for the *Baptismal Font* was at a flat 4 lire per florin.

dismantling of the fountain and its replacement by Tito Sarrocchi's free copy on the piazza, which was constructed between 1858 and 1868) must be depended upon for an appraisal of the fountain.[81] The original fragments have been reassembled in the loggia of the Palazzo Pubblico in an awkward and misleading recomposition. When the fountain was taken apart, by which time it was in a very poor state of preservation, further losses were incurred, but the alteration of its very size and fundamental shape is lamentable.[82] While resting on the upper lip of the piazza facing the Cappella di Campo and the Palazzo Pubblico, the seat of the Republic, the fountain's communal and propagandistic function was readily evident. No convincing analogy can be drawn between its composition and the choir of a church, as has sometimes been argued: the ample width in relation to the abbreviated short wings and the shifting height, rising from front to back to accommodate the sloping site, run contrary to an ecclesiastic metaphor, although the original site is completely forgotten in the present arrangement of the fragments. Also lost is the conception of a principal motif, the flat arches that define the niches, which effectively repeat the fanlike shape of the piazza upon which the monument once rested.

In addition to the figural sculptures, all that has survived is a small portion of decorative reliefs on both the exterior and interior surfaces with floral or leaf motifs, as well as water spouts that were carved in the form of animal heads. In several, the presence of carved nude putti has convinced some critics that Jacopo himself produced portions of this aspect of the decoration. Also lost was a *lupa* (or several?) from which water flowed, as can be determined from old photographs.

Facing the monument from the front, at the visual center, the Virgin Mary with the Child, seated on a obliquely placed throne, dominates the rest of the imagery, as one might expect for the Queen of Siena. She is enhanced by two angels, whose heads were broken off long ago, in narrow niches. On the side niches at the level of the gables that rise directly from the exedralike arches, nude putti hold garlands similar to those Jacopo conceived for the *Ilaria* sarcophagus. Neither Mary nor the angels appear on the drawing fragments as they have survived, but some such element must have been planned from the start, as has already been suggested. Although difficult to decipher in their present state, the angels' niches were, in turn, inscribed within larger arches behind, echoing the unifying motif of the entire fountain.

On either side of the Madonna and angels, who function like a triptych, are four seated Virtues arranged as pairs. Their identities have been generally agreed

81. On the general subject of plaster casts of quattrocento sculpture, essential is *Omaggio a Donatello: Donatello e il primo Rinascimento nei calci della Gipsoteca,* catalogue of an exhibition held at Instituto Statale d'Arte, Dec. 1985–May 1986, published by S.P.E.S. Florence, 1985. Although the calchi of the *Fonte Gaia* were not included, other works by Jacopo are (see pp. 93–108). On these casts in particular see A. Bertini, "Calchi della Fonte Gaia."

82. The Sienese have announced plans to restore the originals and to reconstruct their arrangement, using the old photographs and the calchi as guides. So far (1990), the two standing have been treated.

upon: Prudence and Fortitude on the end sit on the viewer's left (i.e., Mary's right); on the opposite side are Justice and another Virtue usually identified as "Charity," but which I take to represent Humility (see cat. 10, comment). Hope and Wisdom are on the left side arm, matched by Faith and Temperance on the right. On the outermost niches of these short wings are the Creation of Adam (left) and the Expulsion (right). Divine Charity, or Amor Dei (left), and Public Charity, or Amor Proximi (right), should be substituted for the conventional identifications of Acca Laurentia (left) and Rhea Silvia (right) who are standing personifications that set the tone for the entire composition.[83]

A definition of the figural style that Jacopo reveals in the images on the fountain is hindered by their poor state: even those sculptures that have fared the best are little more than magnificent ruins. Consequently one can merely hope to effectively reconstruct the poses, the use of contrapposto, Jacopo's sense of design, proportional relationships, and his unique relief technique. In contrast to many critics, I find no decisive stylistic shift among the sculptures for the *Fonte,* from one to another. Indeed within the chronology I have formulated, the actual carving took place in 1415, part of 1416, in 1417 and 1418, with some final polishing and adjustments in 1419. The apparent differences more often than not result from varying degrees of damage. Putting the issue differently, the carving is stylistically homogeneous, although the condition of preservation is not. A comparison of the bust portion of the Virgin from the fountain and the (stucco?) reduction located on the side wall of San Cristoforo on the Via Cecco Angiolieri in a glass-enclosed niche is instructive.[84] On the more weathered stone original, the edges of the features have become brittle,

83. An analysis of the iconography of the *Fonte Gaia* with a summary of previous opinions is that of F. Bisogni, "Sull'iconografia della Fonte Gaia," in Chelazzi Dini, ed., *Jacopo della Quercia fra Gotico e Rinascimento. Atti,* pp. 109–118. (See cat. 9, comment, for a more detailed discussion.) Bisogni successfully dismisses the generally accepted identifications of "Acca Laurentia" and "Rhea Silvia," which he terms a "mitologico-municipalistica" tradition, terming one "Charity" and the other "Liberalità." My identifications as Divine and Public Charity are based, in fact, upon an analogous situation discussed by D. D. Pincus in "A Hand by Antonio Rizzo and the Double Caritas Scheme of the Tron Tomb," *Art Bulletin* (1969), 51:247–256, as well as suggestions made by Michael Schwartz (in a seminar at Columbia University in 1981), to whom I extend my thanks. Revelant to the discussion is a paper by D. G. Wilkins, "Donatello's Lost 'Dovizia' for the Mercato Vecchio: Wealth and Charity as Florentine Civic Virtues," *Art Bulletin* (1983), 65:401–22, especially pp. 415–22, but as an alternative to his identification of Donatello's lost statue, one should also consider the possibility that it was a version of Flora, which would thus encompass a reference to Florence.

84. Middeldorf (*Kress Catalogue: European Schools,* p. 46) gives a remarkable summary of such partial copies of which he has knowledge, including the head of Wisdom (Sapientia) in the Kress Collection (K2079) deposited at Howard University (Washington, D.C.) and another cast of the same bust in Amsterdam (Stedelijk Museum), one of Faith in the Liechtenstein Collection (Vaduz), a half-length figure of Amor Dei ("Acca Laurentia") in Sarasota (Ringling Museum), and other half-length stuccoes of the Madonna (various locations—see Middeldorf, p. 146 *n*8—including Turin, Museo Civico). He does not date any of them. The Monte dei Paschi of Siena owns a bust-length terra-cotta Madonna and Child (purchased in 1979 from Baron Fabio Sergardi Biringucci) taken from the *Fonte Gaia*—see A. P. Darr and G. Bonsanti, *Donatello e i Suoi* (Florence, 1986), p. 102, with a reference to other examples—but the author of the note on this sculpture, A. Bagnoli, suggests that it derives from Jacopo's shop not long after 1419. (It is identified with the one from the Volpi Sale of 1910, Kunsthistorisches Institut Photograph no. 430901.) He also maintains that Jacopo had a role in the development of terra cotta during the early fifteenth century. Judging from Jacopo's difficulties or at least reluctance at casting, however, I suggest that the opposite was actually the case, Jacopo being essentially a carver.

appearing more linear and more "Gothic" than the rounder-faced, open-eyed, full-lipped polychromed adaptation dating probably from the end of the fifteenth century.

On the other hand, a significant stylistic shift took place in Jacopo's art while he was beginning to carve the sculpture for the *Fonte Gaia* (1415), which is notably diverse from that which appears in the drawing, on the upper section of the *Trenta Altar,* the *Lucca Apostle,* and the *Benedictine Saint,* tending toward a more robust, decisive, and plastic emphasis.

The Madonna and Child

Less erect and less frontal than its counterpart in Lucca, the Virgin from the *Fonte Gaia* is enlivened by a complex shifting of the body's planes in relation to the ground. Her torso is set obliquely in the niche, with her head turned in two-thirds but specifically hinting at a pending pure profile as she looks to the Child in a more intimate, human attitude than her predecessor on the *Trenta Altar.* A cloth of honor hangs on a rod at the level of Mary's shoulders. Her right hand, with an elegant turn of the wrist, is on an axis below her face, as is the right knee. The voluminous, activated drapery flows freely and less schematically than in her Lucchese counterpart, although the present condition does not permit all-embracing conclusions. The half-length version of the Madonna and Child at San Cristoforo along with the nineteenth-century gesso cast allows us to mentally reconstruct the organic qualities and the surface vibrancy of the image when the fountain was unveiled.[85]

The productions of Jacopo's Florentine contemporaries offer suggestive parallels. For example, Ghiberti's seated church doctors and evangelists, and most particularly the Saint Ambrose (in reverse, however) and the Saint Mark from the lower ranges of his first doors to the Florentine baptistery, which were done during the very same years or perhaps slightly before Jacopo's reliefs, are analogous. Nevertheless, the scale and the medium are so different that a one-to-one relationship need not be postulated. Jacopo, surely, was a well-traveled, *au courant* sculptor who was acquainted with high-quality works then being produced in Tuscany, especially in Florence. The angel on the left who accompanies the Virgin has been associated with Donatello's *Saint Mark* (Orsanmichele), but what unites them is not a specific borrowing on Jacopo's part, but a generic solution shared by progressive sculptors in Tuscany during the explosive second decade of the fifteenth century.[86]

85. There was also a half-length relief Madonna (painted terra cotta or stucco?) in the Contini Collection (Foto Reali), which is an inferior version of the relief in Siena with the Child's hand broken off (Kunsthis. Institut Photograph no. 224629). As Bertini observed ("Calchi," p. 35), one of the advantages of the gesso casts is that the unsightly blemishes on the surface of the weathered originals have been eliminated.

86. Francovich's proposal ("Appunti," p. 150) reflects a widely held bias already referred to, to the effect that all new ideas and solutions of any import in the quattrocento must have come from Florence

Unlike his Florentine colleagues, however, Jacopo turned his figures on the *Fonte Gaia* obliquely into space, so that the ground plane became disrupted and even difficult at times to isolate; this, in turn, brought increased movement and excitement into his reliefs. The upper sections of the *Fonte Gaia* niches are concave, with the figural elements, especially the convex heads and necks inside them, protruding like pearls within a shell. Such a studied spatial and planar system, which would be perpetuated at San Petronio, makes the conventional separation of planes irrelevant for studying Jacopo's reliefs.

Ironically the Madonna on the gable of the Porta della Mandorla by Nanni di Banco, which must have postdated most of the *Fonte Gaia* sculpture, was actually attributed to Jacopo by Vasari (see appendix). Close in sentiment and artistic intention to Jacopo's Virtues and his Madonna, at least in pose, Nanni's Madonna retains intact the plane of the relief ground. A rapport between the two sculptors is quite possible, even likely. Nanni and Jacopo shared fundamental traits as sculptors: both were essentially marble carvers, while Ghiberti, Michelozzo, and even Donatello were oriented towards modeling as well as carving.

Although the niches have long ago disintegrated, the plaster casts offer insight, leading one to recognized the visually sturdy frame that Jacopo established for the Virgin and the other images. Staggered, overlapping piers support the wide, slightly flattened arches enframing the figures and their heads like gigantic haloes. Rosettes like those on the *Ilaria Monument* fill the upper corners of the niches where the figures turn and twist, swell and recede.

The elongated hands, the regal turn of the right wrist that is the fulcrum of the composition, and the crackly surface of the garments can mislead one into assuming that Jacopo's Madonna is a flat, unsubstantial invention, analogous to the Virtues in the presentation drawing, which, in turn, suggest connections with the modes of Duccio, Simone, and Pietro Lorenzetti. Nothing could be farther from the truth.[87] The material that is piled upon her head, similar in motif to the headdress worn by the effigy of Lorenzo Trenta on his floor tomb, has in Siena become a fully plastic conception. Jacopo's undulating surfaces provide a sculptural experience without parallel in painted works from the trecento; for that matter, they are without parallel in the upper section of the *Trenta Altar*. In fact, the plaster casts taken shortly before the dismantling reveal the surface bravura: daring undercutting in the material that flows down over the edge of the throne on the left. Coloristic components appear to be entirely forsaken in favor of massive, monumental, space-occupying and space-defining images that are a far cry from their Sienese antecedents, painted or sculpted.

and then have found their way to the provinces, including Siena. I believe that the proposed connection between Jacopo's angel and Donatello's *Saint Mark* is unconvincing on visual grounds and was correctly dismissed by A. C. Hanson (*Fonte Gaia*, p. 56).

87. See for example A. C. Hanson, *Fonte Gaia*, pp. 51–52.

The Christ Child sits cross-legged in the crook of Mary's left arm; with loving admiration she touches the baby's right leg as if playfully tickling. He, in turn, reaches toward the border of her dress near the neck, continuing the reciprocity of grace and gesture that defines the group. Although the head has long since disappeared, with the assistance of the various adaptations one can readily guess that instead of staring straight out at the spectator as in the *Ferrara Madonna* or the relief on the *Trenta Altar,* here Christ reciprocates Mary's affection. The sturdy, well-proportioned infant, who may have held a ball or piece of cloth in his left hand, appears fully absorbed by his mother's presence. The interpretation of human exchange that characterizes the group also is apparent in the reliefs of the Creation of Adam and, especially, in the Expulsion of Adam and Eve from Paradise.

The Virtues

The Madonna and the seated Virtues, all carved at about the same time, are stylistically compatible variations on the same artistic theme.[88] Prudence on the left and Justice on the right of the Virgin, as Hanson has appropriately commented, are virtual mirror images of each other.[89] Both are severely injured. The head of Justice does not fit exactly; an incorrectly repaired old break produces a dissonance between head, neck, and body undoubtedly foreign to the original conception.

Jacopo here approaches the definition of the niche with the figure tending to expand into all the available space. Seen within a wider optic, Jacopo is dealing with a common challenge for a figurative artist, that of representing the seated figure; the eight Virtues and the Madonna present a series of alternative solutions analogous to those by Ghiberti for the lower registers of his first doors, and those Michelangelo was to undertake in treating the seated sibyls and prophets for the Sistine ceiling. The constrictions present from the start are the fixed scale and the space determined by the architectural exedra-niches. Within these parameters, Jacopo arranged the bodies so that in some cases the torso, the legs, and the head turn in the same direction, in others the legs and torso might turn in one direction and the head in another, and there are still other

88. There has been an attempt, principally by A. C. Hanson, to date the different portions of the sculpture on the fountain, dividing it into four phases, the first comprising the year 1414 (*Fonte Gaia,* pp. 80–81). As I have said above, and as already argued by Seymour (*Quercia,* p. 47), there probably was no actual sculpture carved until a year later. I find that all of the sculpture can be dated to 1415–1418, with some final polishing, etc., in 1419, and that it is quite difficult, especially considering the condition of the works, to see a very precise chronology among them. Since the Genesis reliefs were planned as an afterthought, they might have been a shade later than the Virtues, and since the standing Charities were not essential for the structural progress of the fountain, they may have come last (at least in terms of completion). See also the summary in *Jacopo della Quercia nell'arte del suo tempo,* pp. 106–107.

89. A. C. Hanson, *Fonte Gaia,* p. 56.

variations, with the torso seen straight on, and so forth. Fortitute (left) and Humility (right) on the long sides have all but weathered away long ago.

Among the other four Virtues on the wings, Hope on the left matches Temperance in the same position on the right. The body of Hope has vanished: only her head and that of a child with a halo survive, virtually independent of the relief ground, an indication of Jacopo's approach to the reliefs on the *Fonte Gaia*. She turns her head heavenward, not toward the Virgin as is sometimes claimed. Indeed, the limbs and hands of the figures were often daringly liberated from the stone matrix, as is the case in the Expulsion, in which the mutilated torso of Adam is barely attached to the block. In other words, throughout, Jacopo had operated in a very high relief technique, one which is consciously sculptural in almost achieving three dimensions, and in which illusionistic effects are relegated to the background area. To some extent, then, these reliefs have more in common with the *Ilaria Monument* (the garlands and putti, and especially the Ilaria effigy) than with the *Trenta Altar*. Furthermore, the rapport between figure and ground on the *Fonte Gaia* is far less conventional, as can be evaluated in the final two Virtues on either side of the fountain, Wisdom on the left and Faith on the right (figs. 65 and 69).

Wisdom, the better preserved of the two, easily turns her head toward the back wall, but her upper body is almost frontal, with the hips and legs shifted in the opposite direction, creating a particularly lively pose.[90] The draperies spill over the massive, solid, possibly hexagonal base. In a motif shared with Donatello's *Saint John the Evangelist* (Museo dell'Opera del Duomo, Florence), the long fingers of Wisdom's left hand rest upon a book, her attribute, which is centrally located in Jacopo's relief so that her identity cannot be questioned. The head, broken off just below the neck, may have been reattached incorrectly, since she appears to be more upright in the gesso cast, which also calls attention to losses of the veil and to the deeply undercut hair. The noble, unblemished Wisdom, which critics have readily admired since she is in better condition than her sisters, has a presence that places it, along with the other personifications as well as the Virgin, among the most elevated inventions of the type.[91] Vasari's evaluation, coming from a self-proclaimed admirer of Michelangelo, seems particularly appropriate:

> Intorno, poi (Jacopo della Quercia) fece le sette (sic) Virtu teologiche: le teste delle quali, che sono delicate e piacevoli, fece con bell'aria, e con certi modi

90. The head does not fit quite properly on this figure, as is the case with Justice.

91. Michelangelo's *Delphic Sibyl* can be regarded as a prime beneficiary of Jacopo's example. C. de Tolnay (*Michelangelo*, 1:160) long ago pointed out that the early *tondi* Michelangelo produced in Florence and particularly the *Pitti Tondo* (Bargello, Florence) has a heavy Querciesque component, although the author mistook Wisdom for Prudence. Raphael, too, seems to have been aware of Jacopo's Virtues since his seated personifications, also inscribed in *tondi*, for the ceiling of the Stanza della Segnatura belong to the same family of figural solutions. Raphael had been in Siena before undertaking the Vatican frescoes and could hardly have remained unimpressed by Jacopo's public sculpture. Another debt that Raphael shows to the fountain, in this case to the Expulsion relief, is treated by Beck in "Raphael, Florence and Quattrocento Sculpture," in M. Sambucco Hamoud and M. L. Strocchi, eds., *Studi su Raffaello, Atti* (Urbino, 1987), pp. 73–78.

che mostrano che egli cominciò a trovare il buono, le difficultà dell' arte, e a dare grazia al marmo, levando via quella vecchiaia che avevano insino allora usato gli scultori, facendo le loro figure intere e senza una grazia al mondo . . . (appendix 2, p. 570)

Although related to the Virtues on the Loggia dei Lanzi, Jacopo's Sienese examples are better understood as reduced equivalents of the seated evangelists produced for the Florentine cathedral, including Donatello's *Saint John,* which operated like high reliefs in their niches, although strictly speaking they were three dimensional. These statues were conceived from the start to be destined for niches, and the sculptors compensated by giving them less projection than if they were to have been viewed in the round. Thus, to a certain extent, they too are "high reliefs."

The sculpture for the *Fonte Gaia* must have been completed with the same high polish and studied finish as the *Ilaria Monument* and the *Ferrara Madonna,* not to mention the *Trenta Altar.*[92]

By way of summary to this point, the eight Virtues and the Virgin and Child were invented within the same figural mold. Carved with formidable projection within a convex environment, the Virtues are also interrelated to one another, sometimes as matched pairs, or as opposites; all are companions and near equals to the Virgin, whose special status is punctuated by accompanying angels. Stylistically a departure from the more linear treatment of the previous work, they represent a new turn in Jacopo's art, one that is defined by greater internal movement of the figures, with excited surfaces in which the drapery has an undulating, sweeping flow together with an expressive component.

The Genesis Scenes

The narrative Creation of Adam on the left and the Expulsion of Adam and Eve from Paradise on the right in the outermost niches of the fountain present a different genre from the Virtues. But their location suggests that the overall imagery, in the sense that it has to be read temporally, was made to be viewed starting from the outside scene on the left, then up and in to the back wall across from left to right to the other wing, and finally ending with the Expulsion. In this respect the Creation is indeed at the beginning as it should be, and the Expulsion, when man is put to his own devices and consequently required to establish social structures, pertains to the present. Within this pattern, the sturdy Charities, visible at a distance, acted as signposts for the beginning and the end; but along with the Virgin, they also functioned as a link between the clear abundant water beside them and the communal government.

For the first time in his career, at least as far as we know, Jacopo tried his hand at narrative reliefs, which were soon to become the major vehicle for his

92. Pope-Hennessy (*Italian Gothic Sculpture,* p. 213) made the observation.

expression, beginning on the predella of the *Trenta Altar* (which chronologically overlapped the Siena reliefs) and then at San Petronio in Bologna, a decade later. No one can doubt the success of his inventions, which were instrumental in structuring solutions for similar prestigious and influential scenes by Masaccio and Michelangelo, and were very much part of the mainstream of Italian art, carrying on the tradition of Nicola Pisano.

Of the two narrative reliefs, the Expulsion is by far better preserved, and with the aid of the old cast in the Piccolomini Library (Duomo) perhaps dating from ca. 1500, it gives a reasonably effective impression of the work—without, of course, the decisive *tocco* of the creator (fig. 56).[93] The nineteenth-century gesso cast is more informative for the Creation, simply because the original is little more than a ruin (fig. 58). The head of God the Father appears still intact, if heavily weathered, behind the triangular halo, a device Jacopo would use again in the same scene for the Bolognese *Portal*. The somewhat agitated pose of the Creator, whose right leg is bent, functions like the figure of Saint Joseph from the lintel at San Petronio in the Flight into Egypt (fig. 97). God the Father, located on the central axis of the composition, is above the nude Adam stretched out on the ground. In the same subject in Bologna the arrangement of the figures is reversed, and God the Father is more erect, at the same time that Adam already is lifting himself upward. Of course, the format at San Petronio is rectangular, not arcuated, requiring an entirely different composition. One must also take into account the diverse functions of the two scenes within their respective programs. Actually Jacopo frequently emphasizes the central axis, marking points on it as the basis for unfolding the formal features of the relief's compositions, which coincide with iconographic signals.

Adam, Eve, and the angel occupy virtually the entire available space in the Expulsion. On the left the solidly formed, athletic angel stands with feet planted apart in front of the not-so-narrow, proplike gate of Paradise, which looks suspiciously similar to the niches on the fountain. Somewhat taller than the other two, the angel, who forcefully pushes a resisting Adam into the wilderness, is also more erect, giving the impression of resolute inevitability, as he sternly approaches Adam. Adam's pose, as Hanson has shown, has parallels from Meleager sarcophagi, one of which Jacopo must have seen in Pisa (now, Camposanto). Even closer in spirit, with the upper torso turned to the right but the lower part close to full front, the profile left leg cocked and the right one extended and shown full front, is a figure in an Etruscan relief found in Volterra, datable to the second half of the second century B.C. (Museo Guarnacci, Volterra).[94] Ultimately, then, Jacopo is dependent upon the ancient examples for the flavor of the pose in which possibilities had been opened up for him. His figure functions differently, to be sure, with much greater movement within the

93. This category of loss is inevitable for stone sculpture located out-of-doors.
94. Recently published by C. Frulli, "Caratteri etruschi nella scultura fiorentina al tempo di Lorenzo il Magnifico," in G. F. Borsi, ed., *Fortuna degli Etruschi*, exh. cat. (Florence, 1985), fig. 135.

figure and within the spatial context, not merely across the relief but into the matrix, than the prototypes. Medieval adaptations of the same figure, with a straight leg and a bent one, are found in depictions of the same subject, including the treatment on the baptistery ceiling in Florence and the relief on the Orvieto façade, as Hanson has pointed out. Temperamentally, Jacopo must have felt a deeper affinity for Nicola Pisano's Perugian solution.

Eve, who strides out of the gate and beyond, is in a plane behind Adam. Rendered with less projection than Adam, her body is conceived with the same gusto and sensuousness. Her right foot and her right arm match the movement of her husband. She looks gently back to Adam; the turn of her head balances that of the angel to which it is quite similar, judging from the Piccolomini cast. These slow-moving, muscular titans enact the inevitable beginnings of social history.

The unique conception of the relief system found in the Virtues is also revealed in the Genesis scenes. Best observed in the Expulsion, the convex scalloping of the niche is complicated by a spilling out and expansion at the bottom to provide the suggestion of a platform upon which the Biblical heroes move. The convex outward-swelling torso of the centrally located Adam, whose arms, legs, and head have long since suffered irreparable damage, is on the outer perimeter, marking the extreme breadth of the original block. The imprint of the angel's hand on Adam's back remains visible evidence of the virtual "in-the-round" Adam (fig. 57). This aspect of the treatment, the relationship of figure to ground, is virtually lost in the Piccolomini cast and in the little bozzetto study in the Chigi-Saraceni Collection (Siena), which is an eighteenth-century free copy, so that we must turn to the original, however damaged it may be, for an adequate interpretation.

The Genesis subjects unleashed Jacopo's fascination with the nude, a fascination that places him in elite company among early quattrocento artists. While in the Creation Adam and Eve's nudity is required iconographically, for the Expulsion one can expect that they be clothed—as in the medieval examples mentioned above or in Ghiberti's treatment on the Paradise doors—or at least that their genitals be covered; but Jacopo in this work, like Masaccio in the Brancacci Chapel as well as Michelangelo on the Sistine ceiling, does precisely the opposite.[95]

Divine and Public Charity

Jacopo's standing Charities are noteworthy innovations: they are the first purely free-standing, life-size sculptures of the fifteenth century, matching the place that the *Ilaria Monument* holds for tombs. They dominate the airy space of the

95. This element may be tied to issues discussed by L. Steinberg in *The Sexuality of Christ in Renaissance Art and in Modern Oblivion* (New York, 1985).

piazza and were visible from all sides, especially the front and the sides, though also from the back. Like Michelangelo's *David,* which is free-standing, they have "preferred" views, such as that from the front, where the interaction between the standing woman and the two children is most readily observed.[96]

The Divine Charity ("Acca Laurentia") on the left seems to have just finished nursing the clothed, satisfied sleeping child on her left arm as the other one at her feet reaches up to take his turn at the exposed breasts (fig. 53). Essentially nude, he raises his right foot in the dancing pose Jacopo had already used in the *Ilaria Monument* frieze. Divine Charity is part of a compact, columnar, and tightly unified group, like her companion; the basic outline of this group was already sketched out in the drawing of 1408/1409. Standing somewhat flat-footed, the female personifications are similar to the Lucca *Apostle,* without a well-stated contrapposto, although the Sienese figures generically refer to a Greco-Roman plastic tradition—filtered, however, through the medieval applications. There are echoes of an ancient Venus, perhaps the one known to Ghiberti through Lorenzetti's (lost) drawing, or small bronze Etruscan and Roman examples, and more to the point, Giovanni Pisano's Venus-Prudence in the cathedral of Pisa.

The long, thin head of Divine Charity is distinguished by a piling up of drapery at the top, which functions like a crown. Weathering has exaggerated the sharp edges of the folds of the drapery, the hair, and the general impression of a crisp surface; nonetheless this figure is universally accepted as a Quercia autograph, even by those scholars who think Public Charity ("Rea Silvia") should be associated with Francesco di Valdambrino. I consider them both to be by the master and explain the differences between the two as based upon the sculptor's desire to have two different types to represent two different conceptions. Public Charity holds an alert child in her left arm, though higher in the composition (fig. 51). He is nude, as is his brother on the ground. The woman, for her part, is more fully draped than is Divine Charity. Her pose has less internal movement than that of her opposite; she stands more flat-footedly, a circumstance which perhaps has lead to the disattribution to Jacopo. The more severely damaged of the two, with extensive eighteenth-century repairs and with the entire lower section a replacement, Public Charity nonetheless has been

96. A sixteenth-century drawing in the Uffizi (sometimes attributed to Sodoma) shows the statues side by side (see A. C. Hanson, *Fonte Gaia,* plate 75), and provides a picture of their appearance prior to serious breaks and weathering. The height and design of the bases, as executed, vary between the two, as can be observed from the photograph of the fountain before dismantling (fig. 48). Another sixteenth-century, not especially precise drawing attributed to Amico Aspertini (Castello Sforzesco, Milan) shows Public Charity, but it probably was drawn from memory. F. Bisogni, in "Un disegno della Fonte Gaia," *Storia dell'arte* (1980), 38/40:13–17, has published for the first time still another drawing, perhaps dating from the end of the seventeenth century, showing Public Charity from the right profile. Also drawn before the break and repair of the mid-eighteenth century, it provides evidence for the essentially three-dimensional conception as well as execution of the group, and documents the popularity of the statue. As Bisogni has observed, Public Charity's right hand points outward toward the piazza, which he explains as "uno scherzo della memoria" on the part of the artist.

correctly reaffirmed for Jacopo by Seymour and Hanson, among others.[97] Public Charity is more "present" than her counterpart as she looks openly out at the populace in the piazza, as do the children who accompany her.

Previous examples of free-standing statuary may be found in fountain decoration; the most noteworthy is Nicola and Giovanni Pisano's *Perugia Fountain*, whose central figure, a bronze, was conceived in the round. In this case, the figure operates as a support, and is not entirely independent, as with Jacopo's two Charities. Furthermore, the function of distributing the water is quite different than for Jacopo's figures. They are accompanied by robust, active children who are an appropriate next step in this genre after the putti from the *Ilaria Monument*, being among the most classically inspired features of the *Fonte Gaia*. The overall character of the dominant, self-assured, partially nude women and children speaks a language consistent with the ancient world as it was being revived in the early quattrocento.[98] In distinction to the garland-holding putti on the *Ilaria Monument*, those who appear here in the gabled niches of the angles beside the Virgin and Child are not straightforward borrowings or specific paraphrase, but a series of pondered filtrations.

Very likely Jacopo had no monumental in-the-round example that directed him to his final solution; he seems to have relied instead upon a vast experience with ancient sarcophagi reliefs, which he had to reinterpret and three-dimensionalize. On the other hand, he may have had small Roman and Etruscan statuettes or terra cottas, since they turned up from tombs in the Sienese countryside, which were constantly being raided, and he had some such works at the time of his death ("due nudi di metalo"; doc. 497). Jacopo's path of creative invention of these memorable statues was undoubtedly irregular, unpredictable, and indirect.

Medieval reliquaries, staff handles, and croziers offered the possibilities of having figures freely standing, although nothing that occurs in this category of object could have predicted the Charities as Jacopo produced them.[99] Nor could the large, free-standing independent statues common to medieval cathedrals both north and south of the Alps—a tradition still vital in the quattrocento, as witnessed by Jacopo's own *Lucca Apostle*—have provided a crucial impulse for the other figures on the fountain. Although Donatello's marble *David* is a free-standing, in-the-round statue, it was conceived for the high reaches of the Florentine cathedral above the Porta della Mandorla, along with Nanni di Banco's *Isaiah*. During their brief residence on the building, these statues would

97. The attributional question, which is well summed up in A. C. Hanson (*Fonte Gaia*, pp. 71–75), was something of a lively issue in Quercia studies in the past. Those who have been studying Francesco di Valdambrino in recent years have not been able to insert the figure into his *oeuvre* effectively, under any circumstances.

98. The classical *Three Graces*, which it is tempting to bring into the discussion, is probably not relevant, since the group did not become known in Siena until around the end of the century.

99. On such objects see G. Brunetti's important paper "Oreficeria del quattrocento in Toscana," *Antichità viva* (1980), 26(4):21–38, and another work which is useful as a whole, M.-G. Ciardi Duprè, ed., *L'Oreficeria nella Firenze del Quattrocento* (Florence, 1977).

have been visible from various angles to an omnipotent viewer, but a human spectator down on the ground level would not have been able to participate in their three-dimensionality. At the *Fonte Gaia,* where a nearly eye-level communication was established and where loutish youths could give the two marble women irreverent pinchs and worse by merely jumping over the side walls of the fountain, the relationship was quite different. Besides, their identities are without specific sacred references or designations, so a more earthly rapport may be assumed.[100] Indeed, the Charities were unique images in Siena, certainly after the destruction of the Roman Venus that Ghiberti, who knew them only secondhand, passionately described. They embellished a remarkable fountain that became symbolic of the entire city and that provided the sculptor with his nickname ever after: Jacopo della Fonte.[101]

THE *TRENTA TOMB SLABS* (1416)

Jacopo della Quercia interrupted his work on the *Fonte Gaia,* repairing to Lucca in March of 1416 (doc. 59), where he stayed more than half a year, although his passport *(salvacondotto)* was valid for only four months. He is registered back in Siena around mid-September. According to the documentation, he had been cleared of charges connected to the case in which Giovanni da Imola was imprisoned. Indeed, the Trenta family must have orchestrated his reentry into Lucca so that he might complete their family chapel with its altar as well as floor tombs, which originally had been planned for another place.[102] Remarkably, Jacopo felt free to leave his *cantiere* at the *Fonte Gaia* at the busy stage we must assume for mid-1416, in a demonstration of his independent comportment even when dealing with the *comune.* Although it is quite impos-

100. In a Princeton University photograph collection, the Divine Charity ("Acca Laurentia") is labeled "Madonna and Child with the Young St. John the Baptist." A lesson can be learned from this misidentification: both statues are similar to marble and wood standing Madonna and Child images in their poses (even Raphael's *Sistine Madonna* comes to mind). Jacopo's thinking, as he developed the figures, may well have involved standing statues of the subject known to him from the trecento. Michelozzo, along with his partner Donatello, appears to have been the first in the next decade to effectively pick up on Jacopo's revival of the free-standing marble statue.

101. The purely decorative elements on the fountain deserve consideration, although they have suffered along with the others and dimly reflect their original state. Yet there must have been connections between some of the imagery there and the rest of the monument, such as the pomegranate (near Hope and on the decorative pilaster between Hope and Wisdom), which occurs several times in the surviving fragments along with dragon-headed monsters, a fleshy putto among the leaves, and a tense dog. See A. C. Hanson, *Fonte Gaia,* figs. 92–94, 96.

102. Lorenzo Trenta, who had been in business in Paris, was certainly an expert in jewelry and precious stones, and apparently was something of a middleman in trade of these expensive objects for Lucca. He may have introduced in Jacopo della Quercia a taste for such objects. See E. Lazzareschi, "Lettere di mercanti lucchesi da Bruges e da Parigi: 1407–1421," *Bolletino storico lucchese* (1929), 1(3):165–199, especially letters 1, 2, and 12. Lazzareschi's notes are rich in information about the Trenta family in general. See also L. Mirot, "Études Lucquoises, Chapter III, La société des Raponde Dine Raponde," *Bibliothèque de l'École de Chartres* (1928), 89:381, where we learn that Lorenzo had close ties with Dino Rapondi in Paris; and P. Bacci, "L'Altare della famiglia Trenta in San Frediano in Lucca," pp. 230ff. On the Trenta and their palaces, see Paoli, *Arte e committenza privata,* pp. 36–46, especially pp. 38–39.

sible to determine on the basis of the documents precisely what he had done during the Lucchese stay of 1416, a stylistic rapport with the contemporaneous activity in Siena should be expected.

The effigy floor tombs in the Trenta Chapel in San Frediano, that of Lorenzo Trenta and that of his first wife Isabetta (Lisabetta) Onesti, should not offer a problem in dating (figs. 45–47 and cats. 8 and 9). Although the recipients died sometime later, Lorenzo in 1439 and his wife prior to 1426, both markers have the year 1416 inscribed on them, and there is no reason to doubt that year as signifying their completion.[103] They were not put in the present chapel immediately, but in another dedicated to Santa Caterina, also owned by the Trenta, in the environs of the same church.[104] Some of the carving *could* have been begun during Jacopo's previous stay, that is, around 1410 and 1411, but I suspect that only the procurement of the stone and some very preliminary blocking was actually undertaken at that phase, because, simply speaking, the demands to complete the altar were more pressing.

Although the 1416 date of the markers is assured, issues surrounding the authorship remain controversial. Most scholars, even those who accept as Jacopo's the slab depicting Lorenzo Trenta, which was reserved for the male decendents of the family according to the inscription, are reluctant to attribute to him the matching image of his first wife, which was designated for the female line.[105] Giovanni da Imola is the alternative commonly advanced because he was, after all, Jacopo's closest associate on the *Trenta Altar*. On the other hand, Giovanni could not have done any of the carving if 1416 is, indeed, accepted as its actual date, simply because in that year and until June 17, 1417, he languished in prison. This practical circumstance releases Giovanni as a serious candidate for either of the tombs, a conclusion supported by stylistic considerations.

The critics who assume significant stylistic differences between one of these slabs and the other and between both of them and the *Ilaria Monument* have been misled by several factors. First, the *Trenta Tombs* were carved with very different sculptural criteria from the *Ilaria*. As already demonstrated, the effigy of Ilaria is rendered in extremely high relief, being part of an elaborate free-

103. Both tombs measure 247 × 122 cms., in a ratio of about 2:1. For the inscriptions see the appropriate catalogue entries. A summary of the earlier literature is in *Jacopo della Quercia nell'arte del suo tempo*, pp. 136–137. Seymour's explanation (*Quercia*, p. 39n7) that the combination of arabic and roman numerals found in the date on Lorenzo Trenta's tomb ("MCCCC16") reflects a lack of space is incorrect; such usage was common in the period. Morisani (*Tutta la scultura*, p. 64) missed the arabic numbers altogether. A clear reading for Lorenzo's wife is a bit more of a problem. Apparently the inscribed date should be understood as "MCCCCXVI," that is, 1416 expressed without arabic numbers.

104. Paoli ("Jacopo della Quercia e Lorenzo Trenta: Nuove osservazioni," especially p. 33; reprinted in Paolo, *Arte e committenza privata*) too readily dismisses Lazzareschi's conclusion that Lorenzo in one of his wills stated that he wished to be buried "in tumulo seu sepulcro iam diu constructo" in the chapel of Santa Caterina. See Paoli, *Arte e committenza privata*, pp. 257–263, on the cemetery, where the Onesti, significantly, had tombs and where their arms can be seen (p. 260). See also Bacci, "L'Altare della famiglia Trenta."

105. Isabetta Onesti died sometime before 1426, for in that year Lorenzo married Giovanna Lazari, widow of Nicolao Guinigi. For what is left of the Trenta archives, see ASL, Dono Domenici; see also Bacci, "L'Altare della famiglia Trenta."

standing monument. In contrast, the figures on the *Trenta Tombs* are conceived as traditional floor slabs with only moderate projection. Secondly, they were made to be seen on the ground by a person standing at the foot of the slab, quite different from the case of viewing the *Ilaria*. Thirdly, one must take into account the difference in rank of the subjects: after all, Ilaria was the wife of the ruler of the city-state. Furthermore, unlike the figure of Ilaria, the Trenta effigies have suffered severely from wear.

As for the assumed divergence between the two slabs, more relevant is the gender of the subjects, which appears to have induced their creator to call upon alternative figural conventions. Consequently what at first may appear to be a question of different authorship is better understood as a matter of diverse modes of representing male and female images. The states of preservation between the two also vary considerably, serving to accentuate apparent distinctions. The restrained image of Lorenzo Trenta has fared somewhat better over the centuries than the more activated form of his wife, having suffered less from foot traffic.

Both tombs appear to have been conceived and constructed according to a modular system, with the width of the border containing the inscription as the module. The hand and the foot of Lorenzo Trenta are equivalent to one module in width; the head is two units long.[106]

Despite the poor condition, several features deserve attention: the highly styled oversized pillow with decisive rinceaux bands enframing Lorenzo's head, which in turn is crowned with an elaborate headgear; his delicate, sensitive hands with long tapering fingers; and a gusto in the treatment of swelling drapery. These characteristics are consistent with Jacopo's contemporary work on the main field of the *Trenta Altar* probably carved a few years before, and one should look especially to the Madonna in this regard for insight into the appearance of the Lorenzo effigy at the time it was finished. At Lorenzo's feet is another, smaller pillow, a thin cross, and a shield for his coat of arms, which can no longer be read.[107] In distinction to her blocky counterpart, the female effigy is dominated by a lyric, curvilinear treatment. Greater illusionism is attained with the thinner draperies, which betray a subtler movement, while the surface is integrated by active ripples. Her hands now appear awkwardly flat, but that effect is the result of wear, which has negatively affected a proper reading of the work.

The figures of husband and wife are located in a spatially ambiguous world: they lie neither in front of the plane established by the inscription nor behind it.

106. I am indebted to the sculptor Harriet Feigenbaum for these observations.

107. The coats of arms were still legible in the eighteenth century. Lazzareschi in his review of Bacci's *Jacopo della Quercia* points to a drawing made by B. Baroni in 1760 ("Raccolta universale delle inscrizioni sepolcrale lucchesi," MS. 1014, c. 69v in the Lucchese National Library), when the arms of the Trenta and the Onesti (for the wife's tomb) were still visible, as they are on the sides of the *Trenta Altar*. Lazzareschi opposes Bacci, who claims that the tombs were symbolic and not actual tombs of the individuals shown in the effigies. The dispute seems to have little importance in the long run: both positions, which are not mutually exclusive, are surely correct.

Jacopo never reveals in his reliefs the rationalized, measured space manifest in Donatello. Space, for Jacopo, does not exist independent of the figures' existence, and in this case as in so many others, his inclinations are like Michelangelo's, who even in the paintings for the Sistine Chapel ceiling has the figures create the space. In other words, neither Jacopo nor Michelangelo proceeds by constructing a spatial stage and then filling it with figures; quite the reverse seems to be the case.

As Lorenzo and Isabetta (Lisabetta) appear today, tilting their heads toward one another, the slabs form a diptych, a rare example in Tuscany of matching husband and wife tombs. Such a pairing may have been the result of Lorenzo Trenta's northern European orientation.[108] These floor tombs, in any case, demonstrate once again Jacopo's unselfconscious inventiveness in treating conventional types.

THE *BALDUCCIO PARGHIA DEGLI ANTELMINELLI TOMB SLAB* (1423)

Belonging to the same conception as the *Lorenzo Trenta Tomb Slab* is that of Balduccio Parghia degli Antelminelli, which was originally in the cloister of the cathedral; after various moves over the centuries, in recent times it was brought to the Museo Nazionale di Villa Guinigi (fig. 153).[109] Inscribed with the year 1423, it was another example of an individual planning his own tomb (as was the case with Lorenzo Trenta), since Balduccio died only a decade later. While there has been some disagreement whether the work should be regarded as an autograph by Jacopo or as a work of his shop, no one would remove it from Jacopo's orbit, and I believe that it was carved by the master himself, although its condition precludes a secure attribution.[110]

Quite possibly Jacopo was still in Lucca during most of 1423. He was

108. Only Antonio Rossellino's Tedaldi pair in Santa Croce (Florence), a much consumed floor tomb in which husband and wife are together on a single slab, seems to continue this pattern some fifty years later. For this work, see Beck, "An Effigy Tomb Slab by Antonio Rossellino," and Eric Appfelstat, "The Later Sculpture of Antonio Rossellino," Ph.D. dissertation, Princeton University, 1987, pp. 108–143 and especially 135–136. On slab tombs in general for the fourteenth and fifteenth centuries, see Doralyn Pines, "Tomb Slabs and Santa Croce in Florence," Ph.D. dissertation, Columbia University, 1985. An echo of the Lisabetta Trenta slab is that by Leonardo Riccomanni of Margharita da Silico (+1426) in Santa Maria dei Servi in Lucca.

109. The tomb measures 234 × 118 cms. (that is, also in a ratio of about 2:1) and was located at some time in the Cappella Garbesi (constructed in 1702), along with the *Ilaria del Carretto Monument*. We known that Balduccio Parghia donated the famous painted leather box in the cathedral of Lucca, an object he had inherited from Alderigo degli Antelminelli (+1401), for which see P. Campetti, "Il cofano di Balduccio degli Antelminelli nella cattedrale in Lucca," *Dedalo* (1921), 2:240–250; Baracchini and Caleca, *Il Duomo di Lucca*, pp. 155–156; and Meiss, *French Painting in the Time of Jean de Berry*, text volume (London and New York, 1967), pp. 51–52. The swelling surface of this painted leather box is not incongruous to the relief surfaces found in Jacopo della Quercia's panels in Bologna, for example.

110. The inscription is given in the catalogue entry (no. 22). For the work as discussed in the earlier literature, see *Jacopo della Quercia nell'arte di suo tempo*, pp. 172–173, and S. Meloni-Trkulja et al., eds., *Il Museo di Villa Giunigi* (Lucca, 1968), pp. 70–71.

without a major assignment between the completion of the *Fonte Gaia* in 1419 and the commission for the *Portal of San Petronio* in Bologna in 1425, although he still had failed to supply the bronze *istoria* for the *Baptismal Font*. He could have fitted this tomb into his working schedule. The relief marker has survived in a highly worn state, with vast cracks disfiguring the surface. Nevertheless, the heavily undulating surface from which Balduccio emerges from a deathbed of swirling draperies bespeaks Jacopo's formal language. The design and the composition parallel Lorenzo Trenta's tomb slab so closely, in fact, that one might even imagine the new patron having requested that Jacopo pattern his marker after the earlier one in San Frediano. The transformation that was taking place with Jacopo's art could not be sublimated: one finds a thickening of the proportions of the effigy in Parghia degli Antelminelli, just as there is greater weightiness in the predella figures of the *Trenta Altar,* in distinction to those on the main field produced seven years before. We are moving closer in time and in style to what Jacopo will produce in Bologna.[111]

THE *TRENTA ALTAR* PREDELLA (1419–1422)

The completion of the predella zone of the *Trenta Altar* postdates the upper portion of the monument, perhaps by as much as a decade. Not only is there a noticeable shift in style, but the stone is of a slightly different color (and there is variance among the separate stones within the predella).[112] Ironically, an accurate chronology among the zones is complicated by the date and sculptor's name etched on the base of Mary's throne: HOC OPUS FECIT JACOPUS MAGISTRI PETRI DE SENIS 1422. The year conforms to yet another inscription in the chapel, on the floor tomb destined for paupers and pilgrims, implying significant activity, presumably the completion of the entire chapel, rather than merely the altar, in the same year.

At least two of the rectangular reliefs of the predella are demonstrably unfinished, the bust of Santa Cristina (fig. 22) and the Miracle of Saint Richard's Body (fig. 38), neither having received the detailed refinement and surface polishing that define the others.[113] A situation might be reconstructed in which the impatient patron, following years of frustrating interruptions, delays, imprisonments, and disappointments, had finally seen the work as all but finished. He proceeds to have the predella installed, hoping that the temperamental Jacopo will see to the final touches later on. Desirous that the sculptor's name appear prominently in the chapel—evidence of the esteem in which Jacopo was held following the *Ilaria* and the *Fonte Gaia*—the patron has Jacopo carve the

111. Paoli (*Arte e committenza privata*, p. 210) sees an "intervento di un colaboratore probabilmente lucchese del maestro."

112. This was noticed by Seymour (*Quercia*, p. 41).

113. Seymour (*Quercia*, p. 41 and fig. 39) suggests that the Saint Richard relief and the bust of Santa Cristina (which he calls Saint Ursula) may be seventeenth-century replacements. See below, *n*118.

inscription beneath the Virgin; or perhaps the frustrated donor at some point went ahead and hired a local stonecutter to do it.[114]

Jacopo's work on the predella must have followed the completion of the *Fonte Gaia*, late in 1419, although his assistants may have carved selected portions a bit earlier under Jacopo's orders and designs: perhaps the Pietà (fig. 33) and the Saint Jerome in His Study (fig. 36).

The decisive departure in style between the upper portions of the *Altar* and the *Fonte Gaia* is readily discernible. The new approach in Siena is also found in the predella of the *Trenta Altar*, which might even be expected when considering the time that lapsed between the working of the two zones. Several of these tiny narratives, in particular, relate to the standing Charities. On the other hand, the critic must be wary of the inherent pitfalls of comparing relief figures a few centimeters high, as found on the predella, with the life-size, free-standing sculptures. Often for tiny images to be seen up close, a different set of solutions is required than for large representations that must be observed at a distance. Besides, the generic requirements of the size of the different fields and the internal proportional questions come into play. In an analogous situation, the predella renderings by Fra Angelico for the Cortona *Annunciation* are instructive. In both instances, stylistic differences are attributable not so much to collaboration as to conceptual diversity related to size, scale, function, and location.

Before seeking to define Jacopo's stylistic departure, a determination is necessary of those portions of the predella that are autograph and those that must have been farmed out, notably but not exclusively to Giovanni da Imola, who was finally available again in 1417.

On the extreme left in a near-square relief field, the three-quarter-length crowned Saint Catherine of Alexandria holds a palm of martyrdom in her right hand and a book in her left. Turned sharply to her right, her finely incised classical profile leads the spectator's attention to the rest of the predella. The book that the haloless Catherine holds and especially the jagged torture wheel are fashioned in respectably convincing foreshortening. Her long elegant right hand reinforces the direction of her glance, to accommodate the reading of the unfolding stories and images. I consider this figure to be based upon Jacopo's design though executed by an unidentified shop assistant—not Giovanni da Imola.

Next, moving from left to right, is the Martyrdom of Saint Ursula, which is an autograph relief by Jacopo, as is the contiguous Martyrdom of Saint Lawrence. In both, the muscle-bound actors have been rendered in a style that will become a trademark of Jacopo's subsequent efforts, dramatically predicting

114. The inscription appears on that part of the monument that was finished somewhat earlier than the predella, a point I made some time ago in my review of A. C. Hanson's *Fonte Gaia* in *Art Bulletin* (1966); this was accepted by Del Bravo (*Scultura senese del Quattrocento*, p. 24*n*55). Furthermore, one must add, the predella zone would not have afforded an adequate field for a prominent inscription anyway.

Jacopo's Old Testament reliefs at San Petronio. But they also leap backwards in time to figural options forged by Nicola Pisano in Pisa and Perugia. In addition, Jacopo has infused the reliefs with a narrative drama that also will define the Bolognese carvings.

In the Saint Ursula, Jacopo has formulated two spatial planes; within the first, the Roman general on the left edge of the relief field gestures for the inevitable events to unfold. Next to him the heavy-hipped, small-busted young woman is being stabbed, while a companion on the left is being impaled with a long sword by the soldier. In other words, only two incidents encapsulate the slaughter of a vast horde of virgins, in much the same way that Jacopo will realize the Massacre of the Innocents for the *Portal of San Petronio*i (fig. 96).

In a shallow second plane, two heads, a bishop's and a woman's, and the cap of another, are constructed in a much lower relief, one that approaches Donatello's *schiacciato,* but also resembles late antique and Early Christian ivory carving. In all, we have five full figures, the two heads, and part of another, unquestionably an economical presentation consistent with Jacopo's artistic approach. The two devastating confrontations occupy the largest portion of the pictorial field. Neither of the two women being martyred looks like the saint, shown standing in the elaborated niche on the main field of the altar, although we might assume that the central heavy-hipped, high-busted woman who turns away from her tormentor, hands clasped in prayer, to look compassionately at her companion's plight, is actually Ursula. Gesture and glance are the devices that heighten Jacopo's narrative purpose here and in several of the other scenes.

As in the previous relief, the actors in the Martydom of Saint Lawrence are limited in number, here to but six. The muscular nude saint stretched out upon a fiery griddle—who little resembles the elegant, sensitive young deacon saint on the altar above, in a physiognomical shift similar to that of Ursula—is poked at from two directions. The changes may be due to stylistic alterations in Jacopo's figural language; or, as the representational roles change from the iconic on the dossale to the narrative in the reliefs, the inventive artist may be expanding his vocabulary. Here the unmerciful prefect orders Lawrence's martyrdom by roasting, as an armored soldier and a bearded person look on. Amid the agitation the resigned Lawrence remains calm. According to the account in *The Golden Legend,* Lawrence is being held down on the fire with iron forks, while a seated Decius with Hipolytus beside him orders the torture. The background arcade may be understood as a reference to Lawrence's last words before he died, giving thanks: "I thank Thee, O Lord, that I have been made worthy to enter Thy portals."[115] Unlike in the composition of the Ursula relief, the figures here are all on a single plane; behind them is a continuous arcade parallel to the surface plane, which defines the spatial distance. A similar arcade is seen in Donatello's near-contemporary *Saint George and the Dragon,* al-

115. Jacobus de Voragine, *The Golden Legend,* trans. and ed. by G. Ryan and H. Ripperger (New York, 1941), p. 442.

though the architectural motif is partially oblique to the plane of the relief surface in Donatello's treatment.[116]

The centrally located Pietà with Mary and Saint John, on an axis with the Madonna and Child, has no direct participation by Jacopo, nor for that matter by Giovanni da Imola. Perhaps the muscularity of its Christ is an effort, on the part of the Quercia assistant who produced the relief, to establish an accommodation with the panels the master had already finished. But the expression is mechanical and the execution confused, producing a stiff relief that is far removed from Jacopo's personal style.[117] Here the figures are three-quarter length, participating in the same scale found in the two images at either end of the predella.

The polished, highly finished, overtly most pictorial relief on the predella, Saint Jerome in His Study, is often (and I believe correctly) attributed to Giovanni da Imola. A comparison with the neighboring Miracle of Saint Richard's Body, both in strength of figural invention and in the bravura of execution, makes the differences between Jacopo's personal style and that of Giovanni striking. In providing the partially opened interior of the saint's study, the spatial devices are related to trecento usage, showing no insight into the newly evolving perspective. Indeed, with the spatial thrust moving from left to right, one has every right to expect to find the relief on the left side of the altar, but such is not the case. The oversized saint is not merely out of proportion to the room but to the accompanying figures in the scene and in the other scenes as well. An acolyte stands in the doorway with his right hand tucked into his rope belt, a motif found in the youngest king in the Adoration of the Magi on the *Portal of San Petronio,* but without the expressive strength of body language, suggesting that the work was designed by Jacopo but entirely executed by Giovanni da Imola. The saint in the narrative physiognomically resembles the representation on the main field of the altar proper, in distinction to the other three saints.

The Saint Richard relief was the most complex composition that Jacopo had produced up to that time (ca. 1422), and as such has led several critics to see it as not by Jacopo or not even a Renaissance work.[118] This relief, on a separate

116. The date of this influential relief by Donatello is not documented, and 1417, usually given, is not for the relief but for the "base" of the statue. (See Beck, "Ghiberti giovane e Donatello giovanissimo," in *Lorenzo Ghiberti nel suo tempo,* 1:118n8). I date it to ca. 1420 or even a bit later; perhaps it was even exactly contemporaneous with Jacopo's equivalent work.

117. The style and the type of Christ are related to trecento examples, especially those connected with Nino (and Tommaso) Pisano; for example, the relief on the tomb of Francesco Moricotto, in the Pisan Camposanto (see Burresi, *Andrea, Nino e Tommaso scultori pisani,* fig. 31.3), or the *Christ Pietà* in the Museo di San Matteo, Pisa (Burresi, fig. 40.1), or the *Pietà* from the Cappella del Santissimo Sacramento in the cathedral of Lucca, discussed sympathetically by Burresi, pp. 187–188.

118. Both Seymour and C. Freytag, in her review of Seymour's *Jacopo della Quercia* in *Art Bulletin* (1975), 67:442, consider Saint Richard to have been added in the seventeenth century; Freytag assumes this the case also for the Saint Ursula. Seymour (*Quercia,* p. 41, where the Saint Richard is mistakenly referred to as "Miracle of St. Ursula," as well as in the titles of figs. 37 and 38) proposes that this relief

stone that has a noticeably different tonality, is undoubtedly unfinished, without the final polishing and detailing, a condition that leaves a fresh, "impressionistic" aura when the work is viewed at close range. Monumentality and dramatic tension are achieved with a restricted cast (six figures); psychological dimensions effectively link it to the Bolognese reliefs. The bewitched young woman on the left is supported and restrained by two familiar, muscular young men, as she reaches out to touch the body of the deceased young King Richard resting on his bier. At that instant, the demon miraculously issues forth from her body out of the top of her head; a man holding a frightened, recoiling child looks on from the left. Compositionally, this group is related to the Charities from the *Fonte Gaia,* and the woman is perpetuated in the Eve in the Adam and Eve at Work on the *Portal of San Petronio* (fig. 108). The violence of the exorcism, which is at the core of the scene, is emphasized by the aggressive stance of the man in the middle of the visual field who holds the woman around her waist.[119] The compressed space where the action unfolds is entirely without architectural props or implications of an interior room; instead the figural masses create their own environment. Only the deceased saint resting high on the bier punctuates the shallow space. An interplay of bodily gestures and glances intensifies the action: the frenzied woman looks toward and beyond the handsome king whose arms are folded in death. The figure on the left looks directly at her, as does the child at his feet. Even the saint, whose eyes seem closed, is facing the woman whom his body will cure even in death.

The last relief on the predella zone is a three-quarter-length figure best identified as Saint Cristina and not Saint Ursula, as is commonly done.[120] Very likely by Jacopo himself, it has a hazy and not unattractive surface appearance, due less to the technique of carving than to a total absence of the final phases of detailing and polishing. The long-necked woman with flying hair looks intently to her left; she holds a spear in her right hand and a book in her left.

At the short sides at the level of the predella are the coats of arms of the Trenta and the Onesti, which have been partially shaved, presumably during the Baroque rehabilitation of the monument.[121] These arms are authoritatively though mechanically carved and are without special distinction. Jacopo della Quercia may have produced them himself but he certainly placed a low priority on them, perhaps because they were not readily visible aspects of the decoration.

By way of summary, the attributions of the predella with suggested dates, reading from left to right, are as follows:

is a seventeenth-century replacement for the fifteenth-century original, a suggestion I find far-fetched. The discrepancies are due to its unfinished condition.

119. An exorcism of this kind was painted by Sassetta for a predella of the Domenican *Arte della Lana Altarpiece* located in the Bowes Museum, Barnard Castle, Durham (England), which is, however, not clearly understood in Christiansen et al., *Painting in Renaissance Siena,* pp. 72–73.

120. Fabio Bisgoni made the Saint Cristina identification.

121. See Seymour, *Quercia,* p. 43 and *n*13.

1. Coats of Arms (left and right). Jacopo della Quercia, ca. 1420.

2. St. Catherine. Designed by Jacopo della Quercia, ca. 1420.

3. Martyrdom of Saint Ursula. Jacopo della Quercia, ca. 1421.

4. Martyrdom of Saint Lawrence. Jacopo della Quercia, ca. 1421–1422.

5. Saint Jerome in His Study. Giovanni da Imola, ca. 1419.

6. The Miracle of Saint Richard's Body. Jacopo della Quercia, ca. 1422.

7. Saint Christina. Jacopo della Quercia, ca. 1422.

In the past critics have taken various positions concerning the dating of the predella, some holding to around 1412–1413, others to 1416. In the list above, the reliefs are assumed to have been carved from about 1419/1420 to 1422, that is to say, following the completion of the *Fonte Gaia.*

The portions of the predella by Jacopo himself—the Martyrdom of Saint Ursula, the Martyrdom of Saint Lawrence, the Miracle of Saint Richard's Body and the Saint Christina—reveal the significant modification in figural language that has already been alluded to. Presumably the unfinished reliefs were left for last, although they may have been started at different times. Jacopo's figural proportions as revealed in the predella are compressed, lacking the sweeping grace of the saints on the upper zone. Furthermore, the players are muscular, heavy-limbed, and even somewhat clumsy, with smallish, well-proportioned feet and short, rather square hands. They seem to be the grandchildren of Nicola Pisano's figures from the Pisa baptistery and the Siena cathedral pulpits, while in pose, gesture, and ferocity they maintain the technical refinement and control over the material exemplified by Giovanni Pisano's art.

Evidently in the small field and obscure space of the predella, Jacopo was more readily prepared to explore new avenues for his narrative talents, avenues that he would further exploit in the following decade. He continues to avoid commitment to perspective; instead he was almost exclusively devoted to the human figure and the expressive and narrative possibilities it offered.[122] Having achieved fame from the *Fonte Gaia,* to the extent even of having his name attached to the monument, a return to a more private role in the small reliefs for a family chapel must have been a soothing interlude. Just as Nanni di Banco had Jacopo's seated figures from the *Fonte Gaia* in his mind's eye when conceiving his Madonna for the Portal della Mandorla gable, and Masaccio as a mere lad might have chanced to see the Expulsion from the same fountain, only to put it to good use around 1427 for his fresco in the Brancacci Chapel, perhaps

122. Among the earliest manifestations of perspective is, of course, Donatello's relief of *Saint George and the Dragon,* but his figure is placed obliquely in space in a much more daring formulation than Jacopo's. The precise date of Brunelleschi's famous experiments is not confirmed by documents, but I believe that ca. 1420 is the most likely.

Donatello was aware of the *Trenta Altar* and its adventurous reliefs on the predella while evolving his own relief style.

The progressive and original Saint Ursula and Saint Richard reliefs are among Jacopo's finest accomplishments, achieving a balance between formal invention and dramatic expressionism within a narrative framework.

THE *SAN GIMIGNANO ANNUNCIATION* (CA. 1424–1425) AND OTHER WOOD SCULPTURES

By the early fifteenth century carved wood statuary had long been a speciality of Sienese sculptors, who habitually engaged skilled professional painters to execute the final decoration of their figures, in an effective collaboration.[123] Jacopo's companion and sometime collaborator dating back to the time of the baptistery door competition of 1401, Francesco di Valdambrino, became an outstanding exponent of wood sculpture, beginning in the early years of the quattrocento.[124] Jacopo's participation in the medium is not so clearly defined. Only rather late can we locate with absolute certainty wood sculpture by him, although quite likely he produced such objects earlier on, including the *Annuciat Virgin* from San Raimondo al Refugio and the *Benedictine Saint* from Massa, as has been suggested already. The documented life-size statues of the *Annunciation* produced by Jacopo della Quercia for the Collegiata at San Gimignano, where they are still located on brackets on the inside of the façade, falls nearly a decade and a half later.

The San Gimignano group has the advantage of a signature and a date; besides, contemporary documents confirm certain details of the commission. We know (from *spogli*) that the *Annunciation* cost 110 lire and 10 soldi, and that it was commissioned from Jacopo in 1421 (doc. 103). This evidence should be coupled with the inscriptions applied by Martino di Bartolommeo, which offer a date of 1426. As a result, we must assume that Jacopo carved the two statues between 1421 and 1426.

The division of labor for such painted wooden statues is also clearly provided by the two inscriptions. The one on the base of the Madonna reads: MCCCCXXVI MARTINUS BARTHOLOMEI DE SENIS PINXIT. On the accompanying angel is the following, recovered in a cleaning undertaken for the Jacopo della Quercia exhibition held in Siena in 1975: HOC OPUS FECIT MAGISTER GIACOPUS PIERI DE SENIS.[125] The distinction in the roles of the two artists, who were friends, is quite clear: Jacopo sculpted the figures and

123. See especially Carli, *La scultura lignea senese,* and Bagnoli and Bartalini, eds., *Scultura dipinta.*

124. See Burresi, "Incrementi di Francesco di Valdambrino," pp. 49ff, for the discovery of the so-called "Madonna di Palaia" which, fortuitously, bears an inscription with the date of 1403 and is signed by Master "Francis[c]us de se[n]is." For Francesco see also Paoli, "Una nuova opera documentata di Francesco." The so-called San Nicola da Tolentino is currently (1990) being restored in Pisa.

125. P. Torriti, "Il nome di Jacopo della Quercia nell'Annunciazione di San Gimignano," p. 98.

Martino painted them, contradicting older (pre-Bacci) interpretations to the effect that Martino had been responsible for the carving too.

The state of preservation of the group is excellent, due apparently to the quality of the wood used (castagno) and to the craftsman's rigor in the application of the polychromy.[126] The condition makes the *Annunciation* crucial for evaluating Jacopo's approach to the medium, as well as for his evolving style of the mid-1420s.

The question of a more precise dating, with all its implications in reconstructing the stylistic odyssey of the sculptor, remains to be addressed. Torriti at one point suggested that the *Annunciation* was finished in 1421 but that it was left undecorated until 1426.[127] Giulia Brunetti has expressed serious doubts about a dating in the early 1420s, finding it more convenient to her reconstruction of early Quercia to place the work a couple of decades before, that is, at the beginning of Jacopo's career; she suggests that it was "reused" for the San Gimignano commission.[128] Most scholars have accepted the 1421 date, however.

Since Jacopo was an inveterate procrastinator, he probably did not prepare the statues immediately. But the moment he did execute the two figures, probably after inevitable prodding, they were turned over to Martino. If the logic of this scenario fits into what is known of Jacopo, Martino's case is something different. He was neither as famous nor as independent as Jacopo, and probably painted them as soon as he had them on hand. Since he dated the figures 1426, I suggest that the *Annunciation* was carved around 1424–1425, in effect immediately before the commission for the *Portal of San Petronio* in Bologna.[129] The *Annunciation*, consequently, belongs chronologically and stylistically to the moment following the predella reliefs for the *Trenta Altar* (1422) and the *Balducci Parghia degli Antelminelli Tomb Slab* (1423), and represents Jacopo's art shortly before the Madonna and Child (1426–1427) and other examples of his activity on the Bolognese *Portal*, as well as the prophet reliefs for the upper zone of the *Baptismal Font* (1427). An apparent diversity in approach between the Gabriel and the Virgin of the *Annunciation* has been pinpointed by Carli, who judges the angel more "Querciesque" than Mary.[130] Del Bravo attributes the divergence to what he sees as two currents that Jacopo experienced during this period, one emanating from Ghiberti, which explains the Virgin, and the other from Donatello, which defines the conception of the angel.[131] Mary, rather, may be seen as more closely tied to conventional Sienese interpretations

126. See Torriti, "Il nome di Jacopo."

127. Torriti has changed his mind in his most recent discussion of the *Annunciation*, in Bagnoli and Bartalini, eds., *Scultura dipinta*, p. 156.

128. G. Brunetti, "Dubbi sulla datazione dell'Annunciazione di San Gimignano," pp. 101–102.

129. This is also Seymour's view (*Quercia*, p. 56 and *n*35), one that Torriti (in Bagnoli and Bartalini, eds., *Scultura dipinta*, p. 156) has come to accept as well.

130. Carli, *La scultura lignea senese*, p. 71.

131. Del Bravo (*Scultura senese del Quattrocento*, p. 39) views Jacopo as lacking originality, being largely dependent upon progressive Florentine events.

and particularly to examples by or associated with Francesco di Valdambrino, including his Mary from the *Annunciation* now in the Rijksmuseum, Amsterdam.

Abundant features in both statues betray Jacopo's new concerns. When the *Annunciation* is viewed correctly—the heads in profile and the bodies in an easy, unstressful contrapposto with both feet and the lower half of the bodies frontal—interaction between Gabriel and Mary is clear, which, in turn, encourages perception of a terse psychological interplay.[132] Gabriel turns assuredly toward Mary, raising his right hand in a gesture that is half-blessing and half-greeting, while the characteristically "Sienese" Mary thrusts her right arm across her chest, clutching a small prayer book with her left hand. The angel has his right leg loose, with the left bearing the weight; Mary, to the contrary, supports the weight on her right leg. The two unselfconscious participants act out their respective missions, oblivious to—or rather, aloof from—the intervention of bystanders. Gabriel's short hair with bold unfussy locks is encapsulated with a fillet. His head when seen in profile, with the fine forehead, strong nose, and bold chin, leads me to postulate an awareness of Roman examples, most likely as observed on a small scale from sarcophagi. Gabriel's complex draperies form pockets of deep shadows, quite opposite to the more sweeping and curvilinear effect of Mary's garment. Especially in the Gabriel, the distance can be measured effectively that Jacopo had traveled in artistic clarity and expressive direction from the *Apostle* from the Lucca Cathedral of about ten years earlier, which, in juxtaposition, appears indecisively groping.

When seen frontally Mary is similar to the figures on the predella of the *Trenta Altar,* especially to the Saint Ursula in the center of the scene of her martyrdom, with whom she shares similar proportions:[133] heavy hips, high bust, and a rather small head—a type that has its final statement as Jacopo's ideal female figure in the characterizations of Eve at San Petronio. Gabriel may be understood, in effect, as the exemplary masculine type, who holds himself erect with self-confident composure, while Mary, equally self-confident and knowing, tilts her head toward Gabriel's gesturing right hand; her body has less mass, but in the final analysis they are, as it were, two aspects of the same message.

The Anghiari Madonna

Three seated wooden Madonnas holding or prepared to hold the Child, which date from the 1420s or 1430s, have been convincingly associated with Jacopo della Quercia: the *Anghiari Madonna,* the *Louvre Madonna,* and the *Carli*

132. The photographs normally available for the *Annunciation* are taken at improper angles, creating a misleading impression of the statues and mitigating the interrelationship of the two images, which were conceived very much as a pair.

133. This connection is also noted by Seymour, *Quercia,* p. 56.

Madonna. None are documented nor do they contain a signature, like the *San Gimignano Annunciation,* but at least the *Anghiari Madonna,* which is a relatively new discovery for Quercia studies, has a strong claim to autograph status and to being one of Jacopo's most distinguished isolated statues in the medium.[134]

The inventory of the Opera of the Duomo of 1435 offers an indication that Jacopo had a mini-industry of his own in wooden figures (doc. 439). At his death a Sant'Agostino of wood is specifically mentioned by his brother Priamo as one of the objects he left behind in Bologna (a work that has never been identified). The medium offered the artist a suitable expressive vehicle, and wood carving proved to be a lucrative activity that he could engage in without the costs, risks, and effort of marble carving. The *Anghiari Madonna* (cat. 18), which I believe dates close to the carving of the San Gimignano group—that is, immediately before Jacopo's Bolognese involvement—is also well preserved. The color, the deep blue of the mantle, the earthy red of her dress, and the white with red highlights of her scarf, the gilt hair and pale flesh tones, fittingly complement Jacopo's unmistakable sculptural forms. The robust proportions of Mary are accentuated by the undulating draperies that cover her lap. Her solid oval, full-cheeked head rests on a powerful neck; like a confident sibyl, she exists in a world virtually independent of the viewer. A worthy counterpart to the Madonna from the lunette at San Petronio, the *Anghiari Madonna* is more accessible because of the coloristic attractions. The inherent quality of the invention and the refined modeling is evident when compared to a derivation, the so-called *Carli Madonna,* located in a Milanese private collection, which nevertheless retains some of the residual power of the main version.

Perhaps the work that suffers most in comparison with the *Anghiari Madonna* is the Madonna in the Louvre said to have come from Borgo San Sepolcro, and long considered a masterpiece by Jacopo in the medium. It is indisputably inferior in terms of invention and facture, though, on the other hand, the Louvre group retains its original Christ Child, while the very fine Child now shown with the *Anghiari Madonna* does not appear to be the original. The Anghiari Mary should be thought of as almost exclusively an autograph, and the *Louvre Madonna* mainly a shop production.

Another wood statue of high quality by Jacopo that displays sharpened expressive qualities is the *Saint John the Baptist* of about 1430 from the baptistery in Siena, which has been restored in recent times (see cat. 19). The treatment of the Saint John demonstrates an approach to detail that tends toward implication rather than explication, where the eye of the beholder supplies the refinements, for which the artist left behind only subtle signposts.

134. According to the inventory of 1536, there was "uno Agnolo di legno di rilievo di mano di Iacopo dela Fonte" in the sacristy of the cathedral (ASS, Opera Metropolitan, no. 868), at the date and place, according to Dr. Gino Corti, who brought the notice to my attention.

Another wooden figure that can be placed at least in the circle of Jacopo della Quercia is the Franciscan Saint in Bologna's Museo Civico, for which see P. Biavati and G. Marchetti, *Antiche sculture lignee in Bologna dal sec. XII al sec. XIX* (Bologna, 1974), pp. 144–147.

Along with the *Annunciation* in San Gimignano, the *Anghiari Madonna* and the *Saint John the Baptist,* which has a long traditional connection to Jacopo, demonstrate that when he threw himself into the task, he could achieve with polychromed wood effective images, equal to some of his finest in stone.

THE *MAIN PORTAL OF SAN PETRONIO* IN BOLOGNA: FIRST PHASE (1425–1428)

The *Main Portal of San Petronio* was the crown jewel of Jacopo's art from his full maturity, a project that the sculptor evaluated as his most prestigious and best paid. Judging from the documents and especially from the monument itself, he threw himself into the project wholeheartedly at heavy personal sacrifice, including remaining away from Siena for long spans when his credibility there was put in jeopardy. Jacopo recognized in the commission to design and provide the sculptural decoration for the main portal of the Basilica of San Petronio an opportunity to confirm himself as one of Italy's leading sculptors, a reputation he sought. If he also made no secret of the ample financial rewards his activity in Bologna offered, nevertheless the artistic challenge was a prime motivation.

As far as we know, Jacopo had no expertise designing an architectural monument, although the *Fonte Gaia* provided him with an introduction. In the case of San Petronio, however, not merely did he have to design a vast portal but he also had to accommodate his design to the late medieval church still under construction. San Petronio reflected Milanese and Emilian late Gothic currents, a tradition diverse from what was native to him in Tuscany (and Umbria). Furthermore, he was charged with obtaining costly material from far-flung places, generally overseeing a busy shop, and dealing with considerable sums of money.

The Design

Jacopo's original project for the *Portal* fronting the public space in the city with its adjacent communal buildings can be reconstructed on the basis of the contract for the commission, together with a drawing by Peruzzi in which Jacopo's project is specifically recalled, and the portal as it has survived (figs. 78–129). Other data to be taken into account are the fact that the portal remained unfinished at his death, even after thirteen years of work; and that in the early sixteenth century it underwent a dismantling and reconstruction, at which time some unfinished portions were completed and substitutions installed.[135]

135. I treated the *Portal* at length in my 1963 Columbia University dissertation, "Jacopo della Quercia's Main Portal at San Petronio in Bologna," a revised portion of which was published as *Jacopo*

Jacopo's portal, which employed alternating red and white stone, has the appearance of a formidable, round-arched, splayed doorway excavated out of the massive façade wall. The sides are articulated by colonettes and pilasters resting upon a high base that was already conceived before Jacopo had the assignment, and which ran the length of the façade as well as along the entire exterior of the basilica, serving as a unifying feature. The architectural elements of the portal are highlighted by historiated pilasters on the outer face, now divided into five panels on each side, but first planned with seven. This zone is concluded with leafy capitals and the historiated lintel over the actual opening itself, upon which another five scenes were carved. Above is an ample lunette into which three-dimensional sculpture has been placed and the system of decoration used on the embrasure is continued. This modified post-and-lintel composition was given a final feature, a gable or pediment, resting either directly upon the curve of the outermost archivolts like the niches for the angel at the *Fonte Gaia,* or separated by a horizontal stringcourse. In the gable, relief sculpture was envisioned, but no portion of the area was ever executed except the frame of the gable itself.

Reading vertically, then, from the bottom there were four zones: (1) the raised base; (2) alternating decorative motifs of colonnettes, a narrow pilaster strip on each side with nine prophet busts, and the histories on the exterior pilaster, the door jambs with putti brackets supporting the historiated lintel and the capitals; (3) the sculpture in the lunette and provisions at least for large images of saints Peter and Paul standing above the historiated pilasters; and finally, in the uppermost zone, (4) Christ supported by two flying angels in relief and a crucifixion at the apex. Lions were planned either for the ground on each side of the entrance, according to some interpretations, as they were at the cathedral of Bologna (San Pietro) and commonly in Emilia, or they were to rest on brackets on the course above the lintel. What we have now is only three zones: (1) the base; (2) the historiated pilasters, the embrasure elements, and the historiated lintel, and (3) the lunette, with its sculpture, decorated arches, and relief busts (sixteenth century).

From the point of view of a stylistic discussion, Jacopo's conception commonly has been associated with the Porta della Mandorla. The association is motivated by a current of thinking encountered time and time again in Quercia studies: if worthwhile innovations by a "provincial" can be ascribed to an artist

della Quercia e il portale di San Petronio a Bologna: Ricerche storiche, documentarie e iconografiche (Bologna, 1970). The part that was not published deals with the stylistic observations that are specifically treated in this chapter. On the other hand, questions of the design are treated there at length and in my "Jacopo della Quercia's Design for the 'Porta Magna' of San Petronio in Bologna," *Journal of the Society of Architectural Historians* (1965), 24:115–126. Since my views have not changed significantly, I direct the reader to these publications; here I shall summarize them and, where appropriate, modify and expand some points. Gnudi ("Per una revisione critica della documentazione riguardante la 'Porta Magna' di San Petronio") takes issue with certain conclusions made in my *Il portale.* From time to time questions specifically raised by Gnudi will be addressed. See especially cat. 12, and comment.

like Jacopo, at the least he must have been inspired by Florentine prototypes. Judging from Peruzzi's sixteenth-century façade drawing where the Sienese painter/architect proudly asserts to have rendered his portal section from an old drawing by Jacopo, no meaningful connection with the Florentine cathedral can be drawn, however.[136]

In seeking the *cultura* for the portal, Tuscan examples that would have been known to Jacopo should be considered, including the portal of the baptistery in Pistoia, which is a smaller, "flatter" model, and one without sculptural embellishments. But whatever convincing sources may be put forward, the most remarkable and essentially original feature of the San Petronio portal's design was its overall plasticity, the wavelike flow of shadow on the surface in the bright sun-drenched square, and the way in which all of the architectural members as well as the decoration were treated as sculpture—in distinction, for example, to their treatment on the Porta della Mandorla. The undulating splayed arms have buttery surfaces very like those of the historiated reliefs. Here was a sculptor's, not an architect's design, which in that respect was like that of the *Fonte Gaia* but more ambitious and more self-assured, with the implications of a triumphal arch.

The sculpture actually executed by Jacopo and his assistants, in distinction to sixteenth-century additions, includes the following:

I. The ten Genesis reliefs in the exterior pilasters.
 On the left pilaster, reading from top to bottom:
 i. The Creation of Adam
 ii. The Creation of Eve
 iii. The Temptation and Fall
 iv. The Expulsion
 v. Adam and Eve at work
 On the right pilaster, reading from top to bottom:
 i. Cain and Abel Offering
 ii. Cain Murdering Abel
 iii. Noah Leaving the Ark
 iv. The Drunkenness of Noah
 v. The Sacrifice of Isaac
 II. The pilaster strips on the embrasures with nine prophet busts on each side.
III. Mensole putti supporting the lintel.
IV. The lintel, with five reliefs dealing with the early life of Christ.
 Reading from left to right:
 i. The Nativity
 ii. The Adoration of the Magi

136. Supino's reconstruction (Beck, *Il portal*, fig. 8) actually shows a seated Christ in Mandorla, suspiciously similar to Nanni's Madonna relief in Florence.

On the basis of an attentive reading of the documents together with the physical and stylistic evidence, one can conclude that the sculpture on the portal was evidently produced in two basic phases. The first body of work was carved mainly from 1426 until the September of 1428 (when it was put in place on the portal), and includes the Madonna and Child, the eighteen prophet busts, the two mensole putti, and the five New Testament scenes on the lintel. The second phase, dating from about 1429/1430 to 1434, is composed of the ten Genesis reliefs and the statue of San Petronio. Consequently the first phase at San Petronio falls chronologically on the heels of the *San Gimignano Annunciation,* and the sculpture was made simultaneously with the marble Saint John the Baptist and the five prophets on the *Baptismal Font* in Siena.

First Sculptures

The five histories on the lintel, the most maligned and misunderstood sculptures on the portal, were among the first Jacopo made in Bologna.[137] Since these reliefs physically constitute a vital structural element of the doorway, a greater urgency to finish and put them in place must have surrounded their production, simply because they are carved on the outer face of the three blocks that make up the lintel, which rests directly on the vertical door jambs. The uppermost one on each side consists of a *putto* sculpted as part of the supporting bracket, which offers stability to the structure. The stones of the door jambs (*stipiti*) were put in place during 1428, and we must assume that the lintel blocks were not only ready but immediately placed on the portal. Otherwise the situation would have been dangerous on the one hand and somewhat absurd on the other: that is, two robust jambs, each topped with a beautiful muscular putto, would have been standing insecurely without the final locking element, namely the architrave, to complete the post-and-lintel arrangement.[138] We also have

137. Bellosi (in "La 'Porta Magna' di Jacopo della Quercia," 1:162–212), following Gnudi ("Per una revisione critica," p. 46), dates them between 1432 and 1434. Behind the desire to date the reliefs late is the assumption that, being weak, they must be late works, when a decline in the sculptor's powers would have been likely to occur. (Of course, there is no question of an "old age" style operating here anyway, since Jacopo would have been in his early fifties.)

138. Those not well acquainted with payments in the fifteenth-century account books are sometimes confused when certain elements are not mentioned. There are no mentions at all of the lintel *per se* in all the documentation of the *Portal,* early or late, nor specifically, for that matter, of the pilasters with the Old Testament reliefs. But that does not mean that the pilasters did not exist nor that the reliefs were

evidence that one of the pilasters on the embrasure with prophets was placed on the portal at the same time, along with other colonnettes, and without seeking unnecessary complexities, we can assume that they both were also placed on the portal in September 1428.[139] This group of works, along with the Madonna, was executed between 1426 and 1428, a span of intense activity following the initial organizational and planning stages characterized by the purchase of stone and preliminary work on the site.

The New Testament Reliefs

The reliefs form a stylistically homogeneous group, although the Presentation, which is actually on a separate block, was executed by an assistant, as will become clear shortly. The tiny pilaster strip on the adjoining block at the left is unfinished, indicating an oversight, probably the result of haste to complete work on that zone in 1428 while Jacopo was being constantly requested to return to Siena. Due to the structural role of the lintel, it was essential to have it up; hence the urgency.

The five narratives taken as a coherent set have a unique internal order of their own. Perhaps the original three as planned in the first contract were the Nativity, the Adoration of the Magi, and the Presentation, which are now the first three; when the program was expanded to five scenes, Jacopo added the Massacre of the Innocents and the Flight into Egypt, in that order, which reverses convention and implies an intentional shift. The central panel stands alone in both position and in meaning, embracing ideas related to the role of the Church as the instrument of Christ's mission. The scenes on the extremities, the Nativity and the Flight, in idyllic settings, appear to be concerned with an interpretation of the relationship between Mother and Son and the Holy Family. A parallel may be found, too, between the Adoration and the Massacre: their compositions both hinge upon a seated figure from which the action is triggered. Although the themes of these two scenes are diametrically opposed, a common thread, the role of civil authority, serves to connect them. We should in consequence read the entire lintel in the pattern A, B, C, B, A. Within the Presentation, surely designed if not executed by Jacopo, the same pattern is found in the relationship of the figures to one another. The Christ Child, who is somewhat independent in the relief, is at the center of the center, as it were, which is also the central axis of the entire portal and consequently of the entire church.

not put up. The reason the other elements, such as the stones of the lintel, are sometimes mentioned is usually happy accident, when the bookkeeper wants to be quite specific, but there is no issue of "completeness" in these matters. The bookkeeper was only concerned with making sure the payments were properly recorded to the workmen putting the stones up. Actually it is basically good fortune, from the point of view of the history of art, that specific portions of the portal or specific sculptures are mentioned at all.

139. Bellosi (in "La 'Porta Magna' ") takes the date to be 1427, which is either a misprint or a slip.

The New Testament histories reflect the style of relief carving that was first enunciated on several of the small scenes from the predella of the *Trenta Altar,* finished in 1422. The relief figures on the upper section of the *Trenta Altar,* the sarcophagus of the *Ilaria Monument,* and much of the sculpture of the *Fonte Gaia* are conceived as virtually in-the-round, with the visible portions projecting, but the rest buried, as it were, behind a stone curtain within the matrix of the block. Only in the *Trenta* predella, and specifically in the Ursula, Lawrence, and King Richard reliefs, does Jacopo's more pictorial style appear. In these instances and in Bologna the degree of projection gradually decreases in proportion to the closeness of the forms to the front of the relief plane; in Vasari's words, within a "regola dello sfuggiere e diminuire . . . come fa l'occhio . . . tanto che vengono a rilievo stiacciato e basso." Jacopo, however, never sought the systematic organization that appealed to Ghiberti in these years, nor the virtuosity and rigor of Donatello. Neither did Jacopo seriously take up questions of spatial depth in the architrave reliefs at San Petronio, emphasizing instead surface excitement, as was the case with the *Fonte Gaia* reliefs, although within a different scale and proportion. The actual projection is restrained, with the available space filled by the participants rather than with architectural props or landscapes.

In the Nativity only the meanest suggestion of landscape is effected by an outcropping of rock at the top edge of the field (fig. 91). Movement on the surface is achieved with sweeping half-arcs embracing the reclining Virgin, the angels, the two beasts, and the seated Joseph, radiating centrifugally from the Christ Child. The undulating garments worn by the actors participate in the surface liveliness. In terms of its composition, the Nativity can be connected to reliefs by both Nicola and Giovanni Pisano. The pose of the Virgin is a variant of the same figure in the same subject by Giovanni, for his Pistoia pulpit. On the other hand, the ox and the ass curl down into the center of the composition, to unconventionally occupy a dominant place. In terms of figural language, Jacopo's expressive conception of the hands and hand gestures, which recurs throughout the portal, seems to have been newly developed in these years. In the *Nativity,* the massive hands of Joseph the Carpenter, powerful but clumsy, effectively contrast with Mary's tapering, sensitive, aristocratic ones. The features seen in the Nativity are also found in the nearby Adoration of the Magi (fig. 93).

The shallow projection, the figure-crowded spaces, the surface enlivened by active swells of drapery, and the minimal landscape clues are qualities shared by the other reliefs on the lintel. The surface movement radiates from the Child in slow-moving arcs. Like the Nativity, the composition of the Adoration relates to the Pisani, in this case more specifically to Nicola: even the scale of the figures is reminiscent of his treatment of the same subject on the Pisa baptistery pulpit. The motif of the oldest king kissing Christ's foot follows Nicola's scene on the pulpit in the Sienese cathedral, although Jacopo added the tender gesture

of the Child caressing the old man's head, which was not, however, his own invention. Among the examples Jacopo could have known are Orcagna's on the tabernacle in Orsanmichele, Florence, as well as the newly finished Adoration in the Strozzi Chapel in Santa Trinita by Gentile da Fabriano, whom Jacopo probably encountered personally in Siena.

The Adoration, in which left-to-right movement within the relief reconfirms that of the entire lintel, reveals Jacopo's preoccupation with the expressive potentials of hands.[140] Sustaining interest by the diversity of the figural poses, Jacopo's approach may be observed in the details—for example, the way in which the two kings on the left and Joseph on the right hold circular containers. Fingers curl over and around the (wooden?) jars, some hidden, others fully extended. Mary gently holds the Child, but her fingers still indent the soft flesh. The kneeling old Magus' mighty right hand with a decisive forefinger is worthy of Michelangelo. The muscular, thick-set figures, in which the anatomy is occasionally revealed, relate to those from the Martydom of St. Lawrence. But in these scenes, Jacopo has little opportunity to show more of the bodies for iconographical reasons.

The centrally located Presentation of the Child in the Temple (fig. 94) reflects the design by the master; the execution must have been relegated to one of his *garzoni,* presumably the most adept, who may have been the author of the marble triptych in the Museo Civico (Bologna); he may be tentatively identified as Cino di Bartolo (see cat. 14). The figures are essentially pastiches derived from the other four reliefs, which must have been carved previously. Like Duccio, before, and Piero della Francesca, after, Jacopo's working method did involve the repetition of poses, but when he repeated, the purpose was rhythmic; here it seems to have been motivated by convenience. For example, the figure on the left is derived from the youngest Magus on the previous relief, although the proportions differ and the convincing form of the prototype has been virtually lost in the translation. The severe head of the figure on the right has been adapted from the helmeted soldier on the left in the Massacre, while the Virgin's profile is copied from that of the Flight, one of the few directly antique types on the architrave. We must assume that Jacopo had produced a hastily prepared design, perhaps even a little model, and then left his assistant to his own devices. Jacopo's figures potentially tend to explode beyond the available actual space. The weakest section of the Presentation is the High Priest, where the *scolaro* became entirely confused for want of an adequate model. The Presentation, and especially the priest, is executed in quite low projection, with flat, dull passages not found in the other reliefs.

The composition of the Massacre of the Innocents (fig. 96), whose violent intensity echoes that of the Martydom of Saint Ursula on the *Trenta Altar,* also recalls Giovanni Pisano's treatment on the Pistoia pulpit, while the slain chil-

140. Bellosi ("La 'Porta Magna' ") singles out Donatellian elements within these reliefs; quite to the contrary, Jacopo offers an alternative to Donatello in almost every respect.

dren have antecedents in the relief of the same subject on the Sienese cathedral pulpit. They seem to reveal a familiarity with an antique Sleeping Eros. The central theme is explicated by two muscular Roman soldiers with whose brute force and unattractive physiognomy Jacopo had already experimented in the Martydom of Saint Lawrence. The executioners carry out their horrible task with machinelike efficiency. Their large feet and heavy legs convincingly support massive bodies and the burden of intense action. Although the figures are not anatomically "correct," Jacopo delineates the drama with the sparest means: two soldiers stand back to back, each in the act of slaughtering a child, and two dead children lie on the ground. Likewise one mother represents all the mothers, as she vainly writhes to escape the horrid plunge of the monstrous long sword aimed at her child. Even the sparse landscape elements of the other scenes have been eliminated. Whether Jacopo had significant assistance on this relief, as some would have it, may be beside the point, since the power of the conception and the directness of the execution overcome any weaknesses in individual sections.[141]

The Flight Into Egypt (fig. 97) on the extreme right is justifiably regarded as a high point of artistic achievement on the lintel. Its surface has been amply charged with an activated play of light and shadow produced by the figures and the background, which takes on a rhythmic function, operating as a sonorous continuo. Once more the general conditions of the composition are structured upon Giovanni Pisano (pulpit for the cathedral, Pisa), but also refer to an earlier composition attributed to Fra Guglielmo at San Michele, Pisa, while the manner in which the Virgin sits astride the ass recalls a similar motive from the pulpit in Siena. Mary protects the nude Child strapped to her bosom. The intimate relationship expressed by the touching of the heads is related to the Byzantine theme of Glykophilusa ("tender loving") that continued to find favor in Sienese trecento painting. It was used by Donatello in his *Pazzi Madonna*, which has become widely recognized in relation to Jacopo, but the Donatellian composition known as the "Madonna of the Apse," where the Madonna is in profile and the child in seen in full front, is still closer.[142] The delicious configuration is only part of the story. The Child holds onto his mother's neck in a delicate exchange of embraces, as she looks ahead to the road, mindful of possible danger in the rocky wilderness where but a single tree offers shelter. Heavy-handed, clumsy, clodlike Joseph devotedly prods the ass on its way, while the household pet, a faithful mongrel, shows the way in a step mimicking the ass, in a rapport like that of the dog and the horse in Nicola Pisano's relief illustrating Hawking (May) on the fountain in Perugia. Among the most approachable on the entire portal, the Flight relief encompasses a high degree of sympathy for the human condition.

141. Bellosi ("La 'Porta Magna,' " 1:204) finds the execution particularly poor.
142. See P. Schubring, *Donatello: Des Meisters Werk*, vol. 11 of *Klassiker der Kunst in Gesamtausgaben* (Stuttgart and Berlin, n.d.), p. 95.

For both compositional directives and individual motifs, the five reliefs reveal a general debt to both Nicola and Giovanni Pisano, who all through Jacopo's career stood for the highest values from the Tuscan tradition, and who had a local authority in Bologna at the Arca di San Domenico. Although scattered references can be isolated, classical antiquity was not a decisive ingredient in Jacopo's conception of the lintel narratives. Stylistically the most potent specific sources remained his own inventions for the predella of the *Trenta Altar*. However, both Jacapo's expressive powers and his approach to the problem of the pictorial relief had moved beyond these earlier exercises. At the same time he resolutely rejected the new perspective, seemingly disengaged himself from anything like the *schiacciato* technique that Donatello fostered, and chose instead to work out a pictorial and narrative formula independently. As with much of his later reliefs, he achieved a spatial conviction from the figures, rather than first creating the spatial context and filling in the figures in a subsequent step.

The Prophet Busts

The eighteen busts of prophets on the embrasures of the portal are not easily comprehended simply because the pilaster strip of which they are formed is concave, a factor hitherto ignored. The central portions of the figures and especially the heads are carved with substantially higher projection than one might expect.[143] Some of the heads are carved with greater projection than others, producing a considerable variety among them, although this aspect might be the result of different hands, rather than a sculptural intent. The same undulating and exciting surfaces that were achieved for the lintel reliefs, with an analogous concentration on the expressiveness of the gestures, especially the hands, are found here. The identity of these half-figures, ranging from handsome youths to frenzied visionaries, with poses varying from decisive profile to full face, cannot be determined.[144]

The types Jacopo used on the portal may have been motivated by the large busts in quatrelobes on the base of the façade carved before the end of the previous century, although Jacopo's far more activated examples are in rectangular frames.[145] Other local types include the painted prophets in the Bolognini Chapel in San Petronio by Giovanni da Modena, which are enframed like the

143. When the pilaster is seen from above the concavity is readily discerned. The only study specifically devoted to the prophets is that of A. Foratti, "I profeti di Jacopo della Quercia nella porta maggiore di S. Petronio."

144. Although the banderoles have no inscription, an effort to identify the various prophets has been made by Raule ("Il portale maggiore di S. Petronio"), but the approach is necessarily arbitrary.

145. These reliefs have been studied most recently by R. Grandi, "Progetto e maestranze del basamento petroniano," in Rossi Manaresi, ed., *Jacopo della Quercia e la facciata di San Petronio a Bologna* (1981), pp. 177–215, and "Cantiere e Maestranze agli inizi della scultura petroniana," in Fanti, et al., eds., *La Basilica di San Petronio* (1983), 1:125–131.

façade relief from which they derive.[146] Jacopo, however, had already treated similar representations on the *Trenta Altar,* but in Bologna he gives the impression of the whole figure in vigorous movement, although only the heads and torsos are depicted, the implication being that the rest is "concealed." Hips and shoulders turn and twist against each other to create internal activity, further accentuated and underscored by the turn of the heads. Swelling draperies, swirling ribbons, and the mighty hands increase the dramatic effect. Undoubtedly some of these busts were worked on by assistants, but as a group they reflect Jacopo's intention, embody his vision, and have quite properly been understood as having been of interest to Michelangelo, who not only directly quoted them, but perhaps was inspired to include prophets and sibyls in the context of Old Testament histories by Jacopo's example.

In seeking to identify the hands of specific assistants who may have executed one or another of the prophets, we should bear in mind that not a single one of these workers had a significant career outside of the shop; we must assume that Jacopo was "responsible" for all of the busts, although many passages, and a few of the busts, were handed over to the shop people *in toto.* The most persuasive evidence for treating the prophets as largely by the artist is the high degree of lively, prophetic expression and profound inner intensity they communicate, emphasized by the attention given to the heads and the brows of the figures.

THE PROPHET BUSTS FROM THE LEFT PILASTER

Reading from top to bottom, that is, the way the outer pilasters are arranged, prophets 2, 7, and 9 on the left embrasure are the most inventive and reveal the most skillful carving (figs. 118, 123, 125).[147] The second prophet turns fixedly upward to his left so that his face is in profile while the body is seen full front. His left hand crosses over the front of the body in an opposing movement to the ribbon, which continues behind and fills the otherwise empty space at the upper left. A huge knot of drapery on the exposed shoulder echoes the action within the figure, accentuating surface activity. Prophets 7 and 9 are variations of the same youthful type, with rich locks of hair. Prophet 7 has his head thrust backward, while the hair flows as if blown by wind in the direction opposite to his glance. His hands are locked into position on an axis with the head, operating to stabilize the figure's activated movement. Prophet 9, which inspired Michelangelo for his *Joel* on the Sistine ceiling, is similar in pose, but the axis

146. See C. Volpe, "La Pittura Gotica: Da Lippo Dalmasio a Giovanni da Modena," in Fanti et al., eds., *La Basilica di San Petronio,* 1:213–294, especially pp. 220–221.

147. Matteucci (*La porta magna,* p. 50 and note) considers prophets 6, 7, 8, and 9 to be by Jacopo della Quercia unassisted; she apparently follows Foratti ("I profeti"). See also Bellosi's discussion of the prophets ("La 'Porta Magna,' " 1:182). Bellosi has also pointed to relationships to the basement reliefs as well as to those by Giovanni da Modena, as Jacopo's sources.

has been shifted to the left, with the attention focused on the forehead; the head is tilted to the right for balance.

Prophets 1 and 8 are closely corresponding bearded types (figs. 117 and 124). Prophet 1 certainly reveals the master's full participation in the execution, and served as the basis of prophet 8, which was largely carved by an assistant. Prophet 3 is a related type, with the head turned to the right and slightly upward. Prophet 5 and 6 are not particularly striking in terms of the execution, nor have they the same expressive qualities of most of the others, so that significant participation by *garzoni* must be assumed, although 5 is the finer of the two (figs. 120, 121). Prophet 4, in complete profile, has an antique flavor and may be related to a Victory from a Roman sarcophagus, a prototype used by Nanni di Banco for several angels on the Assumption relief on the Porta della Mandorla.

PROPHET BUSTS FROM THE RIGHT PILASTER

At least six prophets on the right pilaster reflect heavy shop participation: prophets 1 (fig. 126), 2 (fig. 127), 3, 4, 5 (fig. 128), and 7. Prophet 9, Jacopo's "Zuccone," seems mostly by the master, but the dull surface and the monotonous curling of the ribbon could hardly have been his.[148] The two "autographs" on the right, then, are numbers 6 (fig. 129) and 8. In trancelike meditation, prophet 6, with Oriental features and sporting an unusual hat, holds a wide scroll.[149] The exotic aspects of the invention recall the fantastical imagination of Giovanni da Modena. Prophet 8 is a handsome youth with a rounded face topped with thick, rather closely cropped hair, in a more relaxed pose than many of his fellows, with merely the slightest shift of the body; he is closer in spirit, at least, to the busts on the *Trenta Altar*.

By way of summary, the busts that I consider to be by Jacopo della Quercia virtually unassisted are, on the left, numbers 1, 2, 7, and 9, and on the right, numbers 6 and 8. All of the others have a significant degree of studio participation, although that participation varies from case to case. On the other hand, the overall responsibility for the entire group was Jacopo's; he must have designed them all and supervised most of the work on them. They are stylistically and chronologically akin to the five prophets on the *Baptismal Font,* which have been preserved in far better condition, due, of course, to having been indoors. In position and in movement, the *Portal*'s prophets connect the Old Law, as exemplified on the outer pilasters, with the Genesis reliefs, and the New Law with the New Testament reliefs on the lintel.

One other aspect of this stage of work needs to be mentioned, the carvings

148. Bellosi ("La 'Porta Magna,' " 1:182) has prophets 1, 2, 3, and 4 as shop works, and 8 and 9 as collaborations between the master and the shop; the others, 5, 6, and 7, he has as Jacopo's.

149. Both Foratti ("I profeti") and Matteucci (*La porta magna*) agree that prophets 6 and 8 are by the master; Matteucci also would add 3, 4, and 5, as does Foratti, who also accepts 2.

that appear to support the lintel. The idea of caryatidlike putti (figs. 84 and 85) on brackets harks back, in a context meaningful to Jacopo, at least to the late trecento application on the Porta della Mandorla, but the motif had already migrated to Bologna in a work by Andrea da Fiesole (also known as "da Firenze"), the *Tomb of Bartolomeo da Saliceto* (+1412) in San Domenico (now housed in Bologna's Museo Civico).[150] As types, however, the nude boys also belong to a category Jacopo favored for the friezes of the *Ilaria Monument,* the Child in the *Ferrara Madonna,* and the swag-supporting putti over the angel niches on the *Fonte Gaia.* Even given their structural and visual function of supporting the lintel, Jacopo has instilled a dramatic tension and internal movement within the bodies. They are unquestionably by the master himself; key connecting points in the anatomy are given attention so that the forms are readily comprehended: the turn of the wrist of the right hand of the boy on the left side is visible confirmation of the confidence of the carving. Although these putti are hard to see in place from ground level, they share physiognomical features with the Christ Child who stands on the lap of the Virgin in the lunette, not far away. Their oval heads, puffy cheeks, and fleshy bodies belong to the same Querciesque mold.[151]

The Madonna and Child (1427–1428)

The most ambitious single product of the first phase of Jacopo's activity on the *Portal* was the Madonna and Child in the lunette (figs. 87 and 88). Widely regarded as an unqualified masterpiece of Italian art, the slightly over-lifesize statue dominates the lunette, the portal, and by extension, the majestic piazza before it.[152] After the passage of fully two decades or more, Jacopo's Madonna at San Petronio shares characteristics with the *Ferrara Madonna,* including the robust proportions of the figures and the significant role played by the carefully conceived draperies, which function as a vehicle for the expression. In each of them, Mary is seated securely on a simple bench without arms or sculptured embellishments. But the differences, beyond the sheer size and the type of stone, are striking.

Gazing frontally, the Ferrara Virgin sits erect. An insistent vertical stress within Mary is repeated in the Child. The sharp chiseling renders each detail

150. On Andrea di Guido da Firenze, see the not altogether satisfactory contribution by Bottari, "Per Andrea di Guida da Firenze." An illustration of the tomb is in Venturi, *Storia dell'arte italiana,* vol. 4, fig. 721.

151. For Bellosi ("La 'Porta Magna,' " 1:186), the putti "sono di un'altissima qualità, di una carnosità ed una tenerezza impressionanti, dati la loro struttura corporea erculea."

152. Gnudi's enthusiasm is recorded in a paper, "La Madonna di Jacopo della Quercia in S. Petronio di Bologna." Seymour (*Quercia,* p. 70) calls it Jacopo's masterpiece. It is not especially admired by Bellosi, however, ("La 'Porta Magna,' " 1:208), who thinks that the final execution was late, that is, close in time to the San Petronio. He also finds close connections with Donatello in certain parts of the statue, which elude me.

with the precision of a goldsmith; the polished Carrara marble is treated like ivory. The San Petronio Madonna and Child, in contrast, is conceived as a compact, indivisible unity, in which no single aspect or detail, not even the Child, can be pried loose from the integrity of the whole. The Child and his mother are fused emotionally and physically, establishing the same deeply human relationships that Jacopo created in the Nativity and the Flight on the lintel below. Mary's clothes located behind Christ encapsulate him within her body, operating like an enframing niche. The two images have an urgent presence, although the observer is not permitted to take part in their thoughts but simply participates in their overwhelming forms.

Time and again Michelangelo's solutions are predicted by Jacopo's art: the prophets and sibyls on the Sistine ceiling are one body of examples, but the *Bruges Madonna* provides another. The tiny marble might well be esteemed as an homage to Jacopo's Bolognese Madonna, whose dominant, omnipresent, uninvolved personality remain psychologically aloof, unperturbed by the mundane activities that unfold in the public piazza below. Perhaps the magical formula is achieved through the vibration of the swelling draperies that enwrap the Madonna, juxtaposed to the flesh of the Child. The thick, abundant, but never ponderous or confining material envelops but never overwhelms the woman; it defines rather than hides her body. Contrary to Sluterian solutions, to which Jacopo's treatment here has sometimes been compared, the drapery is never allowed to take precedence over the figure it clothes.

The statue is a blocklike pyramid, with all of the gravitational security offered by that geometric form: irreducible, permanent, ever present, it is hardly any wonder, then, that in later generations, artists such as Leonardo and Raphael will favor such a composition. The base of the statue is somewhat taller than one might expect, but that aspect is not apprehended from the ground level, due to the angle of vision. Within the compositional vise, the sibyline Mary tilts her head as she looks past the active Child on her lap towards the kneeling papal legate (Louis Aleman), whose presence had been called for in the contract of 1425.

Jacopo has moved full circle from his first freestanding *Ferrara Madonna*, which was indebted to the medieval classicism of Nicola Pisano and especially Arnolfo di Cambio, to an early experience with Giovanni di Ambrogio, and to a direct rapport with the spirit of antiquity. Less dependent upon his progressive Florentine contemporaries, with whose works he was by the 1420s (if not before) quite familiar, Jacopo offers here a viable and influential alternative.

THE *BAPTISMAL FONT* SCULPTURE IN SIENA (1427–1430)

Jacopo's contribution to the *Baptismal Font* in Siena was contemporaneous with the first phase of work on the Bolognese *Portal of San Petronio*. He had

been allocated responsibility for the upper section of the *Baptismal Font* when the decision was made to expand the program in June 1427 (doc. 187). As part of being thus in a position to employ his Florentine friend Donatello, Jacopo not only designed the new elements himself but actually carved five relief prophets in niches for the "tabernacle" as well as the independent statue of Saint John the Baptist surmounting the monument. He also tardily contributed his one bronze relief of the Annunciation to Zacharias in the Temple at this time (fig. 136).

The Design (1427)

When he was given responsibility for the portion of the *Baptismal Font* above the basin, which Ghiberti had devised a decade before, Jacopo projected a portentous pier emanating from the center out of which opens an hexagonally shaped tabernacle, with five marble prophets in niches and the Madonna and Child, which formed a *sportello* (little door) where the holy oil was kept.[153] Six little marble pediments alternating with bronze music-making angels comprise the next level, which is marked off with a cornice. A domelike enclosure terminates this portion of the tabernacle, from which emanates a tall hexagonal pier composed of paired pilasters with a heavily projecting cornice which, in turn, constitutes the base of another pier that supports the statuette representing Saint John the Baptist.

There has been speculation concerning the identity of the designer of the upper portion. Since many Florentine elements associated with the Donatello/ Michelozzo shop have been isolated, especially those related to the *Tomb of John XXIII* in the Florentine baptistery but also the handle of the staff held by the saint in *Saint Louis of Toulouse* (Museo, Sta Croce, Florence), a serious role for Jacopo has been excluded. The design instead has been ascribed to Pagno di Lapo, a Donatello *garzone*, known to have been active in Siena on the *Fonte*. But the design should be assigned to Jacopo himself, as Paoletti has maintained.[154] One can hardly doubt that Jacopo had chosen a mode that was familiar to him through Donatello and the Florentine events of the 1420s. But he combined it with the experience of the medieval baptismal font in San Frediano (Lucca) for the broad outline of the idea, which he "modernized." The design, which indeed lies somewhere between the new revival idiom and the traditional Tuscan usage, well illustrates Jacopo's style as a whole. Although the effect of his art was as progressive as that of his famous contemporaries, his approach was inevitably more oblique. In the conception, ample oppor-

153. On the oil presumably kept there, see Lusini (*Il San Giovanni di Siena e i suoi restauri*, pp. 31–33), and on the entire question of the interpretation of the tabernacle element, see Paoletti, "Il tabernacolo del Fonte Battismale e l'iconografia medioevale."

154. Paoletti, *Bapistry Font*, pp. 94–95.

tunity was reserved for sculptural decoration in which Jacopo himself and Donatello had room to participate, including the influential small bronzes. Jacopo could have easily assigned to himself some of these winged putti, had he so chosen. Instead he elected to execute only the portions in marble, his preferred medium. Perhaps this self-exclusion is symptomatic of an unease with bronze casting, also demonstrated by the Zacharias relief. But Jacopo did reserve for himself prominent exposure for both carved reliefs and an independent statue.

The niches themselves are ingeniously designed, crowned by halolike eleven-lobed shells at the head, with ribs functioning like rays of light. Each niche appears to be scalloped out of the central mass, leaving a curved space, while a simplified border encloses the entire unit; they are not unlike the original shallow niches that housed the seated evangelists on the Florentine cathedral.[155] Each niche, in turn, is defined by pilasters.

To complete the hexagonal system the sixth relief, which was reserved for a Madonna and Child, was assigned to Donatello: his bronze plaque was rejected by the Operai and replaced, presumably by the more conventional one by Giovanni di Turino still on the monument.

The Prophets (1427–1429)

The prophets (figs. 137–141), which must be understood stylistically within the chronological context of contemporary work in Bologna, have their direct counterparts in the eighteen busts on the embrasures of the *Portal,* although here they have grown into full-length relief figures carved from Carrara marble, not Istrian stone. Four of the five are autograph works executed between 1427 and 1429 by the master; the exception is the King David, which appears to be by an assistant (Pietro del Minella?).[156] Only here is there a certain lack of

155. See Florence, Biblioteca Laurenziana, Edili 151, fol. 7v (Francesco d'Antonio del Cherico, Antifonario) with a curved unbroken frame within which an opening is achieved, and with a shell motif above, with the "ribs" fanning outward. The system, which becomes canonical, may have been invented by Brunelleschi, presumably between 1410 and 1415, when it may be conjectured the niches were built. For problems surrounding the niches see A. Rosenauer, "Die Nichen für die Evangelisten-figuren an der Florentiner Domfaçade," in S. Bertelli and G. Ramakus, eds., *Essays Presented to Myron P. Gilmore* (Florence, 1978), 2:345–352. Ghiberti's system, which has been traced back to Orcagna, has the "rays" coming downward. See G. Brunetti, "Ghiberti orafo," in *Lorenzo Ghiberti nel suo tempo,* 1:123–244.

156. Seymour (*Quercia,* p. 66) does not rule out the participation of assistants, but suggests that Jacopo was responsible for the greater part of the execution of the prophets. The most detailed study of the prophets is that of Paoletti, *Baptistry Font,* pp. 160–171. He sees assistants' participation particularly in the prophet shown in profile (no. 4 in Paoletti), which he associates tentatively with Francesco di Valdambrino (p. 168), and he finds certain similarities with the King David. Paoletti has made the fascinating observation that the head of the profile prophet is a replacement, perhaps due to an error or damage while the piece was being carved, according to Seymour (*Quercia,* p. 66). The author of the entry on the *Font* in *Jacopo della Quercia nell'arte del suo tempo* (d.c.g.) observes: "I Profeti nelle nicchie . . . sono quasi interamente di Jacopo; il tentativo di riconoscervi diversi mani, oltre ad essere infruttuoso è anche inutile, data l'alta qualità dell'insieme" (p. 180).

convincing three-dimensional form, and the harsh facial expression as well as the shallow projection is inconsistent with the other reliefs.

The insistence upon variety of types and poses among the Bolognese prophets is also found on the *Font:* here are figures old and young, bearded and clean-shaven, with faces turned upward or to the side. But direct echoes of types are not easily identified. The *Font's* "profile" prophet seems to have a relationship with prophet 5 on the left side of the *Portal,* and the Sienese "bearded" prophet, sometimes linked with Donatello's Abraham or even his *Saint John the Evangelist,* is related to several prophets in Bologna, especially prophet 3 on the left. The standing full-length figures operate quite differently for the spectator from the busts in the *Portal* because of their more prominent position, slightly above eye level in the baptistery.

By establishing excitement and participating in the smooth flow of light on the highly polished surfaces, the undulating drapery is a major expressive component of the prophets, as it is for the Madonna in the lunette of the San Petronio portal. As in Bologna, the articulation of the hands and their tense interrelation are remarkable. Several have big unrefined hands, similar to Joseph's from the lintel reliefs at San Petronio, while others have more elegant forms, typical of the Virgin from the same place. In other words, the different treatments are not the function of lesser or greater ability between master and assistants, but one of variety, meaning, and expression.

Saint John the Baptist (1428–1430)

If four of the five prophets may be regarded as by Jacopo himself, criticism devoted to the *Saint John the Baptist* has stimulated little enthusiasm (fig. 135).[157] Surmounting the monument, which is not actually in the middle of the space but pushed toward the altar, the Saint John is a worthy counterpart if not an equal to the Madonna from Bologna. His aloof demeanor, the certainty of mission, and the visionary, prophetic quality imbued into the figure are affirmed by the enlivened draperies. Broad, slow-moving forces are established and countered in Jacopo's conception, in which the detailing is reduced to a mini-

157. Bacci (*Jacopo della Quercia,* p. 68) doubts that the Saint John is an autograph. Paoletti is very positive, however, finding here "Quercia's ability to infuse monumental and heroic figures with the sense of divine revelation" (*Baptistry Font,* p. 171. A more tentative Seymour (*Quercia,* p. 66) gives the execution "largely, if not entirely" to Jacopo, pointing out the importance of observing the work from the correct position down below. Unquestionably it would be rewarding to see the Saint John close at hand following a good dusting.

The figure had impact on Francesco di Giorgio's *Saint John the Baptist,* the polychromed wood statue in the Museo dell'Opera del Duomo in Siena, datable to 1464, and seems to have been something of a model for Niccolò dell'Arca's *God the Father* in the Arca di San Domenico in Bologna, which serves a similar crowning function. (Precisely how Niccolò dell'Arca became acquainted with the statue in Siena is quite another matter, however!) In terms of contemporary sculpture, an analogy to Michelozzo's over-lifesize Blessing figure for the *Aragazzi Monument* in Montepulciano should be considered.

mum in favor of subtle indications suitable for the statue's distant location, rather small size (hardly 80 cms. high), and dark environment. Only a tiny portion of John's characteristic hair shirt is visible beneath the great swags of cloth that cover the body.

The Annunciation to Zacharias in the Temple (1428–1430)

Among the sculptures Jacopo made for the *Baptismal Font* in the 1420s, the Annunciation to Zacharias in the Temple (fig. 136) is the most difficult to accommodate, although the physiognomic type adopted for the patriarch is akin to prophets 1 and 9 on the right pilaster of the San Petronio *Portal* and to the bearded prophet on the *Font*. It is the same type Jacopo will use for God the Father in the *Portal*'s Creation of Adam and Creation of Eve, as well as for the Abraham in the Sacrifice of Isaac. But there is a real problem in determining exactly how Zacharias is posed, or rather how his pose functions. The upper part of his body is in profile, but the legs are seen in full front, and the left leg, the free one, which is held rigidly, comes forward without apparent motivation. Perhaps Jacopo had technical setbacks, for as far as we know he had not worked in bronze since the competition of 1401, more than a quarter-century earlier, if indeed he actually cast his model at that time (which is unlikely).

The angel too is posed inexplicably, demonstrating that Jacopo had difficulty in spatially integrating the two figures with the altar. Jacopo did not follow Donatello's example, which was actually available as a model for him, since he began the Annunciation to Zacharias after Donatello had delivered his finished panel, as Turini and Ghiberti had theirs. In what must have been a conscious choice, Jacopo failed to organize his relief within the context of the new perspective: quite to the contrary, here and elsewhere in his art Jacopo continued to operate within the pragmatic spatial approach evolved by early trecento masters, the approach of Giotto, Simone, and the Lorenzetti. His expressive requirements and the central function of the figures have precedence over the space in which they operate.[158]

Jacopo's bronze relief has less projection than those of the Turini and Ghiberti, but somewhat greater projection than Donatello's *schiacciato* technique. A gradual diminution of projection between the figures close to the surface, who are rather fully modeled, and those deeper in space can be discerned. The two distant figures shown in profile beneath the left arch are rendered in a very subtle low relief, which might recall Donatello. But the same device is found earlier in Jacopo's own Martyrdom of Saint Ursula and Martydom of Saint

158. Jacopo's treatment was not lost on Sienese artists, as Pia Palladio has pointed out to me; Giovanni di Paolo used it for the *Annunciation to Zacharias* now in the Lehman Collection. See also J. Pope-Hennessy, *Giovanni di Paolo*, (New York, 1938), pp. 24–25 and "Giovanni di Paolo," *Metropolitan Museum of Art Bulletin* (Fall 1988), p. 20.

Lawrence from the *Trenta Altar* predella.[159] The statuettelike figure on the right of Jacopo's relief is analogous instead to the person in profile on the extreme right in Ghiberti's *Saint John Before Herod.*

The group of five characteristically Querciesque onlookers at the left offers the most satisfying aspect of the relief. Balanced by the single regal young man with his left hand tucked into a belt at the hip, they are rather blunt, awkward, simple folk, all turned in the direction of the altar.

THE *PORTAL OF SAN PETRONIO* IN BOLOGNA: SECOND PHASE (1429/1430–1438)

The second stylistic phase of Quercia's Bolognese activity, which coincides with the last decade of his life, is highlighted by the ten Genesis reliefs and the San Petronio from the *Portal* and the *Budrio Tomb;* these efforts represent his final manner. Although Jacopo at this point was not, strictly speaking, old, and thus they do not exhibit a true "old age style" like that of the late Donatello, Titian, or Michelangelo, these sculptures present Jacopo at about fifty years of age and after, and constitute his last works as a sculptor.

The first phase in Bologna, from 1426 until the fall of 1428, a period introduced by the *San Gimignano Annunciation,* was an extremely intense one for the sculptor, with demands to move ahead in Bologna and at the same time to complete the *Baptismal Font* in Siena, which continued to occupy him until 1430. In the second phase, datable from 1429/1430 to the end of Jacopo's life, which falls into the third decade of the quattrocento, neither an abrupt change of direction nor a renunciation of what he had done previously can be pinpointed. Rather, the period was one of consolidation of technical achievements and expressive integrity—a firming up of what had already been announced. On the other hand, the subject matter that remained to be treated, especially the Old Testament histories, were especially suitable to his evolving figurative idiom, and they mark the highest achievement of his art. Perhaps instrumental in leading some critics (especially Gnudi and Bellosi) to a different conclusion is the unstated assumption that the late works, virtually by definition must reveal something of an artistic decline; seeing weaknesses in the Life of Christ reliefs on the lintel, they assume that they must be, in fact, later than the Old Testament scenes, which all agree are undoubtedly majestic. They are, if anything, more satisfying because of the psychological issues confronted and because of their prominent position, readily on view for the public and for Jacopo's fellow artists. Furthermore, the taller-than-wide field was a more harmonious format than that on the lintel.

159. According to Paoletti (*Baptistry Font,* p. 98), although Jacopo turned repeatedly to Donatello, the only direct quotation was the viol player from Donatello's *Feast of Herod,* for the strongly classical right-most head in profile under the left arch.

Old Testament Reliefs

The ten reliefs on the pilasters at the exterior face of the portal are rendered in much lower relief than those on the lintel, and they are different in format, higher than wide, which offered Jacopo an opportunity to give his figuration greater predominance in the composition. In these works, he demonstrated such a thorough control over the technique of stone carving that even the slightest hint of undercutting was sufficient to imply convincing form; to think of them as specifically "pictorial," however, as one might describe the *schiacciato* reliefs by Donatello or Desiderio da Settignano, is hardly accurate.

The reliefs, which were carved on separate blocks, were physically the outer face of the pilasters, together with the decorative intermezzi between them. A little shelf at the bottom of each relief has been established, while the matrix of the stone blocks curves outward toward the shelf; hence there is no uniform single ground plane for the relief surface, which in effect bulges out at the bottom. Although already found at the *Fonte Gaia,* especially for the Creation of Adam and the Expulsion, only in the Genesis scenes in Bologna does this system become fully integrated with Jacopo's expressive intention.

The Left Pilaster

THE CREATION OF ADAM

In the Bolognese Creation of Adam (fig. 99), the mound upon which Adam sits is indicated both physically and pictorially. Although inevitably termed the "Creation of Adam," the subject is better understood as a conflation of the Creation and the giving to Adam of the breath of life ("spiraculum vitae") often shown as an independent scene in medieval cycles, and an aspect of Michelangelo's *Creation of Adam,* as Tolnay has observed.[160] This motif is depicted in the Old Testament cycle by Bartolo di Fredi from the mid-trecento in the Collegiata of San Gimignano, near to where Jacopo's *Annunciation* was placed. Also implicit in Jacopo's relief is the warning not to eat of the Tree of Knowledge of Good and Evil ("ligno scientiae boni et mali," Gen. 2:17). The tree has a prominent place in the composition: God the Father's blessing hand, which is held somewhat differently in the following relief depicting the Creation of Eve, is close to the leaves of the fig, also depicted in the third relief , the *Temptation.*

The compositional relationship between the two figures has been taken over in reverse from the scene in Siena. The pose of God the Father, however, who is identified by the triangular halo, appears to have been adjusted for the portal relief to stand more erectly. Adam, frozen by his gaze upward towards his

160. Tolnay, *Michelangelo,* 2:36.

creator, receives the power of life through the blessing right hand of God, who holds voluminous draperies with his left hand. The rocky outcropping upon which Adam sits and Adam himself are treated similarly, as if to remind the viewer that the first man was created out of earth. His pose, used again for the drunken Noah on the other pilaster, is of antique origin, but had already become commonly used by Italian artists.[161] Adam's right hand is held with the palm outward, perhaps an allusion to the Second Adam and his crucifixion, since the gesture is central to the composition. The outstretched left leg is firmly attached to the ground, while the other one has been freed. The carving of details is so economical that the head of God the Father and Adam's broad torso are flattened out parallel to the plane of the relief; Adam's smallish head is turned sharply, in profile.

The smooth nude flesh of Adam acts to counterbalance the undulating draperies of the Creator. Despite exaggerations and liberties taken with Adam's anatomy, the result is physically convincing.

THE CREATION OF EVE

The sleeping Adam in the *Creation of Eve* (fig. 102) is physiognomically akin to the same figure in the previous scene; he is a robust, muscular youth first found in Jacopo's *oeuvre* in the Martydom of Saint Lawrence for the *Trenta Altar* and seen to a certain extent in the angel of the Expulsion from the *Fonte Gaia* (figs. 35 and 55). Adam's massive shoulders and biceps, the motif of his legs placed closely together, specifically recall the Saint Lawrence, although now the rapport between the head and the body is less awkward. The scene is devoted to the interaction of God the Father with Eve, with Adam's role decidedly secondary.

The facial features of the Creator, again punctuated by a triangular halo above his head, are related in type to several of the prophet busts as well as to Zacharias in the Annunciation relief. Standing erectly, he draws Eve up out of Adam's side. Eve, who is also shown in a forcefully oriented vertical pose, recalls earlier Querciesque types, including the heavy-hipped, small-busted Ursula from the *Trenta Altar* predella, although Eve is more graceful. In profile, she is intently engaged in studying her own hand, as if not quite sure how it functions or what it is for, while the all-knowing God also concentrates on the same hand, the instrument of the Fall depicted in the following scene.[162] The

161. Janson (*History of Art,* p. 312) associates the Adam with the Adam found in an ivory diptych *Adam in Paradise* in the Bargello, Florence, which dates from the end of the fourth century. Not only is the pose close to Jacopo's Adam, but the summary modeling, the schematic simplification in the definition of the torso, the large feet and hands, and most symptomatic of all, the flatness of the surface of the torso and the relation of the figure to the ground have analogies to the other Old Testament reliefs as well.

162. Seymour (*Sculpture in Italy*) has also remarked on Eve's intense preoccupation with her own hand "by which, as a human, she must learn to make her way in the world" (p. 85). The concentration,

tree behind Adam is more feathery than the one in the previous scene, seeming to echo the more elegant though still athletic body of Eve nearby. In the first four reliefs from the left pilaster the sexual organs of both Adam and Eve are liberally displayed.

THE TEMPTATION AND FALL

The first man and woman stand side by side on a rough patch of land flanking the Tree of Knowledge (fig. 104). In the distant background the silhouettes of huge mountains can be detected. The lower portions of the bodies of Adam and Eve are identical, but as they turn towards each other the tilts of the heads and the contours of the necks and shoulders become mirror images. Within this complex interaction of repetition and balance differentiation is established primarily by means of gesture, the position of the hands, and the overtly explicated sexual distinctions. Eve is all women, Woman; Adam all men, Man; and together they share in the consequence of taking the fruit. Eve holds a fig in her right hand, similar to several nearby on the tree from which this one has been plucked, her head turned down, her eyes either closed or nearly closed, as if to deny her act. On his part, Adam, whose head is in insistent profile, turns angrily toward Eve with a fiery *(terribile)* stare. His right hand has the open palm flat against the trunk of the tree; his left hand not so much covers as it calls attention to his genitals. A thick-bodied serpent with a human head rather like Eve's looks intently past the fig in Eve's hand to gaze at Eve herself.

The narrative is ingeniously energized by glances and gestures: Adam demonstrating his genitalia with one hand and thrusting the other against the tree as a prediction of the crucifixion of the Second Adam, the closed-eyed Eve loosely fondling the fig with its inherent sexual symbolism, the harsh glances of Adam, and the serpent.[163] The smooth, sensual nude bodies that occupy most of the height of the relief represent the culmination of Jacopo's genius as an artist, with a unblemished synthesis of form and expression. Nothing of the period surpasses the power of these nudes except perhaps Masaccio's Adam and Eve of the Expulsion.[164] In terms of his own work, the figural types are similar to those found in the previous two scenes and have the same origins, although in this case the intensity of the theme has charged the relief with even greater impact.

as I see it, underscores the theme of disobedience and redemption of the entire portal, as discussed in my *Il portale.*

163. I sought to unravel the iconography of the portal with particular attention to this relief in *Il portale,* pp. 63–78, and my conclusions are summarized in catalogue 12, below. See also L. Steinberg, *The Sexuality of Christ in Renaissance Art and in Modern Oblivion* (New York, 1983).

164. In contrast to Bellosi, I see little connection between Jacopo and Uccello.

THE EXPULSION

For the Expulsion relief on the Bolognese *Portal* (fig. 106), once again Jacopo refers back to the earlier composition of this scene at the *Fonte Gaia*. The firmly implanted expelling angel virtually replicates the earlier figure, including the configuration of the drapery, although on the portal his head is in sharp profile.[165] The conception of Eve also follows the previous Sienese version, but her gesture has been transformed from one of rather meek acceptance to coquettish, almost mocked, shame. The most significant deviation from the *Fonte Gaia* composition is found in the interpretation of Adam, who in the Bolognese relief offers a stubborn resistance to the angel by raising his powerful arms in defiance.

Jacopo has formulated a fascinating pattern of repetition and divergence in the pose of Adam and Eve, more complicated still than was the case with the Temptation (fig. 104). The action and silhouette of Adam's right leg is echoed by Eve's left leg and conversely, Adam's left leg has the same pose as Eve's right one. The bodies of both figures are placed obliquely in the shallow space, the arm movements give them variety, as does the distinctive conception of the male and female bodies. Jacopo has rendered the Gate of Paradise as a rectangular structure with a well-articulated lintel, not unlike the actual portal upon which the relief is applied, although the Gate is without narratives. Since the angel is larger than the opening of the gate from which he has exited and is conceived in the same proportion as Adam and Eve, the effect is to give the corporeality of all three figures a dominating presence.

Adam's intense expression is much the same as that found in the previous scene, and once again may be understood in the context of *terribilità* usually applied to Michelangelo: this time he confronts the angel, who has a similar fiery determination. Adam and Eve on the right half of the relief are isolated by the barely delineated mountain behind them, implying the hard life that will come. The power of the relief rests in part, beyond the effective psychological interpretation, in the juxtaposition of the completely nude actors with the partially clothed angel, whose garment has an undulating surface that is set against his own smooth flesh and that of Adam and Eve.

ADAM AND EVE AT WORK

The final subject on the left pilaster is Adam and Eve at Work (fig. 109), following their expulsion from Paradise, when they are left to their own devices. Jacopo depicts the progenitors unclothed except for bits of drapery that almost by chance cover their genitalia. While the nudity is appropriate for the first

165. P. Frankel ("Die Italienreise des Glasmalers Hans Acker") shows that the motif in Jacopo's relief was soon carried north. Bellosi ("La 'Porta Magna,' " 1:190) has signaled medieval prototypes for the action of the angel.

three narratives, in the Expulsion one normally finds the protagonists at least covered with leaves, in the Work, they are usually crudely though fully dressed, as Ghiberti shows them on the *Doors of Paradise*. Jacopo, it seems, when he had a choice, preferred to portray his figures nude.

Here Adam is intensely digging with a triangular-shaped spade, a type still used in Italy, while Eve looks on calmly as she holds spinning implements with the finely expressive hands of an accomplished musician.[166] More contrite than in the previous scenes, she watches her husband struggling with the barren, rocky soil. Cain and Abel, shown as lively putti, cling to the leg of their mother, who pays little heed to their antics. The child on the left is once more an example of how Jacopo reused his own hard-won earlier inventions; it is a modification of the child from the Public Charity ("Rea Silvia"). Demonstrating Jacopo's awareness of the rapport between foreground figures and background landscape elements, the feathery tree enframes Adam's head, with the pointed jutting of locks and the flowing cape behind his left shoulder, like a gigantic halo of light. Adam is more subdued as he concentrates on his menial task, perhaps pondering the past and the future.

This and all other reliefs from the left side are autographs, and needless to say, are among Jacopo's finest works, in which conception and execution are uniformly impeccable; the *garzoni* could have had only a minor role.

Right Pilaster

If the reliefs on the left pilaster are universally regarded as by the maestro himself, those on the right pilaster have been judged more severely, with specialists assuming marked collaboration. Some reject outright most of the reliefs as by Jacopo.

Reading from the top downward, we find first two stories dealing with Cain and Abel.

166. Jacopo's digging Adam was the source for Michelangelo's digging Noah in the left background of the Drunkenness of Noah on the Sistine ceiling, according to Tolnay (*Michelangelo*, 2:27), who asserts that Michelangelo first adopted the motif in a drawing (*Michelangelo*, vol. 1, cat. no. 13 and fig. 87). In the drawn image the pose is much revamped, retaining Jacopo's type in the upper torso and arms. To be sure, the connection between Jacopo's figure and Michelangelo's is not always accepted (see, for example, Matteucci, *La porta magna*, p. 59*n*).

Jacopo's figure is reflected in the nearly contemporary fresco on the left wall of the main chapel of the Collegiata at Castiglione Olona, with scenes of Saint Lawrence, attributed to Paolo Schiavo and Vecchietta. Another typically Querciesque motif is found on Masolino's Banquet of Herod in the same place, which is part of the frieze of putti on the building at the left, pointed out to me by Richard Fremantle. Apparently the work here seems to date from after 1432; see T. Foffano, "La construzione di Castiglione Olona in un opuscolo inedito di Francesco Pizolpasso," *Italia medievale e umanistica* (1960), 3:169). See also E. Cattaneo and G. A. Dell'Acqua, *Immagini di Castiglione Olona* (Milan, 1985).

CAIN AND ABEL OFFERING

Cain, whose burning offering on the altar is shown being rejected (fig. 110), arrogantly stands in a pose dependent upon Adam of the Temptation, but reversed. Dressed in a heavy drape that cascades about his shoulders and around his hips, Cain places his unelegant left hand, which is on the central axis, beneath his offering. For his part, Abel in profile kneels reverently on the rocky terrain. The blessing hand of God in a segmented disk, also on the central axis, accepts Abel's flaming offering. More of Abel's body is exposed than his brother's, as if to underscore the divergency between the two, who differ in almost every respect, to the extent that Cain wears open-toed leggings while Abel approaches the Lord's altar barefooted. Hand gestures function to define the artist's interpretation: Abel's clasped hands, God's blessing hand, and Cain's gnarled left hand with its thumb pointing downward. If the language of these figures continues to be entirely Querciesque, the standard of execution is inferior to that established in the previous five histories. The youthful head of Cain, with a high forehead and flat nose, is typologically close to prophet 2 on the left and prophet 5 on the right.

CAIN MURDERING ABEL

In the following scene, Cain Murdering Abel (fig. 111), Cain coils his whole body in preparation to deliver the death blow with a menacing club, in what is symbolically the world's first murder. Abel, sitting upright on the ground with legs crossed weakly, raises his left arm in a ritualistic gesture of defense, his open hand flattened out parallel to the surface of the relief.[167] The figural pose is a version, in reverse, of a common one from antiquity, but Jacopo's adaptation appears closer to the medieval variations by the Pisani and particularly Arnolfo di Cambio, from the base of a fountain in Perugia (Museo Archeologico). Massive barren mountains punctuated by a single tree, all rendered in a very low projection, function to isolate one figure from the other in the landscape. The pasta-like draperies worn by both brothers, especially those of Abel, are signals of considerable collaboration here too. In this case the conception is more majestic than in the Cain and Abel Offering, but the actual facture is imperfect. The heads, which demonstrate a decreased three-dimensional conviction in comparison to those on the other pilaster, are so severely damaged that little can be said of their expressive effect or the quality. The head of Abel, if anything, relates to prophet 9 on the left. Everything points to the need to separate the greater part of the execution of this as well as the previous relief from Jacopo della Quercia's own hand.

167. For a closely related pose, see O. Brendel, "A Kneeling Persian: Migrations of a Motive," in D. Fraser, H. Hibbard, and M. J. Lewine, eds., *Essays in The History of Art Presented to Rudolf Wittkower* (London, 1967), pp. 62–70.

NOAH LEAVING THE ARK

Not only of higher quality than the two Cain and Abel reliefs, but of deeper complexity and invention, the Noah Leaving the Ark (fig. 112) has nearly the entire composition filled with human figures or animals; it is the most crowded panel of the portal. Actually, however, only two human figures, one of the animals, and a few birds are shown in their totality; the remaining images are merely indicated by their heads. Noah, who dominates the scene, is a type encountered already in Jacopo's *oeuvre,* especially among the prophets (left pilaster, 3 and 6; right pilaster, 2) and the Old King from the Adoration of the Magi. His powerful, expressive, blocklike hands, clasped in prayerful thanks for deliverance, contrast with the more refined hands of his handsome young son Shem standing nearby, whose facial type is related to several of the young prophets on the portal (especially prophet 5 on the left). Shem's pose is derived from Adam's in the Temptation, or at least they are both based upon the same idea; unlike Cain, he is integrated into the scene with deep understanding of the force of body language, proof that this figure, and indeed the entire relief, one of the most engaging on the portal, was produced by Jacopo himself.

The late medieval zoo of fowl and beasts that has issued forth from the Ark has no particular claim to naturalistic accuracy, and one can never be sure exactly to which species some of them belong. In the Nativity on the lintel, too, Jacopo has offered an example of his handling of an ox and an ass, whose heads are inappropriately similar: without the horns on the ox we would have difficulty in distinguishing them. On the other hand, the juxtaposition of the animals with the family of Noah is another demonstration of the complexities of Jacopo's artistic vision. The animals are strangely anthropomorphic at the same time that the humans, including Noah (compare his head with the lion's), have absorbed animalistic qualities, perhaps from being in close quarters with them for a long stretch.[168] The long-necked birds at the bottom of the composition are among the more naturalistically convincing renderings, a fact which suggests that they were based upon drawings from a pattern book, a practice especially popular in northern Italy but also known in Tuscany (i.e., by Ghiberti). The bird at the extreme right, desperately pecking away at the stony soil, is oblivious to the general excitement.

THE DRUNKENNESS OF NOAH

If the Noah Leaving the Ark is the most crowded of the reliefs, the Drunkenness of Noah (fig. 113) is among the finest. The three primary participants, and the two secondary ones at the back right, interplay by means of their actions, gestures, and glances. Ham, the more erect of the sons, smirks at his fathers' drunkenness and nudity. As a type he is once again a modification of the Adam

168. Tolnay (*Michelangelo*, 2:29) sees the anthropormophic expressions on the animals in Michelangelo's so-called Sacrifice of Noah on the Sistine ceiling as derived from Jacopo della Quercia's treatment.

from the Temptation, although the interaction of the weights within the body is a bit less secure and the drapery bunched upon his left hip functions ambiguously. Shem, who looks back disapprovingly at his cynical sibling, covers his father's shame with a bulky cloth held in both hands. The drunken old Patriarch lying helplessly on the ground, in a variant of the pose of Adam in the Creation of Adam, with his outstretched left leg forming the basis of the composition, is unable to control his head. Unsteady, he looks pleadingly toward Shem. The action unfolds in an arbor of heavy bunches of grapes. One of Noah's daughters-in-law seems to have her eyes closed as if not wishing to see the shameful spectacle, and another diffidently turns away with the same purpose. Jacopo's presentation is a powerful psychological interpretation that treats the old man sympathetically. If the Cain and Abel scenes have considerable collaboration, the more ambitious Noah reliefs are virtual autographs.[169]

THE SACRIFICE OF ISAAC

The final scene on the pilaster is the Sacrifice of Isaac (fig. 115), traditionally a prefiguration of Christ carrying the cross. The naked Isaac, whose robe and bundle of sticks lie on the ground nearby, waits obediently for the crushing blow from the long knife his father has raised against him. At the crucial moment of Abraham's trial, a lithe angel restrains him with his left hand, and with his right gesticulates toward the ram providentially standing nearby. It should be observed that Isaac has his hands clamped together by Abraham's left hand, creating at that point the dramatic center of the narrative from which the action radiates. Although Abraham, based fittingly on the God the Father type from the previous scenes, is almost entirely enveloped by drapery, his left knee has been articulated, serving to explain anatomically the forceful pose. Mainly executed by the master himself, the two figures effectively pertain to Jacopo's vocabulary, although they are not among his finest images. The landscape and the altar have spatial problems, especially with regard to the ram and the figures, who are never clearly located.

San Petronio (finished 1434)

Probably the last sculptural work completed for the portal, the statue of San Petronio (fig. 90) in the lunette, is stylistically the most puzzling image of

169. Bellosi ("La 'Porta Magna,' " 1:212, *n*59, *n*64) has seen connections between Jacopo and Paolo Uccello, especially in the newly discovered fresco in S. Martino Maggiore (Bologna)—for which see C. Volpe, "Paolo Uccello a Bologna," *Paragone* (1980), 365:3–28—dated to the early 1430s on the basis of a date inscribed on the wall. I believe that this *grafitto* is not a date at all and should not be used in trying to establish a viable date. Rather, I propose that the *Nativity* fresco is not by Uccello or by a Florentine painter at all, but should be considered Emilian, dating to the late 1450s or even the early 1460s. Nor do I, in general, share Bellosi's opinion that there was a mysterious connection between Jacopo and Paolo Uccello.

Jacopo's Bolognese efforts. Because it is so advanced, it is not surprising that some modern critics have even ascribed the statue to a sixteenth-century master; the companion Sant'Ambrogio was indeed executed in 1510 by Domenico da Varignana and was carved with Jacopo's San Petronio as a model. It, in turn, has frequently been taken as an original by Jacopo. San Petronio's composed equilibrium sets it apart from the more tense and active figures depicted in the reliefs, making it appear more "modern" than its actual chronological date. Within Jacopo's development, this type of stocky yet relaxed figure with an easy contrapposto and comfortable posture has ancestors, including the much mutilated standing angel on the Virgin's left from the *Fonte Gaia* in high relief, the angel from the *Annunciation* at San Gimignano, and the Madonna and Child for the same Bolognese location.

The Florentine cycles of free-standing figures, though made for niches for the south flank of the cathedral, for the campanile, and for the tabernacles of Orsanmichele, may seem like fruitful places to seek out the ambience for Jacopo's San Petronio. Yet marbles by Nanni and the others and Ghiberti's bronze figures seem to have specifically spoken to Jacopo. Perhaps an accommodation to the *Saint Mark* of his friend Donatello, of two decades earlier, might be singled out. But the spirit of Jacopo's statue is quite different, more reposeful, less self-conscious, more in harmony with itself. Even the "Zuccone," probably from 1423–1425, and the *Habbakuk* of, perhaps, 1427–1435, whose style is marked by an excited drapery style, offer few deep insights into Jacopo's figure; nor, for that matter, does the intrusion of a discussion of Sluterian or Burgundian elements, as has sometimes been suggested.

Standing confidently on the solid base that has been carved from the same block, the bishop saint and patron of Bologna, who died in 450, holds the city with his right arm as he looks out over the main square. His compact, sturdy body is only slightly enlivened by the action of the raised left leg, revealed purposefully from the drapery to help define the pose. His short cropped beard and intense but benign expression can be associated with several of the figures in the reliefs, especially the Saint Joseph on the lintel, although as a free-standing figure the San Petronio presents itself with a more demanding presence. If the type can be associated with the Joseph, an effective stylistic concordance must also be sought in the Old Testament reliefs, including the God the Father both in the Creation of Adam and in the Creation of Eve, who offers close parallels to the San Petronio. Probably this progressive figure was attained by Jacopo, not by mining antiquity, medieval sources, nor even his progressive Florentine contemporaries. Instead he seems to have achieved it through an internal process, as it were, from his own figurative statements among the reliefs. The drapery cascades down, especially on the left side, forming a vertical movement as well as a strong central core that was visually if not physically necessary to stabilize the weight. Once again, Michelangelo can help interpret Jacopo's figure, since he paraphrased it, in reverse, for the statuette of the same saint for the Arca of San Domenico in Bologna.

THE *TOMB OF ANTONIO BUDRIO* (CA. 1430–1435)

Located in a corridor between the church of San Michele in Bosco and the hospital of that institution is the tomb slab effigy of Antonio da Budrio (fig. 130) the only other Bolognese work besides the portal sculpture that can be confidently ascribed to Jacopo without qualification. A stylistic reading confirms the partial and second-hand documentation, which provides the date of 1435, related to the final touches on the slab. The commission must have come somewhat earlier, however, if we use as a standard of judgment Jacopo's established habits together with the style of the relief itself. The main motif of the rather elaborate architectural setting for the figure is a Gothic arch supported by twisted colonettes. Enframing this figure is a surround composed of pilasters, only partially visible with the modified architrave above. The head rests upon a tasseled pillow, while at the feet is a large tome, his professorial attribute. Although the marble has been consumed, especially around the face, hands, and the edges of the garment, the figure remains readable, and distinctly echoes the tomb effigy of Lorenzo Trenta in San Frediano. The *Tomb of Antonio da Budrio* has the same controlled seriousness and composure of the *San Petronio,* and the proportions within the body are analogous, as is the structure of the facial features. With the exception of the draperies on the lower portion of the effigy,[170] the work is by the master himself and should be regarded as Jacopo's ultimate solution for the slab tomb, as the San Petronio is his ultimate solution for the in-the-round statue.

CONCLUSION

In his maturity Jacopo fed lustily upon his own previous inventions, those enunciated in the *Ilaria Monument,* the *Fonte Gaia,* and the *Trenta Altar* predella, from which he adapted and modified ideas for application to the Bolognese *Portal.* Where in the earlier examples his inventions had been for the most part essays of a type or a pose, later they became thoroughly integrated into his art, accruing a combined expressive and iconographic force. From the *Fonte Gaia* he readapted the Creation of Adam and the Expulsion of Adam and Eve from Paradise for the *Portal of San Petronio* compositions, although the interpretations were modified substantially due at least in part to the different formats, round-topped vs. rectangular, and the flatter relief style he employed on the Bolognese portal. From the *Trenta Altar* predella he adapted the physical type of the Saint Lawrence and his two tormentors, which was transformed into the Querciesque norm, signifying a marked departure from the images on the main section of the altar. Lawrence on the griddle became the sleeping Adam of

170. Seymour (*Quercia,* p. 74) sees that "bottega work is evident" in the tomb.

the Creation of Eve, with an interim appearance as the Mary in the Nativity on the lintel. The general who orders Lawrence's torture belongs to the same company as the seated Jerome of the same predella, who was the figural ancestor of Herod in the Massacre of the Innocents in Bologna. Joseph's gait in the Flight Into Egypt had been devised for the child on the left side of the Miracle of Saint Richard, which, in turn, recalls the child beneath the Divine Charity ("Acca Laurentia") from the *Fonte Gaia*. The type recurs in the child beneath Eve from Adam and Eve at Work on the Bolognese *Portal*, although turned into profile. In the case of this figural invention, one can move back to the first phase of Jacopo's art, to the *Ilaria Monument:* the putto on the north flank turns to his left, raising the right leg, and his left arm thrust across his body.[171]

The effective, forceful contrapposto of Adam from the Temptation can be isolated already among the putti from the *Ilaria Monument,* especially the second one from the south side, except that the arrangement of the arms is reversed. And the youngest king in the Adoration of the Magi from the lintel, which in turn may be seen in a nearly contemporary figure of King David on the Baptismal Font in Siena, belongs to the same basic model as does the Cain in the Cain and Abel Offering, and both representations of Seth in the Noah reliefs. Even the God the Father from the Creation scenes betrays a similar effective pose, surely rooted, ultimately, in classical antiquity.

In other words, a constant "source," as it were, for Jacopo della Quercia as time went on was his own past achievements, which in a cumulative equation were especially relevant for his work in Bologna.

Another career-long pattern, evident in the course of the present inquiry, is Jacopo's unwavering allegience to the treatment and solutions of Nicola (and Giovanni) Pisano and of Arnolfo di Cambio. Not only were individual compositional and figurative motives consistently adopted by Jacopo, but a common set of artistic preferences was shared with these masters. Jacopo's earliest extant work, the *Ferrara Madonna,* is highly compatible with Arnolfo's art, while the Madonna in the lunette of the *Portal* in Bologna appears to be a logical conclusion of this line of form-making. The Bolognese reliefs, in particular, reveal a persistent, undisguised reverence for the spirit of Nicola ("famoso nell'arte, gradito per ogni opera—è fiore degli scultori e gratissimo fra i buone," according to a contemporary inscription). Like Jacopo, Nicola prized above all the human figure, treated the nude with gusto, and admired the lessons of the ancients. On the *Perugia Fountain,* the reliefs depicting the Temptation and Fall and the Expulsion are on similarly shaped blocks to Jacopo's, while the inherent reductive system links the artists, in distinction to Ghiberti, for example. By leaping backward over his immediate and quite undistinguished predecessors to

171. Apparently the Lucca predella provided Jacopo with his first opportunity to deal with narrative reliefs following the competition of 1401 in Florence, with the exception of the two scenes for the Sienese fountain.

the Pisani, Jacopo operated much the same as had his younger contemporary Masaccio, who turned back beyond his recent past to his kindred spirit Giotto. This skipping over of a generation or two also defines the action of Michelangelo, who appears to have held his immediate precessors such as Verrocchio, Antonio Pollaiuolo, Domenico Ghirlandaio, and even his guide in sculpture, Bertoldo, in relatively low esteem, favoring an earlier generation dominated by Donatello, Nanni di Banco, and Jacopo della Quercia, whose orientation in sculpture was highly compatible with his own.

In addition to the local medieval tradition, Jacopo had an affinity for the more remote past, represented by classical sculpture. The sarcophagus pertaining to the *Ilaria Monument* was after all a restatement of a Roman invention, charged with Roman borrowings not only for the overall concept but for individual figural types, including the garland-supporting nude boys. Jacopo had before his eyes the same body of Roman and Etruscan examples that had triggered ideas among his contemporaries, especially Nanni, Donatello, and Ghiberti, and achieving a rapport with antiquity through both direct contact and less obvious routes.

Figural similarities between the predella reliefs on the *Trenta Altar* and late antique and Early Christian ivories have been singled out in a line of analysis that promises insights, especially because there are also technical correspondences between the Lucchese and Bolognese reliefs and ivory carving. A stylistic shift in Jacopo's art can be pinpointed to the time when the tiny marble reliefs for Lucca were produced (ca. 1420–1422?), and certainly by the time he carved the histories for San Petronio, and may be explained, at least in the form of a postulate, by his continuing admiration for Early Christian ivories and metal work. Some time ago Baroni singled out connections between Jacopo's Bolognese reliefs and the goldsmith's approach, and in particular he pointed to analogies with reliefs on the *Silver Altar of San Jacopo* in the Duomo of Pistoia, which were worked in part by the same masters who produced the *Silver Altar* for the Florentine baptistery.[172] From a technical point of view, the trecento reliefs from both these impressive monuments must have had a strong impact on Jacopo. His reliefs from the lintel of the Bolognese portal, the prophets on the embrasures and the Noah reliefs in particular, seem to encompass features that recall in appearance the *repoussé* technique. The undulating surfaces, especially on the garments, the tubular draperies, the variety in the degree of projection over the relief field, suggest a relationship to this category of relief, in distinct contrast to casting.[173]

172. Baroni, *L'Arte dell'umanesimo*, p. 55. The monument has been carefully studied by Gai (*L'Altare argenteo di San Iacopo nel Duomo di Pistoia*), whose book supercedes all previous studies on the subject. For the Florentine monument, housed in the Museum of the Duomo, see Becherucci and Brunetti, *Il Museo dell'Opera del Duomo a Firenze*, 2:215–228.

173. Both Florence and Pistoia were on main roads leading from Tuscany to Bologna, a road Jacopo traversed frequently, so that he certainly would have known the two silver altars quite well. The relic of Saint James (Major), which was brought from Santiago di Campostella with much ado, was already

The correspondence with aspects of trecento metalwork, undoubtedly a body of material that held meaning for Jacopo, should not eliminate the possibility that he was drawn to Early Christian metalwork objects as well. They appear to have functioned in the evolution of his relief style. For a progressive fifteenth-century artist, Early Christian ivories and precious metal objects would have combined the heritage of antiquity with the authority of Christian themes, encompassing literally the best of both worlds.[174]

Metalwork and ivory reliefs differ substantially in appearance, yet both are reflected in Jacopo's sculpture. In certain cases a *repoussé* source appears more dominant, as in the New Testament reliefs on the lintel, while in others an ivorylike treatment is stronger, as in the Adam scenes. But they need not be considered mutually exclusive, for more often than not echoes of both occur within a single relief field. H. W. Janson has associated Adam in the Creation of Adam with the same personage as represented in an ivory diptych depicting Adam in Paradise (Bargello, Florence) that dates from the end of the fourth century.[175] Not only is the pose close to that of Jacopo's Adam, but the summary modeling, the schematic simplication in the definition of the torso, the large feet and hands and, most symptomatic of all, the flatness of the surface of the torso in relation to the ground plane have analogies to Jacopo's Bolognese reliefs, especially the five panels on the left pilaster devoted to Adam and Eve.

Analogously, the handling of the figure of God the Father from the Creation

famous in Dante's time (see *Inferno*, XXIV, 11), even before most of the decoration was added; and besides its artistic merit, since it is dedicated to Jacopo's name saint we must assume that he had a direct acquaintance with it. Although Nicola Pisano probably did not in fact have anything to do with the Pistoia altar, the earliest portions do reflect his artistic language—see C. Kennedy, "Niccolò Pisano and the Silver Altar at Pistoia," *Art Bulletin* (1958), 40:255—which would have made it all the more appealing to Jacopo della Quercia. The recently cleaned, extremely high-quality reliefs of the four Evangelists (Museo del Duomo) in Pisa sometimes attributed to Nicola Pisano also would have held an attraction for our artist, notwithstanding their tiny dimensions.

174. M. Meiss, in "Masaccio and the Early Renaissance: The Circular Plan," in I. E. Rubin, ed., *The Renaissance and Mannerism: Studies in Western Art: Acts of the Twentieth International Congress of the History of Art* (Princeton, 1963), proposes that Early Christian art had an impact upon Masaccio, observing, ". . . no one seems to have pointed out that only Early Christian art could have provided figures combining voluminous forms revealed by light with an almost Masacciesque pathos" (2:144). Krautheimer has singled out several works from this period that may have served Ghiberti, underscoring, as well, the Patristic interest of the humanists, which would have been part and parcel of any sort of Early Christian revival during the early Renaissance (Krautheimer and Krautheimer-Hess, *Ghiberti*, passim, especially 169ff). Meiss, on his part, calls attention to the Augustinian elements in the *Tribute Money* (p. 125), and refers to Kristeller's discussion of the subject ("Augustine and the Early Renaissance," pp. 393ff). Saint Ambrose's thinking, which was a component in Ghiberti's cycle according to Krautheimer and Krautheimer-Hess (*Ghiberti*, pp. 177ff), also had an impact on Jacopo della Quercia's program for San Petronio (see my *Il Portale*, p. 78). See also E. Wind, "The Revival of Origen," in D. Miner, ed., *Studies in Art and Literature for Belle da Costa Greene* (Princeton, 1954), pp. 412–424 and especially pp. 419ff, and I. Hyman, "The Venice Connection: Questions about Brunelleschi and the East," in *Florence and Venice: Comparisons and Relations*, vol. 1, *The Quattrocento*, (Florence, 1979), pp. 204–206.

175. See Janson, *History of Art*, p. 312. The figure in turn occurs in Roman gems; see for example the Capricorn relief illustrated in M.-L. Vollenweider, *Die Steinschneidekunst und ihre Kunstler in Spaetrepublikanischer und Augustischer Zeit* (Baden-Baden, 1966), taf. 61, a reference brought to my attention by John MacClaren.

of Adam demonstrates aspects that might be associated with *repoussé* as opposed to the carved technique of the ivories. The treatment of the drapery recalls a method of pushing out from behind, and a figure such as the Christ on the Early Christian silver flagon depicting the Healing of the Blind (British Museum, London) may be cited.

Indeed among the group of reliefs of the Old Testament in Bologna an *all'antica* flavor has been provided. Many examples can be cited where there appears to be a parallel handling of the body—heavy, stocky, even muscular figures, like on the Early Christian *Brescia Casket*. The exaggerated proportions of the hands and feet and the prominence of forceful gesture are shared features.

Among the Early Christian silver objects that might be cited as influential for Jacopo is the reliquary casket in San Nazaro Maggiore, in Milan.[176] The surfaces of reliefs are qualities that unite the ivory with the metalwork traditions. However, the subtle variation within the silver reliefs are more marked than in their ivory (or marble) counterparts.[177]

While Jacopo's experience with Greco-Roman antiquity was often approached through the filter of late antique and especially Early Christian interpretations, he must also have had frequent direct confrontations with original ancient works, especially in Pisa; certainly this was the case with respect to the putti for the *Ilaria Monument* and their carryovers on the *Fonte Gaia*, a subject taken up effectively by A. C. Hanson.[178] Furthermore, an occasional ancient (Etruscan) bronze was almost certainly known to him. Jacopo probably consulted a variety of antique prototypes in achieving the final statement of his Adam, but a major role in the mediation, in addition to the Early Christian examples such as those mentioned, should be awarded to Nicola Pisano.

Several issues clarify Jacopo's relationship to earlier sculpture: first, he approached the ancient material at his disposal very much preconditioned by the

176. On the casket, see Volbach, *Early Christian Art* (New York, 1961), p. 332, with a short bibliography. Its authenticity was questioned by C. R. Morey, "The Casket of San Nazaro" *American Journal of Archaeology*, 2nd series (1919), 23:101–25 and *American Journal of Archaeology*, 2nd series (1928), 32:403–406, who thought it to be a sixteenth century Renaissance forgery. Since that time, however, its authenticity has never been seriously questioned, and the graffiti found on the box appear to be contemporary with its presumed late fourth-century dating. See P. L. Zovatto, "L'urnetta argentea di S. Ambrogio nell'ambito della 'Rinascenza teodosiana,' " *Critica d'arte* (1956), 13–14:2–14; Cagiano de Azevedo, "Sant'Ambrogio committente di opere d'arte," *Arte lombarda* (1963), 8:55–76, especially pp. 65ff; and P. Testini, "Osservazioni sull'iconografia del Cristo in trono fra gli apostoli," *Rivista dell' istituto nazionael d'archeologia e storia dell'arte* (1963), anni 20 and 21, new series 21 and 22, pp. 271–272, who in no uncertain terms concludes, "l'opera, sicuramente autentica, appartiene all'epoca di S. Ambrogio." Morey's objections to the casket, which were primarily iconographic, are answered by Testini. His conviction that the style was ultimately "Donatellian" (but read "Querciesque") is a confirmation of the stylistic affinities also raised above in the text. Certainly those objects pertaining to the so-called Theodosian Renaissance make the best parallels to Jacopo's art, although we cannot assume that he would have been capable of making such fine (art historical) distinctions, limiting himself to a taste for certain objects and representations.

177. I find the forms on the San Nazaro casket so suggestive for Jacopo's art that a direct experience with it on Jacopo's part can be postulated.

178. See A. C. Hanson, *Jacopo della Quercia's Fonte Gaia*, and "Jacopo della Quercia fra classico e rinascimento."

works of the Pisani and appropriated those figurative motifs and types that were already in general use. Second, when he adopted a classical figure or type, he handled it entirely within his own orientation and consequently transformed it for his own artistic and expressive requirements. The search for direct figurative quotations from classical antiquity in Jacopo's work as a whole, with the noted exceptions, has been less fruitful than might have been expected. Like every original, imaginative artist, the course of his development was uneven, irregular, unpredictable, and impossible to lock into a formula. He was constantly aware of what his progressive contemporaries were about, having weighed their innovations in the light of his own formal requirements.

A factor in Jacopo's stylistic biography was experience with Early Christian metalwork and ivories. He may have been engaged by these objects originally because the technical approach to relief in them was in harmony with what he had sought for his own works. Study of these venerable objects brought him close to the figurative foundation of classical art: an *all'antica* flavor to Jacopo della Quercia's art is unquestionably ever present, but with a decidedly Christian flavor.

If in the course of the discussion Michelangelo's name has been raised frequently, my purpose is not to lend authority to Jacopo and his art simply because of affinities with later solutions. Rather we can call upon the example of Michelangelo, among the most familiar of Western artists, to assist in a comprehension of his distinctive predecessor. Jacopo della Quercia readily stands on his own feet, as an innovative, independent, self-confident master who spread his style in at least three influential centers: Siena, Lucca, and Bologna. He was anything but a provincial, and beyond the intrinsic value of the individual works, he participated in the most lofty current of stone carving in Italy, incising a permanent personal mark.

Catalogue of Works

Catalogue 1. The *Ferrara Madonna* (also known as the *Silvestri Madonna*, the *Madonna del Melograno*, and the *Madonna del Pane*)

Illustrations: Figs. 1–2.

Location: Cathedral Museum, Ferrara.

Material: Carrara marble.

Dimensions: 152 cms (height).

Date: 1406 (execution).

Inscription: GIACOMO DA SIENA 1408 (on the base; not original, probably dating from the end of the eighteenth century).

Description: The statue of the sturdy Mary, who gracefully supports the standing Child, insistently retains the integrity of the original marble block. The Child, in an easy contrapposto with the weight on the right leg, holds an object in his left hand, perhaps a piece of bread—hence the work is sometimes called the *Madonna del Pane*—or a piece of crumbled cloth. Mary holds a partially slit-open pomegranate in her left hand, whence the alternative title *Madonna del Melograno*. She wears a heavy, simply designed crown that fits tightly to the contour of her head. A cord binds her garment high above the waist. In profile a portion of Mary's cushioned throne is visible.

Condition: Excellent.

Documents: See docs. 11, 12, 15, 17, 18, and 21. The commission and payments for the statue are well documented, thanks to the research of N. Rondelli, "Jacopo della Quercia a Ferrara" (1964), who found several important notices, only one of which had been known earlier. See Cittadella, *Notizie amministrative, storiche artistiche relative a Ferrara* (1862), p. 64, whose reference is based upon Baruffaldi, who calls the artist "Jacopo da Siena"; see also A. Mezzetti and E. Mattaliano, *Indice ragionato delle 'Vite de' pittori e scultori Ferraresi' di Gerolamo Baruffaldi* (Bergamo, 1983), 3:50.

 The contract was drawn up between Jacopo and the heirs of Virgilio dei Silvestri on September 19, 1403, for making a Madonna for the Silvestri Chapel in the cathedral

according to drawings submitted by Jacopo della Quercia (doc. 11). Three days later the contract was altered. Tommasino da Baiso, who in the previous version was the guarantor, was now defined as a responsible party to the agreement (doc. 12). On January 14, 1406, Tommasino obtained the assurance of payment for the *Madonna*, which he and Jacopo (then not present in Ferrara) promised to produce, with its tabernacle, by September of the same year (doc. 15). The statue had not yet been carved at this time, but the stone must have already been procured, surely by Jacopo himself. Indeed, by January 19, 1407, the statue was mentioned as finished (doc. 18), and the commission for painted decoration of the chapel was turned over to Michele di Jacopo, a Ferrarese painter. Jacopo della Quercia was present at the signing this time. On June 18, 1408, the final settlement of payments was made (doc. 21).

History: Presumably the *Madonna* was set up in the Silvestri Chapel until it was destroyed in a remodeling that took place before the middle of the nineteenth century, when Milanesi saw it in the Chapter House of the Canons in Ferrara (Milanesi, ed., *G. Vasari, Le vite*, 2:113*n*2).

Critical tradition: The statue was first published by Cicognara, *Storia della scultura in Italia* (Prato, 1823), 4:195–96, who knew the inscription but did not attach it to Jacopo della Quercia. C. C. Perkins (*Tuscan Sculptors*, 1864, p. 104), on the other hand, recognized it as an autograph work and was gradually followed by all later scholars with the exception of Cornelius (*Jacopo della Quercia, Eine Kunsthistorische Studie*, 1896), who retained doubts. With the discovery of the documents by Rondelli, any questions concerning Jacopo's authorship have been eliminated.

Comment: One of the reasons Jacopo was hired was his experience with Carrara marble, which is specifically stipulated in the contract. This, in turn, must reflect connections and expertise he had developed in Lucca. The question remains open as to whether he had been called up especially from Tuscany to produce this figure, or whether more likely he was already in Emilia and was known or was recommended to the executors by local friends, possibly the very same Tommasino da Biaso named in the contract.

The sculpture is of prime importance for determining Jacopo's early style and consequently his formation and orientation as an emerging artist; it must form the basis of any speculation related to a large body of miscellaneous works attached to the master's first efforts.

Catalogue 2. *The Ilaria del Carretto Tomb Monument*

Illustrations: Figs. 3–19.

Location: Left transept, San Martino Cathedral, Lucca.

Material: Carrara marble.

Dimensions 244 × 88 × 66.5 cms (including base); 204 × cms (slab with effigy).

Date: 1406–1408 (?).

Description: The recumbent image of the deceased, whose head is raised by two tasseled pillows, serves (now) as a cover for a rectangular marble urn about three times as long as wide, which is composed of individual marble slabs, one for each of the four sides. Only the long sides have the carved putti holding heavy fruited garlands. One of the short sides contains, at the feet of Ilaria (west), a carved cross of acanthus leaves that is the only

Christian reference on the monument; the other short side (east) is occupied by a shield with the arms of the del Carretto and the Guinigi families made with inlaid colored stone and carved acanthus leaves at the bottom.

Similar putti friezes on the north and south flanks each have five winged boys supporting the cord with the fruited garlands. Two of them at the corners near the head of Ilaria turn back toward their companions, while those at the feet look out directly from the corners. An elaborated continuous cornice marks the top of this portion of the tomb, which can be referred to as the "sarcophagus." A black stone base, which follows the contours of the sarcophagus that rests upon it, is not original.

On the upper zone, which is carved from a single monolithic block, Ilaria is laid out with her hands crossed, her fully relaxed body in a sleep of death; at her feet crouches a small dog. When seen in profile from one of the long sides at a distance of about three meters, a sweeping movement can be perceived starting from the dog, who looks up toward the woman's head, rising to where her feet are hidden by the velvety folds of her garment, then gradually rising again. Ilaria wears a fashionable gown known as a *palanda*, which probably was a French importation. The high curving collar emphasizes her fine neck. Her tight-fitting, wide-brimmed headress, a *ghirlanda*, is decorated with rosettes, and she may have once been crowned with a diadem of metal, as observed by E. Lazzareschi and F. Pardi in *Lucca* (Lucca, 1941), p. 98.

Condition: Generally very good, for the parts that have survived. The angel wings from the short side at Ilaria's feet (west) have been removed, probably already in the fifteenth century, when the stone was reused for another tomb marker. Slight damage to the monument was incurred in 1989, and it is now protected from approach by barriers and plate glass.

Documents: None.

History: There are very few known facts surrounding the construction of the sepulcral monument dedicated to Paolo Guinigi's second wife Ilaria del Carretto. The brief publication by G. G. Lunardi entitled *Ilaria del Carretto o Maria Antelminelli* (1928) offers the most complete background surrounding details of Ilaria's death, based upon contemporary documents and later chronicles. Lunardi's study, which is full of precious information, has been neglected because its fundamental premise that the personage represented in the monument is not Ilaria but Maria Caterina is untenable. Guinigi's first wife, who died in 1400 at the age of twelve before the marriage was actually consummated, was Maria Caterina di Valerano degli Antelminelli, a descendent of the infamous Castruccio and apparently an heir to his fortune. (See Bongi, *Di Paolo Guinigi e delle sue ricchezze*, 1871, p. 108).

Ilaria del Carretto dei Marchesi di Savona married Paolo on February 3, 1403, in the Lucchese church of San Romano when she was twenty-four years old, hardly young for the period. Details of the marriage ceremony are reported in F. Bendinell, *Abozzi*, part 3, ms. 2589, fol. 20 in the National Library of Lucca (as reported by Lunardi). Sumptuary laws in effect in Lucca at the time were partially suspended for the marriage in a decree of January 1, 1403; cited in L. Mirot and E. Lazzareschi, "Lettere di mercanti lucchesi da Bruges e da Parigi: 1407–1421," *Bollettino storico lucchese* (1929), 1(3):175n1; also in S. Bongi, *Inventario del R. Archivio di Stato di Lucca* (Lucca, n.d., 19xx), 1:149ff, and in *Archivio storico italiano* (1947), 10:93ff.

There is no doubt that Ilaria was buried in the San Francesco, and Lunardi (p. 13) cites a sixteenth-century chronicle of Salvatore Dalli that clearly states that "fu con honorate e pompose exequie e funerali seppellita alla chiesa di San Francesco." Also cited by Lunardi are Vincenzo Baroni, "Iscrizioni sepolcrali," MS. 1115, and Antonio Iova's manuscript (no.

2599), all of which are located in the same collection. Another useful study is that of E. Lazzareschi, "La dimora a Lucca di Jacopo della Quercia and di Giovanni da Imola" (1925).

Ilaria bore a son on September 24, 1404; after giving birth to a daughter, named Ilaria— for whom see A. Mancini, *Hilaria minor. Nozze Ferrera-Giovannetti* (Lucca, 1922)—she died on December 8, 1405. She was buried in the large semi-independent Guinigi chapel (10.60 × 17.80 meters) erected during the middle of the fourteenth century and dedicated to Santa Lucia in the cloister of San Francesco—not in the cathedral where Vasari saw the monument, as is generally claimed. Offices for her were said in the chapel by a Franciscan frate.

The *terminus ante quem* for the tomb, or at least a date at which it was well under way, is often taken as April 17, 1407, when Paolo married Piagenta, daughter of Rodolfo Lord of Camerino. Following her death on September 11, 1416, she, too, was laid to rest in the same chapel as Ilaria, according to Sercambi (Bongi, ed., 3:233–34), who recounts that "al chiu corpo fu facto sommo honore, come già fu facto a madonna Ylaria." The argument for dating the *Ilaria Monument* shortly after Ilaria's death is convincing: it would have been unlikely for Paolo to have occupied himself with an elaborate, expensive tomb for his second wife when newly married to his third wife.

Other evidence has been brought to the question. The Libro di Camera (Camerlengo Generale) of the Lucchese *comune* is missing for the year 1406, and Bongi (*Di Paolo Guinigi*, p. 16) assumes that the payments must have been made in that year. On the other hand, the monies may have come directly from Guinigi's personal accounts; nevertheless, there is no trace of the payments from any source. Bacci (*Francesco di Valdambrino*, 1936, p. 97) has, correctly in my view, challenged Milanesi's ambiguous statement, "secondo un documento ch'è presso di noi, parebbe che Jacopo lavorasse quella sepoltura intorno al 1413" (Milanesi, ed., *G. Vasari, Le vite*, 2:112n). From the conditional, hesitant language, and the failure to actually publish the evidence, it is likely that Milanesi had in mind documentation related to Quercia's hasty retreat from Lucca at the end of the year, which, however, had nothing to do with the *Ilaria Monument*.

Paolo Guinigi was overthrown as tyrant on August 14, 1430, and at that time or shortly thereafter, the monument was dismantled. The short side of the sarcophagus (east) containing the coat of arms was reused soon after for Beatrice Dati (for which see below). It has been assumed that in the 1480s, some sections were in the shop of Matteo Civitali, but the evidence is sketchy and the unspecific reference was probably to another tomb altogether; see E. Ridolfi, *L'arte in Lucca studiata nella sua cattedrale* (1882), p. 120n1, who cites an order to Civitali from the officials of the cathedral to return a "sepolcro di marmo" that had been in the Chapel of San Regolo. A thorough discussion of these questions may be found in Baracchini and Caleca, *Duomo di Lucca*, (1973), p. 135.

By the middle of the sixteenth century and probably before, what was left of the tomb had been transferred to the cathedral, where Vasari saw it before the appearance of his first edition of the *Lives* (1550), and where it has remained in one state or another ever since. Vasari's description from the second edition (1568) is informative:

A Lucca e quivi a Paulo Guinigi che n'era signore fece per la moglie che poco inanzi era morta, nella chiesa di S. Martino una sepoltura; nel basamento della quale con- dusse alcuni putti di marmo che reggono un festone tanto pulitamente, che parevano di carne; e nella cassa posta sopra il detto basamento fece con infinita diligenza l'immagine della moglie d'esso Paulo Guinigi che dentro vi fu sepolta; e a'piedi d'essa fece nel medesimo sasso un cane di tondo relievo, per la fede da lei protato al marito. La qual cassa, partito o piuttosto cacciato che fu Paolo l'anno 1429 di Lucca, e che la

città rimase libera, fu levata di quel luogo, e per l'odio che alla memoria del Guinigio portavano i Lucchesi, quasi del tutto rovinata. Pure, la reverenza che portarono alla bellezza della figura e di tanti ornamenti, li rattenne, e fu cagione che poco appresso la cassa e la figura furono con diligenza all'entrata della porta della sagrestia collocate, dove al presente sono; e la cappella del Guinigio fatta della comunità. (Milanesi, ed., G. Vasari, *Le vite,* 2:112)

By the time Vasari saw the monument, it had not only been removed from San Francesco and located at the entrance of the sacristy of the cathedral, but it no longer retained its original free-standing, independent appearance. The situation is not altogether clear, however, as can be seen from the account by G. B. Sesti (b. 1606):

Defunta Ilaria le furono fatte nela catedrale con solenne pompa l'esequie, e dopoi da Paolo le fu fatto alzare in mezzo di deta chiesa un nobile deposito di finissimo marmo colla di Lei effigie, opera del Cavaliero Iacopo della Quercia senese, qual deposito l'anno che fu disfatta la vecchia cantoria fu trasportata nella sagrestia, ove ancor oggi si vede. (*Annali di Lucca,* p. 488, Biblioteca Nazionale di Lucca, MS., no. 88; cited in Lazzareschi, "La dimora," p. 78*n*1)

Lunardi, however, observed that Sesti was misinformed about the original location of the tomb, pointing to more authoritative chronicles that placed it in the Guinigi Chapel at San Francesco.

According to V. Marchio's *Il Forestiere informato delle cose di Lucca* (Lucca, 1721), p. 158, in the early eighteenth century the *Ilaria Monument* was still in the sacristy. However, in 1760 the monument was recorded in the no-longer-extant Cappella dei Garbesi, and in 1842, it was described as in the left transept attached to the wall, as reported in I. Belli Barsali, *Guida di Lucca* (1970), p. 68. A few years earlier, in 1829, when the monument was moved from the Cappella dei Garbesi to the transept, parts of the sarcophagus were dispersed (the coats of arms had already been removed in the fifteenth century), and one of the long sides with the putti frieze had been sent off to Florence, first to the Uffizi and then to the Bargello (see Mazzarosa, *Guida di Lucca,* 1843, p. 60).

The *Ilaria Monument,* then, underwent various decisive alterations beginning in the fifteenth century. A recomposition was undertaken only toward the end of the nineteenth century, with final adjustments made in 1913. When reassembled in the sacristy of San Martino, still with the marble casket, it had apparently already suffered substantial losses, including elements from a superstructure. Krautheimer has assumed that the effigy and the casket had been separated from the putti freizes by 1550 ("Quesiti sul sepolcro di Ilaria," p. 91).

As long as the two long sides were present together, perhaps until as late as 1829— although according to Baracchini and Caleca (*Duomo de Lucca,* p. 135) the north flank had been separated earlier and was returned to Guinigi possession—some residual effects of its free-standing character must have been retained. Once one of the flanks had been separated from the sarcophagus and sent off to Florence, however, the implication of independence had disappeared. (For a photograph of the flank while in the Bargello, see Alinari #15462.) In 1889, when the sarcophagus was reconstituted, an effort was made to restore its original state, although no provisions were undertaken to reproduce the casket that had rested on the sarcophagus and upon which Ilaria was laid out, nor was the reconstruction of any hypothetical superstructure contemplated. In 1911 the missing short side was recognized in a local museum, and two years later it was added to the monument. The marble had actually been reused as a commemorative plaque in Santa Maria dei Servi for Beatrice Dati, the wife of

Pietro Guinigi, who died in 1453. At that time the Del Carretto arms were covered over with paint and the Dati arms applied, also proof that the *Ilaria Monument* had been partially dismantled by that date, as is pointed out by Baracchini and Caleca (*Duomo de Lucca*, p. 134). On aspects of the reconstruction, see Morisani, "Struttura e plastica nell'opera di Jacopo della Quercia" (1965), p. 76.

Critical tradition: Debate among scholars concerning the *Ilaria Monument* has centered around four overlapping issues: dating; authorship and the division of hands; assumed "stylistic" differences in the sculptured elements; and reconstruction of the original appearance.

The prevailing view is that the commission, planning, and most of the execution took place during the years from 1406 to 1408, for the reasons already proposed. Some scholars, either on the basis of stylistic assumptions, notions about the priority of innovations during the early quattrocento, or the ambiguous and inconclusive reference given by Milanesi, located it around 1413. A compromise position between the two is taken by Lanyi ("Quercia Studien," 1930, p. 36) and by Krautheimer ("Quesiti sal sepolcro," pp. 91–97; he thinks that the effigy was done in 1407 and 1408 and that the putti date from 1409 to 1412); they accepted 1413 as the year when work was complete. Some others would date the entire monument still later, at least the parts of the sarcophagus with the putti. (For a summary see *Jacopo della Quercia nell'arte di suo tempo*, 1975, p. 87.) Many critics, led by Longhi and Panofsky, have seen a divergence of styles and consequently of dates between the image of Ilaria, which is considered early, and the putti friezes thought of as considerably later.

Concerning authorship, with the exception of A. Marquand, "The Tomb of Ilaria del Carretto," *Journal of the Archaeology Institute of America* (1915), 29:24–33—the only modern author to actually question the entire project for Jacopo—there is agreement that Jacopo was at least responsible for the Ilaria effigy. Wide divergence of opinion remains, however, with regard to the putti friezes on the long sides (north and south), and assumed differences between the two. Most now agree that the south side (fig. 3) is by Jacopo himself, while the north flank (fig. 5) is considered to be either by a collaborator, usually thought to be Francesco di Valdambrino, or by an artist of a later period, possibly someone close to Benedetto da Maiano (Del Bravo, *Scultura sensese*, 1970, pp. 42f), or—attaching the attribution to the notice published by Ridolfi referred to above—by Matteo Civitali. Baracchini and Caleca take the latter view (*Duomo di Lucca*, p. 135), and are followed most recently by Paoli.

Even when Jacopo is considered the author of both main friezes and the effigy, it is frequently observed that the Ilaria effigy is "Gothic" and the sarcophagus reliefs are "classic," representing two antagonistic stylistic models that, in turn, must reflect two different periods or two diverse stylistic orientations.

Other controversial aspects of the tomb involve assumptions about its original appearance. Krautheimer, basing his views on proposals of Bacci, Pope-Hennessy, and Freytag, suggests that there must have been an intervening element between the sarcophagus and the effigy, because, among other reasons, the stone slab out of which the Ilaria is carved is too small to fit properly directly on the sarcophagus. And more pointedly, Vasari specified the existence of such a member (the *cassa*) in both editions of his *Vite*. In a moving essay devoted to the monument (unsigned, but by G. L. Mellini) entitled "Omaggio a Ilaria del Carretto," *Labyrinthos* (1987), 11:101–109, a reconstruction of the tomb is offered (p. 109), which indeed shows an intervening chamfered element. I am, like Krautheimer, inclined to see it as a true rectangular *cassa*.

Comment: The *Ilaria Monument* has at least three principal elements: (1) the *alla antica* sarcophagus; (2) a marble casket, possibly with an inscription; (3) the effigy. There is also very good reason to suspect that there was a fourth, some sort of canopy or baldachin

supported by columns. In a fascinating proposal, S. Meloni Trulja, in *Museo di Villa Guinigi* (Lucca, 1968), p. 101, associates two fragments of mensole with heads in foliage with Jacopo's shop and proposes that they were specifically for the *Ilaria Monument,* and further, that they once supported a superstructure for it.

In more general terms, the monument must have been related to any number of trecento Tuscan wall tombs such as the *Petroni Monument* in the Sienese cathedral, at least in that the same elements are found, although the *cassa* is small in relation to the historiated sarcophagus beneath it. Krautheimer claims a parallel with the *Antonio Venier Tomb* in Saints Giovanni e Paolo, Venice. Apparently this comparison is part of an effort of some experts, led by Krautheimer, to see a heavy Venetian coloration in early Jacopo, more specifically to be understood as deriving from the dalle Masegne workshop style. The choice of the *Venier Tomb,* however, is a particularly poor one because overtly it has so little to do with the *Ilaria,* particularly in terms of the proportions and the structural intention.

The question of whether the *Ilaria Monument* originated as a free-standing or wall monument has also been debated. Distinguished scholars including Longhi, Lanyi, Panofsky, and Del Bravo have claimed that the *Ilaria* must have been conceived and actually first executed as a wall tomb, and only in a subsequent phase readapted into a free-standing monument, either by Jacopo himself or by a later artist. This conclusion seems to be based upon two interrelated ideas: that there is a stylistic abyss between the effigy and the relief putti below, as well as between the north and the south flanks; and that it is awkward, art historically, to find that a dynamic new type of a centrally designed monument was the invention of a provincial (i.e., Sienese) sculptor located in an artistic backwater (Lucca). Thus alternative explanations have been concocted. Furthermore, that Jacopo della Quercia, rather than a Florentine (i.e., Donatello), should have been the first Renaissance master to have readopted from classical art the expressive, thematically engaging, and influential nude boys in a monumental context is unthinkable for many. Indeed Robert Longhi, writing as Ermanno Caratti ("Un'osservazione circa il monumento d'Ilaria," 1926) confessed "ci pare difficile che un'idea siffattamente 'imperiale' potesse sorgere nel della Quercia prima delle frase romane di Donatello."

The first objection has already been partially answered. The *cassa* separating the effigy from the sarcophagus functioned as a transition, making the apparent stylistic differences between the "classical" putti and the "Gothic" effigy less vivid. But are the styles of the two remaining parts really so antagonistic? The proper viewing points for the Ilaria effigy have not been sufficiently taken into account; the usual views, especially those frequently reproduced (from directly above), have led to an improper reading. Such photographs lead us to believe that the monument was designed as a kind of elevated tomb slab, to be perceived from an ideal point in the air. According to this thinking, Jacopo would have conceived the figure as an exaggerated floor tomb effigy; he would then have projected the sarcophagus and the other parts as afterthoughts. In such a hypothetical explication of the creative chronology, Jacopo has been seen as having considered only a wall tomb alternative; then in a supposed third stage, a free-standing notion is introduced, although not necessarily by Jacopo.

The critical purpose of this unrealistically complex sequence appears to be to relieve Jacopo of the responsibility of being original, punishing him for the crime of being too innovative for his provincial station. But could the sculptor have had the degree of independence from his patron that is necessary to accept such a unlikely scenario anyway? Paolo Guinigi married once again after his third wife died; the notion that he was concerned about continuing to change the project for Ilaria several marriages later becomes particularly farfetched.

The sarcophagus with its remarkable putti must be appreciated as a precocious instance

—indeed, the first—of the application of the antique motif in the Renaissance. A drawing associated with Gozzoli of putti after Jacopo, located in the Kuperstichkabinet (no. 5578r), Berlin, indicates a direct confrontation; see Degenhart and Schmitt, *Corpus der italienischen Zeichnungen, 1300–1450* (1968), cat. no. 464.

Nor should such usage be surprising for an artist whose patron was the lord of Lucca, whose territory included the finest marble quarries and whose city had a vital centuries-old tradition of marble carving. Besides, a relation of Paolo Guinigi's through marriage, Giovanni di Parghia dei Antelminelli "de Lucha" (Paolo's first wife was an Antelminelli), had actually reused a Roman sarcophagus (Pisa, Camposanto; see Papini, *Pisa,* vol. 2 cat. no. 81, and Arias, Cristiani, and Gabba, *Camposanto di Pisa,* 1977, pp. 160–161) not many years before, as Bacci *(Francesco di Valdambrino)* has reported. Perhaps if a fine ancient sarcophagus had been available, Paolo might well have made use of it. As things were, he had Jacopo della Quercia create an entirely new monument for Ilaria, one that surpassed the local examples. One should also recall that Paolo Guinigi was a man of considerable cultural pretensions, if his ample library is any indication (for which see Bongi,, *Di Paolo Guinigi e delle sue richezze,* where the important inventory is published). Paolo's interest in antiquity is confirmed by his ownership of "uno idolo di marmo con piedistallo d'attone" in his palace (Bongi, p. 101).

Irrefutable internal evidence confirms that Jacopo planned a free-standing sarcophagus. Each of the long sides with five putti is a single block, composed of two "corner" putti and three "cental" ones: thus all four corners have such figures. The two located at Ilaria's feet are clearly conceived to encourage the spectator to move around the corners. As for the putti at the corners near to Ilaria's head, there is a subtle modification: while also corner figures, they tend to limit but not entirely impede movement around behind her, because the nude boys look back toward the flanks. With refinements such as this one, I suggest we can reconstruct the placement of the monument when it was in the Santa Lucia Chapel in San Francesco. The head of Ilaria and the arms of the Guinigi and the del Carretto must have been located near a wall but not flush against it, maintaining, that is, a passage space between the monument and the wall. Thus the corner putti at the head operated differently from those at the feet. And there seems to be no question about Jacopo's authorship of at least three of the four corner boys, which means that he made both flanks at the same time, and the subtleties were very much part of his plan.

The following conclusions can be drawn: the tomb was produced soon after Ilaria died; it was planned from the beginning as a free-standing monument; the sarcophagus and the effigy were made in the same campaign; Jacopo was innovative in the project and in his use of classicizing putti; and finally, the monument and its sculpture did not have a long-term influence on tomb sculpture in Tuscany because of its remote location and because it was dismantled hardly two decades after completion.

Catalogue 3. The *Fonte Gaia* Drawing

Illustrations: Figs. 20 and 21.

Location: Section A, Metropolitan Museum of Art, New York; section B, Victoria and Albert Museum, London.

Material: Ink on parchment, some wash.

Dimensions: 19.7 × 22.5 cms (section A); 15.3 × 22.7 cms (section B).

Date: 1408.

Description: The two fragments once formed a single drawing in which the central portions must have been cut away, and both sections were also trimmed on all four sides. Section B (London) has been cut down more severely at the top and bottom than its counterpart. Section A shows four seated relief figures in niches, two on the side wing of the fountain, the angel Gabriel (with a lily) and Temperance (with a jar), and two on the black wall, Fortitude (with a column) and Faith (with the Cross). On the left stands a female figure with a nude child in her arms and another at her feet. She is dressed in a full garment with a cape, perhaps of animal skin. On the same zone, at the back left corner of the fountain, is a monkey looking and gesticulating toward a seated dog with bells on his collar, represented on the London fragment (section B), which has the same configuration of figures. Here we find Justice (with a sword) and Hope (or Humility, with a burning candle) on the back wall, and on the side, Prudence (with three eyes) and the Virgin Annunciate, which is the most seriously cropped of all. Matching its counterpart, section B has another standing woman with two children on the left side. The two standing women are usually referred to as Acca Laurentia (Section A) and Rea Silvia (Section B), but they are identified in the present study as personifications of Charity, in the form in which they were carved out in marble.

Condition: Besides the obvious losses from being cut down, there is some fading and staining, especially in the London fragment, but the condition remains reasonably good for both sections.

Documents: Since the first provisions for the commission of the *Fonte Gaia* were made on December 15, 1408, I assume that there must have already been a drawing before that time to be used for the negotiations (doc. 22). On January 22 a drawing on paper is mentioned as being with the notary (doc. 25). Although the present drawing fragments are on parchment and not on paper, I believe that they are, in fact, fragments of the one mentioned. A new drawing was referred to more than seven years later, on December 11 and 22, 1416, but that one must be considered lost, because by that date certain changes in the fountain had been required that do not appear in the fragments. (docs. 63, 64).

There are some unconfirmed notices that were raised by Romagnoli (*Biografia cronologica de'bellartisti senesi dal secolo XII a tutto il XVIII*, ms. 3, fols. 620–621): "A tomo 210 dei Consigli della Campana a carte 127 al 18 marzo 1412 [=1413 modern?] nota che Jacopo in quel giorno presentò il disegno della fonte. Nel bilancio No. del Concistoro trovai pure registrato che in quel epoca Jacopo presentò il disegno della fonte si ha da fare nel champo."

History: The New York fragment has the following provenance: Erasmus Philipps, Richard Philipps, First Lord of Milford (Lugt 2687); Sir John Philipps; the Metropolitan Museum purchased it in London in 1949 (Dick Fund, 49,141). The London fragment: A. Dyce (Lugt 710); Dyce bequest to the Victoria and Albert Museum.

Critical tradition: Section B (London) was first associated with Jacopo and the *Fonte Gaia* by J. Lanyi, in "Der Entwurf zur Fonte Gaia in Siena" (1927/1928), and in "Italian Drawings Exhibited at the Royal Academy, *Burlington Magazine* (1931), no. 7, p. 3; he considers the drawing an autograph work. When Krautheimer published the New York fragment ("A Drawing for the Fonte Gaia in Siena," 1952, he recognized that the two belonged together and that the drawings were for an early project for the fountain. Seymour took up the question of the drawing in a paper, " 'Fatto di sua mano,' Another Look at the Fonte Gaia Drawing Fragments in London and New York" (1968), in which he proposed that the drawing was made for legal purposes and the documents indicated that it had been kept with the notary as part of the contract. As for the attribution, Seymour suggests that the drawing was not by Jacopo in spite of the phrase "fatto di sua mano," but was made for him and

under his instructions by either Parri Spinelli or Martino di Bartolommeo. Lanyi, to be sure, had already raised the name of Jacopo's brother Priamo della Quercia. Seymour rhetorically asks, "Could the mind and will that directed a chisel with such power and determination conceivably ever have changed enough to permit the hand to make these delicate, flower-like, virtually scented forms with a pen?" (p. 95). On the other hand Degenhart and Schmitt, in *Corpus der italienischen Zeichnungen* (1968), 1:203–211, accept the fragments as Jacopo's. P. Ward-Jackson considers both sections copies or derivations of a lost original whose essential character he finds tentative; see *Victoria and Albert Museum Catalogues. Italian Drawings, Vol. 1: 14th–16th Centuries* (London, 1979), pp. 21–24, under no. 17. A doubt is also registered by J. Bean, who lists the New York fragment as "Jacopo della Quercia?"; see *15th and 16th Century Italian Drawings in the Metropolitan Museum of Art* (New York, 1982), pp. 210–211 (with bibliography). E. Carli, in *Gli scultori senesi*, asserts that the drawing is "quasi certamente di mano di Jacopo" (p. 29).

Comment: I consider the drawing to be by Jacopo himself, and I believe that the attributional problems that have been raised are caused by a failure to take fully into account his goldsmith's training.

There is a Querciesque *Lupa* with a nude child beneath in the Palazzo Municipale of Montalcino (Gab. Fot., Florence, no. 11601), which may reflect a lost prototype by Jacopo, one which was still on the *Fonte* before the demolition. Another is in the Palazzo Pubbico (see Seymour, *Quercia*, fig. 44).

Catalogue 4. The *Annunciate Virgin*

Illustrations: Fig. 39.

Location: San Raimondo al Refugio, Siena.

Material: Polychromed wood.

Dimensions: 144 cms (height).

Date: ca. 1410.

Description: The self-confident young woman is represented in an easy contrapposto with her left leg slightly raised and the bulk of mass distributed to the other side, coinciding with sweeping drapes. She seems to look off to the right, if the main view is taken as the one where the body is most completely exposed, which appears to be the preferred one. Her strong neck supports a full, rounded head, with ample hair, rather tight-fitting to the shape of the crowned head, in concentric bands. Beneath her breasts is a thick, tight ribbon that serves as a horizontal element; along with the dress at the level of the shoulders and the left hand, which probably once held a book, it mitigates the insistent verticality of the standing figure and her sweeping draperies. Unlike the later Virgin in the *San Gimignano Annunciation* (cat. 11), this Virgin shows herself in a heavy, deep blue mantle with gilt on the edges, over a deep red dress.

Condition: The figure was transformed completely into another representation around the end of the eighteenth century, when its right arm, which must have originally swung across the body, was replaced with a new one in another pose. Presumably at that time the polychromed surface was sanded and then covered with a layer of gesso, after which it was painted white to imitate marble, and silver was added to the hair. Following the removal of the "new" arm and part of the shoulder, the work presents itself with much of its original

integrity. The painted quattrocento surface was removed at the time of the reformulation, and the color that now appears is a modern restoration based upon a few specks of the original still available. The crown seems to have been shaved down and must have been more noticeable in its original state.

Documents: None.

History: Although its original destination is not known, the work has been located in the church of San Raimondo al Refugio in Siena at least since its eighteenth-century "reformulation."

Critical tradition: Credit for the discovery of this work, supervision of its restoration, and the attribution to Jacopo is due to Alessandro Bagnoli; see Bagnoli and Bartalini, eds., (1987), pp. 153–155. He first saw the sculpture as a somewhat fantastical "Allegory of Faith," holding the tables of the Ten Commandments—or, more likely, a small altarpiece in the form of a dyptich—with her left hand, and raising an oversized chalice with the right.

Bagnoli speaks of its "sofisticata bellezza," referring to the statue as "una splendida e precoce creature di Jacopo." He associates it in style with the angels on either side of the Virgin from the central portion of the *Fonte Gaia*. The *Annunciate Virgin* has been rejected by Pope-Hennessy as an autograph sculpture by the master (*Apollo*, Dec. 1987, p. 431); he considers it instead to have been based upon a Quercia model, seeing the drapery forms as "too tight and too inert" for Jacopo.

Comment: I consider the work closest to the so-called *Benedictine Saint* from Massa (cat. 7), but I date it to ca. 1410; it thus represents the earliest wood statue by the master that has survived, which he must have executed in Siena. Analogies might also be drawn with the two standing figures in the *Fonte Gaia* drawing (cat. 3), but not to the final sculptures, which were made, if my chronology is correct, shortly before the assumed date for this statue. The rather simplified design, schematic pose, and generalized features might reveal an unfamiliarity with the full potentialities of the medium. At the same time, the head and especially the hair is conceived and modeled with originality. The accompanying angel, which must have been conceived with this figure, might also have suffered a similar fate, and may yet turn up.

Catalogue 5. The *Trenta Altar*

Illustrations: Figs. 22–38.

Location: Cappella di San Riccardo, San Frediano, Lucca.

Material: Carrara marble.

Dimensions: 230 (height) × 296 cms (width of upper section), according to R. Silva, *La Basilica di San Frediano;* 43 (height of predella) × 303 cms (width of predella). Individual reliefs: Saint Catherine, 19.5 (height) × 20.5 cms. Saint Ursula, 24.5 × 33.5 cms, Saint Lawrence, 25 × 44 cms; Pieta, 25 × 58 cms; Saint Jerome, 24.5 x 45 cms; Saint Richard, 24.5 × 33.5 cms; Saint Cristina 19.5 × 20.5 cms.

Date: ca. 1410/1411–1422. Upper section, ca. 1410/1411–1413; predella, 1420–1422.

Inscription: HOC OPUS FECIT IACOBUS MAGISTRI PETRI DE SENIS. 1422.

Description: The main (upper) section of the altar is carved from several large slabs of marble, with the main figures about half-lifesize, and the predella images much smaller than that (Silva, *La Basilica di San Frediano*). Each of the figures—reading from left to right,

saints Ursula and Lawrence, the Madonna and Child, saints Jerome and Richard—has its own niche complete with trefoil lunette and sweeping gable. Above all of them except the central group, half-length busts of prophets (or evangelists?) emerge from a compact mass of foliage. The relative size, scale, and the degree of projection among the elements vary widely, providing visual excitement. The prophets are about half the size of the saints beneath and are somewhat smaller in mass than the central Madonna, even though she is seated. In the predella zone, the half-length saints Catherine (left) and Cristina (right) at the extremities are smaller still than the crowning prophets, but more than double the size of the tiny figures who participate in the four narrative panels. In the central relief of the predella the Pietà, Christ, Mary, and John reiterate the scale of the corner images.

The diversity in the degree of relief projection may be seen in the prophet busts, which are virtually free-standing: their heads, necks, and shoulders are independent of the block. Mary's head also projects distinctly, yet the most independently carved of all is the Child, resembling an in-the-round sculpture, in appearance and fact. The standing saints at the sides are less vigorously detached from the matrix of the block, although the deep undercutting of the gables over their heads produces the effect of a shadowy cushion. On the predella, the corner reliefs are rendered in a particularly low, nearly *schiacciato* relief, as is the Pietà, while greater three-dimensionality is found in the narratives. Throughout, Jacopo demonstrates a skillful technical mastery as well as confidence in his design, which permitted him to move from one figural scale and relief mode to another with extreme facility.

Each of the full-length figures has been provided with a carved plinth; the one on which the Madonna and Child rest contains the inscription. The side arms at the level of the predella contain coats of arms of the Trenta (three bull heads) and of the Silk Guild (three crosses inscribed with a triangle surmounted by a cross), to which the merchant patron of the chapel, Lorenzo Trenta, belonged. During a remodeling conducted in the seventeenth century, when Baroque decorations were added to "modernize" the monument, nearly 15 centimeters where shaved off. Originally the altar must have projected more prominently from the wall than it does today. The greater depth of field readily explains the three-dimensional, essentially free status of the prophet busts at the top, images that would have cast distinctive shadows in the flickering candlelight on the wall behind.

The main section of the altar apparently was carved from two reused tomb slabs, representing a *tour de force* for the sculptor; the predella, instead, is pieced together from at least seven stones. Hence in this area, perhaps more than in the upper section, Jacopo could more readily have delegated tasks to assistants.

Condition: Unlike the *Ilaria Monument*, the *Trenta Altar* has survived the centuries reasonably intact and in fine condition, with the exception of losses to the coats of arms on the sides. The left pilaster has some breakage and loose pieces, and the decoration of Saint Richard's niche is partially lost. The fingers of Saint Ursula's right hand have been repaired. The purpose of the unsightly metal hook embedded into the neck of the Madonna escapes me, unless it was used for a candle holder. Screws on the top of Mary's head and the Child's were used to attach metal haloes or crowns. By and large the remaining portions are well-preserved, although there have been unavoidable losses of gilding and paint. Furthermore, some elements from the upper zone of the altar with the prophets may have been lost over the centuries, including an Annunciation at the sides and a bust of the Redeemer above the central niche, postulated by Pope-Hennessy (*Italian Gothic, Sculpture* pp. 213–214) and which iconographically are called for. Lazzareschi (*Lucca,* p. 101) suggests that altarpieces at Sarzanna and Pieve ad Elici (near Viareggio) gives clues to the appearance of missing portions. The prophet busts may also be seen in relation to the Masegnesque busts in

Vienna's Kunsthistorisches Museum (Wolters, *La scultura veneziano*, cat. no. 148, pp. 225–226).

Documents: No contemporary document specifically deals with the *Altar*. The letter written by Giovanni Malpigli to Paolo Guinigi in December 1413 mentions Jacopo della Quercia and Giovanni da Imola as working in the sacristy of the new chapel: "in nella sacristia della cappella nuova di Lorenzo Trenta dove loro [Jacopo della Quercia and Giovanni da Imola] lavorano," which indicates a firm date for studying the *Altar* (doc. 44). The other, largely ambiguous documentary evidence is treated below, under "Comment."

Critical tradition: A good summary of the earlier literature is in *Jacopo della Quercia nell'arte del suo tempo* (1975), pp. 152–155. The best modern treatment of Jacopo's activity in Lucca is still that of Lazzareschi ("La dimora," 1925), who was an exemplary scholar of the documents and local sources. See also Silva, *La Basilica di San Frediano in Lucca* (1985), pp. 75–78 for the chapel and pp. 268ff for the altar. A monographic article by Campetti ("L'altare della famiglia Trenta in San Frediano di Lucca," 1933, pp. 271–94) is still also useful, and articles by Lazzareschi and Campetti exemplify the issues that have occupied most recent criticism: attributions and dating problems. Lazzareschi (and Bacci) conclude that an important role in the altar should be assigned to Giovanni da Imola, while Campetti holds that Jacopo was quite fully responsible for all aspects of the altar.

The most surprising aspect of these and all of the other studies dealing with the chronology of the altar and the related family tomb slabs (cat. 8 and 9) is that the reliability of the seventeenth-century prelate Pietro Carelli has never been questioned (for which see below, under Comment). M. Ridolfi (*Della basilica di San Frediano in Lucca*, 1879, p. 352) appears quite content with what Carelli reported, despite the ambiguities. The records of San Frediano were largely destroyed in a fire in 1596, according to S. Bongi (Inventorio del r. archivio di stato in Lucca, 1872, 1:12). In the most recent monographic article on the *Trenta Altar* (and the *Trenta Tombs*), M. Paoli's "Jacopo della Quercia e Lorenzo Trenta: Nuove osservazioni e ipotesi" (1980), the author accepts the chronology implied by the material reported by Carelli, as do all earlier studies. The proposals of R. Krautheimer ("Un disegno di Jacopo della Quercia," 1928, translated in Krautheimer, *Studies in Early Christian, Medieval and Renaissance Art*, 1969, pp. 311–314), who dates the lateral saints on the upper part of the altar to 1413, the Madonna to 1416, and the predella to 1422, have been influential, although termed "questionable" by Pope-Hennessy (*Italian Gothic Sculpture*, 1955, p. 213).

Seymour in his monograph (*Quercia*, 1973, pp. 401ff) divides the work on the *altar* as follows: the half-length prophets he sees as a collaboration between Jacopo and Giovanni, with the latter responsible for all of them except the bearded prophet on the extreme left, which he gives to Jacopo; of the main figures, he sees Giovanni as responsible for the head of Saint Jerome, the drapery of Saint Richard and some of the drapery in the other figures. Seymour also sees the central predella relief of the Pietà as by an assistant. Hanson rejects the entire upper portions for Jacopo, except possibly the Saint Ursula, but believes that the reliefs below saints Ursula, Lawrence, and Jerome are entirely by Jacopo.

Besides a *garzone* named Masseo and Giovanni da Imola, Nanni di Jacopo and Antonio di Andrea worked for Jacopo in Lucca. The last-mentioned also turned up in Bologna in 1428, as Supino (*Jacopo della Quercia*, 1929, p. 36) reports.

Comment: In order to achieve a working chronology for the various parts of the altar, the confusing situation surrounding the documentation requires a critical review.

More than a year before Malpigli's letter, Lorenzo Trenta obtained permission to rebuild the chapel in San Frediano, according to Pietro Carelli's seventeenth-century history of the

church, "Notizie antiche di San Frediano," located in the Biblioteca Governativa di Lucca, MS. no. 415 (see doc. 32 and comment). That the chapel was entirely rebuilt in little more than a year is difficult to imagine. Lorenzo must have begun the planning and the actual construction of the chapel, together with its elaborate altar, before permission was granted, which in this case must have been merely a legal confirmation of an agreement already entered into with the church officials. Certainly for a man of his power and wealth (for which see M. Paoli, "Jacopo della Quercia e Lorenzo Trenta"), such a scenario would not be impossible.

The Trenta were a wealthy internationally oriented Lucchese family of merchants with connections in Flanders and Paris; in addition to their other businesses, evidently they traded in precious and artistic objects. Lorenzo's son Girolamo seems to have been in charge of the embellishment of the chapel in San Frediano. He certainly had connections with Florence, where he is known to have been in 1418. See Mirot and Lazzareschi, "Lettere di mercanti lucchesi da Bruges e da Parigi (1407–1421), *Bolletino storico lucchese*, (1929), 1:165–199, esp. p. 192*n*1). For what is left of the Trenta archives, see ASL, Dono Domenici. Lorenzo's father Federico was trained as a doctor. Bacci, "L'altare della famiglia Trenta in S. Frediano di Lucca" has a summary of the documentation.

First Phase: 1410/1411–1413: Jacopo must have been in Lucca on and off steadily from 1410 to the end of 1413, although he is documented back in Siena from June through November 1412 (docs. 34–38). December 26, 1413, when he leaves Lucca, marks the end of the first phase of work on the *Trenta Altar*. It is difficult to determine when this phase began, which included the design of the *ancona,* the procurement of the marble, the *abbozzatura* of the upper portions and most of the figurative and decorative sculpture for the same zone. The Trenta arms for the chapel itself, located high on the exterior wall above the arches of the nave, and which were obliterated when the chapel changed patronage, must date from this time as well and were probably made by Jacopo's shop. I suggest that he began the Trenta project—he was responsible also for the rebuilding of the chapel—in ca. 1410/1411, when simultaneously he was carving the large statue of an apostle for the cathedral (see cat. 6). On and off from 1410 to 1412 he would have worked on the building aspects as well as preparing the blocks of stone for carving. Then in 1412–1413, most of the sculpture for the upper portion was executed (that is, before he fled from Lucca under a dark cloud). The style is consistent with the drawing for the *Fonte Gaia* (cat. 3), the *Lucca Apostle,* and the *Benedictine Saint* (cat. 7).

Second Phase: 1416: The second phase of Jacopo's activity on the altar was brief, from about April 1416 until the end of the year (doc. 59). But since he was also executing the Trenta floor tombs, which bear the year 1416, he would have had relatively little time for the altar. His chief assistant, Giovanni da Imola, was still in prison, making it all the more difficult to move ahead on the project.

Shortly before Jacopo's reentry into Lucca in 1416, according to Carelli ("Notizie antiche," fol. 20v), Lorenzo Trenta received permission, on February 16, "di poter refare et renovare [not "remontare," as is sometimes erroneously given] l'altare di San Riccardo in detta cappella et in quella puonerci il corpo di San Riccardo che per l'avenire si chiamasse l'altare dei Santi Riccardo, Gerolamo et Orsola come per [not "fu"] contratto per man di ser Pietro di ser Simone Alberti." The register for 1416 of Ser Pietro di Simone Alberti (ASL, no. 446) is missing, and consequently Carelli's information cannot be confirmed. Still according to Carelli, two days later the body of Saint Richard was solemnly placed at the new altar (docs. 57 and 58). If this exceptional chronology is correct, the only reasonable explanation is that the permission was simply *pro forma,* as I have suggested, with the assignment of the

chapel. Carelli's references to the document notarized by ser Mazino Bartolomei on February 18, 1416, may however be traced, contrary to published opinion, because most of his books are actually extant. On the date in question, an act was indeed drawn up by the notary involving the Trenta and the church of San Frediano, one in which the chapel is specifically mentioned (doc. 58). The contents, however, are quite different from what Carelli reported, if this is indeed the notice he was citing. Lorenzo Trenta was *procuratore* in the rental of part of a large lake located between Lucca and Torre del Lago, called Lago di Massaciuoccoli. The document was drawn up at San Frediano "in capella noviter constructa a Laurentio olim magister Friderigi Trenta." No mention is made of the body of Saint Richard, however. Consequently the data given by Carelli, who seems to have been motivated by a desire to firmly establish the cult of San Riccardo at San Frediano, should be taken *cum grano salis*.

A similarly suspicious situation arises when examining another bit of data supplied by Carelli, who reports that on "... dì 2 Novembre il detto anno [1416] il priore di San Fridiano rattificò la translatione del corpo di San Riccardo fatto come sopra, per man' di detto notaio [ser Mazino Bartolomei]." The document with this text cannot be found either, but for the same date that notary affirms that the prior of San Frediano and the canons were convocated for the purpose of renting a building to Lorenzo Trenta (doc. 61). Girolamo acted on his father's behalf, but nothing is said about the translation of San Riccardo's body.

If the events as described by Carelli have any truth, then the altar table must have been prepared, and quite possibly the upper portion of the *Trenta Altar* was also finished and in place. Jacopo could not have been aided by Giovanni da Imola, who languished in prison, in executing whatever sculpture was done on the altar (and the tombs) in this phase.

Third Phase: 1417–1419: On June 17, 1417, Girolamo Trenta, Lorenzo's son, arranged for Giovanni's release from prison by paying the fine, originally set at 300 florins but reduced by one-third. Since the Trenta were responsible for his release we must assume that they were anxious for Giovanni to get back to work for them, especially because Jacopo was so deeply occupied with finishing the *Fonte Gaia*. This period, from April 1417 until September 1419 (when Giovanni came to Siena; see doc. 94), represents the third phase of work on the *Trenta Altar*, one in which Jacopo must have had only a minor role. In this phase, I suggest that Giovanni finished any remaining work that might have been left for the upper section, probably limited to minor decoration, detailing, and polishing. He may also have had to do the same for the tomb slabs. Quite possibly an expansion of the altar was decided upon, perhaps already in 1416, and Giovanni was concerning himself with preparations for that zone, too.

Fourth Phase: 1421–1423(?): The final phase on the *Trenta Altar* must be pinpointed to 1422, the year inscribed on the altar along with Jacopo's name. He appears to have stayed in Siena until the end of 1420, but there are no notices of him there in 1421 and 1422, when we can assume he was back once again in Lucca. On May 5, 1422, Jacopo's father gave him the power of attorney to collect certain debts owed to him by Giovanni da Imola (doc. 106). We know that Giovanni was also in Lucca, available as Jacopo's collaborator. I suggest the Trenta family had been so pleased with the upper portion of the altar that they were motivated to add the predella, perhaps as early as 1416. The articulation of the main field does not in itself call for a base element, and in any event the predella does seem to have been an afterthought. In any case, a stylistic break with the other portions of the altar has been widely observed by scholars, and most associate the predella with the 1422 date, an opinion I share. Furthermore, the predella was never quite finished: the Miracle of the Body of Saint Richard and the adjacent relief of Saint Cristina were never given a final polishing, which indicates that Jacopo left off work abruptly. Even the inscription with its date may

have been added by order of the patron after the departure of Jacopo (and of Giovanni da Imola), a suggestion supported by Del Bravo (*Scultura senese*, p. 41 and *n*41) following Beck's review of Hanson, *Jacopo della Quercia's Fonte Gaia* in *Art Bulletin* (1966), 48:115. After all, the Trenta had spent a great deal of money and rightly desired that the name of the well-known sculptor be prominently displayed.

Of course some of the circumstances and the chronology suggested here are not based upon confirmable documentation, but rather upon a reading of the monument and upon experience with the habits of the artist.

A. C. Hanson (*Fonte Gaia*, pp. 58–59) is the only scholar to have made useful observations about possible antique quotations in the *Trenta Altar* predella, which after all does have a late classical sarcophagus (which contained that for the relics of Saint Richard) tucked under the altar table. Jacopo's relation to the antique can be readily isolated in examples from the so-called minor arts, especially Early Christian ivories and metal works.

Catalogue 6. The *Lucca Apostle*

Illustrations: Figs. 40–42.

Location: Left transept, San Martino, Lucca.

Material: Marble.

Dimensions: 254 cms (height, including base of 13 cms).

Date: ca. 1411–1412.

Description: The free-standing statue was originally placed outdoors, on the north flank of the cathedral over the side aisle (not the south, as stated in Seymour, *Quercia*, p. 36). Thus situated, standing freely, it could have been viewed from at least the front and the side by observers on the ground.

The confident young apostle stands easily, holding what seems to be the end of a scroll in his left hand. He gathers the drapery, which falls in broad sweeps, with that hand; the anatomy of the upper right leg is, nevertheless, exposed. Movement or even potential movement is suppressed, apparently having been deemed inappropriate for the statue's distant position isolated against the sky. The elongated proportions create an attenuated torso, but the thick neck supports an oversized head, so arranged to compensate for natural distortion when viewed from below. The pupils of the eyes are carved. The solid, powerful feet are covered by a legging, with the strongly wrought toes exposed.

Condition: Due to weathering, damages and losses have been incurred: most of the left arm is missing, and the added wedge that formed part of the right arm has been separated; indeed, the arms were originally carved from separate stones and patched onto the central block from which the figure was rendered. The head has also suffered: the end of the nose has been worn away or broken off: The most serious damage for reading the figure, however, is the discoloration and complete breakdown of the original surface, which has acquired a mottled color and pockmarked texture.

Documents: None.

History: The *Apostle* stood above the north flank of the cathedral, presumably from the time of its original installation until 1938, when it was transferred indoors and placed near the *Ilaria Monument*.

Critical tradition: The attribution to Jacopo, first put forward by E. Ridolfi (*L'arte a Lucca studiata nella sua cattedrale,* 1882, p. 116), was followed by Cornelius (*Quercia,* 1896), pp. 75–76), and has been accepted by all later writers on Jacopo della Quercia. Discussion has centered not on the attribution but on the dating, with opinion fluctuating between 1412 and 1422 and even later (Del Bravo, *Scultura senese,* 1970, pp. 44–45). The argumentation concerning the date is based upon two assumptions: (1) the chronology accepted for the *Trenta Altar,* and (2) the presumed relationship with Donatello's marble *David* and to a lesser extent with Nanni di Banco's *Isaiah.* F. Bellini sees the connections with Donatello as "generiche e più somatiche che stilistiche" in her fine entry in *Jacopo della Quercia nell'arte del suo tempo* (1975), pp. 140–141, countering Morisani (*Tutta la scultura,* 1962, p. 66).

Comment: A vague *terminus post quem* has been adduced from the document of May 4, 1411 (doc. 31), which provides for the sale of certain properties owned by the cathedral in order to pay for "opere sumptuoso et diversis marmorum et aliorum lapidum sculpturis." The dating of the *Apostle* has been related to the question of some of the large decorative heads on the exterior of the building, which apparently were made in this post-1411 campaign.

Catalogue 7. The *Benedictine Saint* (also called *San Leonardo*)

Illustrations: Figs. 43–44

Location: Casa del Prete, Santa Maria degli Uliveti, Massa.

Material: Polychromed wood.

Dimensions: 155 cms (height).

Date: ca. 1412/1413.

Description: The thin, narrow figure set on an octagonal base wears a Benedictine habit; he holds a red book in his left hand and with the right tenderly gathers the folds of his garment. A vague allusion to contrapposto is produced by the relaxed left leg and the weight-bearing right one. The oval-shaped head, with hair snugly following the contours, looks straight out but without a fixed gaze. The eyes are articulated with painted pupils.

Condition: Generally good, especially after the cleaning of 1954 in Pisa, when the original painted surface was revealed.

Documents: None.

History: The statue seems always to have been in the area of Massa, formerly in the church of San Leonardo. It was exhibited in Florence in 1990 as part of *L'età di Masaccio,* held in the Palazzio Vecchio.

Critical tradition: Published for the first time by P. Sanpaolesi in 1938 ("Una figura lignea inedita di Jacopo della Quercia"), it is generally accepted as by Jacopo or by his Lucchese shop; at least some direct participation by the master himself is favored by the majority of scholars, including Nicco (Fasola), Del Bravo, and Carli (see *Gli sculturi senesi,* 1980, p. 32, where he says the head is undoubtedly autograph). Morisani (*Tutta la scultura,* 1962, p. 78) assigns the sculpture to a faithful collaborator "ma non certo al maestro," while Seymour (*Quercia,* 1973, p. 57) calls it by a follower. The attribution and dating are closely related to assumptions about the *Trenta Altar,* to which it is ultimately related. Those who believe that the altar's standing saints were worked only between 1416 and 1422 date the *Benedictine*

Saint to that span, while those who see 1412/1413 as the period of the saints' carving, as I do, place this handsome figure during the first phase of the *Trenta Altar*.

Comment: The style of the figure is related to the preparatory drawing for the *Fonte Gaia* (cat. 3) as well as to the standing saints on the *Trenta Altar*, with the arrangement of the hands most like that of the Saint Lawrence, and in this regard also related to the *Apostle* in Lucca (cat. 6). Of the same stamp are several of the splendid busts from the top of the altar in San Frediano. The head looks up slightly, perhaps an indication that it was made to be placed slightly below eye level.

While not among his finest works, the figure represents one of the earliest identified examples of Jacopo's activity in wood carving, along with the *Annunciate Virgin* recently recovered in Siena (cat. 4), a sculpture with confident, sweeping draperies, one that I consider to be by Jacopo himself. On the other hand, there is no relation to the relief of St. George in Cesena (Handlist 13) as suggested by M. Scalini in L. Berti and A. Paolucci, eds., *L'età di Masaccio* (Milan, 1990), p. 106.

Catalogue 8. The *Lorenzo Trenta Tomb Slab*

Illustration: Fig. 45.

Location: Cappella di San Riccardo, San Frediano, Lucca.

Material: Marble.

Dimensions: 247 × 122 cms.

Date: 1416.

Description: The tomb slab for Lorenzo Trenta rests next to one of identical measurements (cat. 9) dedicated to his first wife, with their heads oriented toward the altar in the family chapel, as is customary. The effigy of Lorenzo Trenta is rendered with a projection of only a few centimeters. In quiet repose, Lorenzo's sensitive hands are crossed; he lies upon a blanket or drape whose fringes are fully visible at the bottom and at the corners of the top portion. Turned slightly to the right, that is, toward his wife, he is capped by a turbanlike headress that cascades down on the left side. A large tasseled pillow with incised decoration serves to enframe the head gently resting upon it. Another similar though smaller pillow supports his feet. An important aspect of the design is the substantial inscription, rendered in bold, deeply incised Gothic letters. Below the feet, which are covered with tight-fitting footwear, are a cross and an escutcheon that once bore his arms.

Condition: Like its counterpart, the slab, whose refinements and subtleties are no longer legible, is severely worn.

Documents: None.

Inscription: +HOC EST SEPULCRUM LAURENTII QUONDAM NOBILIS VIRI MAGIS-TRI FEDERIGI TRENTA ET SUORUM DESCENDENTIUM. ANNO MCCCC16.

History: Lorenzo Trenta ordered his tomb (and his wife's) during his lifetime. He died in 1439, when the tomb is described as finished and located in the Chapel of Santa Caterina adjacent to the church, where the remains of his ancestors rested. In his will of 1439, in fact, is the following passage: "in tumulo seu sepulcro iam diu constructo in cappella sancte Katerine constructa in ecclesia sivi apud ecclesiam sancti Frediani de Luca in quo positum et sepultum fuit corpus suit patris et corpus avi paterni sui ipsius testoris" (cited in Lazzareschi,

"La dimora," p. 72). By the mid-sixteenth century, when Vasari saw it, the tomb (and presumably its companion; see cat. 9) had been moved into the church in the Cappella di San Riccardo, which probably had occurred already in the previous century.

Lorenzo's father Federigo, a medical doctor, had left a provision in his own will of 1387 instructing his heirs not to have any sort of stone marker for his tomb ("prohibuit expresse poni super eius tumulo aliquem lapidem"; cited in Lazzareschi, "La dimora," p. 72*n*3).

Critical tradition: Vasari quite remarkably identified the author of the tomb as Jacopo della Quercia—although he mistook the effigy for Lorenzo's father Federigo—and ever since, it has been associated with the sculptor's *oeuvre*. It is widely if not universally considered to be autograph, but questions of collaboration and dating have been raised. The inscribed year 1416 has been taken as the *terminus ante quem,* but not necessarily for the year when the slab was started, which has been placed by some writers as 1412/1413. If this is correct, a collaboration with Giovanni da Imola, who was arrested in 1414 and not available again until 1417, would have been chronologically possible. Consequently those who see a role for Giovanni in this tomb and its companion (see cat. 9), must assume that they were carved early, around 1412/1413, and that the 1416 date represents a final stage when Jacopo and his assistants put on the finishing touches, an opinion shared by Bacci (*Quercia*) and Seymour (*Quercia,* 1973, p. 42). More recently M. Paoli ("Jacopo della Quercia e Lorenzo Trenta: Nuove osservazioni e ipotesi," 1980) claims that the date of 1416 coincides with the placing of San Riccardo's relics in the chapel and has no particular connection with the execution of the monument (see cat. 5 for a discussion of the reliability of the notices of 1416). He suggests that the carving of the slabs was either before 1414 or between 1414 and 1416, and by some unspecified Sienese helper who Jacopo left behind in Lucca for the purpose.

Comment: Paoli's proposals are not acceptable because: (1) the date of 1416 seems to have been conceived with the rest of the inscription, and was not an afterthought; and (2) the slabs were not made for the San Riccardo Chapel, as Paoli assumes, so that whether the relics of the saint were placed there in 1416 or not—and there is some ambiguity on this point, anyway—has no relevance for the tombs. A more symptomatic date for the chapel and its furnishing is actually 1422, which is incised upon the altar and on the servants' floor tomb in florid Gothic letters: PER FAMULIS SUE DOMUS AND PELEGRINUS AC PAUPERIBUS Xi PRO SALUTE SUE MCCCCXXII. It is not certain whether this servants' tomb was also brought from the Cappella di Santa Caterina with the tombs of Lorenzo and his wife, or whether it was made originally for the San Riccardo Chapel, which I believe is more likely. This tomb was also produced by Jacopo's shop, by Giovanni da Imola or even the aged Piero d'Angelo.

Such doubting of dates so prominently inscribed on both tombs is unnecessary, and if 1416 is correct, then the attribution to Jacopo of both the design and the execution of the *Lorenzo Trenta Tomb Slab* is increasingly convincing. After all, he was present and available in Lucca for many months in that year, when Giovanni da Imola was in prison. Undoubtedly Jacopo had some assistance, but the full responsibility and most of the carving are Jacopo's.

There has been discussion in the older literature as to whether these tomb markers are for Lorenzo and his wife specifically, or for the male and female lines of the family more generally. On the one hand, the conflict seems to be answered by the inscriptions. During the early quattrocento, male and female family tombs were not uncommon. For example, on December 22, 1418, the Pulci in Florence sued the *frati* of Santa Croce because they had promised but failed to provide for "due sepulture honorevoli e condecemti *[sic]* alla nobiltà de' decti Pulzi, coperte di marmi, l'una pe'maschi e l'altra per femene dela decta chaxa" which had been agreed upon back in 1414 (ASF, Mercanzia, no. 1268, fols. 3–6v). Closer to

home, it seems there were tombs for the male and female lines in the Guinigi Chapel in San Francesco, Lucca, according to Lunardi, *Ilaria,* p. 12 *n*3.

The effigy of Lorenzo Trenta compares effectively with the Ilaria Monument effigy, considering the time that had passed, and noting that the Trenta effigy is carved in much lower relief and that, unlike the Ilaria, it was conceived to be seen from above.

Catalogue 9. The *Isabetta (Lisabetta) Onesti Trenta Tomb Slab*

Illustration: Fig. 47.

Location: Cappella di San Riccardo, San Frediano, Lucca.

Material: Marble.

Dimensions: 244 × 123 cms.

Date: 1416.

Description: This tomb matches that of Lorenzo Trenta (see cat. 8). The woman's head is tilted to her right in the direction of her husband, who lies to her left when viewed from the feet of both slabs and looking towards the altar. Her largish hands are crossed and her head rests upon a puffier but somewhat smaller pillow than the effigy of her husband. At her feet is another pillow. Unlike Lorenzo's feet, shown flat on the plane parallel to the surface, Isabetta's feet appear to have been foreshortened, although they are covered by her clothes. She seems to have had a large band on her head, like Ilaria, and also is dressed in a high-waisted, flowing garment. The funerary sheet upon which she rests has knots at the top, producing the effect of a arched niche, while the material floats down in wide sweeps at the edge, ending in a elaborate decorated border.

As is the case for the companion monument, the bold inscription was conceived within the total design.

Condition: Like its counterpart, the monument is severely worn, and not legible in all its sculptural refinements and subtleties. It is imperative to recognize that the woman's slab has suffered even greater wear than her husband's, and therefore is more difficult to "read."

Documents: None.

Inscription: + HOC EST SEPULCRUM DOMINARUM ET DESCIENDENTIUM LAU-RENTII QUONDAM NOBILIS VIRI MAGISTRI FEDERIGI TRENTA DE LUCHA ANNO MCCCCXVI.

History: See cat. 8. Lorenzo Trenta had two wives, Isabetta Onesti and Giovanna Lazari, whom he married in 1426. From early accounts we know that the woman represented here is an Onesti, whose arms were once carved on the escutcheon at her feet, where there is also a cross. (See Lazzareschi, "La dimora," p. 73.) The precise name of Lorenzo Trenta's first wife—Isabetta Onesti—was discovered by M. Paoli (Arte e Committenza, p. 244).

Critical tradition: If there is fairly general agreement that the *Lorenzo Tomb Slab* was made by Jacopo della Quercia, the consensus concerning his wife's slab is quite the opposite. Critics have found it more curvilinear and essentially more "Gothic." The sculptor most frequently suggested is Giovanni da Imola; one should realize that the name has been proposed essentially without considering the problem of chronology or the very limited knowledge we have of Giovanni's independent style as a sculptor. D. Bruschettini, in *Jacopo della Quercia nell'arte di suo tempo* (1975), p. 137, observes that the overall design is

Jacopo's and further, that the relief representing San Marco in the Sienese cathedral, Giovanni's only certain work, does little to confirm the attribution of the slab to him, contrary to Seymour and other recent writers. Pope-Hennessy (*TLS*, Nov. 30, 1973, p. 1476) rejects outright the attribution to Giovanni.

Comment: See cat. 8. If the condition is taken into account, I believe that a good case can be made for assuming that this tomb is by Jacopo della Quercia and that differences between the male and female effigies are due in part to the more severely worn state of the woman's tomb and the differences in custom and conventions in the rendering of a man and a woman.

Catalogue 10. The *Fonte Gaia*

Illustrations: Figs. 49–73.

Location: Loggia, Palazzo Comunale, Siena.

Material: Marble.

Dimensions: Overall, 1.32 meters (maximum height); 10.16 meters (width, central portion); 5.55 meters (width, side wings).

Date: 1408–1419; the sculpture, 1414–1419.

Description: A description of the original appearance must be based upon: (1) the old photograph of the whole before the displacement (fig. 48); (2) the "copy" now in the piazza; (3) plaster casts taken in the nineteenth century of individual parts housed in the Palazzo Comunale and other copies and versions; and (4) the extant portions of the fountain in its modern but misleading arrangement in the Loggia of the Palazzo Pubblico.

The fountain has a trapezoidal plan, enclosed on three sides by walls that are articulated on the inside (i.e., facing the water basin) with relief sculpture and on the outside by marble-incrusted slabs. The fourth side is open and provides access to the water, which, in turn, affected the way the sculpture was viewed, not to mention the impact of reflected images and joyful sprays. Designed for accommodation to the sloping site, the wings are lower at the front where the free-standing statue had been placed. The long back wall had a Madonna and Child in the center in a semicircular niche flanked by a pair of angels in still more elaborated niches. Two niches with seated allegorical figures, separated by wide pilasters containing floral decoration, balance each other on either side of the central Madonna and Child who, in turn, are flanked by angels. Similar figures occupy both wings together with a relief of the Creation of Adam on the left and the Expulsion of Adam and Eve from Paradise on the right. These *istorie* and Virtues are not in simple rectangular niches like those on the back wall since their tops and bottoms tend to converge on the sloping site. Furthermore, a slight shift in scale between them and their sisters on the back wall, as well as a more dramatic shift between them and the figures in the narratives, may be detected. Nor have these reliefs been made to be viewed purely "head on," as was pointed out by Pope-Hennessy (*TLS*, Nov. 30, 1973, p. 1475). The disposition of the sculpture is as follows (cf. fig. 48):

Fortitude	Prudence	Angel	Virgin	Angel	Justice	Humility
Hope					Temperance	
Wisdom					Faith	
Creation of Adam					Expulsion	
Amor Dei					Amor Proximi	

Condition: Poor.

Documents: The Comune of Siena decided to have Jacopo make a fountain in the campo ("locaverunt ad faciendum fontem campi cuidam magistro Iacobo") on December 15, 1408, for not more than 1,700 florins (doc. 22). Slightly over a month later the exact terms of the commission were spelled out in detail and the sum was raised to 2,000 florins (docs. 25 and 26); whether this was the result of a new plan for the project or merely a new and more precise contract with the sculptor is a matter of conjecture. I believe that Jacopo, when working out the project once it had been officially assigned to him, found that the funds were insufficient and insisted upon more money.

The documentation is rich. Essentially no work on the fountain was undertaken until the beginning of 1414, although occasional payments to Jacopo were made in 1412, when efforts to get the project underway seem to have been particularly strong (docs. 34, 38). At the beginning of 1415, the program for the fountain was expanded (doc. 54). About two-thirds of the work on the fountain appears to have been completed by August 1, but not necessarily two-thirds of the sculpture (doc. 55). Discrepancies between the provisions of the previous agreements were rectified on December 11, 1416 (docs. 63–64). On September 17, 1417, Jacopo promised to complete all the work on the fountain within four months, in the first of a series of such extensions, but the final resolution of the contract was recorded only on October 20, 1419 (docs. 78, 84, 91, 96).

Under the year 1416 a local chronicler reported:

> La fonte del Campo di Siena si dilibaro di guastare e di farla di nuovo di marmo intagliata di figure e altri ornamenti. E così si guastò, e mesevisi due tina dacanto; s'inpivano d'aqua per chi ne voleva; e fecesi uno stecato intorno a la muraglia, perche la gente non desse inpacio a chi murava. Di poi si fè che la detta aqua andava per condotto a piè al palagio, e misevisi una colona intagliata di figure che pisciavano aqua, a pie era una tina che vi cadeva la detta aqua, ed eravi ancora di quele figure che pisciavano fuore delle tina. (Muratori, *RRIISS,* vol. 15, part 6, fasc. 9, p. 788)

This temporary fountain had been put up to fulfill the needs of the population while the new *Fonte Gaia* was under construction. One has to wonder whether Jacopo himself devised those clearly amusing figures that "pissed water." We know from payments that some important local artists were involved, including Giovanni di Turino and Martino di Bartolommeo. The payments were published in Bargagli-Petrucci under December 31, 1417 (but referring back to August 15, 1416, the Day of the Assumption of the Virgin):

> Questa è una ragione renduta per Chimento di Biagio, trombatore, d'una fonte che esso fece per la festa di Sancta Maria d'Agosto l'anno 1416 a' piè el palagio de'magnifici signori Priori, de le spese facte in essa fonte et etiamdio de la sua fadiga.

> In primo ò trovato che 'decto Chimento spese in xxii lire di cera per fare le figure de la fonte e tragietarle da Simone di Sano Tegliacci, libr. dieci; et a due orafi che fecere le figure 22 d'essa fonte libr. vi, sol. sviii; a Giovanni Turino, orafo, sol. 33, et per disegnature 33 figure, libr. 4 sol. 10. Anco per le canne del piombo de la decta fonte a Checcho stangnataio *[sic]* libr. septe; maestro Martino per dipignitura de la concha et la colonna et per la concha, libr. 3. Anco per la colonna et per lo pedistallo al maestro che fece, sol. 44; a Nicholò di Giovanni Venture, pizichaiuolo, che fu con lui la nocte, sol. 16. Anco a trombatori suo compagni, sol. dodici per vino perchè sonarono quando si scoperse *[sic]* la fonte, et per sua fadigha, libr. tre.

> Somma in tucto 40 libr., 13 sol.

Et più à speso al notaro de'Regolatori 10 sol.

E al riveditore d'essa ragione 5 sol.

Somma tucta questa 'scita xli libr., viii sol. e così avere dal Comune.

Anno Domini mccccxvii, die vero ultima decembris, lecta et reddita fuit dicta ratio per supradictum Petrum et officio Regolatorum presentata pro bona et recta. (Bargagli-Petrucci, *Le Fonti di Siena*, 2:334)

The same chronicler reported under the year 1417 that "La fonte del canpo *[sic]* era cominciata a murare" (2:789), and under 1419 we have the definitive statement:

La fonte del canpo di Siena si fornì di fare con figure di marmo con altro bello ornamento, come si vede, co' molta abondantia d'aqua, le quali figure furono fatte per maestro Iacomo di maestro Pietro dalla Guercia da Siena, e lui conpose la fonte, e fè tutte le figure e altri intagli come si vede. Anco maestro Francesco di Valdanbrino da Siena fece una di dette figure, e maestro Sano da Siena murò la fonte d'intorno l'anno 1419. (2:793)

The reference is from the authoritative sixteenth-century history by Tizio, *Historiae senensis* (MS. Siena, Biblioteca Comunale, B III 15, pp. 233–234); cf. G. Milanesi, *Documenti*, 2:69n; Della Valle, *Lettere senesi*, 2:162–165; and A. C. Hanson, *Fonte Gaia*, p. 97, doc. 43.

In the somewhat later *Diario senese* (1723) by G. Gigli we have the following:

Ma questa fontana [the *Fonte Gaia*] ebbe poi i suoi maggiori ornamenti da Jacomo di maestro Piero della Guercia scultor sanese intorno agli anni 1419 il quale per dua mila ducento fiorini d'oro vi lavorò quei rilievi così belli e quelle statue, che ancor oggi vi si vedono; onde Jacomo della Fonte fu denominato, e fu fatto perciò Rettore dell'Opera. Dice il Tizio che in ambe quelle due statue, che si veggono sopra la Fonte, significò lo scultore Acca Laurenzia figurata nella Lupa nutrice de due gemelli . . ." (2:187–88)

History: Injury to some of the sculptures has been noted over the centuries. In 1759, the Sienese sculptor Giuseppe Mazzuoli repaired "quella statua già lavorata nel 1419 da Jacomo della Quercia," the so-called Rea Silvia, which had fallen and was broken in pieces in 1743, as reported by G. A. Pecci, *Diario senese* (MS. Siena, Biblioteca Comunale, A IX 6, f. 80; cited by Bacci, *Francesco di Valdambrino*, p. 308 and A. C. Hanson, *Fonte Gaia*, p. 112–113, docs. 130 and 131). The lower segment of the woman and the child are clearly a restoration.

Della Valle, *Lettere senesi*, 2:163 reports another loss: "Nel sovracilio del fonte eravi la figura di un bambino sedente, il quale a giorni nostri fu ridotto in pezzi e disperso da alcuni pessimi giovinastri." We have no clue as to what this seated child was, or what function it had, unless it was one of the putti sitting upon one of the she-wolves.

Shortly before the demolition of the *Fonte Gaia*, Romagnoli (Biografia Cronologica, III, fol. 632) described that ". . . sono quattro piccole lupe che gettano acqua, al presente così deperite che appena si conosce ciò che rappresentano." These wolves were already mentioned in a poem attributed to a certain Vittorio Campatiticense, called *"De ludo pugnae"*:

Nomine fons Gaius, quem circum candida totum Marmora circumdant miris caelata figuris. De quibus astantes, signa urbis quatuor amplo Miscent ore Lupae limphus per concava fontis. (cited by Della Valle, *Lettere senesi*, 2:155)

Jacopo's fountain replaced one constructed in 1343 (Muratori, *RRIISS*, vol. 15, part 6, fasc. 9, p. 538*n*) that was "non molto grande" and that had replaced a still earlier one. A statue of Venus found while excavating a building site in Siena was placed on an earlier fountain. It was destroyed and pieces placed on Florentine territory by superstitious officials a few years afterward. Ghiberti claims to be familiar with the statue, said to have been by Lysippus, through a drawing by Ambrogio Lorenzetti, which also could have been available to Jacopo della Quercia. See Morisani, ed., *I Commentari*, where the fascinating passage reads in part:

> Una ancora [statua], simile a queste due, fu trovata nella città di Siena, della quale ne feciono grandissima festa e dagli intendenti fu tenuta maravigliosa opera, e nella base era scritto il nome del maestro, il quale era eccellentisimo maestro, il nome suo fu Lisippo; ed aveva in sulla gamba in sulla quale ella si posava un alfino [= delfino]. Questa non vidi se non disegnata di mano d'un grandissimo pittore della città di Siena, il quale ebbe nome Ambruogio Lorenzetti; la quale teneva con grandissima diligenza un frate anticchissimo dell'ordine de'frati di Certosa; il frate fu orefice ed ancora il padre, chiamato per nome frate Jacopo, e fu disegnatore, e forte si dilettava dell'arte della scultura, e cominciommi a narrare come essa statua fu trovata, facendo un fondamento, ove sono le case de' Malavoti; come tutti gli intendenti e dotti dell'arte della scultura ed orefici e pittori corsono a vedere questa statue di tanta meraviglia e di tanta arte . . . (p. 56)

Ghiberti must have had this experience on one of his trips to Siena for the *Baptismal Font*, perhaps in 1416 or 1417.

In a contemporary reference Jacopo's fountain is mentioned by Saint Bernardino: "O [voi] dalla fonte, che state a fare il mercato, andatelo a fare altrove. Non odite o voi dalla fonte." Apparently those addressed were standing around the *Fonte* conducting business instead of paying proper attention to the preacher's words.

In a mid-fifteenth-century manuscript dating after December 8, 1443, entitled "Statuti per li fonti di Siena" (Biblioteca San Lorenzo, Florence, Ashburham 682, fols. 8ᵘ−9, n.n.) we find "la fonte del campo detto Fonte Gagia. . . ."

The monument was dismantled in 1858 and recomposed, with substantial losses and approximations, in the Loggia of the Palazzo Comunale only in 1904, on the occasion of the Mostra dell'Antica Arte Senese. The position of the nineteenth-century "copy" on the Piazza del Campo had been shifted 9.60 meters to the left (for a viewer with his back to the palace) and backwards 1.55 meters, that is, further away from the palace. In addition to minor discrepancies, the copy is devoid of the standing figures of the two women and the two children that accompany each of them on the outer edge of the balustrade. Tito Sarrochi's substitution was finished in 1868.

Critical tradition: Serious doubts about the attribution of the sculpture on the *Fonte Gaia* have never been raised, with the exception of the so-called Rea Silvia. This figure has been associated with references in contemporary sources to Francesco di Valdambrino having made one of the statues. Bacci (*Francesco di Valdambrino*, 1936, p. 307) actually assigns it to Francesco. A. C. Hanson (*Fonte Gaia*, 1965 pp. 71ff) takes up the issue but concludes that Francesco's role on the *Fonte Gaia* was essentially supervisory; furthermore, she observes, there are no payments to Francesco for sculpture on the *Fonte*. The differences in style between the two standing women need not, Hanson observes, be the result of different hands, but may represent iconographic requirements of the two diverse historical personages she assumes they depict, as well as differences in the dates of their execution; she finds the

formal language of the two figures essentially the same. On the other hand, Pope-Hennessy (*Italian Gothic Sculpture,* 1958, p. 213) tends to accept the attribution to Francesco di Valdambrino of the "Rea Silvia," as does Seymour (*Quercia,* 1973, pp. 44, 53). Among the modern scholars, those in addition to A. C. Hanson who reject a role for Francesco in this figure include Morisani (*Tutta la scultura,* 1962, p. 25) and Del Bravo (*Scultura senese,* 1970, p. 36), and I am in agreement with them.

Comment: The precise identification of the seated images in relief as well as the standing, in-the-round women is open to interpretation. The former are undoubtedly Virtues, several of whom are now hardly visible at all, and all of whom are difficult to read. Some can be identified by their attributes—Wisdom with a book, Hope characteristically looking upward, Fortutude with a column, Justice with the sword, Faith with a cross—but several are less confidently identifiable. The figure on the back wall at the extreme right, which Tito Sarrochi fancifully turned into a Charity in his "copy," is the most questionable, though its proper definition is important for the iconography of the program and specifically for the proper interpretation of the standing figures. If she were really Charity, then the standing figures, as Charities, would be redundant. I take her to represent Humility.

The entire situation has been appraised by F. Bisogni ("Sull'iconografia della Fonte Gaia," 1977). The earliest mention of the two standing figures is that of Tizio, who refers to them as double images of "Acca Laurentia." In the eighteenth century, they were thought to represent "Pubblica Carità"; see for example G. Savini, *Breve relazione della cose notabili della città di Siena, ampliata e corretta dal Giovacchino Faluschi* (Siena, 1784), p. 89, where occurs the following phrase: "la pubblica Carità espressa nelle due statue." C. Ricci, in *Mostra dell'Antica Arte Senese,* catalogue (Siena, 1904), p. 245, called the "Rea Silvia" standing on the right side, frequently associated with Francesco di Valdambino, "Maternità," while Bacci (*Quercia: Nuovi documenti,* 1929, p. 306) refers to her as "Mother Earth." In 1926 Supino (*Jacopo della Quercia,* pp. 41–42) labeled her "Rea Silvia" to match the "Acca Laurentia," thus positing that the figures represent the mother and the foster mother of Remus and Romulus, founders of Rome (and, according to local tradition, of Siena as well). The identifications proposed by Supino have received wide acceptance.

Determining that Sarrocchi's reconstruction of one of the Virtues as "Carità" was not correct, Bisogni effectively removed the strongest argument for taking one or both women as personification of Charity. Bisogni then proceeded to pinpoint the overall program of the fountain, which he envisioned as a confrontation between Virtues and Vices, a psychomachia, as it were. The woman usually called "Acca Laurentia" is for Bisogni "Liberality," while "Rea Silvia" is "Charity." He sees these Virtues, with the other seated ones, as overcoming Vices, which appear in the drawing in the guise of the dog and the monkey. Bisogni's identification has been followed by Carli (*Gli scultori senesi,* p. 30). Against this interpretation is the fact that the animals, who are located at some distance from the standing figures anyway, seem to be reacting to each other and not to the Virtues, as Krautheimer ("A Drawing for the Fonte Gaia in Siena," 1952) has observed.

I interpret the two figures as two aspects of Charity, reflecting a tradition common to medieval Sienese art: Amor Proximi (not removed from the notion of Public Charity mentioned in earlier sources) and Amor Dei. See R. Freyhan, "The Evolution of Caritas Figure in the Thirteenth and Fourteenth Centuries," *Journal of Warburg and Courtauld Institutes* (*JWCI;* 19xx), 11:68–88 and E. Wind, "Charity: The Case History of a Pattern," *JWCI* (1937/1938), 1:322–330. A latter quattrocento analogy may be found on the *Tron Tomb* by Antonio Rizzo, which is discussed in an instructive paper by D. D. Pincus, "A Hand by Antonio Rizzo and the Double Caritas Scheme of the Tron Tomb," *Art Bulletin* (1969),

51:247–56. If the two extant statues do indeed incorporate these conceptions, the so-called Acca Laurentia on the left, bare-breasted yet aloof and contemplative with one of the children at her breast more specifically represents Amor Dei. The more fully clothed figure traditionally labeled Rea Silvia on the right, who directly and openly looks out toward the spectator, that is, the populace, is Amor Proximi.

Historically connected with the fountain was the idea of the abundance of water. If water were lacking, "sarebbe danno et vergongna *[sic]* de la città di Siena," a document of 1406 specifies, and the need for "Habundantia" of water was mentioned in the previous century as well (see Bargagli-Petrucci, *Le Fonti di Siena,* 1906, 2:4 and 31).

Concerning the election of the Operaio of the aqueducts on June 20, 1425 is the following document:

> Item, veduta et considerato quanto spendio de gli'antichi nostri anno facto in fare venire l'acqua a la fonte del campo e de fonte Branda et quanto honore et utile ne segue a la nostra Città et comodità a tutti e' nostri cittaini et habitatori de quella, et veduto quanto di necessità è l'abbondanza dell'acqua de le fonti predette le quali da uno tempo in qua sonno molto manchate et essi perduta la metà dell'acqua la quale soleva venire a le decte fonti, maximamente quella del Campo (Bargagli-Petrucci, *Le Fonti di Siena,* 2:60)

Undoubtedly, an ample supply of water for the use of the public was one of the most visible and appreciated accomplishments of any Sienese government and must have been, in the final analysis, a political necessity. Public Charity also encompasses this concept: the emphasis upon the abundance of water was almost an equation for "Good Government." Indeed, Krautheimer ("A Drawing for the Fonte Gaia") suggests a civic iconography for the program, an idea that A. C. Hanson (*Fonte Gaia,* pp. 22f) has amplified. The fresco cycle by Ambrogio Lorenzetti in the Palazzo not many meters away has been discussed by Nicolai Rubinstein ("Political Ideas in Sienese Art," 1958, pp. 179–197). As is well known, these frescoes were admired by Ghiberti and thus very much "alive" in the minds of Jacopo's contemporaries. St. Bernardino, another quattrocento contemporary, esteemed these frescoes:

> Io ho considerato, quando so'stato fuore di Siena e ho predicato de la pace e de la guerra, che voi avete dipenta, che, per certo, fu bellissima inventiva. Voltandomi a la pace, veggo racconciare le case, veggo lavorare vigne e terre, seminare, andare a' bagni a cavallo, veggo andare le fanciulle a marito, veggo le gregge de le pecore, ecc. E veggo impiccato l'uomo per mantenere la giustizia: e per queste cose ognuno sta in santa pace e concordia. Per contrario, voltandomi da l'altra mano, non veggo mercanzie, non veggo balli, anco veggo uccidare altrui; non racconciano case, anco si guastano et ardano; non si lavora terre, le vigne tagliano, non si semina, non s'usano bagni, ne altre cose dilettevoli; non veggo, quando si va di fuore, o donne o uomini: l'uomo morto, la donna sforzata; non veggo armenti, se none in preda; uomini a tradimento uccidare l'uno l'altro, la giustizia stare in terra, rotto le bilancie, e le legata co' le mani e co'piei legati; et ogni cosa che altro fa, fa con paura. (D. Pacetti, ed., *S. Bernardino da Siena. Le Prediche Volgari inedite;* Siena, 1935, pp. 458–459)

That Amor Proximi also has to be understood as embracing the notion of Abundantia is supported by an explanation found in Tizio (*Historie senensium,* I, fol. 214v), cited in Piccolomini, *La vita e l'opere di Tizio* (1903), who asserts that the name "Siena" comes from the Etruscan and Aramaic, and signifies "Abbondanza."

Catalogue 11. The *San Gimignano Annunciation*

Illustrations: Figs. 74–76.

Location: Collegiata, San Gimignano.

Material: Polychromed wood.

Dimensions: Angel, 173 cms (height.); Virgin, 174 cms (height.).

Date: CA. 1424–1426.

Inscriptions: On the base of the angel, MCCCCXXVI MARTINUS BARTHOLOMEI DE SENIS PINXIT. On the base of the Virgin, HOC OPUS FECIT MAGISTER GIACOPUS PIERI DE SENIS.

Description: Presumably created for niches that were separated by a few meters, the figures should be read as a tightly related group before they are examined individually. If the frontal masses of the bodies are taken as representative of the principal views, as I believe is the case, the figures turn their heads toward, but not to, one another. The angel gently but emphatically gestures to Mary in an ancient attitude of speech with his upraised right hand, while with the other hand he holds the stem of an olive branch, between the forefinger and the second finger. The Annunciate Mary tilts her head in the direction of the angel but raises her right arm slightly as if to protect herself, while with the left hand she balances a small book. If the angel on the left functions as an openly understood, signifying figure, whose function is to move the narrative beyond itself off to the right, Mary's composition halts that movement, especially with the operation of the left arm at her side. The group was made to be placed substantially above eye level, like the Madonna and Child at Bologna; both are conceived with high octagonal bases, which have been adorned with inscriptions and coats of arms of the church.

The impeccable coloristic features, which are substantially original, enhance the conception and reveal a successful collaboration between painter and sculptor. The uninterrupted orange-red of Mary's garment sets her apart from the angel, whose deep blue-black dress is covered by a heavy red mantle. The two figures and their functions in Biblical narrative are differentiated by physiognomic shifts: the angel is heavier, stronger, more volumetric, with a thicker neck and more classical head; Mary is more sweeping as an overall form, more lithe, with her smaller head, and especially with her finer, more delicate hands and feet. Her drapery is disposed into a single sweeping motif, while that of the angel is more exclamatory. Some portions are deeply cut, as the section of the Virgin's garment covering her legs, which reveals effective and uncompromising control of the medium.

Condition: The sculptures have survived the centuries in admirable condition and present themselves regally with the previous repaintings removed during the most recent restoration, carried out in 1977.

Documents: Although the originals have not been uncovered, a manuscript of *spogli* collected in the eighteenth century contains a record of the total cost of the carving, 110 lire and 10 soldi, in a document of April 1421 (see doc. 103). There is no reason to doubt the authenticity of the copy, and when this is coupled with the information from the inscriptions, it becomes clear that the *Annunciation* should be unambiguously fixed in the *oeuvre* of the master.

History: Jacopo was commissioned to produce the group, as indicated above. The sculpting was, obviously, finished by 1426, when, as the inscription tells us, the painter Martino di Bartolomeo polychromed the two figures. Given the pattern of work Jacopo displayed throughout his career and the fact that Jacopo's position was of greater authority than Martino's, we can imagine that once the pair was carved, Martino went ahead rather quickly with the painted decoration. Thus we can date the actual carving to ca. 1424–1425, that is, immediately before Jacopo began the work in Bologna at San Petronio, or at about the same time. The *Annunciation* was made for the inner façade of the pieve that was frescoed by the Florentine Ventura di Moro; in a later project paintings by Gozzoli were applied to the wall where the works remain today. There were payments for a crown for the Madonna and an olive branch of iron with leaves of leather in 1427 and 1428 (cf. P. Bacci, "Le statue dell' Annunciazione," 1927). The background wall with a God the Father (no longer extant) and damask decoration by Ventura in 1428 is still visible. Evidently the statues were not put into place until after 1427, when the brackets and the little niche covers were done.

Critical tradition: Earlier criticism was reluctant to accept the attribution of the group to Jacopo, until the publication of the document by Bacci in 1927. Sometimes the statues were even given to Martino di Bartolomeo, whose name occurs in one of the inscriptions, which has long been known. The one referring to Jacopo came to light only in 1977, after which time the two works have been universally accepted as Jacopo's. Only G. Brunetti ("Dubbi sulla datazione dell'Annunciazione di San Gimignano," 1977) has raised doubts about a dating in the 1420s, wishing to see it much earlier. The usually accepted date of 1421 has been replaced, correctly, with one closer to 1426 when the statues were painted, as demonstrated by P. Torriti (in Bagnoli and Bartolini, eds., *Scultura dipinta,* 1987, pp. 156–157), who has adjusted his own earlier position (see his "Il nome di Jacopo della Quercia nell' Annunciazone di San Gimignano," 1977, pp. 98–100).

Comment: Not only in my view do these works represent Jacopo at the apex of his artistic maturity, but they also offer a worthy transition to his Bolognese period. Here the sculptor has combined the power of formal, three-dimensional sculpture with a subtle interpretation of the theme, one deeply embedded in the Sienese tradition, both in painting and in sculpture.

Catalogue 12. The *Main Portal of San Petronio*

Illustrations: Figs. 77–129.

Location: Facing the Piazza Maggiore, Bologna.

Material: Istrian stone and red and white Veronese marble; marble from the Lago Maggiore region.

Dimensions (sculpture): Genesis reliefs on pilasters, 99 × 92 cms (with frames); prophets in pilaster strips, 40 cms (height); New Testament reliefs on lintel, 72 cms (height); Madonna and Child (with base), 180 cms (height); San Petronio (with base), 181 cms (height).

Date: 1425–1438 (unfinished). Lintel with Nativity, Adoration of the Magi, Presentation in the Temple, Massacre of the Innocents, Flight Into Egypt, 1426–1428. The putti on brackets, finished 1428; Madonna and Child in lunette, finished 1428(?); San Petronio in lunette, finished 1434), Old Testament subjects—Creation of Adam, Creation of Eve, Temptation and Fall, Expulsion, Adam and Eve at Work, Cain and Abel Offering, Cain Murdering Abel, Noah Leaving the Ark, the Drunkenness of Noah, the Sacrifice of Isaac—1429–1434(?).

Description: The *Portal*, where substantial activity was also undertaken in the early sixteenth century long after Jacopo's death, nonetheless remains unfinished to this day. As it now stands, the portal, which contains a simple post-and-lintel opening deeply set into the mass of the façade wall, represents Jacopo's design and is largely his execution. The unadorned posts are crowned on each side by a bracket that includes a nude *putto*, supporting the lintel, upon which are carved five horizontally oriented scenes from the New Testament. Above, a sturdy round arch composed of plain blocks like the jambs establishes an enclosed semicircular area of "lunette," where the Madonna and Child and San Petronio by Jacopo della Quercia and the later statue of Sant' Ambrogio by Domenico da Varignana are housed.

A high marble base supports the splayed openings, which continue the decorative arrangement of the façade designed as part of the original project by Antonio di Vincenzo, the architect of the basilica. The splayed opening is composed on each side by a twisted column, a pilaster with nine prophet busts, a colonnette with vertical grooves, a decorative three-faceted pilaster, and a segmented one. On the outer surface of the portal, on the same plane as the façade, are substantial historiated pilasters. The five reliefs that make up each of the pilasters are higher than wide. They are separated by decorative bands (*intermezzi*) of a design pattern similar to the same element on the pilasters with the prophet busts.

The articulation of the embrasures is continued in the lunette zone above, at least partially executed in the sixteenth century, when busts were inserted, as was the sturdy base.

Condition: Fair. Considering that the portal sculpture has been exposed to the elements for more than 550 years, the work has come down in reasonably good condition. However, the portal was cleaned and restored between 1972 and 1979, for which see J. Beck, "Reflections on Restorations: Jacopo della Quercia at San Petronio, Bologna," *Antichità viva* (1985), 24 (1/2/3): 118–123, where I express serious reservations, which I will summarize here. After cleaning, the surfaces appear pock-marked, especially in the case of the Madonna; the reliefs have a flatter, more two-dimensional effect than before the intervention; and portions in poor condition were mainly left untouched because the aggressive cleaning would have caused them severe losses. The ultimate result is that different sections and elements reveal different degrees of cleaning. Concern has been voiced about the ongoing conservation of the monument because the layers of film, probably combined with original and later protective applications, perhaps including wax, have all been removed, leaving the sculpture relatively defenseless against modern air pollutants. Public relations pronouncements hardly help to create a dispassionate appraisal of the effects of the restorations; see for example T. Tuohy, "Conservation in Emilia Romagna," *Apollo* (April 1988), pp. 259–261. Recently (1990), it has been determined that the entire portal is becoming grey and "dirty" again. One can only hope that the original sculptured elements will be brought indoors.

Documents: The documentation for the *Portal* is extremely rich, offering a firm foundation for a historical reconstruction of the chronology.

The Contract (doc. 117): Undoubtedly a remarkable document for the entire quattrocento, the contract (doc. 117) drawn up between Jacopo (called Jacopo "della Fonte") and the papal legate to Bologna, the archbishop of Arles, Louis Aleman, on March 28, 1425, is specific on any number of points, although there were changes. Instructions included:

1. The main portal of San Petronio should be made by Jacopo, "intagliatore e maestro del lavoriero di marmore," in the form as it appears in a drawing made by him.

2. Jacopo is to receive 3,600 florins for the work, the first 150 florins from the Fabbrica of San Petronio upon signing the contract.

3. Jacopo promises to complete the work within two years after the stone has arrived at the site.

4. The portal would be between 40 and 43 *piedi* [1 piede bolognese = 38 cms.] in height, and about half that in width.

5. The portal should project out to the basement level (and not beyond).

6. The pilasters of the portal should be 2½ piedi wide.

7. The columns, colonnettes, the bases, and capitals should correspond with what is already present on the building.

8. There should be fourteen individual Old Testament *istorie*, with the figures 2 piedi high.

9. The three historical reliefs on the lintel should have figures 2 piedi high.

10. There should be twenty-eight Prophets, each 1½ piedi high.

11. The Madonna and Child in the lunette should be 3½ piedi high; the pope and San Petronio also 3½ piedi high, standing, and an image of the legate, on his knees, should be in the appropriate proportion.

12. Life-size lions are to be provided at the sides of the portal.

13. The figures of saints Peter and Paul, 5 piedi high, should be made for the place above the pilasters.

14. A seated Christ between 4 and 4½ piedi high, carried by two flying angels four piedi high, should be made (presumably in the gable, in relief).

15. A crucifixion should be carved in a *fiorone* above the gable, 2 piedi high.

16. Jacopo is also obliged to make five figures not in the drawing, a Christ and four others, according to the wishes of the legate.

No doubt modifications in the project were agreed upon from time to time, perhaps the first of them soon after the agreement was signed. Still, the contract stands as the only complete statement of the project.

History: The following is a thumbnail chronology of work on the *Portal*.

1425 Jacopo is paid for the first time for work on the portal in April 1425 (doc. 121). Soon after, Giovanni da Modena begins a large-scale drawing of the *Portal* based upon Jacopo's design (doc. 122). Jacopo must have traveled north to Milan in search of stone in the fall of the year (doc. 129).

1426 A shipment of marble arrives from "Lombardia" (doc. 142). Jacopo is paid in Milan in April (doc. 145) and in Venice in June for Istrian stone (doc. 148), and in Verona for other stone that arrives in July (doc. 151). The stone was, if only in part, for the basement zone and the foundation of the portal, which is begun at this time (docs. 156, 157, and 160). Stone for the door posts ("stipiti") is also mentioned for the first time (doc. 164).

1427 Jacopo makes another trip to Verona for more red marble (doc. 175) and to Venice (doc. 192). Red stone is mentioned for the arch (doc. 184). A scaffolding is constructed at the portal (doc. 196).

1428 Stones that make up the door posts are mentioned again in March (docs. 215, 241, 242, 244, 247, 248, 259). Scaffolding is also mentioned (doc. 221, 238), as are stones for the arch (doc. 226). Door hinges are prepared (docs. 224, 228). A "new drawing" for the portal on a wall is referred to (doc. 227). The pilasters with the prophet busts and other colonnettes are placed on the *Portal* (docs. 252, 253, 254, 255, 256, 260, 261). Stones for the basement level continue to be worked (doc. 264, 267).

1429 In an accounting of January of this year, Jacopo is shown to have received about one-half of the amount due him according to the contract of 1425 (doc. 286). The histories are mentioned as needing to be worked (doc. 297). A contract is drawn up and ratified for Jacopo to do the inner façade of the portal (docs. 305, 308, 309). Ten large Istrian stones are purchased, presumably for the Old Testament reliefs (docs. 315, 316).

1430 Little activity on the *Portal* is recorded in this year.

1431 Relatively little activity on the *Portal* is reported in this year, although some shipments of stone are made (docs. 337, 338, 340).

1432 Marble is purchased in Venice and Verona, including those for the capitals (docs. 344, 345, 346, 349, 350, 353, 357). Scaffolding mentioned (doc. 352). Door hinge is mentioned (doc. 355).

1433 Marble is purchased in Venice and Verona (docs. 370, 371, 373, 375)

1434 Scaffolding at the *Portal* (doc. 393) is removed (doc. 402). The statue of San Petronio is mentioned as having been raised onto the portal (doc. 396). The red marble frieze is prepared (docs. 399, 401).

1435 Jacopo is in Bologna during the second half of year (docs. 423, 428, 435). Work takes place on the inner side (docs. 425, 426, 429).

1436 Jacopo is active in Bologna in this year (docs. 443, 446, 447, 449). New designs are mentioned (docs. 448, 452). Venetian stone is purchased (doc. 451).

1437 Jacopo goes to Verona for stone for the arches and for the brackets to support the lions (docs. 462, 464, 465, 467, 471, 473, 474).

1438 No significant progress on the portal is recorded.

The contract of 1425 was altered or modified rather soon having been drawn up, perhaps several times, and certainly in 1428. Between the contract of 1425 and the time that actual work on the decorative portions was underway, a number of changes must have been agreed upon mutually, including the expansion from three to five for the narratives on the lintel and the reduction from seven to five for the scenes on the exterior pilasters, possibly a change in the number of prophet busts, and the elimination of the images of Pope Martin V and his legate for the lunette. Indeed, the city revolted against papal rule in the summer of 1428, when the papal legate Louis Aleman was expelled (see Beck, *Il portale*, pp. 22–23).

After Jacopo's death the Fabbricieri desired to continue the work on the unfinished *Portal* including the inner side, and sought the services of Jacopo's brother Priamo della Quercia, (see Matteucci, *La 'Portal Magna,'* doc. 133), but apparently nothing came of the efforts. Serious work was only undertaken in 1510 (contract of April 29) when the engineer Arduino Ariguzzi was hired to dismantle the portal, move it forward about half a meter (15 Bolognese

oncie), and put it up again as it was before, as part of a campaign to harmonize the portal and the façade (see Beck and Fanti, "Un probabile intervento di Michelangelo per la 'porta magna' "). At the same time sculptors were hired to execute the busts in the lunette embrasure that Jacopo never made, including Antonio del Minello, Antonio di Domenico da Ostiglia, Domenico da Varignana, and Amico Aspertini (see Matteucci, *La 'Porta Magna,'* docs. 141, 142, 143, 150, 153); Domenico da Varignana executed the *Sant'Ambrogio*. One must assume that certain elements of Quercia's design were altered or dropped, however. Or, they were replaced by new ones. Candidates for sixteenth-century substitutions are the white columns on the portal, as suggested to me by C. Frommel, as well as the tall bases on the lunette level.

Fanti and I ("Intervento," pp. 350–351) assume that Michelangelo played a crucial role at this time. Several years before, he had with great difficulty produced a bronze statue of Julius II that he placed on the *Portal* above the lunette in 1508; he had a first-hand opportunity at that time to examine Jacopo's work carefully, following his youthful encounter in Bologna in the early 1490s. For a notion of the precise location of Michelangelo's statue on the portal, actually in the "gable" where Jacopo had planned a relief of Christ, see N. Huse, "Ein Bilddokument zu Michelangelos 'Julius II' in Bologna," *Mitteilungen des Kunsthistorisches Institutes in Florence* (1966), vol. 12, nos. 3–4, pp. 355–358. The drawing, datable to ca. 1510, is in the Louvre, Collection E. del Rothschild, n. 1466, and is also reproduced in Fanti et al., eds., *La Basilica,* 2:11. See also the contribution of A. Belluzzi, "La facciata: I Progetti cinquecenteschi," in the same collection, pp. 7–28. For a summary of the situation related to Michelangelo's statue see Barocchi, ed., *G. Vasari, La Vita di Michelangelo,* 2:387–401.

When the Bolognese asked permission from Julius II to modify the façade, Michelangelo, who was then busy with the Sistine ceiling, must have been consulted; indeed, he had gone to Bologna more than once to collect money owed to him by the pope. With the Querciesque images fresh in his mind, Fanti and I have suggested that he advised the pope and the legate Alidosi to insist that the Portal be maintained precisely as Jacopo made it. Matteucci *(La 'Porta Magna,'* p. 60n) has expressed doubts concerning the scenario of Michelangelo's intervention, as not sufficently proved. On the other hand, Michelangelo showed respect for the work of early practitioners, including those artisans who made the columns for Old St. Peter's; see A. Condivi, *Vita di Michelangelo,* (Florence, 1938), p. 87. Later on, when he was involved with the building, he tried to maintain a concordance between the Old and the New Basilica, for which see R. De Maio, *Michelangelo e la Contrariforma* (Bari, 1978). Also, as P. Berdini reminds me, Francisco de Hollanda, in *Colloqui con Michelangelo* (Milan, 1945), pp. 260–261, suggests through an account of a purported conversation that Michelangelo had respect for the past by advocating the retention of older structures.

Critical tradition: Matteucci *(La 'Porta Magna,'* 1966, pp. 21–32) gives a thorough exposition of the critical background on the *Portal,* from Vasari's mention in the first edition of his *Vite* (1550) that Jacopo "nel fare le figure in maestà senza torcersi e svoltare le attitutini: e morbidamentes'ingegnò gli ignudi di maschi e di femine far parere carnosi," in what appears to be a specific reference to the portal reliefs.

Beginning with Vasari, if not earlier, the Sant'Ambrogio in the lunette was taken to be by Jacopo della Quercia, an attribution that persisted well into the twentieth century. I published documentation that appears to prove that it was entirely by Domenico da Varignano; see Beck, "A Document Regarding Domenico da Varignana." To be sure, P. Lamo *(Graticola di Bologna,* p. 39) in 1560 had already named Domenico as the author, confusing the statue, however, with the San Petronio. Many authors still continue to see an original role for

Jacopo in the statue: the issue is taken up even-handedly by Matteucci (*La 'Portal Magna,'* pp. 56–59), who considers the statue begun by Jacopo and finished some eighty years later by Domenico, an opinion shared by H. W. Janson (private communication). On the other hand, consideration of the base of the Sant'Ambrogio, much lower and far less blocklike than Jacopo's authentic statues, should serve as a confirmation that he had no role whatsoever. Buscaroli, "Il Fonte Battesmale," pp. 56–57, recognized Domenico's responsibility for the statue.

The documentary accounts that were published in the nineteenth century did a great deal to clarify commonly held mistakes about the *Portal*. Exemplary for its time is V. Davia's *Le sculpture della porte della basilica di San Petronio* (1834), which presents many original documents and seeks to date the reliefs in the period from 1430 to 1433. As Matteucci recognized (*La 'Porta Magna,'* p. 26), Davia ascribes the *Vari/Bentivoglio Monument* to Jacopo in a short study, *Cenni istorico-artistico intorno al monumento di Antonio Galeazzo Bentivoglio* (1835).

Studies by A. Gatti—*La fabbrica di San Petronio* (1889), *La basilica petroniana* (1913), and *L'ultima parola sul concetto architettonico di San Petronio* (1889; 1913)—and especially those of I. B. Supino in his basic *Le sculpture delle porte di San Petronio in Bologna* (1914) and *Jacopo della Quercia* (1926) take up issues raised by the building of the *Portal* and the façade as a whole. Supino, in particular, sets the stage for a modern art historical treatment of the Bolognese portal.

In studies specifically devoted to the *Portal*, following that of Beck (dissertation, 1963, and *Il portale*, 1970) one must also refer to the excellent work of Matteucci, *La 'Porta Magna'* (1966), and the entries in *Jacopo della Quercia nell'arte del suo tempo*, (1975), pp. 220–251. Carli's *Gli scultori senesi* (Milan, 1980) has sensitive observations about Jacopo in general and the *Portal* (see especially pp. 32–33.) Carli continues to believe that the Sant'Ambrogio was roughed out by Jacopo and that the Madonna and Child, although among the earliest works from the portal, was given finishings touches as late as 1434.

In relation to the restoration of the *Portal* conducted in the 1970s, a publication was issued, sponsored by the Centro per la Conservazione delle Sculture all'Aperto in Bologna: *Jacopo della Quercia e la facciata di San Petronio a Bologna*, ed. by R. Rossi Manaresi (Bologna, 1981). Rossi Manaresi wrote an essay, "Indagini scientifiche e techniche" (with an English translation), pp. 225–252; and Ottorino Nonfarmale, the chief of the restoration, also made a contribution; "Metodi di intervento" (with an English translation), pp. 279–289. For Jacopo's role, C. Gnudi's paper should be consulted: "Per una revisione critica della documentazione riguardante la 'Porta Magna' di San Petronio," pp. 13–52, which is largely an effort to reformulate the chronology of work on the portal that I had proposed. Gnudi seeks to date the Old Testament scenes as among the earliest work on the portal, while I dated them to the early 1430s. (I shall treat in detail Gnudi's interpretation of the documents below and under "Comments" to the revelant document entries).

The most thorough new stylistic interpretation is that of L. Bellosi in Fanti, et al., eds., *La Basilica di San Petronio in Bologna* (1983), 1:163–212, with ample illustrations from the monument following the restoration. Bellosi, who follows Gnudi's chronology and is misled by it for the most part, gives nonetheless a highly sympathetic analysis of the artist's Bolognese contribution. He tends, however, to see frequent parallels with Florentine contemporaries, especially Donatello, the same view expressed by Del Bravo in his review of my *Il portale* in *Antichità viva* (1971).

Comment: The "new" reading of the documentation offered by Gnudi ("Per una revisione," 1981) seems to have been motivated by a desire to support a chronology of the sculpture

that coincides with his vision of the artist, formulated decades earlier. His case for a revision is based in large measure on the assumption that much of the actual sculpture Jacopo carried out was carved in "Lombard" marble from the Lago Maggiore region north of Milan, more specifically marble from Candoglia, a stone widely used for sculpture at the cathedral of Milan. There is no doubt that Jacopo went to Milan to purchase "white" marble, but exactly what that marble was and for what purpose is not easy to determine from the documents. The visual evidence does not contribute to Gnudi's thesis, since pinkish-rose Candoglia marble is quite unmistakable to the naked eye. And, of course, there are different kinds of marble from the Lago Maggiore region, anyway. (I would not preclude outright that such stone was used in making portions of the portal, but it does not necessarily mean that it came form Candoglia, in any case, nor that it was used for the principal sculptural elements. A few pieces seem to have found their way into the base level of the portal, possibly during the sixteenth-century recomposition.)

Gnudi thinks that the marble shipped to the Fabbrica on March 22, 1426, which was described as "da Lombardia," must be from Lago Maggiore (doc. 142). The term "Lombardia" at the time, however, was used quite generically and could as easily have meant Verona and, in any event and under any circumstances, certainly does not imply Candoglia marble. The sheer number of separate stones—166—indicates that they were basically *not* for sculpture but were for construction.

In a delayed effort of testing the stone on the portal, the restoration team came up with the idea that what they had first published as Istrian stone was really Candoglia marble; (see Beck, "Reflections on Restoration: Jacopo della Quercia at San Petronio," 1985). One should be clear on one point: "Candoglia" marble is *never* specifically mentioned in the vast documentation for the *Portal,* but is simply a leap in thinking by late Professor Gnudi. At the same time that the visual evidence is unconvincing, there is no indication in the published ("scientific") reports that comparative testing was actually undertaken. In the most recent report by the Foundation, R. Rossi Manaresi, *Restauri a Bologna e Ferrara* (Bologna, 1986), no reference is made to Candoglia marble but generically to "cystalline marble," in what appears to be a step back from an earlier position. (I have taken a piece of Candoglia marble to the portal in the bright light of mid-day, and the visual comparison, at least, fails to support Gnudi's judgment.)

According to Rossi Manaresi ("Indagini scientifiche e techniche," p. 227*n* 4), the narrow sides of the large pilasters containing the Old Testament reliefs, which Gnudi asserts were the purpose of the ten stones from Istria mentioned on December 24, 1429 (doc. 315), are indeed Istrian stone ("che in effetti sono di pietra d'Istria"). These are the sides of the very same ten stones that I have maintained *(Il portale)* were those from which the famous reliefs themselves were carved. In other words, according to Rossi Manresi, the sides of the historiated pilasters are of Istrian stone but the central reliefs are of Candoglia marble: in actual fact, however, they are part of the identical stone blocks in each case, and must *per forza* be the same stone.

For Vasari's evaluation of Istrian stone, see G. B. Brown, ed., *Vasari on Technique* (New York, 1960), pp. 56–57. In praise of Istrian stone, F. Sansovino, in *Venetia città nobilissima et singolare* (Venice, 1581), has the following passage:

Ma bella e mirabil cosa e la materia delle pietre vive, che sono condotte da Rovigno et da Brioni . . . sono di color bianco et simili al marmo; ma salde et forti di maniera che durano per lunghissimo tempo a i ghiacci et al sole; one ne fanno statue, le quali polite con feltro a guisa del marmo, poi che cosi fatte, si incrostano le faccie interne delle chiese et de i palazzi, con collone alte grosse et lunghe di un pezzo quanto si vuole,

perche le cave di Rovigno abbondano di questa sorta di pietra, chiamata Istriana, et Luburnica da gli scrittori . . . (p. 139)

To further demonstrate the precariousness of Gnudi's case, it is sufficient to look at the *intermezzi,* those carved inserts between the scenes, because they are solid pieces which are one and the same for the outer surface (that is, side edge) and the front sides of the pilasters. Thus, on the outer surface of the pilasters, one should find that there is a noticeable difference between the intermezzi, which must be Istrian stone, and the reliefs themselves, which according to the recent assumptions of Gnudi and Rossi Manaresi must be a rosy, pinkish Candoglia marble.

Instructive is the passage by Malvasia in which the stone is termed Istrian:

(San Petronio)
Ma prima d'entrare in Chiesa, risguardando noi, il principio dell'oranta marmoreo, vedremo, per la lontananza de' marmi, ed in consequenza per la penuria d'Artefici che quelli lavorino, essersi convenuto, nella scarsezza altrettanto veramente nella Scoltura, quanto abbondanza incomparabile ch'abbiamo nella Pittura, il valerci di Sculturi stranieri; mentre a Giacomo della Fonte, alias della Quercia Sanese, per scudi 600 d'oro, dando egli i marmi d'Istria condotti sino a Ferrara, fu data ad ornamentare la porta maggiore, facendovi le statue della Beata Vergine Col Figliuolo, e SS Petronio, e Ambrogio, e nelle due pilastrate laterali, e architrave sopra de esse, 15 istorie del Testamento Vecchio, della Creazione di Adamo fino al Diluvio. (C.C. Malvasia, *Le Pitture di Bologna* [1686], ed. by A. Emiliano [Bologna, 1969], p. 236)

Making their case still less tenable, these intermezzi even include portions of the carved frames of the famous Genesis reliefs they were created to separate, so that we should be able to see the change very readily on the tops and bottoms of each relief history, but that is not the case. Indeed, they all appear to be and are of the same stone. Rossi Manaresi, "Il Restauro della facciata," in Fanti et al., eds., *La Basilica* (1984), 2:100, repeats again the idea that the histories are not "pietra d'Istria," but without evidence, and furthermore states that the ten stones purchased in 1429 were for "le dieci lastre di pietra d'Istria applicate ai fianchi esterni dei due pilastre."

As for the interpretation of the language, "li dalati de li pilastri de l'istorie," see comment to doc. 315. The fact remains that although the usage is peculiar, there was no "correct" word for the form anyway, and if an incorrect or imprecise term was used, it would not have been the first time in the fifteenth century. Indeed we have examples from the early quattro- cento when a sculpture by Donatello was referred to as a painting, as in the Opera del Duomo documents in Florence. In fact, in the contract of 1425, reference is made to "la colonna" when referring to the pilaster, indicating the difficulty of finding the proper word (doc. 117). How much more difficult would it have been for a simple bookkeeper to define the unfamiliar element properly? I suggest, therefore, that the phrase "li dalati de li pilastri" means "pilastrate laterali" as in Malvasia, cited above.

Nor could one, I suggest, imagine a sculptor designing such an awkward and arbitrary combination of two kinds and colors of stone for the same relief, anyway. In other words, if the sides of the pilasters, the intermezzi, and parts of the relief frames are Istrian stone, so are the reliefs. Thus, the documented purchase of the ten stones does indeed provide a convincing *terminus post quem* for the sculpture of the ten reliefs, that is, after the end of 1429. If such a situation, in turn, produces problems for a preconceived notion about the stylistic evolution of Jacopo della Quercia, I suggest that the interpretation must be discarded in favor of one that conforms to the visual and documentary evidence, and not vice versa.

Still another confirmation that the Genesis reliefs were begun after 1429 is that Jacopo had been called back to Bologna in that year, and while his living quarters were being prepared, the document specifically mentions that he had returned in May "per lavorare a le istorie" (doc. 297)—an indication that, to be sure, the reliefs still needed to be worked. Furthermore, the dimensions of the ten stones, and especially their breadth ("grozesa") of about one piede, make it quite unlikely that they were for molding, because of the cost of such a block; their size and expense suggests instead that they were destined for important sculptural elements, since they were, besides, singled out and reported in the fiscal accounts.

Equally erroneous, I maintain, is Gnudi's assumption that the lintel with its five scenes from the early life of Christ only began to be worked in 1432 ("Per una revisione," p. 46), a theory that hinges upon payments for shipments of stone to Bologna via Torre della Fossa (Ferrara). But without any basis at all, Gnudi assumes the scenes to be of Candoglia marble; actually they are almost certainly related to stone purchase by Jacopo in 1432 in Verona and Venice, not in Milan. The authoritative and confident tone of Gnudi's assertions might leave the impression that what he claims is actually stated by the documents, but again and again that is far from being the case. Indeed, a basic flaw in Gnudi's approach is a fundamental misunderstanding of the purpose of the documents, which were not written so that a nice chronology of work could be deduced from them by art historians, but exclusively for accounting purposes—that is, to keep careful track of where the money was going.

Now to return to the reliefs on the lintel: there is no specific documentation. We can probably reconstruct the situation on the basis of the documents for the *stipiti* mentioned for the first time in 1426; they were put in place in 1428, with the final, top stone on each side containing the mensole with the putto. According to Gnudi's reasoning, these door jambs would have been left standing free—without the lintel—for as many as six years, an unthinkable scenario and a dangerous one as well. The jambs *must* have been put up in order to immediately lay upon them the lintel, which action also served to support the jambs, and more importantly, perhaps, to allow the portal to function when necessary. Thus, I suggest that the reliefs on the lintel were finished and on the portal by the end of 1428. A. Bertini (*L'Opera di Jacopo della Quercia*, 1966, p. 82) suggested that Jacopo had in fact begun his work on the portal with the reliefs of the architrave and the prophets, a position with which I concur.

Although certain critics see the lintel reliefs as more "Gothic" than the "classic" Genesis reliefs, and therefore later, as evidence of Jacopo's decline, the documents and the other evidence, as well as common sense, indicate otherwise. The *fabbricieri* surely would have wanted to get the door jambs in place as well as the lintel, to be in condition to move on to the next zone, upward to prepare the lunette, outward to prepare the embrasure, and finally to complete the pilasters that are the least functional element of all, along with the lunette sculptures.

If sculpture was put into the lunette during the period when work was still going on, it would have had to await the lintel, so that Gnudi's date 1433/1434 for the Madonna vs. my date of 1428 makes a considerable difference. To be sure, there is no direct evidence to determine when the Madonna was put up, although I believe that it was lifted onto the *Portal* in 1428; but I have associated a payment with the completion of the San Petronio and its placement on the *Portal,* with the assumption that the Madonna was already there. On the eve of the feast day of the Assumption on August 14, 1434—the date is hardly a coincidence—nine soldi were paid to several porters to help to set the statue of San Petronio presumably beside the Madonna and Child—"aidono a maestro Jacomo dala Fonte a dirzare la imagine de Sam [sic] Petronio" (doc. 408; see also doc. 406). Gnudi ("Per una revisione," p. 46) claims that the payment was not for placing the statue in the lunette but was merely

to bring it to an upright position in Jacopo's workshop. The amount is far too great, however, for such a tiny task as setting upright a life-size statue of marble, since Jacopo's shop people could have done this by themselves; and besides, precisely the same language is used to refer to workers putting the parts of the door jambs onto the portal ("per dui fachini che aidono al'arghano a rizare suxo lo stipido sovro l'altro"), and they received only 1 soldo 6 denari (doc. 241). Probably more than two men would have been needed to bring the statue to the lunette, making the 9 soldi a more credible amount. Gnudi was misled in part by his assumption that the lunette was empty until 1510. Indeed the main arch was already mentioned in the documents by 1428 (doc. 236), and the back wall of the lunette may have received some painted decoration before 1435 (doc. 437).

From the discussion just presented, I am obliged to conclude that Gnudi's new readings are neither helpful nor correct in reconstructing the situation surrounding Jacopo's activity on the portal and should be discarded. His dating of the Old Testament reliefs to 1426–1428 (?), when he also sees a good deal of other work, cannot be supported by a close reading of the documents, and Gnudi's promise that he would expound his view in another place ("che esporrò in altra sede," "Per una revisione," p. 17) is hardly an adequate explanation. We must assume that at the start Jacopo was busy getting the project underway, traveling for the purpose of purchasing stone, getting the structural questions straightened out, and then beginning the actual work. Furthermore, Jacopo also had important obligations in Siena during the same period and could not even spend much of his time in Bologna.

Catalogue 13. The *Tomb of Antonio da Budrio* (+ 1408)

Illustrations: Fig. 130

Location: Corridor, San Michele in Bosco, Bologna.

Material: Marble (?).

Date: 1435 (finished).

Inscription (as read by Zucchini): QUE LEGUM ANTE ALIOS INTERPRES VIXIT ACUTUS SCEVOLA PRO IURIS COGNITIONE NOVUS ET CONANUM PRINCEPTS NULLI PIETATE SECUNDUS TRAIANO ET CONPAR [?] INTEGRITATE FUIT CONSILIO AEQUAVIT MAGNUM ET GRAVITATE CATONE ANTONIUS DE BUTR[I]O QUANTA SEPULCRA COLIT. MCCCCVIII–IIII OCTOBRIS.

Description: The deceased is shown lying with his hands crossed and his head supported by a tasseled pillow; an oversize book is at his feet. He wears a full garment with a hood. The figure is enframed by a faintly pointed arch supported by twisted colonnettes, which forms part of the larger structure, composed of an engaged, segmented pilaster supporting an undecorated entablature. Toward the bottom of the figure is a architectural object, possibly a foreshortened tomb. Shields with arms surrounded by leaf forms are in the spandrels formed by the arch and the entablature. The inscriptions runs around the entire slab.

Condition: The relief as a whole has suffered from centuries of wear, with the most severe losses on those parts that protruded the most, the hands and the head. Perhaps when the monument was moved indoors, the upper right corner was chipped, along with some losses to the block.

Documents: The Bolognese expert Guido Zucchini ("San Michele in Bosco," 1943, pp. 22–23) discovered a copy of a payment for 13 lire on account to Jacopo della Quercia from the year 1435 for this tomb slab of the professor of law Antonio da Budrio, who died in 1408;

the tomb was originally in the cloister of San Michele. Zucchini's source for the notice was "Notizie antiche spettanti al monastero di San Michele in Bosco," an eighteenth-century manuscript in the Biblioteca Malvezzi-De Medici, housed in the Biblioteca Comunale dell' Archiginnasio of Bologna (vol. 51). Although the document has not come down in the original form, there is no reason to doubt the reliability of the notice. For further documentary sources on the monastery see M. Fanti, "S. Michele in Bosco di Bologna," in G. Spinelli, ed., *Monasteri benedettini in Emilia Romagna* (Milan, 1980), p. 185.

History: The tomb was made for a cloister at San Michele, where it was mentioned in 1841 by S. Muzzi ("Lapide con bassorilievo sepolcrale di Antonio da Budrio nel famoso chiostro a S. Michele in Bosco," in Visibelli, Annali della città di Bologna dalla sua origine al 1796, vol. 3 (Bologna, 1841), but was moved indoors in recent times. Zucchini wrote about the tomb first in 1943 in the article cited above, and then in a second article, "Un'opera inedita di Iacopo della Quercia" (1949), which was followed by E. Gualandi, "Di lapidi sepolcrali ancora esistenti in S. Michele in Bosco in Bologna" (1955–1956). See also R. Grandi, *San Michele in Bosco* (Bologna, 1971).

Critical tradition: Since Zucchini's discovery, the Andrea da Budrio tomb, which previously was dated to around 1408, the year of Andrea's death, has been widely regarded as by Jacopo; only Seymour *(Quercia,* 1973, p. 74), remains unimpressed by the tomb's quality, which leads him to suggest that it was a shop production. The work is enthusiastically accepted by Matteucci *(La 'Porta Magna,'* 1966, p. 85) and myself *(Il portale,* 1970, p. 53); both of us associate it stylistically with the San Petronio on the *Portal of San Petronio.*

Comment: Due to the severe wear, the character of the relief has surely lost the original surface articulation, and although the invention is not among Jacopo's finest, the figure tends to fill the available space as is typical of his Bolognese works. The sturdy proportions also are in accord with the late work on the *Portal,* as are the heavy, square hands and feet. The power of expression lies principally in the agitated draperies.

Catalogue 14. *Triptych with Madonna and Child, Saint George, Saint Peter, and Other Saints*

Illustrations: Fig. 131.

Location: Museo Civico, Bologna.

Material: White marble (?).

Dimensions: 102 cms (height) by 98 cms (width).

Date: ca. 1427–28.

Inscription: None.

Description: Composed of up to five separate stones, this small private altar has the central Madonna and Child seated on a throne decorated with lion heads, in a concave niche. The Child, who moves vigorously toward the left, is almost restrained by his mother, who rests upon a shallow bracketlike base that protrudes from the ground plane of the relief. Above, on a segment of a round arch are three angels enclosed in a gablelike format. Leafy forms rise like flames from the top of the triangular form.

On the left is a Saint George with the dragon at his feet in a niche, with the same flattened, segmented arch, behind which is a shell motif, similar to that for the prophets of the

tabernacle of the *Baptismal Font* in Siena. On a separate stone in the gable above is the half-length figure of a saint who may be Saint Catherine. On the right side, also on a separate stone, is a Saint Peter with an identical niche background. Though missing from the altar today, obviously there was another gable above the Saint Peter, which has been identified with a "San Bonaventura" in the W. R. Schütegen Museum, Cologne (West Germany), itself cut down.

Condition: The sculpture seems to have been mishandled; breakage in the little bracket beneath the Madonna and surface loss of the head of the Child and the frame of the Saint Peter can be singled out as damaged. The "San Bonaventura" was trimmed all around, but most drastically at the top.

Documents: None.

History: At an undetermined time various parts of the triptych were separated. In the nineteenth century the central Madonna and the Saint George with the upper section were in the collection of the University of Bologna. The Saint Peter was purchased by the Museo Civico and united with the other sections in the museum, with the exception of the fragment in Germany, which was shown at an exhibition of sculpture held in Detroit in 1938 (for which see Ragghianti, "La mostra di scultura italiana antica a Detroit," pp. 181–182).

Critical tradition: A summary of the attributions is found in *Jacopo della Quercia nell'arte del suo tempo*, pp. 270–271, where the work is mainly assigned to Jacopo himself due to its connections with reliefs on the *Portal of San Petronio*, following Ragghianti ("La mostra"). Matteucci *(La 'Porta Magna,'* 1966, pp. 86–87) attributes the altar to Jacopo's Sienese collaborator Cino di Bartolo, to whom she would assign a role for the *Bentivoglio Monument* as well as the *Birth of John the Baptist*, a relief also in the Museo Civico of Bologna. I did not discuss the *Triptych* in *Il portale* (1970), at that time considering it without a specific share by the master. Seymour *(Quercia,* 1973, p. 74) thinks it was almost entirely a workshop effort.

Comment: Possibly the altar was originally all of one piece and was subsequently cut up for the purpose of being sold off in separate pieces. I see the altar as essentially Jacopo's, but heavily assisted. The Saint Peter, which may have derived from some sort of *bozzetto* he had provided, is the most remote from Jacopo's style; nor does the bust of the saint that was above Peter speak of the master's direct participation. Despite a certain fascination, the execution of Mary also leaves much to be desired. On the other hand, the angels above are ambitiously and originally posed, the interplay of hands and heads is undoubtedly attractive. The section with saints George and Catherine is, in my view, the finest, and is very likely autograph. George's body type and his proportions are analogous to the soldiers in the Massacre of the Innocents from the *Portal*'s lintel, although carved with greater projection.

Catalogue 15. *Baptismal Font (Jacopo della Quercia's Contributions)*

Illustration: Figs 132–141.

Location: San Giovanni Battista, Siena.

Material: Marble, bronze, enamel, colored tesserae.

Date: 1416–1434. Jacopo's sculpture: relief of the Annunciation to Zacharias in the Temple, 1428–1430; relief Prophets in niches, 1427–1428; in-the-round statue of Saint John the Baptist, 1428–1429.

Description: Two hexagonal marble steps, containing inlaid decoration that varies slightly between the first and the second, function as a platform for the *Font*. The monument has a hexagonal basin raised upon an ample base. On each of the six sides, rectangular bronze plaques with an episode from the life of Saint John the Baptist in relief have been set into finely conceived marble frames. As one enters the church and reads around to the right, the scenes are: the Baptism of Christ, John the Baptist Brought Before Herod, the Annunciation to Zacharias in the Temple, the Birth of John the Baptist, and John the Baptist Preaching.

Between the reliefs are niches with elaborated Gothic gables, into which statuettes of Cardinal and Theological Virtues have been placed. Once again as seen from the entrance of the church, on the left of the Baptism is Prudence, and then reading around to the right are Faith, Hope, Fortitude, Justice, and Charity. Thus Prudence and Faith may be understood as enframing the Baptism, and Justice and Fortitude the Annunciation to Zacharias by Jacopo della Quercia at the back, which faces the main altar of the church.

On the top of the basin, within the articulation of the sturdy cornice, is an inscription rendered with gold and enamel that reads as follows:

S MATH EUNTES DOCETE OMNES GENTES BAPTISANTES EOS INOMINE PATRIS ET FILII ET SPIRITUS SANCTI. S MAR QUI CREDI DERIT ET BAPTISZ-ATUS FUERIT SALUUS ERIT. S LUC VENIT IN OMNEM REGIONEM IORDANIS PREDICANS BAPTISMUM POENITENTIAL IN REMISSIONEM PECCATORUM. S JOHS NINI QUIS RENATUS FUERIT EX AQUA ET SPIRITU SANCTO NON POTEST INTROIRE IN REGNUM DEI (transcribed by Paoletti, *Baptismal Font*, p. 142).

A hexagonal domed tabernacle grows out of a robust clustered pier fixed in the basin, culminating in a capital. On five of the sides of the tabernacle, which is completed by a dome, there are marble shell-niches with figures of prophets, none of whom have been convincingly identified with the exception of King David, on the front. David, who is recognizable by his attributes, is on axis with Christ in the Baptism relief and the statue of John at the top of the monument. The sixth side consists of a bronze door with a relief image of a standing Madonna with the Child. It is possible, considering the inscription and the numbers, that instead of prophets we have represented the Four Evangelists with David and Mary. These figures are enframed by pilasters that support a forcefully articulated cornice, with miniaturized triangular pediments above each of the figures. Standing free on the cornice were six dancing or music-making nude bronze putti, four of which are still on the monument (two others have been dispersed, one presumably in Berlin, Staatliche Museen, and the other in Florence, the Bargello).

A narrow pier, a decorative translation of a lantern, rises from the dome functioning like a pedestal upon which stands the statue of the Baptist.

Condition: A thorough scientific analysis of the monument's condition, especially the bronze portions, needs to be undertaken. There are some obvious signs of deterioration that undoubtedly require treatment.

Documents: The abundant documentation has been thoroughly transcribed and treated by Paoletti in *The Siena Baptistry Font* (1979); there is an overview of the documents in *Jacopo della Quercia nell' arte del suo tempo*, pp. 178–199.

History: The need for a new font was recognized in 1414, but action was not taken for another two years, when Ghiberti was brought to Siena (all expenses paid) to make recommendations. He was back in Siena at the end of the year and in the following one, at which

time he prepared a sample narrative relief and probably a scale model for a section of the *Font*.

The monument must be understood to have been designed and worked in two stages: (1) the basin level, and (2) the tabernacle and the superstructure. Jacopo della Quercia was brought into the operation on April 16, 1417, at which time he was commissioned to produce two of the six reliefs for the basin, along with Ghiberti and the firm of Turino di Sano and his son Giovanni di Turino (doc. 73). Later documents indicate that these reliefs were the Annunciation to Zacharias and the Feast of Herod, for which Jacopo was supposed to be paid the sum of 180 florins each, calculated at a favorable four lire and four soldi per florin. Although Jacopo was obliged to complete them within a year, he turned over only one relief thirteen years later.

Among the workers who were looking after the marble portions of the *Font* were Sano di Matteo and Nanni di Jacomo, who had been collaborating with Jacopo for the *Fonte Gaia*, and Jacomo di Corso, called Papi, from Florence (doc. 76). Jacopo della Quercia received a payment of 120 florins in 1419, presumably an advance of one-third, for the two reliefs. In 1423 he appears to have handed over one of his two to Donatello, which indicates that he probably never even began either of them (doc. 95 and comment). Indeed on August 18, 1425, Jacopo returned the entire amount of his advance, presumably because he had done nothing about the bronze reliefs and did not think it was possible to proceed with the one he kept for himself, since he had been awarded the commission for the *Portal of San Petronio* in Bologna (doc. 125). While the other sculptors, Ghiberti, Donatello, and Giovanni di Turino, had completed their reliefs by 1427, Jacopo still had done nothing on the Zacharias.

In the same year, plans were drawn up to expand the monument, and this time Jacopo was brought in to direct the creation of the upper zone, including the tabernacle and the crowning statue (doc. 187). A scale drawing was made by the painter Sassetta of the projected design of the *Font* with its new upper zone, which was paid for in December 1427 (doc. 203).

At this time the statuettes for the niches in the lower zone were finally assigned—not to Ghiberti, who seemed to have had a claim, but to Donatello, Goro di ser Neroccio, and to Giovanni di Turino; the assignments were presumably made by Jacopo, who was in charge by then. He also apparently arranged that the commission for the free-standing bronze putti at the level of the dome was passed on to Donatello and Giovanni di Turino.

The marble for the tabernacle was ready in Siena in early 1428, a time when Jacopo was deeply occupied with work in Siena and also with his Bolognese *Portal;* he had also managed to procure stone for the statue of the Baptist in Pisa (doc. 220). In the same year (1428) he seems to have agreed to take up again the final relief for the basin (doc. 223). In the meantime, in 1429 the marble sections of the upper portion were put into place (docs. 289, 291, and 292). In the same year some highlighting with gold and blue paint was undertaken (doc. 295). Jacopo's role appears to have ended with final payments for the Zacharias relief on July 31 and August 1, 1430 (docs. 325, 326), and the final payments for his share of work on the upper section of the *Font* on August 5 and 6, 1430 (doc. 327).

Work on the putti and some refinements continued until 1434, although apparently no longer under the direction of Jacopo della Quercia.

Critical tradition: As stated elsewhere, there is a current of opinion that finds it difficult to attribute to Jacopo the design of the upper section, simply because of its "progressive" architectural and figural elements. This view is revealed for example by Volker Herzner in *Donatello e i Suoi: Scultura Fiorentina del Primo Rinascimento* (Florence, 1986), pp. 136–

137, who asserts that while the putti must have been part of the original design, they could not have been invented by Jacopo della Quercia.

The portions for which Jacopo was directly responsible—the relief of the Annunciation to Zaccharias in the Temple, the five prophets in relief in shell niches, the statue of John the Baptist, and the design of the upper section of the monument—have not on the whole been received enthusiastically by critics.

The bronze relief, which is habitually compared with that of Donatello, comes out rather poorly, and since Jacopo seems to have rejected any commitment to the new linear perspective, his panel can be considered as old-fashioned by the time it was finished. There has also been a tendency to see Donatellian elements in Jacopo's relief, because it was only begun after Donatello consigned his Feast of Herod. Paoletti in fact seeks to pinpoint specific borrowings *(Siena Baptistry Font,* pp. 99ff.).

It has been widely recognized that the prophets are stylistically related to the prophet busts at San Petronio, which were executed at about the same time, and for the most part Jacopo is given the major role for these full-length, standing figures in Siena. Less favorable has been the evaluation of the *Saint John the Baptist,* which has its advocates, however, including Paoletti, the authors of *Jacopo della Quercia nell'arte del suo tempo,* and myself; its detractors include Bacci *(Quercia: Nuovi documenti,* 1929, p. 68) and Seymour *(Quercia,* 1973, p. 66).

Comment: The tabernacle on the upper zone of the *Baptismal Font* was, in effect, the container for the holy oil, and the bronze plaque with the image of the Madonna and Child by Giovanni di Turino (a substitute for one originally assigned to Donatello but rejected) served as the door to the receptacle where the precious oil was stored. Of the three kinds of holy oil, the one preserved in the *Font* must have been the Sanctum Chrisma, a mixture of olive oil and balsam blessed by a bishop that was used for consecrations and the unction of the newly baptized and new bishops. Because of the extraordinary value placed upon the oil, it was required to be placed under lock and key within tabernacles, as was the case here; on the use of the oils, see B. Montevecchi and S. Vasco Rocca, eds., *Suppellettile ecclesiastica* (Florence, 1988), 1:151. The design of the tabernacle zone was probably motivated by its function as container for the holy oil, and in fact visual parallels may be drawn with small vessels that actually held the liquid as a category of reliquary. (For the *reliquiari architettonici* see Montevecchi and Vasco Rocca, see pp. 201ff.) The overall design of the tabernacle section seems to have been motivated by reliquary architectonics, thus uniting the design, the function of the monument, and its form effectively into a comprehensible unit.

Catalogue 16. The *Madonna and Child with Saint Antonio and Cardinal Casini (Casini Madonna)*

Illustrations: Figs. 142–143.

Location: Museo dell'Opera del Duomo, Siena.

Material: White marble.

Dimensions: 120 cms (height) × 139 cms (width).

Date: ca. 1437–1438.

Description: Mary is seated upon a pillow on a throne looking outward toward the left, while the nude Christ Child, supported by her left arm, stands somewhat uneasily on her lap. He gestures toward the kneeling donor, undoubtedly a cardinal since his traditional hat rests

on the base of the throne. The standing Saint Anthony Abbot presents the donor, who must be Cardinal Antonio Casini, to the holy group. The relief is still unfinished, lacking final detailing and polishing (as pointed out to me by Enzo Carli).

Condition: The relief as it has been preserved is really a large fragment with nearly one-third of the original missing. There has also been damage, perhaps incurred during the various moves that the work seems to have undergone, especially breaks in the lowest zone, including the toes of Mary's right foot and the left foot of Saint Anthony. A muddy yellowish tone to the front surface suggests that the relief had been painted or at the least was coated with a varnishlike substance.

Documents: In the inventory taken at the end of 1435, "La Cappella di Santo Bastiano" had a painting of a Martyrdom but no relief (yet), so we must assume that the work dates from after that time (AODS, no. 510, fol. 18; cf. Bacci, *Quercia: Nuovi documenti*, p. 382). By 1458 (AODS, no. 510, fol. 25v; Bacci, *Quercia: Nuovi documenti*, pp. 329–331) a painting "con Nostra Donna da chapo a detta tavola di marmo et altre figure di marmo" is indicated.

Jacopo worked on the Casini Chapel during the last phase of his life, while Operaio of the Duomo. He was, in fact, accused of diverting workmen employed by the Opera for work there. In a document dealing with Jacopo's debts owed to the Opera of June 27, 1439 (doc. 501, item 6), it is apparent that a few years before he died, Jacopo privately had been awarded a contract to make the chapel of Antonio Casini, Cardinal of San Marcello, a position to which Casini was elevated by Martin V in 1426 (May 24). Previously he had been the Bishop of Siena (1408–1426). (For Casini, who died on February 4, 1439 [modern], see B. Sani, "Artisti e committenti a Siena nella prima metà del quattrocento," in R. Fubini, ed., *Certi dirigenti nella Toscana del '400. Atti del V e VI convegno, Firenze, 10–11 Dicembre, 1982; 2–3 Dicembre 1983* [Impruneta, 1987], pp. 491–492.) Casini gained control of the chapel, dedicated to Santa Maria e San Sebastiano, in the cathedral at least from 1430; provisions for new decorations were mentioned for the first time in 1433 (see Bacci, *Quercia: Nuovi documenti*, pp. 284–285). All of Jacopo's work for the chapel was produced from marble owned by the Opera and was worked by employees of the Opera, so that over 342 lire for material and labor were debited to Jacopo's estate. The same information is found in another document of the same time (doc. 503, item 6).

History: From the documents it appears that substantial work had taken place for the Casini Chapel while during Jacopo's lifetime, and we can assume that the lunette was all but finished. The chapel was in the left transept where the altar of the Crucifix of Monte Aperto is now located; it was demolished in 1639, when, presumably, the lunette was removed and modified as an independent relief. Perhaps then the left side of the lunette, which was found at Corsano, near Siena, before World War I, had been cut off. In recent times the relief had found its way into the collection of Ugo Ojetti at Villa Salviatino outside of Florence, from which it passed to the Opera dell'Duomo in the mid-1970s.

Critical tradition: A summary of the attributions is found in *Jacopo della Quercia nell'arte del suo tempo*, 1975, pp. 274–275, where the work is assigned to Jacopo himself. C. L. Ragghianti ("Novità per Jacopo della Quercia," 1965, pp. 44–45) proposes that a relief of Sant'Antonio Abate from a town outside Bologna (Ozzano) was the missing section, but the quality of stone is quite different and the style utterly diverse. The lunette apparently rested over a painted altarpiece, which contained a Saint Sebastian. Seymour (*Quercia*, 1973, p. 75), who rejects the suggestions that the missing portion contained either Saint Anthony or Saint Sebastian, proposes instead a female saint, which in turn he relates to a drawing showing only three figures in Vienna. On the other hand in the drawing the Madonna is

shown standing, so it would have had to have been for an earlier project, were it for the Casini lunette.

Comment: Morisani *(Tutta la scultura,* 1962, p. 42) sees the sculpture as completely by the master. Carli also *(gli scultori senesi,* p. 33) holds the relief in a high esteem: "L'opera è un capolavoro improntato di dolci mestizia nella Madonna." Seymour *(Quercia,* p. 75) suggests that it was carved of local Sienese stone (from Ravaggione). He recognizes the share done by the shop, singling out the Christ Child.

I believe that the only part that can be safely considered to have been carved by Jacopo is the Madonna, although the overall design must have been his. In this respect, it may be considered a relief interpretation of the lunette arrangement at San Petronio in reverse, with the child blessing the kneeling donor. The majestic head of the Virgin and her beautiful right hand must be placed among Jacopo's last personal efforts in sculpture. The two side figures do not have convincing mass: their draperies appear to remain on the surface, utterly failing to imply the volume, as is characteristic of Jacopo's autograph sculptures. Perhaps the individual responsible for much of the carving was Pietro del Minella, who is mentioned as one of Jacopo's assistants at this time, and the very young Antonio Federighi.

Catalogue 17. The *Louvre Madonna*

Illustrations: Fig. 144.

Location: Louvre, Paris.

Material: Polychromed wood.

Dimensions: 180 cms (height).

Date: ca. 1435.

Description: Enveloped in ponderous draperies, the stiff, frontal Madonna leans off slightly to her right, where the Child stands in an insecure contrapposto, his nude body partially covered by a swag of material. Mary holds him with fine thin hands, while her expression is at once aloof and concerned.

Condition: The surface has suffered losses of color and there are cracks and breaks throughout.

Documents: None.

History: The work was purchased in Italy in 1896, perhaps from the estate of Cardinal Giordani, who is said to have obtained it from a Carmelite convent in Ferrara, according to some accounts, or from Bologna *(Jacopo della Quercia nel arte di suo tempo,* p. 218), according to Seymour *(Quercia,* p. 69). Another account suggests that it comes from Borgo San Sepolcro (C. von Fabriczy, "Kritisches Verzeichnis toskanischer Holz und Tonstatuen," 1909, p. 64. It was published for the first time by A. Michel, "La Madonna et l'Enfant statue en bois attribuée a Giacomo della Quercia" (1896).

Critical tradition: A summary of the attributions is found in *Jacopo della Quercia nell'arte del suo tempo,* (1975), p. 218. A number of Quercia specialists have accepted the Madonna as the master's, including Morisani *(Tutta la scultura,* 1962, p. 42). Suggestions have been made connecting the wood sculpture to the Madonna in the lunette of San Petronio. Seymour *(Quercia,* 1973 p. 70) tentatively proposes that the *Louvre Madonna* was a close derivation from the hypothetical second design for Jacopo's stone version, and said that the *Madonna,*

which he dates to 1428, "deserves to be ranked with the wooden polychrome Virgins in Berlin and San Gimignano as being by Jacopo himself—or at least very close to his personal touch." In the caption to his illustration (*Quercia*, fig. 126), however, Seymour is more tentative, and dates it to 1430–1435(?).

On the other hand, critics led by A. Venturi (*Storia dell'arte*, 1908, 6:104), myself (review of Morisani, *Tutta la scultura* in *Arte antica e moderna*, 1962), and Del Bravo (*Scultura senese*, 1970, pp. 71–76), have all rejected the wood group for Jacopo, and Del Bravo goes so far as to date it to the 1450s, attributing it to Federighi.

Comment: Although I do not consider it a particularly strong work, I would now keep the Madonna within Jacopo's *ouevre*, as emanating from his Bolognese shop from about 1435, although he does not seem to have done much more than supply a rough modello of some kind, turning over the execution to a helper (Cino di Bartolo?). It lacks the touch of the master, as revealed in the absense of convincing volume and of the plastic quality that characterizes Jacopo's autograph works. Furthermore, rather than being related to the Bolognese Madonna at San Petronio, it belongs instead to several wooden, seated groups including the one in Anghiari (see cat. 18), which is, however, far superior and earlier.

Catalogue 18. The *Anghiari Madonna*

Illustrations: Fig. 145.

Location: Museo Statale di Palazzo Taglieschi, Anghiari.

Material: Polychromed wood.

Dimensions: Madonna, 140 cms (height); Child; 70 cms (height).

Date: ca. 1424.

Inscription: QUESTA FIGURA A FATTA FARE LA COMPAGNIA DI SANTA MARIA DE LA MISERICORDIA.

Description: The regally seated Madonna looks off slightly to her left, her right hand placed across the body and the left one outstretched. There is little movement either in the pose itself or within the heavy draperies that enclose her. Her strongly ovoid head, which is covered by a whitish shawl that spreads out across her upper body, is supported by a robust, cyclindrical neck. The mantle falls in a mound on the lap, effectively covering much of the lower portion of the figure. Coloristic qualities contribute to the beauty of the work: the golden hair, the pale white scarf highlighted with red decoration, the warm flesh tones, the deep red dress and the blue mantle, embellished with embossed gold trim. The figure, supported on a red polygonal base, with an gold inscription set against the deep blue ground, is sometimes shown accompanied by a separate wooden statue of the Christ Child, which evidently was not made for the statue.

Condition: Excellent, with original polychromy.

Documents: None.

History: The carved sculpture was in the Church of the Compagnia di Santa Maria della Misericordia in Anghiari and is listed in an inventory of that church on March 4, 1526, as on the main altar (together with a Christ Child). Later on it was separated, and the present child was attached at an undisclosed time. (See A. M. Maetzke, in Bagnoli and Bartalini, eds., *Scultura dipinta*, pp. 158–160.) It was seen in the Galleria Sangiorgi in Rome, and was

purchased by the Italian Government in 1977; following restoration, it was deposited in the Museo di Palazzo Taglieschi, Anghiari.

Critical tradition: The *Madonna* was first identified by C.L. Ragghianti ("Novità per Jacopo della Quercia," 1965), who considers it a masterpiece of Jacopo's but thinks the Child was later and was neither made for the work originally nor carved by the master, a judgment that Carli ("Un inedito quercesco," 1977, p. 141) shares. Seymour (*Quercia*, 1973, p. 57) sees the statue as an echo of the *San Martino Madonna*, which he considers to be by Jacopo, but is noncommittal about this one in terms of an attribution. Following cleaning the estimate of the work has been positive (see Maetzke in Bagnoli and Bartalini, eds., *Scultura dipinta*, pp. 158–160).

Comment: A Child must have been produced together with the Madonna, quite possibly one that was removable and that could have been used independently during appropriate occasions; thus the separation, which was the case for the *Carli Madonna* (see below). Although the Child now connected with the statue is fine, especially as revealed following the cleaning, I do not consider it to be by Jacopo and tentatively date it to the next generation. Its rather slight upper body in juxtaposition with the much heavier lower body and legs, and muscular arms, should give pause to anyone who would attribute it to Jacopo or his shop.

Carli ("Un inedito quercesco") has proposed a varient of this work in a Milanese private collection as also by Jacopo and his shop. The work is rather poorly preserved and without the original surface; in addition to other variations the base is less elaborated. It also has an added Child, this one an adaptation of the sleeping child from the *Fonte Gaia*'s so-called Acca Laurentia (Amor Dei), which Carli recognizes as a late seventeenth-century adaptation. I believe that the *Carli Madonna* may have emanated from Jacopo's shop but even if this were the case, it came without his actual participation. (Having never seen the work, I must reserve final judgment.) A reevaluation might be required following a modern cleaning.

Catalogue 19. *Saint John the Baptist*

Illustrations: Figs. 146, 148.

Location: San Giovanni, Siera

Material: Polychromed wood

Dimensions: 98 cms (height)

Date: ca. 1430.

Description: A fully clothed and bearded John the Baptist is presented as a middle-aged man of fiery appearance who seems to have stopped momentarily in his constant travels. He looks straight out, his smallish mouth, partly open, with the right arm down and the left hand gesturing ahead. Beneath a cloth drape flung across his body is a long hairy garment that is matched by the beard and heavily falling strands of hair from his head.

Condition: Fair. The left forearm is a restoration dating from the seventeenth century; the index finger and thumb of his right hand were remade in the nineteenth century.

Documents: None.

History: The statue appears to have been donated to the baptistery at the beginning of the seventeenth century, at which time it was already considered to have been carved by Jacopo della Quercia; at that time it was gilded and repaired, including a new left arm. For the

documents of 1616 (ASS, Patrimonio Resta 875) see Alessandro Bagnoli's "Su alcune statue lignee della bottega di Jacopo," p. 153*n*9, and his *Mostra di opere d'arte restaurate nelle provincie di Siena e Grosseto* (Genoa, 1981), pp. 78–80, no. 23; Bagnoli dates the statue between 1422 and 1428. The attribution and the information that it was carried in processions is confirmed by Fabio Chigi, Pitture, sculture, e architettura di Seina (1625–1626; ms. Chigiani, 1.1.11, Biblioteca Apostolica Vaticana), and published by P. Bacci, "Elenco delle pitture, sculture e architetture di Siena compilato nel 1625–26 da Mons. Fabio Chigi poi Alessandro VII," p. 304.

Critical tradition: The basic modern analysis is that of Bagnoli, "Su alcune statue lignee della bottega di Jacopo," (1977). The earlier attributions are treated in *Jacopo della Quercia nell'arte del suo tempo* (1975), p. 296*n*6 where it becomes clear that the overwhelming opinion was against an attribution to Jacopo himself, as exemplified by Carli, *La scultura lignea senese* (1954), p. 148, who called it by a follower of Jacopo della Quercia.

Comment: I consider the work as by Jacopo della Quercia; this attribution is attested to by the confident, summary treatment of the hair, beard, and draperies and especially the powerful facial expression. As a type, especially the head, it paves the way for Francesco di Giorgio's wood statue of the same personage (Museo dell'Opera del Duomo, Siena) of a generation later, datable to the time Jacopo was finishing work on the *Baptismal Font*. The left arm was probably originally located around the body, gesticulating upward or across rather than outstretched as it appears now (cf., for example, Domenico di Niccolò dei Cori, *Saint John the Baptist* in the Sienese Pinacoteca).

Catalogue 20. The *San Martino Madonna*

Illustrations: Figs. 147, 149.

Location: Museo dell'Opera del Duomo, Siena.

Material: Polychromed wood.

Dimensions: 140 cms (height).

Date: ca. 1423–1425.

Description: A slightly elongated Mary stands with feet close together in an uneasy contrapposto, with the right leg extended outward at the knee and the left one bearing most of the figure's weight. She supports the Child with her left arm while she tried to tickle him with her right hand, which is extended across her body, although she does not look at him, but stares out rather vaguely. The chamfered, decorated base is in the shape of a hexagonal lozenge.

Condition: Very good.

Documents: None.

History: Until recently in the church of San Martino, apparently its original location, the Madonna and four slightly smaller accompanying male saints—Anthony Abbot, Bartholomew, John the Evangelist, and John the Baptist—have been moved to the Museum of the Cathedral.

Critical tradition: This group was mentioned for first time with an attribution to Jacopo della Quercia by Romagnoli, *Biografia cronologica de'bellartisti senesi*, 2:29. A difference in handling has been noticed frequently between the Madonna and the saints, and to some

extent among the saints themselves. On the whole the saints are now universally rejected as works by Jacopo (they are often given to Giovanni da Imola), while the Madonna is widely accepted and datable to the mid-1420s. Seymour *(Quercia, 1973, pp. 56–57, fig. 69)* considers the Madonna by Jacopo and "a figure of great monumental dignity mingled with a striking expression of human tenderness." Carli *(Gli Scultori senesi, 1980, p. 31)*, long a proponent of the Madonna as Jacopo's, calls the Madonna "splendida creazione." A summary of the attributions is found in *Jacopo della Quercia nell'arte del suo tempo* (1975), pp. 278–283, where the Madonna is assigned to Jacopo himself. Among recent writers only Del Bravo *(Scultura senese del Quattrocento, 1979, pp. 71, 73, 76)* has emphatically removed the *San Martino Madonna* from Jacopo along with the accompanying statues, which were probably incorporated into an altarpiece.

Comment: Unfortunately the *Madonna* and the other figures were not included in the recent exhibition "Scultura dipinta" (1987), nor have they undergone a modern cleaning. Until they are cleaned, a thoroughly convincing attribution is difficult, especially in light of the new information that has been obtained as a result of recent restorations of early quattrocento wooden sculpture and new Querciesque works that have turned up. My own evaluation of the *Madonna* has vacillated from outright rejection to a tentative acceptance as Jacopo's. The draperies appear to be too nervous and haphazard for Jacopo, certainly of the 1420s; the proportions, the heavy upper body, yet the rather narrow and elongated lower body result in a somewhat incongruous figure. At the same time the structure of the ovoid head of the *Madonna*, without the flatter areas one might expect for the area of the face, does not fully correspond to the San Gimignano figures. Despite these disparities with what one assumes for an autograph of the artist, the quality and nobility of expression remain high. Besides, it is virtually impossible to offer a viable alternative attribution for this *Madonna*, in distinction to the case with the four saints. For example, Del Bravo's suggestion of Antonio Federighi, while correctly revealing reservations, is unconvincing; to be sure, we have no secure examples of wood sculpture by that artist (nor, for that matter, by Giovanni da Imola).

Perhaps a compromise might be achieved to allay some of the inherent doubts, in the following scenario: the commission for the group of figures was given to Giovanni da Imola *and* Jacopo; Giovanni did the male saints on his own. Jacopo blocked out the *Madonna*, executed some portions, including the Child, Mary's hands, and much of her head, and left the rest to Giovanni, perhaps with some sort of *modello* as a guide. Surely the gilding and painting was given over to a local painter, perhaps Martino di Bartolommeo, who had done the *San Gimignano Annunciation*.

In an anonymous seventeenth-century source (Biblioteca Comunale di Siena, C.v. 24, fol. 39v) there is mention of "un altare di legno in S. Martino hora della famiglia de'Santi." Actually the Church of San Martino in Siena had a rapport with San Frediano, Lucca, which was reaffirmed in 1419; see E. Lazzareschi, *Carteggio di Guido Manfredi* (Pescia, 1933), registri 3, parte 2, p. 60 (letters nos. 335, 389, 461).

Catalogue 21. Pilaster Insert, *Main Portal of San Fortunato,* Todi

Illustrations: Figs. 150–152.

Location: Right embrasure, main portal of San Fortunato, Todi

Material: White marble

Date: 1416–1418.

Documents: See History, below.

Description: An entire pilaster strip has been set into the left side of the main portal of San Fortunato in Todi, with twelve *santini* in niches, not only presenting a distinctly high quality of carving but a different stone, marble; the rest of the portal is of local sandstone. The handsome, sensitively rendered figures with their bases and niches project from the matrix of the stone. The figures are characterized by small hands and feet, delicate faces, and finely conceived draperies, all handled in a miniaturelike style.

Condition: Good.

Documents: In a letter dated November 28, 1418, directed to the Sienese government, the priors of Todi requested permission to have Jacopo come to Todi for the purpose of advising them about the stone ornamentation at San Fortunato (doc. 89). Around this time, activity was known to have been underway on the façade and on the portal.

History: From documents published by L. Branzoni in *Il Tempio di S. Fortunato in Todi* (Terni, 1909), it has been ascertained that the first payments for work on the base of the façade were in 1415. The crucial account book, largely unpublished, located in the Archivio Comunale di Todi (armadio IV, casella VII, no. 81), is seriously damaged, with losses in the text. It can be determined, however, that there were payments for closing the arch of the portal on June 5, 1417 ("serratura del'archo de la porta de Sancto Fortunato," fol. 91) and that at the end of 1418 there was a celebration at which wine was provided, connected with "una pietra di marmo" that may have been Jacopo's contribution (fol. 81v).

Critical tradition: In 1978 I sketched out the suggestion of Jacopo's direct participation at San Fortunato for the monumental portal ("Jacopo a Todi," *Quercia fra Gotico e Rinascimento*), but since that time there has been no following. A. Venturi *(Storia dell'arte italiana,* 1908, 6:102–103) has made some interesting observations about the Annunciation group on the façade of the church, which dates to the early 1430s, in relation to Jacopo della Quercia.

Comment: The niches, which are fashioned with elegantly scalloped gables, differ among themselves. They are in some cases similar in design to those Ghiberti conceived for the niches on the basin of the Sienese *Baptismal Font,* which would also connect the work to Jacopo in Siena and confirm the date.

A situation might be reconstructed in which Jacopo was consulted already in 1415 or 1416, at which time he may have prepared a sample segment of a pilaster for the left embrasure of the portal. His contribution was intended to be used by the local artisans as a model to continue the decoration.

The extent to which this element is actually by the master or a product of his Sienese *bottega* is more difficult to determine. Considering the relative provincialness of Todi, at least artistically, and the inexperience of the *capomaestro* (a certain Giovanni di Santuccio da Fiorenzuola di Spoleto) in this kind of sculptural decoration, quite possibly Jacopo felt free to turn the assignment over to one of his helpers, merely giving generalized guidance. The figures relate most closely to those saints on the upper section of the *Trenta Altar,* but they are much smaller. In the last analysis, only a tiny share of the actual carving can be assigned to the master, but he does seem to have conceived of the idea and supervised the production.

Catalogue 22. *The Balduccio Parghia degli Antelminelli Tomb Slab*

Illustrations: Fig. 153.

Location: Museo di Villa Guinigi, Lucca.

Material: White marble.

Dimensions: 234 × 118 × 18 cms. (height).

Date: 1423 (?).

Inscription: HOC EST SEPULCRUM CLARISSIMI ET NOBILIS [ISIMI VIRI] VETUSTIS-SIME DOMUS P[ARCHIA] DE A[N]TERMINELLIS DE LUCA. A.D. MCCCCXXII[I].

Description: The figure easily rests his head upon the puffy, embroidered pillow, with hands crossed; beneath is a sheet with swirling folds. The dignified garment he wears has billowing sleeves that sweep down in slow, unagitated movements, while the wide inscription in Gothic lettering takes on a decorative as well as informational role. Coats of arms are found on either side of the feet.

Condition: The relief is severely damaged, with a large crack across the lower body and breakage at the corners and generally throughout, as well as extensive wear on the surface. The face and hands are entirely obliterated.

Documents: None.

History: Originally in the cloister of the Lucca cathedral, the tomb was made well in anticipation of Balduccio's death (1432), much as was the tomb for Lorenzo Trenta a few short years before (see cat. 8). Balduccio Porghia's tomb was transferred to the Garbesi Chapel in the eighteenth century; in recent times it has been deposited in the Museo di Villa Guinigi.

Critical tradition: A summary of the attributions is found in *Jacopo della Quercia nell'arte del suo tempo* (1975), pp. 172–173. See also S. Meloni Trkulja, *Museo di Villa Guinigi* (Lucca, 1968), pp. 70–71, for an informative entry, as well as Baracchini and Caleca, *Il Duomo di Lucca* (1973), pp. 59 and 152.

Comment: There is general agreement that this is the work of Jacopo himself at this date, which is either 1422 or more likely 1423, that is to say, shortly before he embarked upon the San Petronio project. Were the work in better condition it would be an important link between the style of the predella of the *Trenta Altar* and the earliest reliefs in Bologna.

 The *Tomb for Caterina degli Antelminelli,* now also in the Villa Guinigi (Meloni Trkulja, *Museo di Villa Guinigi;* pp. 72–73), it seems to have been a pendant with the *Balduccio Parghia Tomb Slab,* and they are identical in size. The inscription reveals that she died on January 11, 1422; unlike the case of its counterpart, Caterina's tomb seems to have been occasioned by her death, which may have been the motivation for Balduccio to have his own made as well. Indeed, this Caterina was apparently the wife of Balduccio (the alternative is a certain "Alderigo"), but in the inscription, the name of the husband is no longer legible. It is certain, however, that Balduccio Parghia had a wife named Caterina, according to an unpublished document dated December 4, 1416, in which it is stated that he had power of attorney in "Nomine domine Caterine eius uxoris" (ASL, Notari, no. 384, fol. 181r).

As for an attribution of Caterina's tomb, Jacopo does not seem to enter into the question. One should not, however, exclude Giovanni da Imola as a candidate, not only for this tomb itself, but as a collaborator for Balduccio's slab (especially for the inscription). The architectural setting for the Caterina slab is a traditional carry-over, but the design is connected with Jacopo's *Fonte Gaia* niches for the angels, and has features in common with the *Tabernacle at San Eugenio a Munistero* (see Handlist of Rejected Works, no. 19).

Handlist of Rejected Works

What follows is a listing of sculptures that often have been attributed to Jacopo della Quercia, and that have had a certain following in subsequent criticism. I do not accept any of them as by the master. I consider that including them in the main body of this book would serve to perpetuate misleading attributions.

Handlist 1. *Piccolomini Madonna.*

Location: Piccolomini Altar, Cathedral, Siena.

Date: 1397(?).

Comment: Despite illustrious support for the attribution of this marble statue to Jacopo della Quercia, first proposed by Enzo Carli ("Una primizia di Jacopo della Quercia," 1949), it cannot be connected with any firmly established work by the artist. See *Jacopo della Quercia nell'arte del suo tempo*, pp. 26–27, for the critical history of this statue; apparently it was gilded by Andrea Vanni in 1398, a date that can be interpreted as an *ante quem* for its carving, when Jacopo was in Lucca. Although it is widely accepted as Jacopo's, there is no sensible reconstruction of Jacopo's early career into which this Pisanesque sculpture (which especially recalls Nino Pisano) can be inserted, and consequently it must be rejected. The most recent discussion is that of A. Bagnoli, "La Madonna Piccolomini e Giovanni di Cecco," *Prospettiva*, 53–56 (April 1988–Jan. 1989), pp. 177–183, in which he proposes a date of *ca.* 1369.

Handlist 2. *Pietà with Bust-length Saints.*

Location: Altar (predella), Cappella del Sacramento, San Martino, Lucca.

Date: ca. 1380.

Comment: This attribution, put forward by M. Salmi ("La giovinezza di Jacopo della Quercia," 1930), has not received acceptance, although the implication that early in his career (that is, before the turn of the century) Jacopo in Lucca was attracted by works in the style of Nino Pisano such as those represented here is illuminating. Actually the date of these reliefs is far from certain, and Burresi (*Andrea, Nino e Tommaso scultori pisani*, 1983, pp.

189–190) sees them as from the late 1370s, which of course would preclude any role whatsoever for Jacopo.

Handlist 3. *Tomb Relief of Sant'Aniello* (or *Agnello*).

Location: First Sacristy, San Martino, Lucca.

Date: ca. 1410.

Comment: Proposed in a learned paper by A. Kosegarten ("Das Grabrelief des San Aniello Abbate in Dom zu Lucca," 1968) as a work by Jacopo della Quercia, the attribution has not received wide support. The previous attribution to Antonio Pardini (Ridolfi, *L'Arte in Lucca studiata nella sua cattedrale,* 1882, p. 386n1) has been restated by Baracchini and Caleca *(Il Duomo di Lucca,* 1973, p. 148). The dating is anything but certain, however, and I find that it should be placed immediately after the *Ilaria del Carretto Tomb Monument,* upon which it reveals a dependence.

The closest stylistic analogy I known is the relief representing San Marco in the Cathedral of Siena, one of the reliefs for the new pulpit begun in 1423 by Giovanni da Imola. Despite the span of time which is assumed to have passed between it and the *Sant' Aniello,* both share a similar severe treatment. Giovanni is known to have collaborated with Jacopo on the *Trenta Altar* and was very likely already working with him on the *Ilaria Monument,* and I believe that Giovanni was also responsible (on his own) for the *Sant'Aniello.*

Handlist 4. *Annunciation.*

Location: Museo dell'Opera del Duomo, Florence.

Date: ca. 1402–1404.

Comment: Of great beauty, this finely rendered marble group is both difficult to date and to assign to its proper inventor. The attribution to Jacopo della Quercia by Brunetti ("Jacopo della Quercia a Firenze," 1951) cannot be sustained.

I suggest that it was a Florentine work and probably resulted from a collaboration between Giovanni d' Ambrogio and his son Lorenzo d'Ambrogio. In any case, the connections with the young Jacopo della Quercia are merely chronological and generic.

Handlist 5. *Reveal Sculpture.*

Location: Porta della Mandorla, Cathedral, Florence.

Date: 1390s.

Comment: The attribution of portions of the reveal sculpture on the Porta della Mandorla to Jacopo forms part of an ingenious reconstruction of the early career of Jacopo della Quercia by Giulia Brunetti ("Jacopo della Quercia a Firenze," 1951). Of extremely high quality, the sculptures are progressive in treatment, while demonstrating a sophisticated and essentially precocious use of ancient Roman prototypes. Nonetheless an attribution to Jacopo should be ruled out on both stylistic and chronological grounds. I find that Giovanni d'Ambrogio and Lorenzo di Giovanni are the best candidates for the sculptures associated with Jacopo, including the brilliant Hercules. A review of the literature is in *Jacopo della Quercia nell'arte del suo tempo,* pp. 62–63. Brunetti's thesis has been supported by L. Becherucci ("Convergenze stilistiche nella scultura fiorentina del Trecento," in Chelazzi Dini,

ed., *Jacopo della Quercia fra Gotico e Rinascimento, Atti,* pp. 30–37), who proposes the beautiful Apollo relief as another possible candidate for Jacopo's youthful chisel.

Handlist 6. *The Madonna of Humility.*

Location: National Gallery of Art, Washington, D. C.

Date: Nineteenth century (?).

Comment: Originally published by Seymour and Swarzenski ("A Madonna of Humility and Quercia's Early Style"), this sculpture has entered the Quercia literature with a question mark. Alternatives have been put forth, including attributions to Domenico di Niccolò dei Cori and Giovanni di Turino (see *Jacopo della Quercia nell'arte del suo tempo,* pp. 74–75, for a summary); Seymour himself has expressed doubts about the attribution to Jacopo in his monograph *(Quercia,* 1973, pp. 26–27). A determination of the correct viewing point and of the purpose and function of the group within the context of early fifteenth-century habits is virtually impossible. On the other hand, C. Freytag ("Jacopo della Quercia ed i fratelli Dalle Masegne," in Chelazzi Dini, ed., *Jacopo della Quercia fra Gotico e Rinascimento, Atti,* pp. 81–87) is a strong advocate of the authenticity of the work. The same author brings into discussion a bronze standing Madonna and Child in the Victoria and Albert Museum that is not without interest for Quercia studies, but is certainly somewhat later than the author suggests, and appears to be Florentine. The Madonna is strongly supported as Jacopo's in a paper by D. Strom, "A New Look at Jacopo della Quercia's Madonna of Humility."

I believe that the work was produced in the nineteenth century, in the style of the early Renaissance, not necessarily as a forgery, however.

Handlist 7. *Holy Water Basin.*

Location: Left transept, San Martino, Lucca.

Date: ca. 1450.

Comment: Attribution of this work, which was transferred to the cathedral in the nineteenth century from San Pier Maggiore, has vacillated between Jacopo himself and his *bottega.* I wonder, instead, if it is not a imitation of Jacopo's manner by a local master, executed several decades after Jacopo had died.

Handlist 8. *Decorative Heads.*

Location: Exterior of San Martino, Lucca, north and south flanks. Some of the heads are exhibited in the Museo dell' Opera, San Martino, Lucca.

Date: Fifteenth-eighteenth centuries.

Comment: Attention was first brought to these decorative heads on the cathedral of Lucca by A. Venturi ("San Martino di Lucca," 1922), who raised the name of Jacopo; the argument was taken up by L. Grande Mezzetti ("Teste quattrocentesche del Duomo di Lucca," 1936), who claimed that the group in question belonged to the first half of the quattrocento and specifically to Jacopo della Quercia and his school. Klotz ("Jacopo della Quercias Zyklus der 'Vier Temperamente' am Dom zu Lucca," 1967) saw an iconographical pattern among four of the heads, which he attributed to Jacopo and his shop. Baracchini and Caleca *(Il Duomo*

di Lucca, 1973, pp. 120–124) attribute heads to Francesco di Valdambrino, Jacopo della Quercia, Giovanni da Imola, and Antonio Pardini. A summary of the attributions can be found in *Jacopo della Quercia nell'arte del suo tempo,* pp. 144–151.

I cannot dispel my lingering, long-held doubts to the effect that these heads are actually, at least in many cases, replacements executed centuries following their presumed dates. For example, Baracchini and Caleca's fig. 400 must be sixteenth or even seventeenth century, as is also the case for their fig. 402 and fig. 411, which are direct Roman imitations. Since no documents have yet been unearthed for these monumental heads, caution seems the wisest approach in making specific attributions to known fifteenth-century sculptors.

On the other hand, the heads that E. Carli has associated with Domenico di Niccolò dei Cori on the exterior of the Sienese baptistery ("Sculture inedite senesi del Tre e Quattrocento," in Chelazzi Dini, ed., *Jacopo della Quercia fra Gotico e Rinascimento, Atti,* pp. 15–29) are, for me, more convincingly contemporary (whoever the precise authors may turn out to be).

Handlist 9. *San Maurelio Bishop.*

Location: Museum, Cathedral, Ferrara.

Date: ca. 1455.

Comment: Although there was a consistent trend to see this statuette as by Jacopo following its publication by A. Venturi ("Una statuetta ignota di Jacopo della Quercia," 1980), more recent criticism is more reluctant to accept it (see *Jacopo della Quercia nell'arte del suo tempo,* pp. 252–253). In my opinion this fine marble must date to a period substantially after the master's death and could be a work executed by Niccolò dell'Arca before his activity on the San Domenico Altar in Bologna.

Handlist 10. *Anton Galeazzo Bentivoglio Tomb Monument.*

Location: Ambulatory, San Giacomo Maggiore, Bologna.

Date: 1443–1445 (?).

Comment: The monument, which is set upon brackets on the wall facing the entrance to the Bentivoglio Chapel, was first discussed in relation to Jacopo della Quercia by V. Davia *(Cenni istorico-artistico intorno al monumento di A. G. Bentivoglio,* 1835). It is known that Jacopo della Quercia had ordered a stone for a tomb for a member of the Vari family of Ferrara, which is mentioned in 1442 as "quandam sepulturam marmoream laboratam et sculptam per dictum quondam dominum Iacobum [Jacopo della Quercia] ad instatiam illorum de Varis de Farraria . . ." (cited in Supino, *La scultura a Bologna,* doc. 76). The document has been associated with the *Bentivoglio Monument* by modern critics. On the other hand, G. Milanesi reports that Jacopo had made a "sepolcro ad un medico di casa Vari, il quale andò disperso, allochè la chiesa di San Niccolò ov'era posto, fu nel secolo scorso distrutto" (Milanesi, ed., *Giorgio Vasari, Le vite,* 2:13n2). Were this the case, one should disengage altogether the Vari aspect from the *Bentivoglio Monument,* which in turn, would also remove the connection of the tomb with Jacopo della Quercia.

As for the identity of Vari, there was a Giacomo Varri da Reggio who was a Professor of Medicine at the University of Bologna from 1392 (for which see Alidosi, *Li dottori forestieri che in Bologna hanno letto teologia, filosofia, medicina e arti liberali,* 1623, p. 30).

Whatever the case, it is relatively easy to eliminate from Jacopo's *oeuvre* all of the free-standing sculpture found on the tomb and concentrate upon the effigy on the lid and the

front side of the sarcophagus, which shows a traditional representation of a university professor with his students in the classroom; these two elements have better claims to be associated with Jacopo, at least on the basis of quality. The hands of the deceased are crossed in death; he is dressed in a doctor's cap and gown. Although certainly a dignified and skillful work, it does not correspond to Jacopo's late style as exemplified on the *Portal of San Petronio*, being somewhat more crisp and harsh was well as being a bit fussy. Although the *Tomb of Antonio da Budrio* (cat. 13) is badly worn, making comparisons difficult, one would be hard-pressed to see the two images as coming from the same artist. Although alternatives to Jacopo do not readily present themselves, one might suggest a northerner, probably from Milan, as the author of the effigy. Earlier attributions are found in *Jacopo della Quercia nell'arte del suo tempo*, pp. 254–263. See also Beck, *Il portale*, pp. 55–56.

What is true for the effigy is also true for the relief below, although here there are if anything more specific Querciesque quotations, together with certain of his mannerisms, like the gesturing and pointing figures. The possibility that Cino di Bartolo had a share, as Seymour has suggested *(Quercia*, pp. 73–74), is reasonable on historical grounds, although Cino's personal style is too little known to say much more. Nonetheless, I reject any share in the *Bentivoglio Monument* for Jacopo della Quercia, a conclusion that is confirmed by appreciating the excessive demands upon his time in the mid and late 1430s and in view of his declining health.

Handlist 11. *The Judgment of Solomon.*

Location: Northwest corner, Palazzo Ducale, Venice.

Date: ca. 1430–1435.

Comment: The association of this distinctive composition with Jacopo of about 1410 to 1412 was made by Cesare Gnudi in a 1966 lecture at the Gallerie dell'Accademia of Venice (summed up by E. Arslan, *Venezia gotica*, 1970, p. 194; see also *Jacopo della Quercia nell'arte del suo tempo*, 1975, pp. 100–105). In addition Gnudi proposed that the Annunciation on the façade of San Marco and some of the *doccioni* were attributable to Jacopo.

Not only is this 1410–1412 dating for the Solomon impossible on stylistic grounds but it is impossible, too, in terms of the building history of the Palazzo Ducale, since that section was constructed long after Gnudi's presumed date for the group. The possibility of a role for Jacopo della Quercia is no longer considered seriously by modern critics, although the difficult question of the *Judgement*'s authorship remains open. At issue is whether the sculpture was produced by a Tuscan workshop headed by Nanni di Bartolo or by a Venetian one directed by Bartolomeo Buon, an idea put forward by W. Wolters *(La scultura veneziana gotica, 1300–1460*, pp. 287–288). Both positions have merit, and I am undecided, recognizing the attraction of Pope-Hennessy's suggestion *(Italian Gothic Sculpture*, p. 220) of a collaboration between a Tuscan sculptor and the Buon studio.

Handlist 12. *The Contini-Bonacossi Francescan Saints.*

Location: Castel Sant'Angelo, Rome, and Art Market (?).

Date: 1440s.

Comment: I consider these figures, including San Francesco and San Gherardo di Villa-magna, to be markedly fine sculptures that may be connected with one of the hands active on the *Bentivoglio Monument*. They appear to me to have been executed for the most part in the 1440s (see the entry in *Jacopo della Quercia nell'arte del suo tempo*, pp. 264–267).

The rather small heads, deep-set eyes, and specified expressions have little to do with Jacopo's late style as exemplified by the *Casini Madonna* relief. Rather these works look forward to the manner of Niccolò dell'Arca and perhaps represent a local post-Quercia tradition in Emilia that has not yet been thoroughly defined.

Handlist 13. *Saint George and the Dragon Relief.*

Location: Museo storico dell' antichità, Cesena.

Date: ca. 1440.

Comment: The relief, which is accompanied by the coats of arms of the Malatesta, has been attributed to Jacopo by G. Brunetti ("Sulla'attività di Nanni di Bartolo nell'Italia Settentrionale," in Chelazzi Dini, ed., *Jacopo della Quercia fra Gotica e Rinascimento, Atti*, pp. 189–191). I find nothing Querciesque about the relief whatsoever, nor do I believe that it was carved by a Tuscan artist.

Handlist 14. *San Martino* (also known as *Sant'Ansano* or *San Cassiano).*

Location: Pieve, San Cassiano di Controne (Bagni di Lucca).

Date: ca. 1407.

Comment: This imposing under-lifesize group was first published by P. Bacci in *Rassenga d'arte senese e del costume* (1927), vol. 1, and was later associated with Francesco di Valdambrino by Ragghianti ("Su Francesco di Valdambrino," 1938, pp. 140–141), an attribution that has had a wide acceptance. The alternative attribution to Jacopo was put forward by U. Middeldorf ("Due problemi querceschi," 1977, pp. 147–149) and more extensively by D. Strom ("A New Attribution to Jacopo della Quercia: The Wooden St. Martino in S. Cassiano in Controne," 1980), who correctly identified the subject as San Martino, not Sant'Ansano. Freytag, somewhat earlier, suggested that it was produced as a collaboration, with the figure of the saint by Francesco di Valdambrino and that of the horse by Jacopo della Quercia ("Beiträge zum Werk des Francesco di Valdambrino," 1971, p. 376).

This is a work of great beauty, although the original polychromy has been lost and it has suffered considerable damage. Not only is the attribution a problem but so is the dating, which has varied from around 1406/1407 to 1421. The late date was put forward by Del Bravo *(Scultura senese del Quattrocento,* 1970, p. 48) and upheld by M. Burresi ("Incrementi di Francesco di Valdambrino," 1985, p. 59n20) Instead, I accept the earlier dating range and consider the group to be exclusively by Francesco di Valdambrino. There is nothing in the known sculpture by Jacopo della Quercia that reveals the "impressionistic" handling found in the head of the saint, for example. I find correspondences with the superb reliquary busts in the Museo dell'Opera of Seina Cathedral.

Handlist 15. *The Santuccio Annunciation.*

Location: Pinacoteca Nazionale, Siena.

Date: ca. 1455.

Comment: Recently reproposed as a work by Jacopo della Quercia by Alessandro Bagnoli (in Bagnoli and Bartalini, eds., *Scultura dipinta,* 1987, pp. 161–163) following an indication

of L. Bellosi, the group, which was given a heavy gilding in the seventeenth century, has few direct links to Jacopo della Quercia. I concur with Pope-Hennessy ("Painted Sculpture in Siena," *Apollo,* Dec. 1987, p. 431) that the group merely reflects Jacopo's style but is later; I do not believe, however, that it is necessarily by Antonio Federighi as does Seymour *(Quercia,* fig. 96).

Handlist 16. *Tabernacle with the Annunciation.*

Location: Collezione Chigi Saracini (formerly Sant'Eugenio a Monistero), Siena,

Date: ca. 1410–1415.

Comment: A gesso press is currently in the church in place of the original marble, which was sold at the Mazzoni Sale in Siena (in May 1928) as a Tino da Camanio (attribution). The copy was published by Garzelli *(Sculture toscane,* 1969, pp. 160–161). G. A. Pecci made a drawing of it ("Raccolta iscrizioni . . . Terzo di S. Martino," libro 2, no. 297, fol. 84 in the Biblioteca Comunale, Siena) when the work was in San Maurizio. It was known to Bacci (see *Francesco di Valdambrino,* 1936, p. 408, a reference supplied to me by John Paoletti) who attributed it to Domenico di Niccolò dei Cori. In "Jacopo a Todi" (1977), p. 106, I dated it to 1395–1400 and proposed Jacopo for the original, seeing connections with the Pisani on the basis of the plaster cast.

In an exhibition in Siena at the Palazzo Chigi Saracina (Nov. 12, 1989, to Feb. 28, 1990), the relief is exhibited as by Giovanni di Cecco, and dated between 1363 to 1376. The coat of arms on the bases of the two figures has been identified as belong to the Lucarini. After having seen the original (1990), which I was finally able to examine, I believe that it should be dated to the second decade of the fifteenth century. The tiny half-length Christ represented prominently in the lunette would be unusual for a trecento work. I tentatively accept the attribution to Domenico di Niccolò dei Cori.